D0408754

Theories of Contemporary Art

(signature: Richard Hertz)

Richard Hertz

Art Center College of Design

PRENTICE-HALL, INC. *Englewood Cliffs, New Jersey 07632*

Library of Congress Cataloging in Publication Data
Main entry under title:

Theories of contemporary art.

 Bibliography: p. 306
 Includes bibliographical references and index.
 1. Art, Modern—20th Century. 2. Art—Philosophy.
I. Hertz, Richard.
N6490.T494 1985 709'.04 84-6940
ISBN 0-13-913666-5

FOR FELIZA, PAMELA, MELISSA, AND JULIA

Editorial/production supervision and
 interior design: Dan Mausner
Cover design: George Cornell
Manufacturing buyer: Harry P. Baisley

Printed in the United States of America

10 9 8 7 6 5 4 3 2 1

ISBN 0-13-913666-5 01

PRENTICE-HALL INTERNATIONAL, INC., *London*
PRENTICE-HALL OF AUSTRALIA PTY. LIMITED, *Sydney*
EDITORA PRENTICE-HALL DO BRASIL, LTDA., *Rio de Janeiro*
PRENTICE-HALL CANADA INC., *Toronto*
PRENTICE-HALL OF INDIA PRIVATE LIMITED, *New Delhi*
PRENTICE-HALL OF JAPAN, INC., *Tokyo*
PRENTICE-HALL OF SOUTHEAST ASIA PTE. LTD., *Singapore*
WHITEHALL BOOKS LIMITED, *Wellington, New Zealand*

Contents

Introduction

The essays in this anthology respond in different ways to "modernism," a complex theory of art which was developed in England in the writings of Clive Bell and Roger Fry and promoted most influentially in the United States by Clement Greenberg and Michael Fried.

Greenberg believed that the task of art was to oppose the infiltration of kitsch into contemporary life, where kitsch is understood to be a popular art of instant assimilation—art produced for mass consumption. Greenberg viewed kitsch as a complete compromise of aesthetic standards, an art of mere entertainment. The alternative that Greenberg proposed (in "Modernist Painting") was modernism's pursuit of purity through self-criticism.

> The task of self-criticism became to eliminate from the effects of each art any and every effect that might conceivably be borrowed from or by the medium of every other art. Thereby each art would be rendered "pure," and in its "purity" find the guarantee of its standards of quality as well as of its independence. "Purity" meant self-definition, and the enterprise of self-criticism in the arts became one of self-definition with a vengeance.

Greenberg concentrated on self-criticism in painting, which became a preoccupation with the medium of painting. He argued that when painters emphasized the literal qualities of the paint materials, reinforced the objecthood of the canvas, applied paint in an impersonal way by spraying, rolling, or pouring, and created optically "flat" paintings which did not bring to mind three-dimensional objects, they were discovering the irreducible essence of painting.

Michael Fried (in "Shape as Form Frank Stella's New Paintings") developed Greenberg's insistence on quality and medium without, however, sharing Greenberg's view that the essence of painting is timeless.

> What the modernist painter can be said to discover in his work—what can be said to be revealed to him in it—is not the irreducible essence of _all_ painting, but rather that which, at the present moment in painting's history, is capable of convincing him that it can stand comparison with the painting of both the modernist and the pre-modernist past whose quality seems to him beyond question.

For Fried, the criteria of ambitious painting, comparable with those of the old Masters, are "self-sufficiency" and "presentness," qualities which emphasize the instantaneous apperception of a work and discourage any reflections on narrative content. Narration is rejected because it is associated by Fried with the "theatrical" in the broadest sense—art forms that develop in time. For Fried, the distinguishing characteristic of the best painting is that it is self-sufficient—that it does not address the concerns of its viewers. These characteristics of modernism—the opposition to popular culture, the emphasis on high art and self-sufficiency, the preoccupation with medium and purity, the desire to maintain a rigid distinction between art and popular culture—are debated, and usually opposed, in the essays collected here.

If "modernism" has developed a coherent meaning over the years, "post-modernism" is much less well defined. It has taken on the generic function of signaling a contrast to modernism, in particular to modernism's insistence that the standards of judgment and criticism pertain to a work's medium. Some of the characteristics of postmodern art, the specifics of which are developed in the forthcoming essays, include a preoccupation with the deconstruction of "real life" ideology, especially the languages of television, advertising, and photography; the recognition that fine art exemplifies the prevalent political, cultural, and psychological experience of a society; the acknowledgment and analysis of the usually hidden contexts of art—museums, dealers, critics, and art markets; the willingness to borrow indiscriminately from the past; and a realization that more than one approach to art and artmaking is necessary in order to reflect contemporary life.

In short, rather than exclusivity, purity, and removal from societal and cultural concerns, the emphasis is on inclusivity, impurity, and direct involvement with the content of contemporary experience.

In choosing the essays included in this book, all of which deal with these themes, I wanted to make sure that the material would be readily understood by people who are receiving their first introduction to contemporary art theory. I chose articles which were influential when first published, which were an especially clear statement of a widely held point of view, or which provided a provocative, and even extreme, analysis. I had originally intended to divide the essays into four sections; I also wished to include an extensive selection of art criticism concerning particular artists and their work in order to relate theory to practice. Because of limitations of space I have not been able to carry out this plan.

The articles are ordered in a loosely thematic way, focusing first on painting in general and neoexpressionist painting in particular; second on the use of art as a tool in cultural analysis; third on the revised meanings of contemporary sculpture; and finally on time-dependent performance modes of art. The articles are for the most part from "mainstream" American art journals and reflect their biases. There is little material specifically on ethnic arts, mural art, mail art, photography, video, and much else, even though all of these practices have had a decided effect on contemporary art. There simply is not enough room to do justice to all of these influential modes of contemporary art.

I am grateful to the authors and publishers of the articles for granting me permission to reproduce their material. For clerical assistance, I am indebted to Mary Morris. For recommendations of specific articles, I am obliged to my students at Art Center College of Design as well as to Linda Burnham, David Carrier, Laurence Dreiband, Thomas Lawson, Stephen Nowlin, Peter Plagens, Stephen Prina, and Robert Rosenblum. For their encouragement and friendship over the years, I thank Ali Acerol, Diane Buckler, John King-Farlow, Don Kubly, Robert Rosenstone, Robert Rowan, and Imogen Sieveking. For her advice, love, and support, I especially thank my wife, Pamela Burton.

R.H.

Critic Kim Levin argues that seventies' art, which seemed so ill-defined, in fact marked a transition in consciousness from those qualities associated with modernism—ahistorical, scientific, self-referential, reductionistic—to some of the multiple emphases of eighties' art—historical, psychological, narrational, political, synthetic. Modernist dogma and purity were overthrown by an openness to form and content, a revolt against a *priori* norms governing what is or is not "allowable" art.

Farewell to Modernism

Kim Levin

The '70s has been a decade which felt like it was waiting for something to happen. It was as if history was grinding to a halt. Its innovations were disguised as revivals. The question of imitation, the gestural look of Abstract Expressionism, and all the words that had been hurled as insults for as long as we could remember—illusionistic, theatrical, decorative, literary— were resurrected, as art became once again ornamental or moral, grandiose or miniaturized, anthropological, archeological, ecological, autobiographical or fictional. It was defying all the proscriptions of modernist purity. The mainstream trickled on, minimalizing and conceptualizing itself into oblivion, but we were finally bored with all that arctic purity.

The fact is, it wasn't just another decade. Something did happen, something so momentous that it was ignored in disbelief: modernity had gone out of style.[1] It even seemed as if style itself had been used up, but then style—that invention of sets of forms—was a preoccupation of modernism, as was originality. The tradition of the New, Harold Rosenberg called it. At the start of the '70s there were dire predictions of the death of art by modernist critics and artists. By now it is obvious that it was not art that was ending but an era.

We are witnessing the fact that in the past ten years modern art has become a period style, an historical entity. The modernist period has drawn to a close and receded into the past before our astonished eyes. And because the present was dropping out from under us, the past was being ransacked for clues to the future. The styles of modernism have now become a vocabulary of ornament, a grammar of available forms along with the rest of the past. Style has become a voluntary option, to be scavenged and recycled, to be quoted, paraphrased, parodied—to be used as a language. Modernist and pre-modernist styles are being used as if they were decorative possibilities or different techniques—breeding eclectic hybrids and historicist mutations—by narrative artists and pattern painters, by post-conceptualists

Reprinted from Kim Levin, "Farewell to Modernism," *Arts Magazine* (October 1979). © 1979 by Kim Levin.

and former minimalists and unclassifiable mavericks.[2] For many artists, style has become problematic: it is no longer a necessity.

The art establishment is still uneasy with the idea.[3] It is more comfortable searching short-sightedly for the trends of the decade—as if it were just another decade—or calling it "pluralistic," or proclaiming, as Philip Lieder did recently, that pure abstraction is still the new paradigm.[4]

Nevertheless, post-modernism is fast becoming a new catchword, and it is full of unanswered questions and unacknowledged quandaries. What is it that has so irrevocably ended, and why, and when did the break occur? If we are going to talk about post-modernism, we should start by defining modernism, by questioning how we can recognize whether something is—or isn't—modernist. For those who have stepped outside modernism, the successive styles of the modern period, which seemed so radically different from each other at the time, are beginning to merge together with shared characteristics—characteristics that now seem quaintly naive.

Modern art was scientific. It was based on faith in the technological future, on belief in progress and objective truth. It was experimental: the creation of new forms was its task. Ever since Impressionism ventured into optics, it shared the method and logic of science. There were the Einsteinian relativities of Cubist geometry, the technological visions of Constructivism and Futurism, de Stijl and Bauhaus, the Dadaists' diagrammatic machinery. Even Surrealist visualizations of Freudian dreamworlds and Abstract-Expressionist enactments of psychoanalytical processes were attempts to tame the irrational with rational techniques. For the modernist period believed in scientific objectivity, scientific invention: its art had the logic of structure, the logic of dreams, the logic of gesture or material. It longed for perfection and demanded purity, clarity, order. And it denied everything else, especially the past: idealistic, ideological, and optimistic, modernism was predicated on the glorious future, the new and improved. Like technology, it was based all along on the invention of man-made forms, or, as Meyer Schapiro has said, "a thing made rather than a scene represented."

By the 1960s, with Pop art embracing the processes and products of mass production and Minimalism espousing the materials and methods of industry, the ultimate decade of technology had arrived. By the time men were traveling to the moon, art was being assembled in factories from blueprints, Experiments in Art and Technology (E.A.T.) was showing the results of its collaborations at the Armory and the Brooklyn Museum, the Whitney had a light show, MOMA had a machine show, Los Angeles had a technology show, and at the ICA in London there was an exhibition of cybernetic art made by machines.[5] It seemed as if the glorious technological future the early modernists dreamed of had arrived.

But at the height of this optimism, modernism fell apart. The late '60s was also the time of Vietnam, Woodstock, peace marches, race riots, dem-

onstrations, and violence. 1968 may have been the crucial year, the year we stopped wanting to look at art as we knew it, when even the purest form began to seem superfluous, and we realized that technological innovation wasn't enough. The work of a great many artists underwent radical changes. Minimalism, the last of the modernist styles, collapsed in heaps of rubble on gallery floors as scatter pieces proliferated, the Castelli Warehouse opened, the Whitney had its anti-form anti-illusion exhibition, earthworks went into the wilderness, Conceptualism came out of the closet, and art became documentation.[6] In a sense it was the ultimate god-like act of modernism: creating a work out of nothing. In another sense it was obvious that something was over.

It may have been especially obvious to the surviving Surrealists who had spent a lifetime interpreting the unconscious. In September 1969, on the third anniversary of André Breton's death, "a group of followers announced that the historical period of Surrealism had ended but that it had eternal values."[7] At the time it seemed a belated Surrealist joke. In retrospect it proves uncannily accurate: the modernist era, within which Surrealism had existed somewhat unwillingly,[8] had actually just ended. It could be argued that the precise moment of its demise was signaled a few months earlier by the revelation of Duchamp's *Etant Donnés*—with all its hybrid impurity, illusionistic theatricality, narrative insinuations, and counter-revolutionary contradictions—opening a peephole into a magical natural world as if predicting the concerns of post-modern art.

It has taken ten years to realize we had walked through the wall that was blocking out nature. Modernism, toward the end of its reign, came to be seen as reductive and austere. Its purity came to seem puritanical. It was in the terminology—in a word, formalism—which implied not only the logical structures of modernist invention but also the strictures of rigid adherence to established forms. "There is no other democracy than the respect for forms," one of the new French philosophers has remarked. Like democracy, modernist art is now being reinterpreted in terms of its insistence on forms and laws rather than in terms of liberty and freedom. The modernist vision may have had democratic aims—a progressive emancipation of the individual from authority in an age of unlimited possibilities, as Schapiro has noted—but in practice it was elitist: the public never understood abstract art. It was as specialized as modern science. And emphasis on structure rather than substance is what we came to see in it. Like science, modernist art has begun to seem dogmatic and brutal.

Because it was competitive and individualistic, it saw everything in terms of risk. Like capitalism, it was materialistic. From its collage scraps and fur-lined teacup to its laden brushstrokes, I-beams, and Campbell's soupcans, modernist art insisted increasingly on being an object in a world of objects. What started as radical physicality turned into commodity; the desire for newness led to a voracious appetite for novelty. Post-modernism

began, not just with a disillusionment in the art object, but with a distrust of the whole man-made world, the consumer culture, and the scientific pretense of objectivity. It began with a return to nature. The mood was no longer optimistic. Logic no longer sufficed. Technology has undesirable side-effects and in a world threatened by defoliated land, polluted air and water, and depleted resources, by chemical additives, radioactive wastes, and space debris, progress is no longer the issue. The future has become a question of survival.

Only now can we begin to realize just how widespread this shift of consciousness was. In 1967 the art magazines were full of sleek cubic forms; by 1969 those steel and plastic objects had been replaced by natural substances, ongoing processes, photographic images, language and real time systems. It wasn't simply the appearance of another new movement, as in the past. It was a crucial change that affected artists of all persuasions. For a large cross-section of the artworld it was a turning point.[9] And all the changes can be traced, by various circuitous routes, to a strong desire to make things real, to make real things. Those photographs from the moon of a marbleized little blue earth may have altered our perception. In diverse and unexpected ways, art was going back to nature. But having been absent for so long, nature was unrecognizable. In the beginning it looked like demolition. But the post-minimal movements—statements against formal purity that were modernist reductions as well—were not just an issue of withholding goods from the marketplace, an embargo on the object.[10] Returning materials to their natural state, subjecting them to natural forces, sending art back to the land or internalizing it within the body,[11] they were evidence that time and/or place were becoming crucial, clearing the way for the psychological and the narrational, for personal content, lifelike contexts, and subjective facts. The feeling against style and objectivity proved more subversive than the antipathy toward objects and form: post-modernism arose out of conceptualist premises—that art is information—while protesting its modernist aridity.

Post-modernism is impure. It knows about shortages. It knows about inflation and devaluation. It is aware of the increased cost of objects. And so it quotes, scavenges, ransacks, recycles the past. Its method is synthesis rather than analysis. It is style-free and free-style. Playful and full of doubt, it denies nothing. Tolerant of ambiguity, contradiction, complexity, incoherence, it is eccentrically inclusive. It mimics life, accepts awkwardness and crudity, takes an amateur stance. Structured by time rather than form, concerned with context instead of style, it uses memory, research, confession, fiction—with irony, whimsy, and disbelief. Subjective and intimate, it blurs the boundaries between the world and the self. It is about identity and behavior. "That the artist is now ready to lay his life on the line over a silly pun begins to define the sensibility of the Seventies," commented *Esquire* magazine early in the decade.[12] The return to nature is not only

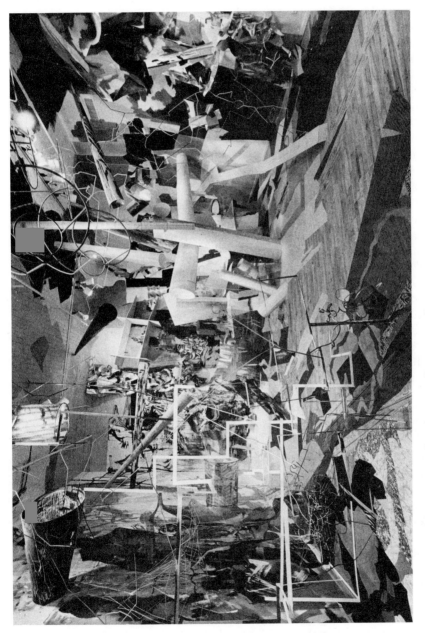

JUDY PFAFF, "3-D": Installation at Holly Solomon Gallery 1983 45' × 22½'
Photograph courtesy Waring Abbott.

an involvement with the natural world but an acceptance of the frailties of human nature. Which may have something to do with the fact that, if the artist as god-like Creator[13] was the leitmotif of modernism, the absent artwork—non-visual, shrunken or expanded beyond visibility, hiding out in the world or within the artist—has been a theme of the '70s.

But just what is post-modernist? Separating late modernist works from post-modern ones is no easy task at this juncture of periods. As in late Roman and early Christian art, or late Gothic and early Renaissance, they coexist. And right now a great deal of what is passing as post-modern is really late modernist or else transitional—a confusing mixture of both. The '70s has been a hybrid decade in more ways than one.

Doug Davis jokingly called post-modernism the fast-food chain of art, a phenomenon of late capitalism. And, with its accessibility, its informality, its unpretentious self-service and self-deprecating banality, it is certainly more like a Big Mac or a Whopper than the formal feast of modern art. But fast-food is all form and no content, preformed and packaged, reduced to a scientific formula, technological and sterile—exhibiting all the qualities of late modernism. And that is where the confusions lie. Because we thought the severity of Minimalist sculpture, of Ryman and Marden and Conceptualist art, signaled the ultimate reduction and the end of modern art, we have not been prepared to recognize that the appearance of decorativeness and ornamentation can be another manifestation of the late stage of a period—traditionally characterized by extremes and excesses, and veering from severity to over-elaboration.[14] Playing with modernist forms, elaborating on them, making them mannered and extreme, sacrificing structural honesty to appearance and decorative effects is—in art and architecture and hamburgers—a late modernist trait. Where is the line to be drawn between late modernist excess and post-modern recycling?

The intricate mannered space and ambiguous spatial illusions of the '70s are even more perplexing, for in those distortions and compressions the elastic space of post-modernism begins: an irrational, inclusive, and warping space has entered art during the past ten years, curving to encompass the totality of vision, and it can be seen either as a late modernist stylistic trait or as a post-modern perception of an insecure earth.[15] In the same way, mimicking the methods of science and technology or parodying their procedures, as some recent art has done,[16] may be another late-modernist excess, but at the same time the romanticization of science and technology into something personal and mystical—into a doubtful fiction— is post-modern. But, then, I should also point out that the act of defining and analyzing and trying to categorize is probably modernist. Old habits die hard. The modernist era may be over, but modernist art is still being made, sometimes by self-proclaimed post-modernists, just as post-modern work is being done by artists who still think of themselves as modernists. Almost everybody during the '70s has been transitional and hybrid.

If the grid is an emblem of modernism, as Rosalind Krauss has proposed—formal, abstract, repetitive, flattening, ordering, literal—a symbol of the modernist preoccupation with form and style, then perhaps the map should serve as a preliminary emblem of post-modernism: indicating territories beyond the surface of the artwork and surfaces outside of art; implying that boundaries are arbitrary and flexible, and man-made systems such as grids are superimpositions on natural formations; bringing art back to nature and into the world, assuming all the moral responsibilities of life. Perhaps the last of the modernists will someday be separated from the first post-modernists by whether their structure depended on gridding or mapping. But because the substructure of any terrain re-created on another scale depends on lines of longitude and latitude (the grid with which we have ordered the earth), maps are the secret and not-so-secret grids of reality, grids gone back to nature, hugging the earth, delineating content. The graph-paper diagrams of the '60s reduced the grid to its final stages: it became useful, a blueprint for making instead of a formal device. In our transitional time, the grid—when it is not elaborated into a decorative motif—has become a tool for making scale flexible, a device for mapping the features of an imagery, the memory of an experience, a place somewhere else, or a visionary plan.

And if psychoanalysis is the mode of self-discovery analogous to modernism, perhaps we should look to the self-awareness movements that have become popular during the '70s for a terminology appropriate to the new art.[17] Based not on scientific reason and logic and the pretense of objectivity but on presence, subjective experience, behavior, on a weird kind of therapeutic revelation in which it is not necessary to believe or understand— it is enough if it works. Or should we say that these fast-food chains of enlightenment are late modernist too? And instead of structuralism, linguistics, semiotics, what shall we propose? For the grid-like mental structures of those fashionable systems of analysis are already a little outmoded. They too belong to the transition.

Ten years after the end of the modernist age—but end sounds too final, age too grand—ten years after, the last modernists are still clinging to power and the post-modern forces are still a ragged band lurking in the underbrush, to put it in purple art prose. They don't always even recognize themselves, or each other, for mostly they are caught in the middle with sympathies on both sides of this metamorphosis that is taking place. Post-modernism has barely begun. It is too early to predict whether it will open a new era in art's history, or merely provide a final perverse coda to modernism.

NOTES

[1] And it wasn't just art. In fashion, the decade that marched in on space-age platform shoes is ending up in classic clothes and a series of revivals of past styles. In music, too, the past is being scavenged for alternate sounds.

[2] Artists as apparently unlike as Frank Stella and Lucas Samaras, Charles Simonds and Scott Burton, Dottie Attie and Eleanor Antin, Peter Saari and Roland Reiss, Jennifer Bartlett and Alexis Smith, for example, are joined by this attitude toward style.

[3] The architectural world, however, has openly welcomed post-modernism, perhaps because of the sterility of modern architecture or the writings of Robert Venturi and Charles Jencks. Or perhaps during the '70s—with sculpture largely a matter of natural structures, habitations, observatories, miniaturized villages, rearranged landscapes or imaginary civilizations, and painting often moving directly onto the wall to deal with the support structure—architecture has become the dominant art. Nevertheless, the genealogy of post-modern architecture is at variance with that of art. For example, Venturi traces the origins of post-modernist archi-tecture to Pop art. Hilton Kramer erroneously follows that cue for art, claiming that Pop art was anti-modernist while dismissing post-modernism as "revisionism from within." On the contrary, Pop art was thoroughly within the modernist tradition in its acceptance of tech-nology, and its formal use of contemporary objects from everyday life as abstract signs was not essentially unlike that of the Cubists.

[4] In his catalogue essay on Frank Stella's work of the '70s.

[5] And at Wise on 57th Street there was always a show of electronic or kinetic art. Rauschen-berg's *Soundings* at MOMA and Whitman's *Pond* at the Jewish Museum were two of the more memorable works fusing sound and light.

[6] The language shows at Dwan focused attention on words, and in January 1969 Seth Siegelaub opened and closed his hit-and-run gallery with a show of things that weren't there. Heubler's statement in the catalogue ("The world is full of objects, more or less interesting; I do not wish to add any more. I prefer, simply, to state the existence of things in terms of time and/ or place.") defined the new mood.

[7] According to Nicolas Calas.

[8] The position of Surrealism within modernist art is complex. The Surrealists had contempt for Cubism, they scorned Art Deco, their space was borrowed from the Renaissance, and though they were revolutionaries, they didn't quite share the modernist faith in progress and objectivity. But their use of the unconscious derived from scientific technique. And, as Moth-erwell noted in 1944, "plastic automatism . . . is actually very little a question of the unconscious. It is much more a plastic weapon with which to invent new forms. As such it is one of the twentieth century's greatest formal inventions." And now, as we move beyond modernism, the question of Surrealism is cropping up. Stella's most recent reliefs have Surrealist traits; so do Morris' irrational mirrors. Lichtenstein has been using Surrealist motifs. Samaras, whose art has often anticipated post-modern concerns, has always been accused of being a Surrealist. And there are Surrealist overtones in the work of the Poiriers, the Harrisons, Baldessari, Acconci, Oppenheim, Jonathan Borofsky, Jared Bark, and many other recent artists. It may be significant that the big Surrealist exhibition at MOMA took place in 1968.

[9] A glance at almost anyone's chronology reveals this shift. It isn't only the long list of artists whose careers start at that time, or the many artists who gave up painting or sculpture for process work, documentation or performance, who shifted to natural substances and gave in to gravity. To name just a few, Baldessari burned his paintings and began painting lettered statements; Irwin started using light instead of paint; Eva Hesse's work became snarled and visceral; Newton Harrison switched from technology to ecology; Samaras gave up the box form and began his chair transformations. Others gave up art entirely. Super-realist objects and images began to emerge. Renegade artists like Beuys and Haacke, like Nauman, Morley, and Les Levine, and eccentrics like Cornell and Westermann began receiving attention. Stein-berg's cartoons began to be accepted as art. And long-established artists like Guston, Held, and Tworkov gave up Abstract Expressionism for idiosyncratic illusions or ominous personal imagery.

[10] Nor was the new randomness and informality simply a formal move. Barbara Rose's recent theory of the influence of the 1967 Pollock exhibition on scatter works is somewhat misleading.

In 1969 Robert Morris wisely warned against identifying the new art with Pollock's fields on the grounds that this would be a formalistic misunderstanding. Robert Pincus-Witten's collection of essays on Post-Minimalism locates the shift in sensibility in the late '60s, but places it within the modernist tradition; and indeed most of the artists he chose to write about were still primarily involved in reductive modernist logic—in the analysis of pure form. His own style of writing since 1976, however, has been diaristic and narrative, more post-modern than the art it discusses.

[11] The photographic documentation of this work, along with the snapshot imagery of Photo-Realism, led to photography becoming the new medium for art by the early '70s. Susan Sontag, viewing the popularity of photography as a result of the destruction of modernism, has said, "I wasn't writing about photography so much as I was writing about modernity." The same could be said of art's sudden enthusiasm for the photograph: it was another sign of the demise of modernism and the acceptance of nature.

[12] The comment referred to a piece by Chris Burden, whose body works at the time were literalizing the modernist idea of risk.

[13] The Matisse chapel at Vence, the Rothko chapel in Houston, the Citicorp Nevelson chapel are not anachronisms, and recent *Artforum* articles comparing abstract art and religious icons are not irrelevant: the modernist condition alternated between puritanical denial and endless desire. Each style had its catechism of sins, its pantheon of saints. It is just that, religion having withered away, what was being worshipped was the spirit of invention.

[14] The late Minimalist proliferation of forms seen in the work of artists like Sol LeWitt and Jackie Ferrera belongs to this final stage of late modernism, but so does the pattern painters' multiplication of minimal forms into ornamental designs, and the decorativeness of recent work by Mel Bochner and Dorothea Rockburne, who started out with the severest of notions, and the wild profusion of elements in Stella's metal reliefs and in Samaras' aptly titled fabric "reconstructions." "Structural excess," Arthur Drexler called it in recent architecture, and in fact, much so-called post-modern architecture would seem to be late modernist, for a facade that tilts wildly or a reflective shiny surface may negate modernist functionalism with its excesses, but basically it is nothing other than an elaboration of modernist forms.

[15] This space can be found in Chuck Close's heads and in Al Held's geometry, in the three-dimensionalization of painting by Ralph Humphrey and Stella and in Lichtenstein's two-dimensionalized sculpture, in the spatial distortions of Samaras' Polaroids and the undulating space of Morris' recent mirror works and Kenneth Snelson's photographs, and in Morley's "plastic drift." There is even something of it in the bloated mannerism of Pearlstein, Leslie and Beal, in the awkward foreshortenings of Alex Katz and Alice Neel, in the violent perspectives of Estes and Cottingham.

[16] For example, work by Les Levine, Arakawa, the Harrisons, Chris Burden.

[17] Along with their counterparts, the self-effacing mystical religious cults of the '70s, these searches for fulfillment and meaning in life parallel art's new concerns with human potential. "This self-absorption defines the moral climate of contemporary society," writes Christopher Lasch in *The Culture of Narcissism*, viewing it as a desperate concern for personal survival, a symptom of the late 20th century. Even in science, the trend is away from objectivity. A noted astronomer recently remarked that perhaps it was time to stop seeking the origins of the universe in logical systems and turn instead to mysticism for explanations.

AGNES MARTIN, "Untitled" 1961 Ink and pencil on paper, 8" × 8¼"
Courtesy Margo Leavin Gallery, Los Angeles.

For painter Marcia Hafif, monochromatic painting can function as a method of gaining knowledge, as a deconstruction of the process of painting into its component parts—ground, paint, brush, and support. The resulting "esthetic primitivism," which allows for signs of the artist's hand, can be a personal search for the foundations of painting, not a blind application of modernist theory.

Beginning Again

Marcia Hafif

The options open to painting in the recent past appeared to be extremely limited. It was not that everything had been done, but rather that the impulses to create which had functioned in the past were no longer urgent or even meaningful. Tracing magic images, storytelling, reporting, representing in a one-to-one relationship a scene or figure in paint—none of these acts was credible in the way it once had been. Abstraction appeared to be used up; expression through shape and color was very familiar and had become meaningless. The process of flattening out the canvas had reached an end; formalist painting had soaked color into the canvas and moved shape to the edge, presenting an almost, but not quite, unbroken field. We no longer believed in the transcendency of paint and saw little reason to use the medium of painting for making art.

In the middle '60s some expressed surprise that I was still using a brush. By 1975 Max Kozloff could say, "for at least five years . . . painting has been dropped gradually from avant-garde writing, without so much as a sigh of regret"[1] (an odd situation was implied as he went on to admit that there were still plenty of artists painting).

The enterprise of painting *was* in question, *was* "under erasure." I use this term of Derrida's[2] to denote a state in which painting appeared to be no longer relevant, not quite right, and yet the only possible activity for one who has been or is a painter—an artist deriving satisfaction from painting, drawing, the ordering of space, with a sensibility directed to paint, to pencil, to materials in general. But there was no dialogue, no discourse.

It was necessary to turn inward, to the means of art, the materials and techniques with which art is made. Artists still interested in painting began an analysis—or deconstruction—of painting, turning to the basic question of *what painting is*, not so much for the purpose of defining it as to actually be able to vivify it by beginning all over again. That question led to examination of the discipline of painting, the taking apart of it as an activity; it led to a restatement of what we already knew along with an investigation

Excerpted from Marcia Hafif, "Beginning Again," © *Artforum* (September 1978).

11

of it in depth. We pretended in a certain way that we didn't know anything about painting. We studied and rediscovered it for ourselves.

This pretending resulted in a kind of extraconsciousness, a looking in from the outside. We were no longer "involved" in painting in the sense of engagement, but now saw clearly what we were doing from an exterior position—an attitude appropriate for the interim period of work which some saw this to be.

The notion that this was the last painting was not difficult to hold. And this greater consciousness could allow parody and the easy summation of painting, including the idea that it was actually possible for its relevance to have expired. Art could merge with other disciplines—science or religion—and cease existing as an independent activity. The idea of the end of painting had been around for a long time, long before Ad Reinhardt talked about the one size, the one color. . . .

Much of what I am talking about has had to do with the emptying of the field of work. A surface apparently without incident reveals to the artist the impossibility of eliminating it altogether and gives to the viewer the experience of seeming emptiness and the option of dealing with her/himself in that emptiness. What is there when we have taken everything away? What happens when there is very little to see? Painting has long flirted with emptiness. Think of Malevich, Humphrey, Reinhardt, Marden, Ryman. We could not say of any of these painters' work that everything else but one color has been removed. It is not a difficult task to distinguish between these "empty" paintings. The removal of known subject matter opened the way for other content to enter in. A painting without interior relationships of color and shape is not empty.

Although in these new explorations decisions are limited, one painting being very much like another—perhaps otherwise the same, but with minor changes—a differentiation should be made here between repetition and series. In order to treat one concern in depth the artist may indeed repeat work, knowing that repetition leads to a similarity and not to the *same*. This is very different from extending permutations, working in series. Every painting is complete in itself and, rather than being a variation on earlier work, is more like the earlier work than it is different—although it is different. The desire is not to work out all the possibilities so much as to refine central decisions, not to search for the new and different so much as to move toward the *one*.

With the elimination of drawing on the surface, painting is freed from the structural necessity, so strongly felt in the '60s, of relating shapes to the outside edge. The painting *is* the shape, and the horizontals and verticals of the canvas shape relate to the space it is expected to be seen in; but the surface is, in a sense, free. The use of the grid in the '60s also represented that kind of rigid structure, although it could be used with a certain purity

and a retaining of the personal—at least by Agnes Martin. In relation to the new work, however, the grid—as well as its atomized expression, the all-over—represents a control far too structural for acceptance of integral imagery that is now searched for. The grid provides a way to divide things into manageable chunks that is too easy. It is now too *known*.

The new, often monochrome work, insisting on a restatement of the essentials of painting, was begun with the idea that quality might be in some way definable, that at least painting must have meaning, must have credibility to our present way of seeing. The issue of "quality" has been discussed at length in recent years and I do not want to go into the entire question now. The quality which is felt to be definable here is felt in a wholeness existing in the work, through an integrity of the factors involved in its making, and it is measurable by the criteria set up in the work itself. Although the work is not pushing a message, the meaning inherent in it is crucial to its viability, and, on some levels at least, is very direct.

Painting can be understood on at least four important levels. First, the painting exists physically, as an object in the world which can be responded to directly; it is tactile, visual, retinal. Secondly, technical factors exist in the making of the painting; inherent qualities of material determine method; formal aspects of the work can be examined and understood, and therefore must stand up to certain criteria. Thirdly, a painting also exists as an historical statement; it is made at a particular time and represents the artist's view of the state of painting at that time, whether consciously or not. Finally, the painting represents a form of thought, indirectly reflecting the world-view of the artist and the time and transmitting philosophical and spiritual experiences. . . .

The work I am talking about is involved with the experience of *being*. It begins with givens. The material exists; decisions are made as to format, combinations of materials, tools, arena. Given one choice, others are made on the basis of that. A certain integrity pervades the whole. The artist is involved in *being* as a way of doing and in letting *be*, developing the materials worked with. The experience is one that few other activities allow us to know: the possibility of direct action in work with final materials, of seeing what was visualized materialize itself in our own hands. In that search for the present, for perception of being, the artist discovers a wholeness, a means of deriving beauty from within the area set out, from the nature of the materials together with the techniques and human attributes chosen to be dealt with.

I use the word "beauty" cautiously. One wonders if the term is valid, if it any longer has meaning, but we do need some way of indicating the psychotropic action of visual stimuli. It is undeniable that an effect is felt in the presence of certain phenomena—an awe, an excitement. That can be as simple as a reaction to a landscape undergoing the change of autumn

colors, or the sense of grandeur felt in the face of dramatic mountain scenery. The courtyard of an Islamic mosque can provoke that feeling, as can a simple bowl with a calligraphic inscription. We respond to the ingenious economies of Shaker furniture and to present-day work in similar ways.

This work is quiet, contemplative, and, as I have suggested, even meditative. This is a most difficult quality to discuss. We are used to talking in terms of materials and formal elements, but not of subjective content. Perhaps we feel that too much discussion dissipates the fact of it. We are trying to talk about an experience which is essentially personal. All monochromatic painting has something of this in it. (Other artists one might think of here are James Bishop and Susanna Tanger.)

Recent monochrome has been called Minimal or Reductivist. Because of the apparently reduced surface, it has been easy to relate this work to Minimalism. However, the recent work is not involved in modules, fabrication or industrial finish. This differentiates it, too, from Suprematism and Constructivism, where the goal was to eliminate the marks of the hand. The new painting accepts the marks of human touch and idiosyncrasies of the artist in conjunction with the varying results obtainable from given materials.

From process art such work took its tendency to set up a procedure, and accepting the results of carrying it out. Conceptual drawing also works this way: rules are given, and the work carried out. The product is the result of that action, although here personal content *is* allowed to enter. Art Povera contributed another concept, that of using simple methods and materials rather than difficult and costly ones. A term to consider is "esthetic primitivism" (borrowed from Robert Goldwater's *Primitivism in Modern Art*), which Carter Ratcliff says, "appears whenever an artist of any period intends to work with formal 'essentials,' either to establish the fundamentals of his medium or to engage perception at the deepest levels."[3] Both of these intentions are basic to recent work.

There have been in Europe in recent years such shows as "Fundamental Painting," "La Peinture en Question," "Analytische Malerei," "Bilder ohne Bilder," "Pittura." The Support/Surface group and related artists, analyzing the materials of painting and influenced by color-field painting, have written and theorized about their work. Claude Viallat has made work out of the elements of canvas, the stretcher, color, location. Dezeuze elaborates on the components of the stretcher. Louis Cane last year showed paintings in which even elements from figurative art were abstracted and incorporated in his generally flat color surfaces. Work shown in Italy, Holland and Germany, as well as the American work discussed here, grew largely out of a rejection of color-field painting and its atmospheric quality. More than the French, it tends to put elements together into a whole, rather than opposing them; it is less involved in binary opposition and Structuralism.

The artist I am talking about keeps work whole and within the vision of one author, rarely using an assistant, ordering work from a factory or working in a group. Painting has been able to gather new energy by throwing things out and starting afresh. Although much of it has seemed to continue reduction, it has been, more precisely, involved in a deconstruction, an analysis of painting itself. With belief remaining in the potentialities of abstraction, and in reaction to the apparent exhaustion of painting, the artists cited above, and others, began the inventory—the cataloging, the examination—of the parts I have spoken of. Painting became demonstrative, conceptual, a thing to be examined, more passive than it had been. The artist was making personal work. Thus certain changes came about. The format became generally smaller. Color became opaque, seen for itself rather than being used to create an illusion or to express. Line was used for itself rather than to delineate shape or form. Personal touch was readmitted; the sign of the brush and the artist's hand were again visible. These are elements of *painting.*

A certain span of this analytic period appears to be concluded now, although much about painting remains to be investigated. The whole area of relational color and shapes has barely been touched upon. Devices for creating illusion, and the history of painting itself, could provide further subject for study. Individual artists will decide whether or not this is necessary. But there has been through this analysis a reaffirmation of the strength of nonobjective means of artistic expression. If one phase of this period of analysis is coming to an end, we may be ready to enter still another phase of abstraction, a synthetic period.

NOTES

[1] Max Kozloff, "Painting and Anti-Painting: A Family Quarrel," *Artforum* (September 1975), p. 37.

[2] Jacques Derrida, *Of Grammatology*, trans. Gayatri Chakravorty Spivak (Baltimore: Johns Hopkins Press, 1974).

[3] Carter Ratcliff, "On Contemporary Primitivism," *Artforum* (November 1975), p. 58.

ROBERT ZAKANITCH, "Fruit Appeal" (Copa Series) 1984
Acrylic on canvas, 103" × 60"
Courtesy Robert Miller Gallery, New York.

Pattern painting was one of the first, cautious attempts to introduce content into mainstream painting in the mid-seventies. It was influenced by feminist artists' emphasis on crafts, weaving, and quilting, as well as by historical examples of patterning. Critic John Perreault still thinks of pattern painting as making a high art statement, with greater complexity and richness but without being merely self-referring. Its decorative function is viewed within the context of the grids and non-illusionistic paintings of orthodox modernism.

Issues in Pattern Painting

John Perreault

Pattern painting is non-Minimalist, non-sexist, historically conscious, sensuous, romantic, rational, decorative. Its methods, motifs, and referents cross cultural and class lines. Virtually everyone takes some delight in patterning, the modernist taboo against the decorative notwithstanding. As a new painting style, pattern painting, like patterning itself, is two-dimensional, nonhierarchical, allover, a-centric, and aniconic. It has its roots in modernist art, but contradicts some of the basic tenets of the faith, attempting to assimilate aspects of Western and non-Western culture not previously allowed into the realms of high art.

Pattern painting does not necessarily obviate or preempt other possibilities. It does, however, seem to be the most vital of several new directions for painting at this time.[1] An artist-generated movement that presents serious critical problems, it may signal a major change in taste. Naked surfaces are being filled in; lifeless redundancy is being replaced by lively fields that engage the eye as well as the mind. The grids of Minimal-type painting are being transformed into nets or lattices for the drawing out of patterns that are sensuous and that have content that goes beyond self-reference and the immediate art context, although including both. As a structure and a process, patterning allows a greater complexity of visual experience than most non-realist, advanced painting of the recent past.

It is helpful to see a new artistic style in terms of both continuity and discontinuity with other styles, not simply, as some would have it, in terms either of tradition or revolt. New art exists within history, because it both continues the past and breaks with it; also because it is made within a contemporary context and by individuals who themselves exist within history. Cultural need contributes to a new style as well, providing its ground. For some time some have felt that what we need is an art that will acknowledge Third World art and/or those forms traditionally thought of as women's work: an art that will enliven a sterile environment, an art that

Reprinted from John Perreault, "Issues in Pattern Painting," © *Artforum* (December 1977).

offers direct meaning without sacrificing visual sophistication, an art that will express something other than withdrawal, scientism, or solipsism. It can be claimed with considerable justification that pattern painting is precisely that kind of art.

Pattern painting, although it violates standard modernist taste—and that violation is the major form of its historical discontinuity—did not appear from nowhere. It has many sources, not the least of which are what has been called systemic painting, grid painting, Minimalist painting. In terms of continuity, pattern painting can be seen as a logical outgrowth of allover painting (Jackson Pollock) and grid painting (Agnes Martin), both of which broke with relational composition (Picasso, Mondrian)—grid painting itself being a rationalized, geometric extrapolation from allover painting and/or an analysis of its substructure. On the other hand, it is perfectly possible for some to continue to see pattern painting as a betrayal of this line of thought. That it is antipuritanical, that it has direct referents and therefore direct content, and that it is not rigidly self-referring represent important obstacles for some who might otherwise be able to see pattern painting adding remarkable possibilities for art. But these very "obstacles" are why pattern painting is necessary and generative. Like what was once touted as Lyrical Abstraction, pattern painting is allover painting and to some extent a kind of color field painting. Yet, unlike Lyrical Abstraction, it has structure. It also has content: it refers to patterning in the world. And for many it is even a feminist or pro-feminist statement, thanks to associations with decorative art. Furthermore, pattern painting is unashamedly decorative.

Whether painterly (Robert Zakanitch, Cynthia Carlson) or non-painterly (Valerie Jaudon, Mario Yrisarry), floral (Zakanitch, Robert Kushner, Kim MacConnel) or totally abstract (Jaudon, Yrissary, Joyce Kozloff), pattern painting challenges accepted notions of the division between fine art and the decorative arts. Whether quoted from, or at least based upon, historical patterning systems (Kozloff)—Islamic, Far Eastern, Celtic, Native American, et al.—or invented (Kendall Shaw, Jerry Clapsaddle), the use of patterning acknowledges, usually intentionally, the decorative function of art. That is a use of art that even Minimal/Conceptual art does not entirely manage to circumvent, since the empty canvas, the typed document, or the photo-joke still ends up over someone's sofa. Performances and video art are the only nondecorative—and nonobject—art modes, but it remains to be seen if their limits can be transcended, given a limited public and the ephemeral nature of both types of art. For the decorative qualities of works of art ironically assist their longevity and their preservation as much as they court the vicissitudes (and boredom) of fashions.

Pattern painting is part of a larger tendency that could be labeled "The New Decorativeness." Some artists, starting with an interest in patterning, have come to accept the decorative aspect of the results of their interest.

Other artists, primarily interested in challenging the decorative taboo, have quite naturally employed patterning as a means toward effecting that challenge, since patterning is an almost universal decorative device.

Patterning shares one important characteristic with recent abstract painting: in whatever form it takes it is flat. Pictorial space is at a minimum. Now a great deal of the anti-decorative bias has nothing at all to do with a defense of seriousness, but is an effort to claim a uniqueness for "mainstream" abstraction in regard to flatness, dogmatically disassociating it from its roots in the decorative arts.[2] But there is obviously no good reason why a painting cannot be both decorative and meaningful. The decorative is not necessarily the ornamental, and it may indeed have content. In the case of Islamic patterning, the content is often of a high religious and philosophical order that is unmatched by all but very few works of modernist abstraction.

In the past, within Western high art, artists have used pattern as one of many elements in a painting. Portraiture has been particularly rich in this regard, since the socio-economic status of the subject could be demonstrated by the representation of expensive garments and possessions, many of which were patterned in fashionable, intricate and/or exotic ways. Pattern painting brings this and other uses and depictions of pattern into renewed consciousness.

Modern art itself has not been immune. Patterning in the works of Gauguin and Klimt, and in many works of Matisse, is used as visual texture and for the evocation of luxury, voluptuousness, or the foreign. There is, furthermore, the hint of visual rhyme between the woven cloth that is the canvas itself and the patterned fabric that is depicted upon that cloth. The descriptive and semi-descriptive use of patterning within modernism thus often plays with flatness and provides the tension of a flirtation with decorativeness.

In the realm of present-day realism, Philip Pearlstein often portrays his studio nudes positioned on patterned rugs; Sylvia Sleigh displays a fondness for William Morris wallpaper and for patterns of all kinds, lovingly presented. One could provide countless examples of the use of patterns in painting, but in most instances pattern is only one element among many, and usually not the most important one. What is different about pattern painting is that it offers patterning *itself*.

What makes the use of patterning in pattern painting different from patterning in what is usually referred to as the useful arts—weaving, mosaic, and so on—and especially in the art of non-Western cultures, is in part the use of pigment on canvas, but also, and more importantly, intention and context. The intention is to make a high-art or fine-art statement within a contemporary context by referring to, and utilizing, what to many still remains within the world of non-art.

Actually, pattern painting presents a non-art look that is startling. Is

it a fabric design or a painting? This non-art quality can be associated with the "startlingness" of new art in general, which may be as good a definition of what used to be called "avant-garde" as any other. One way that art proceeds—it does not progress—is by the inclusion of methods, materials, systems, attitudes, or even subjects previously thought of as non-artistic. The new art that is going to add something to the already overloaded accumulation of art experiences, art objects, and art history usually does not look like the art we are already used to. When first seen it causes a double-take.

The double-take effect begins with the Readymades of Marcel Duchamp. It depends a great deal upon context. A bottle-rack would have little or no effect in a junk shop, but placed in an art context and considered as art, it reverberates; and by questioning, art becomes art. Its presence is a dislocation of expectations, so the first response is one of doubt. Since Duchamp this doubt has been provoked over and over again—by Abstract Expressionism, Pop Art, Minimal Art, Conceptual Art, Photo-Realism, and now pattern painting. The double-take effect has to do with cognitive readjustment—the time it takes to convert one "set" into another, the shift from seeing something as non-art to seeing it as art. Pattern painting does indeed look like wallpaper, at first.

Nevertheless, pattern painting comes in many shapes, sizes, and formats. The materials are also various. Cynthia Carlson favors impasto. In her *Wallpaper Pieces* she has abandoned the canvas altogether, affixing the thick acrylic motifs directly to the wall. Robert Kushner paints robes that are sometimes worn in fashion show performances before they are hung, unstretched, as "paintings" or decorations. Miriam Schapiro uses collage materials.[3] Tina Girouard, who quite early exhibited an unorthodox interest in commercial patterning with her linoleum floor pieces, uses stencils in her recent paintings, employing literal "patterns" (stencils) to make pattern paintings. Mario Yrissary for many years has deftly wielded the airbrush to create large and technically daring expanses of sensuous variations on the grid. Kim MacConnel often paints patterns on chunky used furniture. What connects all these artists, and many others, is the use of patterning.

Although most of us can recognize patterning when we see it, it is difficult to define. The usual definition is the most serviceable one, however. Pattern is the systematic repetition of a motif or motifs used to cover a surface uniformly. One recent critic insists that it is the intervals between the motifs that are the defining factor.[4] There is some truth in this, particularly concerning the simple patterning of fabrics and wallpaper that involves the use of the "brick" or the "half-drop" grid and when the motifs are fairly well separated by a blank ground. But using the intervals between motifs as the defining factor is inadequate. The only virtue in that is that the term "interval" can then be used to associate patterning with music.

Certainly there is a relationship, whether conscious or not, between pattern painting and the relatively tonal "avant-garde" music of such composers as Phil Glass, Steve Reich and Terry Riley, a music that involves degrees of repetition not usually permitted in Western music. This kind of music is sometimes referred to as "trance" music, or else as the aural equivalent of Minimal art, but it can just as easily be seen as the aural equivalent of pattern painting, particularly since its overall textural feeling approaches "prettiness" in a way that the music of John Cage does not.

Anyway, the spaces between motifs are either other motifs or are an integral part of the repeat. Furthermore, the interval theory is of little or no use in describing Islamic tessellation, interlocking motifs, vermiculation, interlacing, fretwork, or the kinds of patterns that can be derived from networks or lattices created by superimposing several grids.

Most texts on patterning, ranging from Islamic high art to the strictly commercial, identify the grid as the basis of all patterning. With the possible exception of the mandala (if indeed the mandala is a "pattern"), this is undoubtedly correct. Patterning may have begun with the marking out on bone or rock of astronomical phenomena, but it is more likely that weaving is its true source. The lines of warp and weft or of interwoven reeds make up the primordial square or block grid. This is what we usually mean when we speak of grids in contemporary art, ordinary graph paper being a ubiquitous example. The block grid in itself is not a pattern, but from it patterns can easily be derived—although Islamic tradition prefers the idea that patterns are discovered *within* grids rather than invented. Magic squares are sometimes the basis for elaborate patterns and motifs, but a simple process of counting will serve to illustrate: by coloring in every other square in a grid of squares, working continuously from left to right and top to bottom, if the number of squares in each row is odd, a checkerboard pattern will emerge, and if the number of squares is even, the result will be a series of stripes. From such simple procedures enormous systems are built.

Islamic patterning systems are probably the most complicated and most symbolic in the world. The approach is Pythagorean, neo-Platonic, and physiognomic. Regular polygons, for instance, have specific meanings that are seen as innate.[5] Here it is interesting to note a connection between Islamic abstract patterning and the early theosophically influenced ideas about nonobjective art in the writings of both Mondrian and Kandinsky, the pioneers of totally abstract art in modernism.

In the Islamic theory of patterning there are only three basic grids: the block grid (squares), the isometric grid (equilateral triangles), and the hexagonal grid. These are made up of the only regular polygons that can be arranged to cover a flat surface completely. However, a further reduction can be obtained, since the hexagonal grid can be derived from the isometric grid. Grids are the basis of nets or lattices which in turn are the basis of artistic patterns. All lattices are themselves patterns. In terms of

grids, only the block grid is not a pattern—but, even here, if the grid is rotated 45 degrees it immediately becomes a diamond pattern. A text on commercial patterns lists eight basic grids: square, brick, half-drop, diamond, triangle, ogee, hexagon, and scale.[6] These can be reduced to the two basic grids of Islamic patterning quite easily.

Another text classifies patterns by motifs, listing eight categories: animals, enigmas, figures, florals, geometric, novelties, scenics, textures.[7] There are certainly many more. One becomes aware of unusual motifs: a log being sawed (on pajamas), a moon landing complete with free-floating astronaut and earth-rise, a housedress patterned with pink chains on a yellow ground. The text already referred to illustrates not only "Bizarre Silks" made in early 18th-century Venice, but also patterns with the following motifs: dog heads, a man sowing grain, Gibson Girl faces, skeletons, and "paintings" showing Canadian scenes.

But patterning, even when using floral or other representational motifs, is usually nonillusionistic. The repetitions flatten out the space. Minor exceptions are Op art patterns, which, since they are impossible to look at for any length of time, are unsuccessful as patterns. Interlacing, in which "thickened lines" seem to move over and under each other in closed or open "knots" or elaborate "weaves," might be seen as the major exception: if so, it only presents the slightest illusionism and one that constantly reaffirms the surface. Frank Stella's "Protractor" series of paintings borrows this device (some of his paintings are patternlike, but they are not pattern painting, since the regular repetitions serve another end, that of underlining the objectness of the paintings).[8] Among the pattern painters, a full-fledged interlacing is, however, used quite successfully, by Valerie Jaudon, whose invented patterns to some extent refer to Islamic and Celtic interlace. Jaudon's paintings, like most other examples of pattern painting, have referents and therefore content.

Indeed, one of the most significant aspects of pattern painting is content. The usual resolution of the form-versus-content argument is to demonstrate that form is content, implying the physiognomic. That is quite in keeping with the Islamic theory of patterning, but it is as a resolution far too often used at the expense of other kinds of meaning where content is the product of a relationship between a sign and its referent, and where intention and context must be taken into account. The extremely limited and limiting notion that art—or if not all art, then at least the best art—can only be defined, and should only be defended, in terms of its self-referring qualities ("formalism") is virtually useless. The most vital art to emerge in the '70s is no doubt in large part a reaction against formalistic views, and displays in one way or another a concern with content. Perhaps the apparent meaninglessness of the political events of the turn of the decade has provoked a desire for meaning in art? Social concern and feminism have had a strong impact. Pattern painting, like some socially

aware concept art and like some new forms of realist art, is as concerned with meaning as it is with form.

That most patterning has always been abstract, examples of representational patterning notwithstanding, also means that once we get rid of our cultural bias against Third World art, "decorative" art, and traditional women's art, we may be able to break down the superficial elitism of Western abstract art. Patterning could be more of an art of the people than most forms of social realism. One characteristic of significant new art is that it calls attention to aspects of the world previously invisible to, or not attended to by, consciousness. Pattern painting does that. One becomes pattern-*conscious*.

NOTES

[1] Some of my thoughts on pattern painting were suggested by my work as guest curator of an exhibition at P.S. 1 entitled "Pattern Painting" (November 13 to December 4, 1977) featuring the work of over 20 artists. The exhibition might be subtitled "An Interim Survey." It calls attention to individual accomplishment and documents the great range of possibilities within the pattern painting style.

[2] See Joseph Masheck's "The Carpet Paradigm: Critical Prolegomena to a Theory of Flatness," *Arts,* September 1976, for a detailed discussion of flatness in terms of the "decorative" arts as genesis.

[3] Jeff Perrone, in "Approaching the Decorative," *Artforum,* December 1976, is struck several times by the collage analogy in a discussion that relates to the present one.

[4] Amy Goldin, "Patterns, Grids, and Painting," *Artforum,* September 1975. Amy Goldin is an early and sensitive supporter of the kind of art under discussion.

[5] David Wade, *Pattern in Islamic Art* (London: Studio Vista, 1976), is the best book I found on Islamic patterning, a complicated subject to say the least. In one instance, however, Plato's symbolism of polyhedrons (*Timaeus*) is misquoted.

[6] Richard M. Proctor, *The Principles of Pattern* (New York: Van Nostrand Reinhold, 1969).

[7] William Justema, *Pattern: A Historical Point of View* (Boston: New York Graphic Society, 1976).

[8] *Ibid.*, p. 88: "Although none of these paintings by Frank Stella could be called formal pattern, the artist has employed such pattern devices as recurring intervals, element rotation, overlapping and symmetry." Jean Lipman's slim but amusing *Provocative Parallels* (New York: E.P. Dutton, 1975) juxtaposes Stella's *Gran Cairo* with a traditional pieced quilt, c. 1875. Solutions to different problems may produce similar results. Some pattern painters, such as Robin Lehrer, however, have gone directly to traditional patchwork quilt designs.

DON BACHARDY, "Christopher Isherwood" 1982 Acrylic on paper, 40" × 26"
Courtesy the collection of Robert A. Rowan.

Art historian Linda Nochlin regards the "law of modernism" which dictates self-referential and non-illusionistic painting as being a reductionist and idealistic myth, excluding by fiat realist painting as a viable mode of contemporary art. She describes some of the historical precursors to modernism's emphasis on the abstract and the rational. For example, Bernard Berenson and Roger Fry criticized realism for being too unselective. They were in favor of an art founded on purely aesthetic criteria such as form and movement, structural design, and harmony. Nochlin argues that the precedence of modernism was not "inevitable," as some claimed. Realism's strength is precisely its close investigation of the moral values and specifics of everyday experience—plot, atmosphere, setting, and character.

The Realist Criminal and the Abstract Law

Linda Nochlin

"What is really important is that the criminal is at the very heart of the law. It's obvious: the law could not exist without the criminal."
——André Breton

I

The value of realism remains one of the basic issues facing art. Naturally, the value of art itself has a certain theoretical priority. But if we accept art at all, then the issue of realism must be dealt with in the context of its perennial antagonism to antirealism, whether this be idealism, symbolism or abstract art.

A historical phenomenon, Realism with a capital R, dominated art and literature in the West from the mid-nineteenth century until the 1880s, and it is now part of the past. But there were realisms before there was Realism. In its various guises and metamorphoses—naturalism, social realism, Magic Realism, *Neue Sachlichkeit*, even some Surrealism, and the various New Realisms of the present—realism has survived, been revived and reinvented until this very moment. Realism, of course, is a mode of artistic discourse, a style in the largest sense, not, as its enemies would have it, a "discovery" of preexisting objects out there or a simple "translation" of ready-made reality into art. Like other artists, realists must create a language of style appropriate to their enterprise; they may or may not reject previous nonrealist or antirealist styles; often their work modifies or

Reprinted from Linda Nochlin, "The Realist Criminal and the Abstract Law," *Art in America* (September, November 1973).

adapts them. Yet on the whole, realism implies a system of values involving close investigation of particulars, a taste for ordinary experience in a specific time, place and social context; and an art language that vividly transmits a sense of concreteness. Realism is more than and different from willful virtuosity, or the passive reflexivity of the mirror image, however much these may appear as ingredients in realist works.

The dominant imagistic structure of realism is metonymy—association of elements through contiguity—as opposed to the domination of metaphor in symbolist or romantic works. Whereas the nonrealist may work through distillation and exclusion, the realist mode implies enrichment and inclusion. Realism has always been criticized by its adversaries for its lack of selectivity, its inability to distill from the random plenitude of experience the generalized harmony of plastic relations, as though this were a flaw rather than the *whole point of realist strategy*. The "irrelevant" distractions characteristic of realist styles are not naïve mistakes in judgment but are at the heart of metonymic imagery, the guarantors of realist veracity. Irrelevance is indeed a prime feature of the intractable thereness of things as they are and as we experience them.

In realist works, details often function synecdochically, substituting the part for the whole, not because they have any "meaningful" relation to the larger whole—on the contrary—but merely because they are a part of it in the realm of things as they are. As Roman Jakobson has pointed out in a brief but suggestive article, "The Metaphoric and Metonymic Poles," "following the path of contiguous relationships, the realist author metonymically digresses from the plot to the atmosphere and from the characters to the setting in space and time. He is fond of synecdochic details. In the scene of Anna Karenina's suicide, Tolstoi's artistic attention is focused on the heroine's handbag."[1] The deliberate attention lavished on Proudhon's shoes in Courbet's well-known portrait of the philosopher; the abandoned corset occupying center stage of Degas's *The Interior;* the painstakingly delineated double- or triple-cast shadows in the Master of Flemalle's *Merode Altarpiece* or Philip Pearlstein's nudes; the minutely depicted rosewood grain of the furniture in Holman Hunt's *Awakening Conscience*; the individually drawn hairs of beard stubble in Jan van Eyck's *Man with the Red Turban* or in Chuck Close's portraits, different as they may be, are all at the very heart of the realist enterprise. They are far from being, as antirealist criticism would have it, a misreading of esthetic priorities.

Some critics, notably Eric Auerbach in his study of literary realism, *Mimesis*, have chosen to deal with realism as an evolutionary trend. But in the case of the visual arts it may also be subsumed as one pole of a long-standing opposition, with its contrary generally conceived of as some kind of idealism. With certain notable exceptions, realist art has been looked on as inferior to more idealized art forms. To ask why realist art continues to

be considered inferior to nonrealist art is really to raise questions of a far more general nature: Is the universal more valuable than the particular? Is the permanent better than the transient? Is the generalized superior to the detailed? Or more recently: Why is the flat better than the three-dimensional? Why is truth to the nature of the material more important than truth to nature or experience? Why are the demands of the medium more pressing than the demands of visual accuracy? Why is purity better than impurity? We shall consider these questions later.

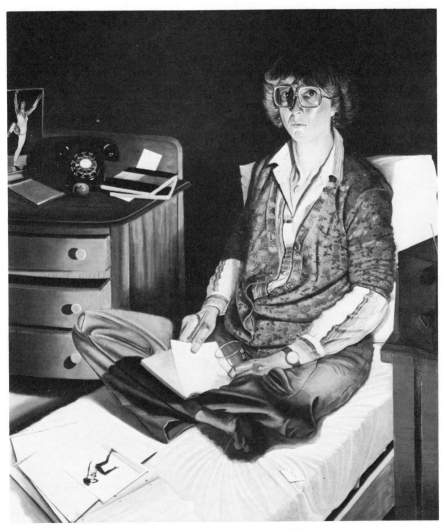

ALFRED LESLIE, "In the Studio of Gretchen McLaine" 1979 Oil on canvas, 84" × 72"
Photograph courtesy Allan Frumkin Gallery, New York.

Yet, while realism may be a perennial phenomenon, one might do better to talk about "realisms" rather than a single unitary "realism." A wide range and variety of stylistic possibilities are subsumed under the general category. Indeed, it might be fruitful to think of realism as a country on a map, surrounded by other countries, whose borders often merge imperceptibly with it. One such borderline might be primitivistic, popular or naïve art; another might be Surrealism; still another, Cubist collage and papier collé—where reality is introduced wholesale into the unreality of the picture world. Nor are the larger ramifications of realism always similar. In France in the mid-nineteenth century, realism may be associated with progressive, indeed radical social and esthetic currents. In relation to the avant-garde movements of the earlier twentieth century, it may assume a more conservative stance. In the fourteenth and fifteenth centuries, it may peacefully coexist or alternate with more idealized or conventional styles. Indeed, it was one of the requirements of traditional systems of literary and artistic decorum that the lower classes and coarser, more trivial events must be dealt with "realistically," the more elevated and idealized styles being reserved for the noble characters.

The antagonism between realism and antirealism only assumes important theoretical dimensions in the context of larger socioesthetic conflicts—during the Renaissance, for example, when artists wished to differentiate their creations from the mere products of craftsmen, or when, in the later nineteenth century, advanced artists wished to set themselves off from the banal naturalism of official art as martyr-prophets of a higher truth, of a purer reality beyond mere sense perception.

Though working in the opposite direction, Courbet, Zola and other supporters of the realist cause in the sixties and seventies viewed the breaking away from the artifices of empty purity as part of a larger struggle for scientific truth, progress and social justice. This does not reduce artistic phenomena to superstructures of an "underlying" social causality, but rather, sees stylistic and social phenomena as integrated and interdependent.

II

For Modernism, we may take it that abstraction is the law and that realism is the criminal. Abstract art in this century, and antirealism generally, purges art of its gross impurities, its tawdry accessibility, its general inclination toward what Rosalind Krauss has called the "documentary" mode. The law of Modernism—the use of the characteristic methods of a discipline to criticize the discipline itself; according to Clement Greenberg, the emphasis on the "ineluctable flatness of the support" in painting—is unthinkable without the criminal, realism, and its accessories before the fact, the representational and the sculptural.

In his definitive article, "Modernist Painting,"[2] Greenberg repeatedly

stresses the built-in antagonism between Modernist attempts to purify the discipline of painting and realist impurity. As against Modernism's use of art to call attention to art, presumably a good thing, "realistic, illusionistic art had dissembled the medium, using art to conceal art," obviously a bad one.[3] "Whereas one tends to see what is *in* an Old Master before seeing it as a picture, one sees a Modernist painting as a picture first. This is, of course, the best way of seeing any kind of picture, Old Master or Modern, but Modernism imposes it as the only and necessary way, and Modernism's success in doing so is a success of self-criticism."[4]

As opposed to realism's enthusiasm for breaking through the limitations of art, Modernism demands, in the name of scientific consistency, restriction: "That visual art should confine itself exclusively to what is given in visual experience, and make no reference to anything given in other orders of experience, is a notion whose only justification lies, notionally, in scientific consistency."[5] Interestingly enough, Zola, like so many of the realist theorists of the nineteenth century, had used the rationale of scientific method—which itself had different implications at the time—in quite a different way, to justify breaking through the conventional barriers separating art and life, in order to include "other orders of experience."

Central to the whole antirealist thrust of Modernism is the notion that the flat surface of the canvas makes some sort of absolute demand on the painter—indeed, that it was the mission of Modernism to strive for the self-definition of painting through flatness. This is of course a reductionist myth, which a dispassionate examination of the innovative painting of the last century or so hardly supports. Like so many passionately held myths, it has proved to be extraordinarily fruitful, a myth begetting further myths, in fact generating a whole ideology which in turn had some serious effects on the evolution of painting itself. That it is a mythology specifically aimed at the high or "pure" art of painting rather than other visual art forms is made clear by the different treatment accorded film.

If the self-definition of the medium demands flatness in painting, precluding representation as "impure," one would think that the same demands would hold good for film, which is, after all, a series of flat images projected on a flat surface, and is even more bound to abstraction or antirealism in that it shares with music—the most abstract of all the arts—the quality of temporal progression and, in addition, consists of projected light, surely the most "dematerialized" of media. Interpreted in these terms, film should be nothing but a succession of flat abstract light-images, non-narrative and nonrepresentational; indeed, some filmmakers and videotape artists make a good case for such a position.

Yet many of those who hold the Modernist position in regard to painting manage to find a different rationale, or rationalization, for supporting a narrative, representational, reportorial or documentary—in short, a real-

ist—film esthetic, presumably on the grounds of the implacable demands imposed by the medium. Yet one suspects there are other reasons besides purely esthetic ones lying in the background of this double standard for film and painting. Film, the latecomer to the arts, was plebian in its genesis and appeal, universal and popular rather than exclusive and difficult. By virtue of its social context, film is an essentially impure medium; the same high standards of purity and self-definition do not apply to it as they do to the elite realm of painting. It is as though looser standards of behavior were set for the slum child than for the little aristocrat. Indeed, one often suspects that Modernist critics go "slumming" in the less rigorous area of the film as a sort of relief from the perpetual high-minded purity they demand of the other visual arts.

This Modernist view of modern painting as a teleological progression toward more and more stringently defined purity excludes a great deal of modern art itself, not just the *Neue Sachlichkeit* or the New Realism, but much of Dada and Surrealism and even a great deal of the work of such a Modernist hero as Picasso, once he abandons strict Cubism. From the late twenties onward, Picasso is linked to the camp of inimical impurity. Says Greenberg of Picasso: "In 1927, execution and resolution begin to falter. . . ."[6] Indeed, the art of Picasso after the late twenties is never "pure" in the Modernist sense. While certainly not realist either, it is inextricably bound up with a deeply personal way of experiencing reality and with the artist's need and desire to grasp, possess and project this experiential reality through the art work. The most concrete details of Picasso's intimate sex life, a new mistress, trouble with his current companion, anticipation of a new passion—create explosions in the universe at large, embodied in the formal structure of his art.[7]

New languages and a new iconography must be invented by the artist, in which alchemical symbols mingle with antique deities, bathing huts assume the significance of primeval shrines, women's buttocks merge with the heavenly spheres to celebrate a new sexual conquest. As in the Renaissance, man, the microcosm, and the universe, the macrocosm, are seen as inseparably entangled. All effects in the one have counterparts and reverberations in the other, except that in Picasso's case, the microcosm is not the generic "man" but the singular and sexual Picasso himself, and the universe a novel constellation generated by his wit and desire. One might say that it is precisely the urge toward "other orders of experience," the fatal flaw according to Modernist critical theory, which is in this case the sign of the great, innovating artist. He can reject or transform the very conventions he helped to create, seeing them not as nonnegotiable demands of the *Kunstwollen*, but as barriers to be broken through in an effort to attain new and more urgent realities, while talents of the second level push his discoveries to their "logical" conclusions. It is precisely the urge toward

"other orders of experience," specifically those considered ordinary and down-to-earth, that tends to make realism inimical to so many theoreticians of art, from Antiquity through the Renaissance, and down to the present day.

In a sense, an antirealist viewpoint was implicitly incorporated into the very values that gave rise to a theory of art at all. It was the attempt to *create* a theory of art, to distinguish the modality of the esthetic from that of everyday experience, that conferred art's ideal, elevated status on one group of objects and experiences as opposed to another.

Status is generally conferred upon art insofar as it is separate from and superior to life itself. Realism, with its mundane attachment to the here and now, to the specific detail, to all that is transient, shifty and shapeless, with its tendency to transubstantiate the surface and the medium into the simulacrum of life itself, has been a villain—in the original sense of the term—for a long time.

Perhaps the realist-antirealist polarity is simply a sub-category of a still more encompassing evaluation of experience itself. Ever since antiquity, purified essences have been considered higher than material specifics, the Idea nobler than its concrete manifestations in earthly experience. The Platonic Ideal is beauty freed from its earthly dross, a dispassionate contemplation of the distilled and accident-free. This distinction, reinforced by and made more absolute in Neo-Platonic interpretations of Plato's doctrines, subordinated matter to spirit, substance to form.

A similar scale of values dominated French thought of the Renaissance and seventeenth century. The French dictionary attempted to purify the language of all plebian, practical and technical terms; Descartes posited two distinct modes of experience: Primary versus Secondary Qualities— the first abstract, qualitative, attainable by reason, permanent and superior; the second, ephemeral, decidedly inferior, even deceptive, the concrete sights, smells and sounds available to the senses. Still later, Kant and Hegel provided firm support for an idealistic, antirealist position in the arts.

None of these ways of dividing up and evaluating experience can be reduced to a simplified system of social causes and esthetic effects. And it is similarly impossible to make any absolute distinction between "aristocratic" modes of experience on the one hand and "plebian" ones on the other. But nevertheless, it is possible to assert that the values assigned to the ideal side of the dichotomy were generally associated with the nobler or more elevated segments of society, and their opposites to the lower echelons. It stood to reason that those crude in manners and dress, who had to work with their hands and stick their noses in manure, would hardly be concerned with abstract reasoning and elevated feeling. Living through their senses and utilitarian calculation, the lower orders would naturally

be bound to the concrete; their spirits, such as they were, could hardly be free from the gross specificity of everyday concerns. As such, those poor in wealth or social standing could hardly be expected to respond to the more universal manifestations of beauty.

In the past this attitude was generally expressed by the roles these lower-class characters occupied in the arts and in the way they were treated or depicted. According to Eric Auerbach's rich analysis of the evolution of literary realism, Mimesis,[8] only kings, nobles or heroes could be the subjects of tragedy or epic. The very terms "base," "ignoble," "low" imply social inferiority as well as moral opprobrium. Vestiges of these social determinants still linger in present-day literary terminology: the word "villain," which now simply designates a "person guilty or capable of great wickedness, a scoundrel," or the hero's antagonist, regardless of social class, originally referred to the "feudal serf, tenant holding by menial services," a clear designation of social inferiority. While the protagonists of classical art might be evil, cruel, or otherwise morally imperfect, they could never appear as ugly, petty-minded or ludicrous. Nor could they be guilty of incorrect deportment or behavior; this was reserved for lower-class characters engaged in low comedy or farce.

Thus what we might loosely call realism—prosaically described characters in specific everyday situations, with the social context often indicated by dress and setting—was originally reserved for the representation of lower orders of humanity. Indeed, the association of realism with the lower classes was a part of the Realist program enunciated in the mid-nineteenth century by such spokesmen as Courbet, Champfleury, Zola and Thoré. Realism with a capital R redeemed lower orders of class and experience through a style that evolved along with the demand for greater political and social democracy. The exaltation of the peasant, the worker and the petty bourgeoisie, and the birth of the self-conscious Realist Movement in the context of the 1848 Revolution were far more than coincidental.

The notion that ordinary experience per se might serve as the subject for serious art was still a relatively revolutionary one in the middle of the nineteenth century. Its more idealistic antagonists met the realist challenge head-on:

> It is a great pity that in the year 1851, one is reduced to demonstrating the most elementary principles of art, to repeating that art is not the unselective reproduction of the first object you happen to come across, but the delicate choice of an intelligence refined by study, and that its mission is . . . to raise us continually above our weak and unfortunate natures,

declared the critic of the Revue des Deux Mondes in 1851, when confronted with the outrage of Courbet's Stonebreakers and his Burial at Ornans in the Salon.

III

Neither Realism nor the antirealist attack upon it was, of course, completely new to the history of Western art. The realist vision had been the dominant mode at least three times previously: in Italy, in the art of Caravaggio, and, even more unequivocally in the Netherlands, during the fifteenth and seventeenth centuries. Yet while the Netherlandish art of the fifteenth and the Dutch masters of the seventeenth centuries certainly have had their admirers, they have for the most part been invidiously compared by the most authoritative spokesmen to the more elevated productions of the very font of Ideal Art: Italy. From Michelangelo to Berenson, Roger Fry and Clive Bell, the realist impulse of the North has served as a bad example for those who would establish the highest standards for art. In a way, the Modernist position is simply a variation and exaggeration of the antirealist stance of these illustrious predecessors. Only the specific content of the issue and the cast of characters have changed.

According to Francisco de Hollanda, Michelangelo scorned Flemish art for its unselective imitation of nature and its deceptive sensuality, saying:

> It will appeal to women, especially to the very old and the very young, and also to monks and nuns and to certain noblemen who have no sense of true harmony. In Flanders they paint, with a view to deceiving sensual vision. . . . They paint stuffs and masonry, the green grass of the fields, the shadow of trees, and rivers and bridges, which they call landscapes with many figures on this side and many figures on that. And all this, though it pleases some persons, is done without reason or art, without symmetry or proportion, without skillful selection or boldness, and, finally, without substance or vigor. . . . for good painting is nothing but a copy of the perfections of God and a recollection of his painting; it is a music and a melody which only intellect can understand, and that with great difficulty.[9]

In the seventeenth century, the classicistic theorist Joachim Sandrart criticized Rembrandt for his ignorance of the elevating properties of antiquity and for breaking the rules of art. Rembrandt's work, he implied, lacked the ideal clarity of classical sculpture, because the Dutch artist was unable to draw accurately. In addition, Sandrart complained (incorrectly) that Rembrandt, instead of devoting himself to subjects appropriate to a painter of the first magnitude—classical, allegorical or historical—tended to resort to ordinary insignificant subjects found in nature.[10] Another contemporary critic, Samuel van Hoogstraten, though he found a great deal to admire in Rembrandt's work, criticized his ignorance of the immutable laws of painting, his tendency to rely merely on his eye and experience,[11] and was particularly harsh with the artist for having included two copulating dogs in his grisaille of *The Sermon of St. John the Baptist.* Though such a natural occurrence could have taken place, to include it within the context of a religious painting was a vulgar and unfortunate lapse of taste and displayed ignorance of the laws of decorum.[12]

Still another near-contemporary faulted Rembrandt for having chosen a washerwoman rather than a Greek Venus as his model for a nude: ". . . Flabby breasts/Ill-shaped hands, nay the traces of the lacings/Of the corsets on the stomach, of the garters on the legs,/Must be visible, if nature was to get her due. . . ."[13] Rembrandt's proclivities for nature-in-the-raw were associated with his plebian manners and his unfortunate taste for the company of those beneath his station. The same association of realist art with coarse, lower-class behavior had been directed at Caravaggio and was later leveled at Courbet, who, of course, reveled in such accusations. According to Rembrandt's Italian biographer, Baldinucci, "the artist's ugly and plebian face was accompanied by dirty and untidy clothes because it was his habit to wipe his brushes on himself while he worked and to do other things of a similar nature."[14]

Even the relatively liberal French seventeenth-century art theorist, Roger de Piles, who really admired Rembrandt, included him in a blanket condemnation of the impurity and lack of selectivity of Netherlandish painters in general. Commenting on the statement of another French academician that "The principal and most important part of painting is to know how to recognize that which nature has made most beautiful and most suitable for this art," he wrote, "This is where almost all Netherlandish painters fail; most of them can imitate nature at least as well as the painters of other nations; but they make a bad choice, either because they have not seen the ancients, or because natural beauty is not ordinarily found in their country."[15] In general, to borrow the words of Seymour Slive, in his important article "Realism and Symbolism in Seventeenth-Century Dutch Painting,"

> De Piles and other seventeenth- and eighteenth-century theorists who maintained that painting should idealize man and generalize nature objected to the works by Rembrandt and other Dutch painters because they did not show knowledge of the ancients and did not know how to select the most beautiful from nature. They objected to Dutch painting because it was specific and familiar.[16]

In other words, they objected to Dutch art's realist elements.

It is of course understandable that these classicist theoreticians of the seventeenth century were anxious to elevate the status of art to that of the liberal arts and professions through the imposition of bias. Less obvious is the fact that similar extraesthetic factors have entered into the artistic positions of many more recent art theorists as well. One of the most influential of all English-speaking critics and art historians, Bernard Berenson, shared the antirealist bias of his predecessors. While in no way denigrating his achievements, it is, nevertheless, important to see them in perspective.

Like his seventeenth- and eighteenth-century predecessors, he attempted to establish a canon, a standard of judgment not merely for as-

sessing the genuineness of Italian paintings, but for making universal statements about the quality of art in general as well as its relation to other aspects of experience. His conception of art as life enhancement, caused by the effects of ideated sensations, in turn reducible to the components of tactile values, movement and space composition, is firmly directed against realism. In an admirable eulogy, Kenneth Clark explained Berenson's low opinion of Uccello and Pietro Lorenzetti by pointing out that "to condemn a Renaissance painter in the 1890s for naturalism is surprising and impressive." It was Berenson who reversed the customary fin-de-siècle evaluations of the more realistic Ghirlandaio—then thought to be the climax of the Quattrocento—dismissing him as the "painter for the superior philistine," and the then-undervalued Botticelli, whom Berenson elevated to the position of "the greatest artist of linear design that Europe ever had."[17] Indeed, it is precisely his bold rejection of the standards of banal naturalism of his day, as well as of realism generally, that unites Berenson with the art theory and practices of the twentieth-century avant-garde, despite his professed dislike for Modernism.

Clement Greenberg may indeed be right in maintaining that "when Mr. Berenson intimates that the very highest qualities of art are defined for all time in canons derived from Greek art, and from its tradition as continued in Postmedieval European art, he is being dogmatic, not philosophical"[18] but Kenneth Clark seems equally justified in suggesting that Berenson's theories provided a rationale for those of abstract artists.[19] In any case, like Michelangelo and the seventeenth- and eighteenth-century classicistic critics before him, Berenson castigates realist styles, mainly those of the early Netherlandish painters—along with the fatal subcurrent of naturalism marring the purity of his beloved Italians. In *Italian Painters of the Renaissance,* he speaks out against the "inferior race of whom . . . Uccello was the ancestor . . . the Naturalists," and continues:

> What is a naturalist? I venture upon the following definition: A man with a native gift for science who has taken to art. His purpose is not to extract the material and spiritual significance of objects . . . his purpose is research, and his communication consists of nothing but facts. . . . What the scientist who paints—the naturalist, that is to say—attempts to do is not to give us what art alone can give us, the life-enhancing qualities of objects, but a reproduction of them as they are. . . .[20]

Like Michelangelo before him, who had declared with great assurance that "it is practically only the work done in Italy that we can call true painting,"[21] Berenson maintained that nothing of eminent quality had been created in the North. Despite an occasional word of praise for Jan van Eyck, he maintained that the early Flemings were naïve copyists of nature, seduced by "mere appearances," hence unselective—the usual criticism of realist values.

> *In their delight in nature they were like children who, in making the first spring excursion into the neighboring meadows and wood, pluck all the wild flowers, trap all the birds, hug all the trees and make friends with all the gay-coloured creeping things on the grass. Everything is on the same plane of interest and everything that can be carried off, they bring home in triumph. To this pleasure in the mere appearance of things, the greatest of the early Flemings, the Van Eycks, joined, it is true, high gifts of the spirit and rare powers of characterization. They had, as all the world knows, a technique far beyond any dreamt of in Tuscany. And yet the bulk, if not the whole of Flemish painting, is important only as Imitation and Illustration. . . .*
> *The trouble with Northern painting was that, with all its qualities, it was not founded upon any specifically artistic ideas. If it was more than just adequate to the illustrative purpose, then, owing no doubt to joy in its own technique, it overflowed into such rudimentary decorative devices as gorgeous stuffs and spreading, splendidly painted draperies. It may be questioned whether there exists north of the Apennines a single picture uninspired by Florentine influence, in which the design is determined by specifically artistic motives: that is to say, motives dictated by the demands of Form and Movement.*[22]

Like Berenson, Roger Fry, one of the founding fathers of Modernism, had strong reservations about the esthetic quality of Flemish painting. In reading his *Flemish Art: A Critical Survey* of 1927, one is strongly tempted to believe that Fry undertook his study largely to administer a salutary rap on the knuckles to the philistine British public, which was flocking admiringly to the current Burlington House exhibition of Northern art. While admitting the Northern artists' extraordinary control of the medium, the richness and glow of their colors and the precision and accuracy of their outlines, Fry nevertheless finds the early Netherlandish painters lacking in those principles of plastic design which mark "the great European tradition founded by Giotto,"[23] and thus esthetically inferior. "If," he continues, "we consider a minute and detailed verisimilitude a great pictorial quality, then the Flemish primitives stand almost unrivalled. . . . The vision of these painters was so little removed from the vision we employ for buying stuffs in a shop that it required no effort of reflection to recognize its accuracy and effectiveness." (This is obviously a dig at the taste of the materialistic British art lover.) "But," adds Fry, and the "but" is at the heart of his esthetic judgment,

> . . . *this everyday vision has not been the concern of the greatest painters; they have sought to place themselves at a greater distance from the phenomena of nature, to view them with a more detached eye, to be less entangled in their immediate references and implications. They have sought by that contemplative and disinterested vision to discover those more universal truths which escape the untrained vision, distorted as it is from infancy, by the needs of the practical and instinctive life.*[24]

Fry does not, of course, go as far as his friend and fellow critic Clive Bell,

who declared that "detail is the heart of realism, and the fatty degeneration of art."

But it is clear that in Fry's view the universal is more valuable than the particular, abstract relationships better than concrete contiguities, selection and distillation preferable to completeness and profusion, the detached more worthy of praise than the involved. Despite Jan van Eyck's remarkable gift of "reporting what the vision of life affords," he was, according to Fry, "entirely innocent of the contemplative vision which discovers universal principles underlying the particular forms with which it is confronted."[25] Thus Jan van Eyck is immediately, if regretfully, excluded from the realm of the highest artistic achievement: "On the whole we must, I think, conclude that Jan van Eyck's immense reputation rests mainly on his preternatural skill in reporting rather than on the importance of his imaginative attitude or on any remarkable aesthetic sensibility." Basically, Fry is, as he himself admits, in sympathy with Michelangelo's critique of the early Flemish painters, convinced that "the highest pleasures which the imagination can derive from the art of painting are dependent upon our understanding that harmony of form which Michelangelo describes as the language of painting."[26]

Fry's antirealist position is entirely consistent with his view of the evolution, characteristics and aims of the Modern Movement as he interpreted them in 1917, an interpretation which provides a link between the idealist or antirealist positions of the past and the Modernist stance of the present:

Impressionism marked the climax of a movement which had been going on more or less steadily from the thirteenth century—the tendency to approximate the forms of art more and more exactly to the totality of appearance. When once representation had been pushed to this point where further development was impossible, it was inevitable that artists should turn round and question the validity of the fundamental assumption that art aimed at representation; and the moment the question was fairly posed it became clear that the pseudo-scientific assumption that fidelity to appearance was the measure of art had no logical foundation. From that moment on it became evident that art had arrived at a critical point, and that the greatest revolution in art that had taken place since Greco-Roman impressionism became converted into Byzantine formalism was inevitable. It was this revolution that Cézanne inaugurated and that Gauguin and van Gogh continued. There is no need here to give in detail the characteristics of this new movement: they are sufficiently familiar. But we may summarize them as the reestablishment of purely aesthetic criteria in place of the criterion of conformity to appearance—the rediscovery of the principles of structural design and harmony.[27]

By creating a dichotomy between "fidelity to appearance" and "purely aesthetic criteria," and rejecting representation as a goal for art, Fry laid the foundation stone for the Modernist critical position—the ultimate purification of the temple of art from realist profanation. This purist position demands a purification and restriction of the audience as well:

VIJA CELMINS, "Untitled (Big Sea #1)" 1969 Graphite on paper, 34⅛" × 45¼"
Collection: Chermayeff & Geismar, Associates, Inc.

*The artist of the new movement is moving into a sphere more and more remote
from that of the ordinary man. In proportion, as art becomes purer the number
of people to whom it appeals gets less. It cuts out all the romantic overtones of
life which are the usual bait by which men are induced to accept a work of art.
It appeals only to the aesthetic sensibility, and that in most men is comparatively
weak.*[28]

Of course, the Modernist stance has affected our reactions to the art
of the past, particularly realist art. As Fry himself pointed out as early as
1917: "The new movement has led to a new canon of criticism and this
has changed our attitude towards the arts of other times and countries."[29]
Part of the difficulty in dealing with realist art past or present lies in the
nature of our critical language. Despite Max Friedlander's brilliant and
phenomenologically accurate analysis of individual works, the ultimate art
historical redemption of the fifteenth-century realist art of the North re-
mains Panofsky's *Early Netherlandish Painting* (published in 1953, but based
on lectures given in 1947–8). Panofsky tends to justify Northern realism
more in terms of iconography than formal values. Indeed, there seems to
be something inherently embarrassing to present-day critics and historians
about talking too much about the actual *quality* of a work such as Jan van
Eyck's *Arnolfini Wedding Portrait;* tiny apples, charming hairy dogs and
minute reflections in glass simply do not have the esthetic *éclat* of broad
plastic masses, stylized contours or the artist's concern for maintaining the
picture surface.[30]

In the face of Jan van Eyck's stubborn fidelity to the visual facts, his
obvious joy in punching a hole in the picture plane, his uncanny ability to
crystallize natural light in the oil medium and his refusal to leave behind
traces of his personal handiwork, most critics fall back with relief on the
incorrectness of the perspective, the stiffness of the gestures, the symmetry
of the composition and, of course, the underlying symbolic meaning. Es-
thetic value must be snatched from the jaws of mere factual fidelity, insig-
nificance redeemed through the innocent and unintentional failure of the
artist to capture reality whole. That Jan van Eyck might have been happier
with a Nikon and indoor film is unthinkable, despite evidence that some
of the later Netherlandish realists, such as Vermeer (the formalist art critic's
preferred seventeenth-century Dutch master), actually resorted to the photo-
reproductive devices of their times.

From antiquity onward, the naïve spectator has admired feats of ver-
isimilitude; Pliny waxed rhapsodic about a bronze dog licking its wounds,
so lifelike that its guardians had to pledge their lives for its safety, and
recalls the story of Zeuxis deceiving the birds with his painted grapes with
obvious relish. But for theoretical discourses, attachment to the concrete
is less amenable, more recalcitrant to the very *modes* of discussion, than
commitment to Man (generalized), Form (absolute) and Plasticity (abstract).
This kind of Platonism lurks behind most sophisticated art history,

theory and criticism, and is often accompanied by a built-in aristocracy of attitude, institutionalized in the "objective" language of esthetic judgment: that which is removed from actuality is, by definition, the most esthetically valuable. Cézanne's apples are esteemed insofar as they are remote from juiciness, crunchiness, intestinal satisfaction, fruit stores, childish desire or, symbolically, more adult passions—they have been transmuted into pure tactile values. Their clear revelation of the pictorial means places them in the mainstream of the Modernist effort to use art to call attention to art; Jan van Eyck's fruits are clearly in the camp of "realistic, illusionistic art, dissembling the medium, using art to conceal art,"[31] and thus are reprehensible.

Yet realism involves both more and less than visual veracity. As J. P. Stern recently pointed out in an interesting article on literary realism, the issue in realism is "the creative acknowledgement of the data of social life at a recognizable moment in history."[32] And this is true from antiquity on, despite significant differences in formal elements, content or syntax. Inseparably related to the insistence on the social data is the preponderance of metonymic rather than metaphoric imagery in realist structure: the veracity of the image is attested to by the authenticity of the contiguous relationships existing among concrete figures, costumes, settings, gestures, textures and substances at a specific time and in a specific place. This, not generalization, idealization or atemporality, is realist truth.

This insistence on the "data of social life" and metonymic veracity has perceptible effects, of course, on the style of the art work in question. Let us take, for example, the differences in treatment of comparable Greek and Roman works—both reliefs depicting religious processions—the Parthenon frieze and that from the Ara Pacis. The Romans were always more interested in specific social and historical events.[33] Although the Ara Pacis frieze bears strong marks of Hellenization (in itself a symptom of social striving, since it indicated an awareness of the cultural values of Greek art), the Roman monument, unlike the Greek work, is strongly committed to describing place and communicating a sense of who is who, in considerable detail. This is borne out not merely by the portrait character of the heads in the procession of members of Augustus's household, but in the clear differentiation between dignified, aristocratic adults, their equally aristocratic children, and servants, priests, gods and animals. These distinctions, embodied in anatomy, pose and details of surface treatment and position, do not exist in the Parthenon frieze.

If we compare the images depicting the sacrificial animals being led to the altar in both works, these differences are striking. In the south side of the Parthenon frieze, against a neutral background, the forms of men, animals and drapery are interwoven in the general forward-surging rhythm of the design. Robes, flesh, mouths and muzzles all seem to have been

wrought on the same principles and out of the same harmonious substance. The noble yet gentle head of the bull is tilted upward, pressed flat against the breast of the man behind him, creating an intimate relationship between beast and man. Indeed, while completely retaining his character as an animal, there is something actually human in the poignancy of his glance and the flowing contours of his heavy form. Nor are the gods, maidens, pedestrians or horsemen in any essential sense distinguished from one another. The controlling convention of isocephalism—the rule that all heads must be on the same level—creates a unified rhythm of design and, at the same time, precludes any differentiation of status. In the Ara Pacis frieze even the sacrificial animal assumes a specific role. He is literally on a lower level (the abandonment of isocephalism would account for this), but he is also differentiated spiritually from the human beings—a mere victim, standing meekly apart with lowered head, physically, emotionally and composition-ally discrete.

The less elevated art created for the nouveau riche Roman citizens is indeed filled with what Rodenwaldt has called "a hard realism, which de-rives from unplumbed depths of popular feeling."[34] In a work like the *Lateran Chariot Race Tomb Relief,* the urge to show the "real" life, status and occupation of the departed all at once has led to a kind of primitive super-realism. In the interest of truth to location and occupation, the sculptor has shown the chariot race taking place within an enclosure surrounded by an arcade. Without any kind of consistent perspective to help him out in this task, he simply flattens out the wall to the right, allowing a man on a horse to pass in front of it; yet he does not flatten it out completely, like a map, but allows it to rise upward to the right in a sort of bent curve, indicating that the wall has height and, at the same time, that it is enclosing the event taking place within it.

Medieval art is generally thought to be nonrealistic, and indeed care-fully qualified parallels have been suggested by Greenberg and Robert Rosenblum between certain aspects of medieval art and Modernist abstrac-tion.[35] But it is important to remember, especially in a discussion of the relevance of social contexts to realist veracity, that realistic detail is present in the art of the Middle Ages, and that it is reserved almost exclusively for the depiction of the lower orders of society, to distinguish them from their superiors. In dealing with a theme like the *Annunciation to the Shepherds,* a remarkable paradigm of the interpenetration of the world of ordinary experience and the realm of the eternal, the eleventh-century Master of the Pericopes of Henry II has clearly differentiated the status of his angelic messenger from that of his plebian auditors in terms of pose, costume and sheer amount of concrete detail, without in any way destroying the con-ceptual and decorative basis of the work: it is simply a matter of degree. The dignified atemporality of the Angelic Being is suggested by the rem-

iniscence of classical dress in his drapery, the intensity of his message by the dynamic crossover of the enlarged annunciatory arm and hand against the gold background. The shepherds, however, humble lower-class embodiments of Everyman, are endowed with more contemporary costumes, poses and setting. They sit or stand on the hills rather than hovering before a gold backdrop. Wavering lines of grass have been provided for their flocks to graze on; if the sheep resemble goats and donkeys, they have at least been depicted with "fleece" and cloven hooves. The head shepherd wears a warm cloak, a tunic and tight-fitting blue breeches tucked into leather boots, distinguishing him from his assistants, who are both cloakless and barefoot, as befits their lower status and subordinate role.

More than a century later, in the lintel sculpture of the right portal of Chartres West, the shepherds have attained a far greater individuation than the sacred figures around them, their earthy coarseness immediately setting them off as representatives of that lowest order of humanity which also benefited from the birth of Christ. Stiff-legged and slack-jawed, their blunt features and dumb expressions are illuminated with a kind of dawning realization of an imminent miracle—thereby elevating them a notch above their sheep, who simply continue their placid grazing. The costumes seem amazingly accurate, down to the sags and wrinkles of different kinds of woolen homespun: the hose are more regular in their pattern of folds than the sleeves; even the strands of hair are differently treated for each of the shepherds. One can find a vivid paradigm of the realism-low social status syndrome in the way the plebian blunt features and the irregular wrinkles of the left-hand shepherd's garments are—apparently—deliberately played against the stylized scallops of the angelic wing behind. The contingent irregularities of the natural world are unselfconsciously contrasted with the sublime regularity of the world beyond time; the angel is planted in a pose of eternal—i.e. classical—harmony, while the shepherds are caught in the midst of more momentary physical and emotional transactions.

It is precisely the combination of concreteness and immediacy which endows the shepherds in Hugo van der Goes's *Portinari Altarpiece* with their preternatural vividness. Despite the work's spatial, sculptural and tactile verisimilitude, distinctions of socio-spiritual status are still maintained by degrees of concreteness, the most realistic being reserved for the shepherds. The eldest of the three has fallen to his knees, hands clasped in reverent adoration; a second opens his hands wide in a gesture at once protective and admiring; the third, low-browed, snub-nosed, snaggle-toothed, his awkward mouth parted in amazement, his hair windblown, his eyes pulled back with the pressure of haste and eagerness, straw hat clasped reverently to his heart with gnarled hands, is the very epitome of peasant awkwardness. The directness of the shepherds' response is supported by the veracity of their accoutrements and that marvelously adaptable language of form that

makes them convincingly bulky and monumental, yet distinguishes between the grizzled texture of the old man's beard and the cornsilk wispiness of that of his younger confrere. The all-important barriers separating them from the idealized, aristocratic angels kneeling below are subtly yet tellingly reinforced by echoes in pose and gesture, as though to emphasize their equivalence as adorers of the Christ child, but their utter difference in every other respect.

Shepherds serve the same function elsewhere in Hugo's work; in the far distance of the Berlin *Monforte Adoration of the Magi*, they provide a striking contrast not so much with the main event in the foreground, but with two elegant young pages in the middle distance.

Perhaps the most extraordinary of all in their impulsive gestures and attitudes are the shepherds in the Berlin *Adoration of the Shepherds*, hurtling forward in adulation, hose falling, lips parted. Here we are on a borderline between realism and something more: the elements of realism are electrically charged and the experience approximates the theatrical. Two prophets, like the narrators in Brecht's plays, pull the foreground curtains aside, distancing us and revealing the ambiguous status of the event so vividly brought into being behind them. The portentious bundle of wheat—a reference to Christ's ultimate sacrifice—lies on the threshold of the mystery. And by making a direct connection with us, the spectators, these prophets make the concatenation of dynamic immediacy and dreamlike stasis, of descriptive realism and supernatural eloquence, a more acceptable way station between the painter's realm of possessed invention and the spectator's ordinary experience.

For Rembrandt, as for van der Goes at his most intense, it is the immediacy of the apparition that is the point of the event in his etching *Angel Appearing to the Shepherds* of 1634, in which effects of light and motion annihilate concrete detail. The angel's world, a funnel-shaped, putti-encircled spiral, whirls upwards towards pure radiance, separated from the multivalued blacks and grays of the sheep and cattle and the mysterious exotic foliage. One might well maintain that Dutch seventeenth-century realism avoids the dichotomy between the sacred and the ordinary, embedding the one so firmly into the other that, until fairly recently, the Dutch little masters were accepted as purely objective recorders of experienced reality.

In the most successful seventeenth-century genre paintings, quotidian fact and transcendent significance are woven together so seamlessly that a certain amount of detective work is required to rend the two asunder. In such a less successful example as David Tenier's banquet scene, which incorporates a "five senses" allegory and a warning on the vanity of all earthly pleasures into its overstuffed repertory of activities, one tends to wonder just what an ape is doing in the midst of all the merrymaking, and

why he should be brooding directly under a picture of the crucifixion. In the greatest, like Vermeer's *Pearl Weigher*, the *Vanitas* theme is conjoined with the concreteness of the genre scene as unobtrusively as the daylight itself.[36]

In the *Annunciation to the Shepherds*, the sacred is contrasted with the secular. A more appropriate example of the seventeenth-century Dutch realist approach to the Christmas theme is Jan Steen's *Feast of St. Nicholas*, which exists within a purely secular and middle-class setting, rich in metonymic veracity. Here realism is all-pervading—it is the crux of the event. Yet here too are interwoven the aura of moral judgment and references to the *Vanitas* theme. The wicked are punished and the virtuous rewarded within the context of genre down-to-earthness. The sacred meaning, if present at all, is incorporated into the scene in the form of a holy doll, clutched by the little girl in the center of the stage. The socially distinguishing function of the realist mode has been abandoned (since there are, in effect, no classes to be distinguished) for a style where moral implications are maintained precisely by the ordinariness of the mise-en-scène.

It was characteristic of Courbet's leadership to reject all metaphysical overtones, declaring that he could never paint an angel because he had never seen one. He presumably rejected moral allegory for the same reason, although in *The Painter's Studio* he did put forth his own views and aspirations in the novel form of an "allégorie réelle." The immediate social context and a richly detailed style are characteristic of Courbet's great realist works. For those nineteenth-century realists, deeply concerned with conveying a sense of moral values or dealing with conventional or "modernized" religious themes, realist veracity, far from being a token of inferior social status, becomes the guarantor of transcendent truth. As John Duncan Macmillan recently pointed out in a discussion of Holman Hunt's *Hireling Shepherd* of 1852, scientific accuracy in the representation of light and color and intense moral purpose are absolutely at one for the artist: "For him, scientific truth and God's truth are the same,"[37] and, one might add, returning to the theme we dealt with above, the spiritual meaning is necessarily embodied in the socially humble realm of shepherds and sheep.

If a nineteenth-century realist artist turns to a scene from Christian narrative, it may well be a relatively novel, deliberately "everyday" scene from the life of Christ such as that invented by John Everett Millais in *Christ in the House of his Parents*. Here the veracity of the spiritual meaning is guaranteed by the authenticity of the humble setting, an actual carpenter's shop on Oxford Street. The validity of Christ's sacrifice is indicated by the accuracy of the details: carpenter's tools, wood shavings, figure types—a work-worn Joseph, an aging Mary, sheep painted from life—or rather death—since Millais, in the absence of flocks within miles of Gower Street, was forced to resort to two sheep's heads with the wool on, purchased from

a neighboring butcher.[38] By depicting Christ in a humble carpenter's shop, and by depicting the shop itself in such detail, Millais hoped to establish the meaning of His life for a contemporary mid-nineteenth-century English audience.

A more sentimental nineteenth-century realist, like Fritz von Uhde in his triptych *The Holy Night* of 1888, translates the traditional theme of the *Adoration of the Shepherds* into the language of Milletesque peasant naturalism. Neither the stocky peasant Mary nor the barefoot country children with wings attached to their white dresses are in any way distinguished from the local shepherds who come to adore the child in the very ordinary stable. A conspicuous, abandoned wooden shoe seems less a traditional symbol referring to a sacred place, like the wooden clogs in the *Arnolfini Portrait,* than an element of "irrelevant" realist metonymy, a guarantor of the authentic peasant milieu.[39]

In two contemporary realist works, Robert Bechtle's *Christmas at Gilroy* and Diane Arbus's *A Christmas Tree in a Living Room in Levittown, Long Island, 1962,* the "Christmas" now exists—if it does at all—as an ironic reminder of mundane factuality. In both cases, the segment of contemporary reality chosen functions as a synechdoche for a larger but no less banal totality. While neither work is in any sense symbolic, each, by merely documenting how things were at a certain time in a certain place, stands as a cool, incontrovertible fragment of a larger reality. And in both cases, the richness of "irrelevant" detail is the very essence of the style One might almost say that the imagery has become nothing but the contingent relationships existing among the elements. In fact the imagery is held together by nothing but sheer contingency.

We have examined realist theory and practice within the context of idealist, antirealist criticism, and we have attempted to characterize realist modes of expression and the changing nature of realist styles and intentions throughout history. Despite certain identifiable characteristics, Realism exhibits a remarkable flexibility and range, springing to new life, like a phoenix, just when its adversaries proclaim it dead. Clearly the realism of today is not the same as the realism of the past. To condemn contemporary realism as resurgent academicism or trivial deviation from the mainstream—Modernism—is to falsify the evidence and prevent any just evaluation of its actual quality.

Reading sanctions for one's own cherished beliefs into the historical process is an ongoing phenomenon, particularly in the arts, where, unlike the realms of politics or economics, there seems to be little justification in actual *praxis* for the exclusive domination of any one position. To interpret particular styles or outlooks as inevitable expressions of particular world views, to see the hand of destiny, the demands of the *Kunstwollen* or of internal consistency at work in any given form of artistic expression is sadly

to misread, overinterpret and oversimplify the infinitely more open, complex and chancy processes of history. Many of the predictions and manifestos of the more articulate prophets and supporters of new styles tend to be self-fulfilling. This is not the result of some sort of in-group confidence trick, but rather, especially in recent years, of a natural interaction of theoretical and creative efforts struggling for existence and then gaining supremacy at given moments.

But there is nothing "inevitable" about the triumph of any given style or group in the sense that, say, death is inevitable. Nor is there ever a single style which absolutely captures the spirit of the age—whatever that may be—to the exclusion of other possibilities, any more than there is a single "correct" direction to be predicated by any art medium. Such an interpretation of art history is a case of misplaced intentionality—seeing the particular decisions, needs, desires and inventions of particular persons or groups as predestined expressions of historical will. Some spokesmen for particular artistic movements see themselves as actually "outside of history," as having reached some sort of Platonic or Kantian absolute of artistic expression, unique in purity, timeless in eternal value, to which all other forms of expression must ultimately give way. To attempt to place art outside of history by claiming, even for a small portion of it, absolute, immutable values, and yet at the same time, to view it as the inevitable product of historical forces seems to be the self-contradictory ideological basis of much Modernist criticism.

Surely it is the art world in its broadest sense (and in a narrower one, the art market—a complex infrastructure of artists, dealers, buyers, museums, gallery-goers, critics, media interests and so on) that ultimately decides the fate of art movements. At any moment in history, several different modes of expression—and furthermore, several innovative and valid ones—may flourish concurrently. Any or all of them may be interpreted as "expressing the spirit of the times." Indeed, do we not derive many of our notions of what constitutes the "spirit of the times" from works of art themselves? Dada and Surrealism are certainly as valid expressions of the "spirit" of the twenties and thirties as pure abstraction. At the very moment of the triumph of color field painting, both Pop art and the New Realism in different ways forced its "absolutism" into a more relative stance. It is sobering to realize that Courbet and Baudelaire, one the champion of fidelity to the visible world, the other a communicant with mysterious intangible forces for whom nature was a "forest of symbols," were contemporaneously embodying the "spirit of their times." Redon and Moreau were exploring a world of fantasy and subjective invention at the same time that the Impressionists were attempting to probe the visible world with objective fidelity; such diametrically different novelists as Henry James and Emile Zola were almost exact contemporaries; the very moment that Marshall McLuhan and his followers were proclaiming the triumph of a unified,

mass-produced technological-electronic global village, young people began casting off the plastic benefits of mass culture and going in for communes, homespun, bread-baking, arts and crafts, logs, ropes, earthworks and ecology; at this very moment, cinema vérité and abstract video art can equally claim to be expressing contemporary life and the demands of the medium. For it is not history, or the arts media, or their internal teleology that impose demands. It is human beings in specific situations who make decisions and choices. At the moment, it is being proposed that art itself is dead, and that only the conceptual framework or substructure of art remains a valid area of investigation. As usual, the future of this outlook depends not on the mysterious forces of esthetic destiny, but on the ability, determination and power to convince and convert, and the susceptibility to this message of artists and public—in other words, on the politics of art.

NOTES

[1] R. Jakobson and M. Halle, eds., *Fundamentals of Language* (The Hague, 1956), p. 78.

[2] Clement Greenberg, "Modernist Painting," first published in *Art and Literature* 4 (Spring 1965). For the best critique of Greenberg's position from a very different vantage point, see Leo Steinberg, "Reflections on the State of Criticism," *Artforum* 10 (March 1972), pp. 37–49 passim.

[3] Greenberg, "Modernist Painting," in *The New Art*, ed. Gregory Battcock (New York, 1966), p. 102.

[4] Ibid., pp. 103–4.

[5] Ibid., p. 107. Steinberg has pointed out the relation between this Modernist notion of art as "internal problem solving" and a "corporate model of artistic evolution," seeing the analogy more as one with a peculiarly American brand of technology than with science per se. Steinberg, "Reflections," p. 43.

[6] "Picasso at Seventy-Five" [1957], *Art and Culture* (Boston, 1961), p. 59.

[7] Both Leo Steinberg, in extensive publications, and Lydia Gasman, of Vassar College, have shed new light on the interrelation between personal meaning and formal invention in Picasso's work.

[8] Eric Auerbach, *Mimesis*, trans. W. Trask (Princeton, 1953).

[9] R. Klein and H. Zerner, eds., *Italian Art: 1500–1600: Sources and Documents* (Englewood Cliffs, 1966), pp. 34–5. The analogy of the abstract or elevated qualities of painting with music, in its appeal to the spiritual rather than merely sensual faculties, is a perennial theme of antirealist criticism. It appears again in Symbolist art theory at the end of the nineteenth century, in the writing of Gauguin and his followers, who in turn were probably influenced by Schopenhauer's ideas.

[10] Seymour Slive, *Rembrandt and his Critics, 1630–1730* (The Hague, 1953), p. 91.

[11] Ibid., p. 96.

[12] Ibid., p. 99.

[13] Ibid., p. 102, translation from Borenius.

[14] Ibid., p. 113.

[15] Ibid., p. 130 [the author has corrected the translation].

[16] *Dedalus* 91, No. 2 (Spring 1962): p. 477. For late eighteenth- and early nineteenth-century justifications of Dutch realism see P. Demetz, "Defenses of Dutch Painting and the Theory of Realism," *Comparative Literature*, 15, Spring 1963, 97–115.

[17] Kenneth Clark, "Bernard Berenson," *Burlington* 102 (September 1960): p. 384.

[18] "Greenberg on Berenson," *Perspectives USA* 11 (Spring 1955): 151.

[19] Clark, "Berenson," p. 385.

[20] Bernard Berenson, *The Italian Painters of the Renaissance* (Oxford, 1930), pp. 86–8.

[21] Klein and Zerner, *Italian Art,* p. 34.

[22] Berenson, *Italian Painters,* pp. 236–37.

[23] Roger Fry, *Flemish Art: A Critical Survey* (London, 1927), p. 8.

[24] Ibid., p. 5.

[25] Ibid., p. 16.

[26] Ibid., p. 28.

[27] Roger Fry, "Art and Life," *Vision and Design* (London, 1923), pp. 11–12.

[28] Ibid., p. 15.

[29] Ibid., p. 12. Perhaps the most remarkable example of the way a new canon of criticism can change an attitude toward the Flemish painters is Clement Greenberg's article, "The Early Flemish Masters," *Arts* 35 (December 1960): 28–32, written on the occasion of a major exhibition at the Detroit Institute of Arts. In this article, the critic redeems Flemish realism in terms of late fifties abstraction, insofar as the fifteenth-century works made him realize "how much sheerly pictorial power color . . . is capable of even when it doesn't 'hold the plane' " and that the "detached" color characteristic of some of these painters is in fact "the kind of color that is closest to that in the best and most advanced of very recent easel painting in America."

[30] In the same way, realist works suffer more in transmission or translation: while the basic structure of a Michelangelo work may still shine through the schematic reduction of a Marcantonio engraving, the whole *point* of a realist work like the *Arnolfini Portrait* is lost in anything but the fullness and physical plenitude of the work itself.

[31] Clement Greenberg, "Modernist Painting," first published in *Art and Literature* 4 (Spring 1965); reprinted in G. Battcock, ed., *The New Art* (New York, 1966), p. 102.

[32] J. P. Stern, "Reflections on Realism," *Journal of European Studies* 7 (March 1971): 12. The author develops his ideas further in his book, *On Realism* (London and Boston, 1973).

[33] For a detailed, scholarly discussion of this issue, see Charles Rufus Morey, *Early Christian Art* (Princeton, 1953), p. 49.

[34] George Rodenwaldt, "The Transition to Late Classical Art," *The Cambridge Ancient History* 12 (Cambridge, 1939): 563.

[35] Clement Greenberg, "Byzantine Parallels," *Art and Culture,* 1958, pp. 167–70 and Robert Rosenblum, *Cubism and Twentieth-Century Art,* 1960, p. 66.

[36] For a more detailed discussion of the Teniers painting and of the *Vanitas* theme itself, see Herbert Rudolph, "Vanitas: Die Bedeutung mittelalterlicher und humanistischer Bildenhalte in der niederländischen Malerei des 17. Jahrhunderts," *Festschrift Wilhelm Pinders* (Leipzig, 1938): 405–433.

[37] John Duncan Macmillan, "Holman Hunt's *Hireling Shepherd:* Some Reflections on a Victorian Pastoral," *Art Bulletin* 54 (June 1972): 195.

[38] John G. Millais, *The Life and Letters of Sir John Everett Millais,* I (London, 1899), p. 78.

[39] That von Uhde himself seems to have been aware of the problems involved in forcing the realistic secular idiom of the nineteenth century to fit the demands of traditional religious iconography is suggested by his far more consistent, and appealing, *The Rest of the Models in the Studio.* In this work, the models for what is probably a "Flight into Egypt" or an "Adoration," including two very contemporary children, their wings strapped on to their backs, their black stockings peeping out from under their white angel robes, take their ease in the artist's studio between sittings. See Gustav Keyssner, "Uhde," *Klassiker der Kunst* (Stuttgart and Berlin, 1923), reproduction p. 90.

Many American realists influenced by Fairfield Porter have continued to follow their own interests, uninvolved in debates over the purity of modernism. Poet and critic Gerrit Henry describes painterly realists as motivated by the desire to communicate subjective experience and insight through traditional landscapes and interiors while at the same time clearly displaying the artifice of their paint and brushstrokes. The works are generally not mythical or narrative; they record concrete experience, the ways of seeing, with little or no interest in ideological issues. They represent a direction which the acceptance of modernism had thoroughly eclipsed.

Painterly Realism and the Modern Landscape

Gerrit Henry

When Photo-Realism came to the forefront of the art scene in the late '60s and early '70s, it was greeted—after some flurries of modernist indignation—as a "return to realism." Critics, forced to look at realism again in a way they hadn't since the days of Wood and Benton, noted that a new investigation of the American scene was going on; meanwhile, the art-buying audience made stars of such painters as Richard Estes and Audrey Flack. In the intervening years, enthusiasm has spread to encompass realist work of all sorts. Today, allegorical realists have replaced the academic realists who replaced the Photo-Realists. There are galleries specializing in various forms of realism, and the art schools turn out realists with the alacrity with which they once produced Lyrical Abstractionists.

In all the fuss a decade ago, observers generally failed to note two things. First, Photo-Realism was, below the surface and despite its Pop overtones, an offshoot of the then-dominant Conceptual art—it was the *idea* of painting from photographs that shocked and appealed even more than the results, which were nothing more or less than super-accurate records of that idea. Secondly—and this is a point often overlooked— realism in general wasn't all that new. Certain artists had been working in realist styles since the '50s, even during the halcyon days of Abstract Expressionism. Indeed, these painters—among them Alex Katz, Fairfield Porter, Philip Pearlstein, Jane Freilicher, Robert Dash and John Button—had been influenced by the Abstract Expressionists, and some had begun their careers as abstractionists.

A few of these realists have become major figures in the past decade— Katz and Pearlstein are particularly well known today. It is a curious fact

Reprinted from Gerrit Henry, *Art in America* (September 1981).

of contemporary American art history that certain others of these artists—
those known as Painterly Realists, including Freilicher, Dash and Button—
were and often still are overlooked in discussions of painting of the past
30 years. Contemporary art surveys like Sam Hunter's *American Art of the
20th Century* deal with de Kooning and Pollock while making no mention
of the late Fairfield Porter, the undisputed father of Painterly Realism.
And we look in vain for references to Freilicher or Button in books like
H. H. Arnason's *History of Modern Art,* even though the quality of these two
painters' work is equal to that of many contemporary artists included.

Why the oversight? Perhaps one reason for their neglect is that the
Painterly Realists, until very recently, have comprised something of a co-
terie; as one observer has said, they were mostly "written about in the '60s
by poets in *Art News*." Porter lived in Southampton, Long Island, with Dash
and Freilicher (in the summer) nearby—perhaps their geographical loca-
tion isolated them from the New York mainstream. Certainly they have
had close relationships with poets, particularly poets of the New York
School, such as John Ashbery and James Schuyler. As well as being a
painter, Porter was an art critic, a very dedicated and trenchant one. Per-
haps his dual role as observer as well as participant symbolizes a certain
detachment from the New York art world that his Painterly Realist fellows
have also tended to exhibit.

But there are other, deeper reasons for the neglect of Painterly Re-
alism. One is ably expressed by critic John Arthur in his recent book *Realist
Drawings and Watercolors.* "Whether out of bias or linear thinking," he writes,
"we were educated in the fifties and sixties to believe that the only valid,
intelligent contemporary American art excluded figurative and narrative
elements." The Painterly Realists have long been victims of this prejudice.

Still, such Realists as Katz and Pearlstein have managed to achieve
renown despite this bias. Perhaps the fact that the Painterly Realists' aims
and ambitions remain rather ambiguous to most contemporary art viewers
has kept them from widespread appreciation. It is the goal of this article
to clarify these aims and ambitions by focusing on nine Painterly Realists,
both "first" and "second generation." The survey will be limited to land-
scape, since it is in this peculiarly American mode that many of these artists
have produced their finest paintings.

Painterly Realism can best be defined at the outset by what it is not. It
is not naturalism, the style in which such artists as Philip Pearlstein, Alfred
Leslie and Jack Beal have made their reputations. Nor is it the hyper-
realism of Richard Estes or Janet Fish. It is no accident that the Painterly
Realists grew up alongside the Abstract Expressionists, for like Abstract
Expressionism, Painterly Realism is a style concerned not with verism but
with painting. The essential difference between the two is that the Action

Painters were painting their reactions to emotional stimuli, while the Painterly Realists paint their reactions to the natural world.

Obviously, then, the solutions of naturalism or hyper-realism—solutions in which paint and brushstroke are subservient to the needs of illusionism—would not suffice for the Painterly Realists. For them, the physicality of the paint and the personality of the brushstroke have equal visual importance with "getting it right." Indeed, the challenge of Painterly Realism is to get it right while respecting the plastic nature of the painter's medium. There is a fastidious modernist integrity to Painterly Realism—a desire that the viewer should at every moment see both the illusion of reality *and* the component parts of that illusion.

It is this modernist integrity that makes the Painterly Realists the more conservative cousins of the Abstract Expressionists. Perhaps their relative lack of popularity during the '50s and '60s was due to the fact that they are so conservative, so interested in evoking the appearances of the natural world. Yet there has always been a certain heroism to their efforts, a heroism not unlike that associated with the Action Painters, one that has become more apparent with the passage of time and by comparison with the "easy" illusionism of the Photo-Realists. "I paint what is," said a Painterly Realist to a friend. "You mean, you paint what you see," the friend replied. "No, I paint what *is*." He was, of course, speaking metaphorically; yet his hyperbole indicates the risk that the Painterly Realist, like the Abstract Expressionist, takes upon himself. Whereas Abstract Expressionists attempted to make inner reality objective, the Painterly Realist risks making outer reality subjective. He paints not only *what* he sees, but *how* he sees. The picture becomes not a record of itself, as with the Abstract Expressionists, but a record of perceiving, an on-the-spot document of what is going on both inside and outside the artist, and in this sense a record of "what is." Painterly Realism is reflection made visible—the artist's meditations on nature embodied on canvas.

So Painterly Realism bears little resemblance to naturalism or hyperrealism. The style is closer to Impressionism in its insistence on depicting form and light as paint, and certainly the abstractions-from-nature of Bonnard and Vuillard have something to do with it. Perhaps the American Impressionists, such as Hassam and Twachtman, and certain of the more painterly of the Eight—Robert Henri, especially—have also been influences. Edward Hopper, though superficially seeming to be a kind of grandfather figure, was probably too involved with representation as such to have been much of an inspiration. Finally, of course, there are very obvious European antecedents for the style's painterliness, from Rubens to Rembrandt to Constable to Monet. Nevertheless, given the undeniable proximity and magnetism of the Action Painters and the energies of the Painterly Realist's stroke, the style emerges as a very contemporary, and distinctly American, mode of its own.

Painterly Realism, then, is a style which reaches beyond *l'art pour l'art* in a modern attempt to reconcile reality with the artist's perceptions of it. The style may represent the quintessence of the tradition of humanist art begun in the Renaissance—man, as the painter, is the measure of all things, those things being nature. Painterly Realism is devoid of religious or mystical sentiments (even pantheistic ones); indeed, it is painting in which artfulness, the very act of painterly perceiving, is sanctified beyond religion, and even beyond esthetics, a style in which painting itelf is seen as the best equipment with which to face reality.

But perhaps it is best to explore Painterly Realism by discussing the painters themselves. As John Arthur has said of the style's chief figure, Fairfield Porter is "to realism what Jackson Pollock is to Abstract Expressionism." Porter has been described by a friend as a "Bonnard nut," and certainly the influence of French modernism is strongly felt in his work. The outspoken fluidity and grace of his Hamptons scenes were arrived at with painstaking care, yet the paintings look remarkably spontaneous. Porter's is a world in which landscape elements—trees and bushes, houses, sky, light and figures—stand only for themselves. There is no symbolism or allegory in a Porter canvas, and not even much narrative. His is a thoroughly nonmythical world that is at the same time, by virtue of color and stroke, an earthly paradise. Porter is not strictly a Romantic, but he is certainly a romancer: the high, fine drama of painting reality is his love, and the viewer is made acutely aware of the artist's presence, his ongoing artistry, in any work.

Robert Dash began his painting career as an Abstract Expressionist, and in his renderings of scenes from around his Bridgehampton home there is a strong emphasis on gesture as the motor force of a canvas. Of all the painters under discussion, Dash's achievement stands closest to that of Fairfield Porter: he too would seem to be concerned with depicting an earthly paradise, with capturing moments in the day or in a season when the landscape and the artist's perceptions of it are in utter synchrony. In recent work, Dash has included the figure in the landscape; he paints it with the same lusciously summary stroke as the landscape and sky, giving it no special emphasis, but instead treating it as merely another element of the scene in all its generalized particulars.

Jane Freilicher stands somewhat apart from Porter and Dash, although she is also a Hamptons resident in the summer. Freilicher too takes great delight in the physicality of her medium, but the character of her work is always—to paraphrase the title of a poem by her friend John Ashbery— ascetic sensualism. Freilicher doesn't go in for the heroic intimacy of Porter or the sweeping land-and-sky effects of Dash; rather, she is extremely careful, almost tentative, in her depiction of natural details, as if the advisability of representing a view in paint had at every moment to be tested.

In Freilicher's work there is a constant dialectic between color and paint, between form and gesture; the viewer is let in on what is almost a visual conversation between artist and landscape, one in which brushstroke has a pithy character, and color is employed almost as casually as a remark. Freilicher is perhaps the most traditionally painterly of the artists under discussion, yet her painterliness never reads as a superfluous device; it is always an appropriate esthetic stratagem for achieving acutely pictorial ends.

Of the painters under discussion, Neil Welliver is no doubt the most popular. In Welliver's views of Maine woods, gesture is a telegraphic means for conveying nature's effects, and the physicality of paint is subdued in favor of exceedingly smooth representation. Nevertheless, the viewer is subtly requested to respect the character of paint as paint and brushstroke as brushstroke, if only because Welliver's illusionism is so invigoratingly worked out through these elements. No doubt it is Welliver's great facility for representational painting that, coupled with his sparkling out-of-doors subjects, makes his work so appealing to a broad range of viewers.

George Nick is not strictly a landscape painter—that is, he is a landscape painter who includes architecture in his work. He is best known for paintings of Victorian houses in snow; in these, he is certainly painterly in a most generous manner. Paint is applied thickly, and brushstroke is only as subservient to rendering as it has to be. Like Freilicher, Nick takes pleasure in the physicality of his medium; it is a mark of his talent that he is able to fulfill the exigencies of architectural rendering with such a "loaded" brush.

If Porter represents the French influence on Painterly Realism, John Button owes more to such Northerners as Casper David Freidrich. Button is best known for paintings of the corners of buildings, seen from an odd angle below, jutting out into cool, technicolored skies; but his most recent show evidenced a return to the sort of landscape that is simultaneously intimate and panoramic. Button is a super-Romantic; his scapes are impossibly beautiful renderings of land and sky at extreme times of day, much more cleanly painted than Porter or Dash, and attempting more overtly stunning effects. Button is probably the least painterly of the first-generation Painterly Realists; still, he belongs in this category, for in his work the presence of the artist is always felt, broadly interpreting nature and informing it—if not with gesture, then surely with touch. With Button we are in the company of a visionary, one who "sees" nature at the height of her plentitude—and of her inscrutability.

Among the second generation of Painterly Realists, three artists stand out. One is Bill Sullivan, who has taken a cue from Button and adopted effects from Northern Romantic painting—and artists like Frederick Church—in depictions of the Hudson and New Jersey shore at twilight,

or, more recently, in flagrantly romantic renderings of the primeval land-scape of Colombia, where the artist spent two years. Gray-blue mist rises from Sullivan's mountains, rainbows crystallize over his waterfalls, and his skies glow a preternatural orange and scarlet. Like Button, Sullivan would seem to be concerned with nearly cinematic effects; the dialogue between self and landscape takes on almost mystical tones, although there is always more than a trace of self-reflective irony in the sheer glamor of it all.

Robert Berlind has rung an interesting change on the Painterly Realist oeuvre. Berlind paints landscapes seen at night, light spilling out from a window onto vast expanses of pitch black. The main interest of Berlind's work grows out of his painterly, quite gorgeous handling of black. The viewer sees almost nothing but darkness, yet that darkness is alive with gestural paint manipulation. Here again, there is a suggestion of other-worldliness; in its latest manifestations, Painterly Realism would seem newly caught up in exploring the darker side of the painterly paradise.

Darragh Park, however, is a young painter still absorbed in exploring Fairfield Porter's nonmythical, earthly paradise, transposed, in this case, to New York City. Park takes near-photographic shots down streets in his Chelsea neighborhood; his work seems precisionist in relation to Dash or Porter, but his daylight-hour colors and personalized perspectives reveal an artist both struggling with and controlling his visual experience. The result is that Park discernibly achieves peace with his surroundings—even his urban surroundings—through the medium of style.

There are numerous other Painterly Realists who have not been dis-cussed here for reasons of space: Wolf Kahn, with his Rothkoesque country scenes, Nell Blaine, with her jazzy, expansive mountainscapes, and Paul Resika, with his brushy renderings of the French countryside, are just three among many. Others include Arthur Cohen, Marcia Clark, Jane Wilson, Elias Goldberg, Raoul Middleman and Rudy Burckhardt.

By now, Painterly Realism is an American tradition that seems likely to have a future. It has survived many another style—including Abstract Expressionism—perhaps, just perhaps, because of its very conservatism. Grounded in the real world, Painterly Realism still gives its practitioners the opportunity for modernist experimentation. And it may be that the style is even braver than we know: in the 30-odd years of its history, it has not yet self-destructed.

In the 1960s, Andy Warhol, in company with other Pop artists like Roy Lichtenstein and Claes Oldenburg, brought the subject matter of contemporary life into mainstream painting. Warhol used the photographic image as the source of his portraits, allowing him to manipulate the vocabulary of commercial photography and to project his detached and ironic view of the world and its political and entertainment leaders. Warhol's manipulation of the mass media to his own ends provided an important precedent for more recent appropriation of such imagery. By his example, Warhol deflated modernism's desire to effect a strict distinction between high art and popular culture, between the techniques of artists and those of professional designers. Art historian Robert Rosenblum describes the innovations and insights of Warhol's portraits and places them in the context of the history of portraiture.

Andy Warhol: Court Painter to the 70s

Robert Rosenblum

If anybody had been asked in the 1950s to check the pulse of contemporary portraiture, the diagnosis would have been gloomy. "Moribund" might have said it discreetly; "Dead" would have been more like it. Were any humanoid presence to emerge from that distant, mythic world conjured up by Rothko, Newman, and Pollock, it could only have been the Holy Shroud, Adam, or Thor; and even if one of de Kooning's women were to congeal into an identifiable being, she would probably turn out to be Lilith or the Venus of Willendorf. The prospects of any mortal, not to mention contemporary, man or woman surfacing in that lofty pictorial environment seemed slim indeed.

But art and history are full of surprises, and few were more startling than the way the younger generation of the 1960s wrenched the here-and-now (which are now the then-and-there) facts of American life back into art. The doors and windows of the ivory-tower studios were suddenly opened wide, and the pure air inside was instantly polluted (or some would say rejuvenated) by the onslaught of the ugly but irrefutably vital world outside. Of the many things that demanded immediate attention, from city streets, highways, and supermarkets to billboards, newspaper print, and television sets, the pantheon of 1960s celebrities was high on the list. If everybody in the civilized and not-so-civilized world instantly recognized Elvis Presley or Marlon Brando, why should their images be censored out

Reprinted from Robert Rosenblum, "Andy Warhol: Court Painter to the 70s," catalogue essay, Whitney Museum of American Art, 1979.

of the history of serious art? If a pall was cast on this whole planet in the summer of 1962 when news of Marilyn Monroe's suicide instantly circled the globe, why shouldn't a painter commemorate her for posterity? If, in the following year, Jacqueline Kennedy helped the nation and the world bear their collective grief by maintaining a public decorum worthy of a Roman widow, why shouldn't there have been a living artist who could record for future generations this modern Agrippina? Luckily, there was.

Andy Warhol, in fact, succeeded virtually single-handed in the early 1960s in resurrecting from near extinction that endangered species of grand-style portraiture of people important, glamorous, or notorious enough—whether statesmen, actresses, or wealthy patrons of the arts—to deserve to leave their human traces in the history of painting. To be sure, this tradition, which grew ever more feeble in the twentieth century, occasionally showed a spark of life in the hands of a few ambitious painters, above all in England. Here one thinks of Graham Sutherland's portraits of the 1950s and 1960s of the likes of Lord Clark, Sir Winston Churchill, Helena Rubinstein, Dr. Konrad Adenauer, or the Baron Elie de Rothschild, where the tradition of Titian, Velázquez, and Reynolds seems not quite to have given up its ghosts and where, for a moment, the sharp facts of universally known physiognomies seem to blend with a pictorial environment of old-masterish resonance and aristocracy. And a decade or two earlier, and again in England, one thinks of the neglected late portraits of Walter Sickert, who, in the 1920s and 1930s, often used for his depictions of eminent contemporaries the most informal news photographs, which provided an underlying image of reportorial truth for, say, a glimpse of King George V and Queen Mary passing by in a royal automobile or of King Edward VIII greeting troops. Indeed, as Richard Morphet has already proposed, there are prophecies of Warhol in Sickert's strange amalgams of London press photos and the lofty traditions of state portraiture.[1]

More often than not, however, paintings of public figures in the last decades belong, especially in the United States, to the domain of Portraits, Inc., and its ilk. When confronted with the prospects of eternity in depicting a great man of state, most official painters rattle around in a graveyard of traditions. A pretty funny case in point is Wayne Ingram's portrait-apotheosis of Lyndon Baines Johnson in the LBJ Library, in Austin, Texas, where the thirty-sixth President of the United States first faces us real as life, and then ascends, via a shower of de Kooning-plus-LeRoy Neiman brushstrokes, to a secular baroque heaven where his watchful spirit still floats on high.

It was Warhol's masterstroke to realize (as Sickert and even Bacon had tentatively suggested in eccentric ways) that the best method of electrifying the old-master portrait tradition with sufficient energy to absorb the real, living world was, now that we see it in retrospect, painfully obvious. The most commonplace source of visual information about our famous con-

temporaries is, after all, the photographic image, whether it comes from the pages of the *Daily News* or *Vogue*. No less than the medieval spectator who accepted as fact the handmade images of Christian characters who enacted their dramas within the holy precincts of church walls, we today have all learned to accept as absolute truth these machine-made photographic images of our modern heroes and heroines. When Warhol took a photographic silkscreen of Marilyn Monroe's head, set it on gold paint, and let it float on high in a timeless, spaceless heaven (as Busby Berkeley had done in 1943 for a similarly decapitated assembly of movie stars in the finale of *The Gang's All Here*), he was creating, in effect, a secular saint for the 1960s that might well command as much earthly awe and veneration as, say, a Byzantine Madonna hovering for eternity on a gold mosaic ground. And when he reproduced the same incorporeal divinity not as a single unit, holy in its uniqueness, but as a nonstop series, rolling off an invisible press in endless multiples, he offered a kind of religious broadsheet for popular consumption, suitable to the staggering, machine-made quantities of our time, where the tawdry imperfections of smudged printer's ink or off-register coloring have exactly the ring of commonplace truth we recognize from the newspapers and cheap magazines that disseminated her fame.

By accepting the photograph directly into the domain of pictorial art, not as an external memory prop for the painter's handmade re-creation of reality but as the actual base for the image on canvas, Warhol was able to grasp instantly a whole new visual and moral network of modern life that tells us not only about the way we can switch back and forth from artificial color to artificial black-and-white on our TV sets but also about the way we could switch just as quickly from a movie commercial to footage of the Vietnam war. For Warhol, the journalistic medium of photography, already a counterfeit experience of the world out there, is doubly counterfeit in its translation to the realm of art. He takes us into an aestheticized Plato's cave, where the 3-D facts outside, whether concerning the lives of a superstar or an anonymous suicide, are shadowy fictions of equal import. In terms of portraiture, this second-degree reality dazzlingly reinforces the inaccessible human presence of those remote deities—a Liz Taylor or a Happy Rockefeller—whom only a select few have actually seen at eye level in three corporeal dimensions; and in terms of our more general awareness of what is really happening on the other side of our movie and TV screens, it frighteningly reflects exactly the way in which, for the television generation, which has now become our future population, the eyewitness fact of Jack Ruby's on-the-spot shooting of Lee Harvey Oswald in a Dallas police station was almost to be confused with the fictional murders that followed and preceded this real-life, but scarcely believable, event on the same channel.

That Warhol could paint simultaneously Warren Beatty and electric

chairs, Troy Donahue and race riots, Marilyn Monroe and fatal car crashes, may seem the peculiar product of a perversely cool and passive personality until we realize that this numb, voyeuristic view of contemporary life, in which the grave and the trivial, the fashionable and the horrifying, blandly coexist as passing spectacles, is a deadly accurate mirror of a commonplace experience in modern art and life. It found its first full statement, in fact, a century earlier in the work of Manet. Like Warhol, Manet wears the disguise of an aesthete-reporter whose camera-eye range extended from the haut monde of famous people (from Mallarmé and George Moore to Clemenceau and Chabrier), of proto-Fauchon luxury edibles (from salmon and oysters to brioche and asparagus), and of pampered dogs (from poodles to terriers), all the way to contemporary events which would earlier have been interpreted as harrowing tragedies (a bullfighter killed in the ring, a barbaric execution of an Austrian emperor, a hair-raising maritime escape of a political prisoner from a penal colony, an unidentified man who has just shot himself on a bed). The familiar complaint that Manet painted the harshest facts of death with the same elegant detachment, cold-blooded palette, and unfocused composition that he used for still lifes, picnics, pet animals, and society portraits is one that could be leveled at Warhol. But in both cases, it perhaps is not blame but gratitude that we owe these artists for compelling us to see just how false our conventional moral pieties are when judged against the truth of our usual shoulder-shrugging responses to what often ought to be the shattering news of the day. And in both cases these reportorial observations about the facts of modern life are lent further distance by being seen literally through a pictorial skin that insistently calls attention to itself. The subtle chill of Manet's and Warhol's view of current events through the aesthete's tinted glasses often cuts more deeply than the louder screams of Expressionist psychology.

For Warhol's seeming moral anesthesia, his poker-faced rejection of the conventional hierarchies of the tragic and the silly become still more detached and ironic through his manipulation of the look of commercial photography as a new vocabulary to be explored as an aesthetic language in itself. The blurrings of printer's ink, the misalignment of contours, the flat graininess of shadows, the brusque and arbitrary change from one colored filter to another, the new plastic spectrums of chemical hues both deadly and gorgeous—such products of the mechanized world of photographic printing and retouching are isolated by Warhol and provide him with a fresh range of visual experiences that usurp the earlier artifices of picture-making. They become, in fact, the stuff from which new cosmetic layers are made, ugly-beautiful paint surfaces that turn the truth of the silkscreened photographs on the canvas into a distant shade of an ever more intangible reality.

The contradictory fusion of the commonplace facts of photography and the artful fictions of a painter's retouchings was one that, in Warhol's

work, became a particularly suitable formula for the recording of those wealthy and glamorous people whose faces seem perpetually illuminated by the afterimage of a flashbulb, and whose physical reality might be doubted by the millions who recognize them. In the 1970s, Warhol's production of such society portraits accelerated to a point where he and his paintings constantly intersected the world of paparazzi and of high-fashion photography. If many of the celebrity portraits of the 1960s, whether of Jackie or Marilyn, smacked of the *New York Post* or *Screen Romances* and almost made us feel that our fingers might be stained with cheap newsprint if we touched them, those of the 1970s belong to the glossy domain of *Vogue* and Richard Avedon. The Beautiful People have replaced the dreams and nightmares of Middle America; the world of the Concorde, that of the U.S. highway accident. From those first days of Bonwit Teller window displays and starry-eyed, adolescent pin-up fantasies, Warhol's upward mobility was supersonic. Instead of getting the superstars' photos from movie magazines or the Sunday color supplement, he himself quickly invaded their society on equal terms, and could be begged by prospective sitters to turn his own Polaroid camera on their fabled faces in both public and private moods. He had become a celebrity among celebrities, and an ideal court painter to this 1970s international aristocracy that mixed, in wildly varying proportions, wealth, high fashion, and brains.

With Warhol's gallery of contemporary faces, the decade of 1970s high society is instantly captured. In this glittering realm, light and shadow are bleached out by the high wattage of spotlights; colors seem selected from the science-fiction rainbow invented by the likes of Baskin-Robbins; and brushstrokes offer an extravagant, upper-income virtuosity which appears to be quoting, for conspicuous consumption, a bravura tradition that extends from Hals through de Kooning. By comparison, the look of Warhol's 1960s paintings was often of lower-income austerity and dreariness, of Brillo boxes and Campbell's soup cans, of the faces of criminals, innocent victims, or remote superstars who could barely sparkle through the smeared newsprint. On more than one level, Warhol has wrapped up two decades for our social time capsule.

But however time-bound these portraits of the 1970s may be, they also belong to a venerable international tradition that had its heyday in the late nineteenth century. In the familiar way that new art alters our perception of old art, Warhol's society portraits may have given a fresh lease on life to the achievement of those moneyed, high-fashion portraitists who, at the turn of the last century, were feted as honored guests in the drawing rooms and villas of the fabled patrons whom they also painted.[2] This lustrous roster can count as members the Italian Giovanni Boldini, the Spaniard Joaquín Sorolla, the Swede Anders Zorn, the American John Singer Sargent, the Frenchmen Jules Clairin and Jacques-Emile Blanche, and hordes of others who aspired to be accepted as equals in the company of Sarah

Bernhardt and Ellen Terry, Marcel Proust and Henry James, Isabella Stewart Gardner and Mrs. Potter Palmer. The Warholian connections here are not only social but aesthetic. In a typical Boldini portrait, that of Mme Charles Max of 1896, the truths of physiognomy, of mannered gesture, and designer clothing are first seized, but then submerged under a pictorial veil of artifices, which here include fencing-lesson brushstrokes that evoke the most supple human animation but are then contradicted by grisaille tonalities that immobilize the sitter in an environment of chilly aristocracy.

That Warhol himself is hardly unaware of this tradition is evident in, for instance, his choices for the "Raid the Icebox" exhibition held (1969–70) at the Rhode Island School of Design, in Providence, where he was allowed to select a show from the storage vaults and came up with, among other things, some late-nineteenth-century American examples of this elegant, brushy portrait tradition by William Merritt Chase and Frank Benson, as well as sterner royal prototypes from earlier decades, such as Joseph Paelinck's state portraits of King William and Queen Hortense, the Napoleonic rulers of the Dutch Netherlands. (It should be no surprise either that Warhol's 1978 auction-purchases included first-class replicas of Allan Ramsay's full-length coronation portraits of King George III and Queen Charlotte, which, like many official royal portraits of the eighteenth and nineteenth centuries, were turned out by highly skilled assistants in the artist's studio as multiples for wider image distribution. As usual, Warhol has shrewd intuitions about his own art-historical pedigree.)

If it is instantly clear that Warhol has revived the visual crackle, glitter, and chic of older traditions of society portraiture, it may be less obvious that despite his legendary indifference to human facts, he has also captured an incredible range of psychological insights among his sitters. From the utter vacuity of the camera-oriented smile of the wife of an international banker to the startling disclosures of moods fit for private diary, these painting-snapshots add up to a Human Comedy for our time, in which pictorial surface and psychological probing are combined in differing proportions and in which the very existence of not one but two or more variations on the same photographic fact add to the complex shuffle of artistic fictions and emotional truths.

Take the pair of Liza Minnelli portraits. What we may first see is how a familiar face is flattened to extinction by the blinding glare of a flashbulb or by the cosmetic mask of lip gloss, hair lacquer, mascara. Almost like Manet in *Olympia*, Warhol has here retouched reality to push his pictorial facts to a two-dimensional extreme. Middle values vanish (the nose and shoulders are swiftly ironed out to the flatness of paint and canvas), and we are left with so shrill and abrupt a juxtaposition of light and dark that Courbet's quip about *Olympia*'s resemblance to the Queen of Spades might be repeated here. But as in *Olympia*, this insistent material façade of opaque, unshadowed paint cannot annihilate a psychological presence. From behind

this brash silhouette, a pair of all too human, almost tearful eyes returns our gaze.

Or take the portraits of Ivan and Marilynn Karp. Even if we don't know that Ivan, the art dealer, thinks, moves, and talks faster and clearer than most of us mortals, Warhol has told us all by fixing a momentarily steady gaze, in synch with the cool puff of a cigar, amid a nervous flutter of brushwork that first dissolves the hand and then leaves centrifugal traces of wriggling, linear energy at the edges of hair, shoulder, lapel. As for his wife, Marilynn, a counterpersonality is instantly indicated by Warhol's revival, so frequent in these portraits, of Picasso's use of a profile on a frontal view to evoke an external-internal dialogue with the more concealed recesses of psychology. Here, the furtive glance of the pink profile, underscored by a stroke of blue eyeshadow, is given even greater emotional resonance by the murky glimpse of the far side of the face, which anxiously meets our gaze from the deepest shadows.

The range of human revelation, both of public and private personality, is no less dazzling in these portraits than their seductive surfaces. (For comparison, one might check the inert products of an imitator like Rodney Buice, who uses the Warhol formula for everyone from Arnold Schwarzenegger to Prince Charles.) Here are Leo Castelli, at his dapper and urbane best; Alexander Iolas, in an intimate glimmer of frightening vulnerability worthy of the portrait of Dorian Gray; Brooke Hayward, at once ravishingly wordly and devastatingly innocent; Carolina Herrera, a queen tigress among tiger-women; Henry Geldzahler, his cigar and elusive gaze forever poised for public view; Sofu Teshigahara, in a cool flash of yen-to-dollar business acumen; David Hockney, with that beguiling shock of blond hair above a lovably callow face; John Richardson, in a sinister, black-leather mood; Marella Agnelli, a living embodiment of patrician elegance and hauteur; and Norman Fisher, as a bone-chilling phantom, a white-on-black negative image all too grimly appropriate to a posthumous portrait of a snuffed-out life.

Even when Warhol leaves, from time to time, the jet-set world of art, business, fashion, the results are equally incisive. It is something of a miracle that a contemporary Western artist could seize, as Warhol has, the Olympian Big Brother image of Mao Tse-tung. In a quartet of canvases huge enough to catch one's eye at the Workers' Stadium in Peking, Warhol has located the chairman in some otherwordly blue heaven, a secular deity of staggering dimensions who calmly and omnipotently watches over us earthlings. Not since the days of rendering Napoleon as God or Jupiter has an artist come to successful grips with the frighteningly serene and remote authority of the leader of a modern totalitarian state. One need only look at Warhol's cornily matter-of-fact portraits of the all too earthbound and fallible Gerald Ford and Jimmy Carter to realize how much has been said.

At the opposite end of Mao's daunting image of inscrutable power,

the posthumous portraits of Julia Warhola, the artist's mother, cast an alien spell. That she has gained access at all to this International Portrait Gallery may not be so surprising when one remembers that another famous artist-dandy, Whistler, could paint, almost as pendants, portraits of both his mother and Thomas Carlyle, as if the sitters' human realities were second-ary to the decorative realities asserted by the artist's titles, "Arrangement in Grey and Black, Nos. 1 and 2." But if Warhol's aestheticism is often close to that of the nineteenth century, implying that all is sheer surface and that art levels out the distinction between great men and flower ar-rangement, here, with Julia Warhola, the posture cracks. For beneath these virtuoso variations, there presides in both clear focus and ghostly fade-outs a photographic image of a bespectacled old lady, the artist's mother, a haunting memory at once close and distant. In the midst of this racy and ephemeral company of *Women's Wear Daily* and *Interview*, her glamourless countenance is all the more heart-tugging, an enduring and poignant re-membrance of family-things past. She reminds us of the last thing we expected to think about in Warhol's fashionable Hall of 1970s Fame: that art and life, that personal and public history may overlap but, in the end, are very different things.

NOTES

[1] Richard Morphet, "The Modernity of Late Sickert," *Studio International*, vol. 190 (July–August 1975), pp. 35-38.

[2] Warhol's relation to this tradition of upper-class portraiture has already been pointed out in David Bourdon's excellent and informative article, "Andy Warhol and the Society Icon," *Art in America*, vol. 63 (January–February 1975), pp. 42-45.

Like Clement Greenberg, critic Barbara Rose believes that art should resist popular culture with its emphasis on innovation and novelty, and instead should employ visionary imagery that expresses universal truths. Rejecting the idea of art as social comment, her exhibition "American Painting: The Eighties" focused on painters whose work was sensuous, imagistic, and metaphorical, without resorting to the "regression" of realist illusion. Rose champions art which is generated by the subjective unconscious to reveal the metaphysical and transcendent content of the imagination.

American Painting: The Eighties

Barbara Rose

You know exactly what I think about photography. I would like to see it make people despise painting until something else will make photography unbearable.
——Marcel Duchamp, Letter to Alfred Stieglitz, May 17, 1922
(Beinecke Library, Yale)

To hold that one kind of art must be invariably superior or inferior to another kind means to judge before experiencing; and the whole history of art is there to demonstrate the futility of rules of preference laid down beforehand: the impossibility, that is, of anticipating the outcome of aesthetic experience . . .
. . . connoisseurs of the future may be able, in their discourse, to distinguish and name more aspects of quality in the Old Masters, as well as in abstract art, than we can. And in doing these things they may find much more common ground between the Old Masters and abstract art than we ourselves can yet recognize.
——Clement Greenberg,
"Abstract, Representational and so forth," 1954

Ten years ago, the question, "Is painting dead?" was seriously being raised as artist after artist deserted the illusory world of the canvas for the "real" world of three-dimensional objects, performances in actual time and space, or the secondhand duplication of reality in mechanically reproduced images of video, film and photography. The traditional activity of painting, especially hand painting with brush on canvas, as it had been practiced in the West since oil painting replaced manuscript illumination and frescoed murals, seemed to offer no possibility for innovation, no potential for novelty so startling it could compete with the popular culture for attention, with the capacity of the factory for mass production, or the power of political movements to make history and change men's minds. In the context of the psychedelic sixties and the post-Viet Nam seventies, painting

Reprinted from Barbara Rose, "American Painting: The Eighties," catalogue essay, Grey Art Gallery, 1980.

seemed dwarfed and diminished compared with what was going on outside the studio. In the past, of course, the painter would never have compared his activity with the practical side of life; but by the time Senator Javits presented President Kennedy with an American flag painted by Jasper Johns, the idea that art was an activity parallel in some way with politics, business, technology and entertainment was on the way to becoming a mass delusion.

Once Andy Warhol not only painted the headlines, but appeared in them as well, the potential parity of the artist with the pop star or the sports hero was stimulating the drive to compete instilled in every American by our educational system. In the past, a painter might compete with the best of his peers, or in the case of the really ambitious and gifted, with the Old Masters themselves; but now, the celebrated dissolution of the boundary between art and life compelled the artist to compete with the politician for power, with the factory for productivity, and with pop culture for sensation and novelty.

Perhaps most pernicious, the drive toward novelty, which began to seem impossible to attain within the strictly delimitative conventions of easel painting, was further encouraged by the two dominant critical concepts of the sixties and seventies: the first was the idea that quality was in some way inextricably linked to or even a by-product of innovation; the second was that since quality was not definable, art only needed to be interesting instead of good. These two crudely positivistic formulations of critical criteria did more to discourage serious art and its appreciation than any amount of indifference in the preceding decades. The definition of quality as something that required verification to give criticism its authority contributed to the identification of quality with innovation. For if quality judgments had any claim to objectivity, they had to be based on the idea that an artist did something *first*—an historical fact that could be verified through documentation. The further erosion of critical authority was accomplished in other quarters by the denial that quality was in any way a transcendent characteristic of the art work; for if a work validated its existence primarily by being "interesting" (i.e. novel), then qualitative distinctions were no longer necessary. Far more aligned than they might appear at first, these two materialist critical positions conspired to make painting less than it had ever been, to narrow its horizons to the vanishing point.

Thus, in the sixties and seventies, criticism militated on two fronts against styles that were based on continuity instead of rupture with an existing tradition. The term "radical" vied with "advanced" as the greatest accolade in the critic's vocabulary. Slow-moving, painstaking tortoises were outdistanced by swift hares, hopping over one another to reach the finish line where painting disappeared into nothingness. Such an eschatological interpretation of art history was the inevitable result of the pressure to

make one's mark through innovation; for those who could not be first, at least there was the possibility of being the first to be last.

I. REDUCING RECIPES

This drive toward reductivism, encouraged and supported by a rigorously positivist criticism that outlawed any discussions of content and metaphor as belonging to the unspeakable realm of the ineffable, was a surprising finale to Abstract Expressionism, which had begun with an idealistic Utopian program for preserving not only the Western tradition of painting, but also the entire Graeco-Roman system of moral and cultural values. Of course this was to ask of art more than art could deliver; the revulsion against such rhetoric was a primary reason for the rejection of Abstract Expressionist aesthetics by pop and minimal artists beginning around 1960.

To be accurate, however, one must recall that the subversion of Abstract Expressionism began within the ranks of the movement itself. A popular art world joke described the demise of "action painting" as follows: Newman closed the window, Rothko pulled down the shade, and Reinhardt turned out the lights. A gross over-simplification of the critique of gestural styles by these three absolutist artists, this pithy epithet indicates the superficial manner in which the works of Newman, Rothko and Reinhardt were interpreted by art students throughout America, anxious to take their places in the limelight and the art market, without traveling the full distance of the arduous route that transformed late Abstract Expressionism into simplified styles subsuming elements from earlier modern movements into a synthesis that, while reductive, was still a synthesis. What lay behind Abstract Expressionism was forgotten ancient history in the art schools, where recipes for instant styles (two tablespoons Reinhardt, one half-cup Newman, a dash of Rothko with Jasper Johns frosting was a favorite) pressed immature artists into claiming superficial trademarks. These styles in turn were authenticated by art historians trained only in modern art history, and quickly exported to Europe, where World War II and its aftermath had created an actual historical rupture and an anxiety to catch up and overtake American art by starting out with the *dernier cri*. Soon the minimal, monochromatic styles that imitated Newman, Rothko and Reinhardt in a way no less shameless than the manner de Kooning's Tenth Street admirers copied the look of his works, gave a bad name to good painting on both sides of the Atlantic.

Yet more disastrous in its implications was the haste to find a recipe for instant innovation in Pollock's complex abstractions. Not well represented in New York museums, rarely seen in the provinces at all, these daring works were essentially known through reproduction and in the widely diffused photographs and films Hans Namuth made of Pollock at

work. The focus on Pollock as a performer in action rather than as a contemplative critic of his own work and student of the Old Masters— which was closer to the truth—meshed perfectly with the American proclivity to act first, think later. With little or no idea of what had gone into the making of Pollock's so-called "drip" paintings, which vaulted him into international celebrity as the last artist to genuinely *épater le bourgeois*, young artists turned to Happenings, the "theater of action", and other forms of public performance. Later, Namuth's photographs, which made the liquid paint look solid, promoted a series of random "distributional" pieces of materials poured, dropped or dumped on the floor of museums and galleries. These ephemera signaled the end of minimal art in a misguided attempt to literalize Pollock's "drip" paintings in actual space.

This is not to say that all the artists of the sixties and seventies who interpreted Abstract Expressionism literally—seizing on those aspects of the works of the New York School that seemed most unlike European art— were cynical or meretricious. But they were hopelessly provincial. And it is as provincial that most of the art of the last two decades is likely to be viewed when the twentieth century is seen in historical perspective. By provincial, I mean art that is determined predominantly by topical references in reaction to local concerns, to the degree that it lacks the capacity to transcend inbred national habits of mind to express a universal truth. In the sixties and seventies, the assertion of a specifically American consciousness was an objective to be pursued instead of avoided. The Abstract Expressionists by and large had European or immigrant backgrounds; they rejected the strictly "American" expression as an impediment to universality. Beginning around 1960, however, the pursuit of a distinctively American art by native-born artists provided the rationale for the variety of puritanically precise and literalist styles that have dominated American art since Abstract Expressionism. A reductive literalism became the aesthetic credo; the characteristics of painting as mute object were elevated over those of painting as illusion or allusion.

II. TECHNIQUE AS CONTENT

Even those artists who maintained closer contact with the European traditon, like Bannard and Olitski, avoiding the provincial American look, were unable to find more in painting than left-overs from the last banquet of the School of Paris, *art informel.* However, *tachiste* art, with its emphasis on materials, was nearly as literal as the local American styles. The absence of imagery in Yves Klein's monochrome "blue" paintings, the ultimate *informel* works, identifies content not with imagery or pictorial structure, but with technique and materials. In identifying image and content with materials, *informel* styles coincided with the objective literalist direction of American painting after Abstract Expressionism.

The identification of content with technique and materials rather than

image, however, also had its roots in Abstract Expressionism. In seeking an alternative to Cubism, the Abstract Expressionists, influenced by the Surrealists, came to believe that formal invention was primarily to be achieved through technical innovation. To some extent, this was true; automatic procedures contributed in large measure to freeing the New York School from Cubist structure, space and facture. But once these automatic processes were divorced from their image-creating function, in styles that disavowed drawing as a remnant of the dead European past to be purged, the absence of imagery threw the entire burden of pictorial expression on the intrinsic properties of materials. The result was an imageless, or virtually imageless, abstract painting as fundamentally materially oriented as the literal "object art" it purported to oppose.

The radicality of object art consisted of converting the plastic elements of illusion in painting—i.e. light, space and scale—into actual properties lacking any imaginative, subjective or transcendental dimension. No intercession by the imagination was required to infer them as realities because they were *a priori* "real". This conversion of what was illusory in painting into literal realities corresponds specifically to the process of reification. As the fundamental characteristic of recent American art, anti-illusionism reveals the extent to which art, in the service of proclaiming its "reality", has ironically been further alienated from the life of the imagination. The *reductio ad absurdem* of this tendency to make actual what in the past had been a function of the imagination was so-called "process art", which illustrated the procedure of gestural painting, without committing itself to creating images of any permanence that would permit future judgment. In conceptual art, the further reification of criticism was undertaken by minds too impotent to create art, too terrified to be judged, and too ambitious to settle for less than the status of the artist.

Thus it was in the course of the past two decades that first the criticism, and then the art that reduced it to formula and impotent theory, became so detached from sensuous experience that the work of art itself could ultimately be conceived as superfluous to the art activity—which by now epitomized precisely that alienation and reification it nominally criticized. Such were the possibilities of historical contradiction in the "revolutionary" climate of the sixties and seventies. In painting, or what remained of it, a similar process of reification of the illusory was undertaken. Edge had to be literal and not drawn so as not to suggest illusion; shape and structure had to coincide with one another to proclaim themselves as sufficiently "real" for painting to satisfy the requirements of radicality. In reducing painting to nothing other or more than its material components, rejecting all forms of illusionism as *retardataire* and European, radical art was forced to renounce any kind of illusive or allusive imagery simply to remain radical. And it was as *radical* that the ambitious artist felt compelled to identify himself. In its own terms, the pursuit of radicality was a triumph of posi-

tivism; the rectangular colored surface inevitably became an object as literal as the box in the room. Even vestigial allusions of landscape in the loaded surface style that evolved from stained painting in gelled, cracked or co-agulated pigment—reminiscent of Ernst's experiments with decalco-mania—express a nostalgia for meaning, rather than any convincing met-aphor. For radicality demanded that imagery, presumably dependent on the outmoded conventions of representational art, was to be avoided at all costs. The result of such a wholesale rejection of imagery, which cut across the lines from minimal to color-field painting in recent years, was to create a great hunger for images. This appetite was gratified by the art market with photography and Photo-Realism.

III. AGAINST PHOTOGRAPHY

Photography and the slick painting styles related to it answered the appetite for images; but they did so at the enormous price of sacrificing all the sensuous, tactile qualities of surface, as well as the metaphorical and met-aphysical aspects of imagery that it is the unique capacity of painting to deliver. Pop art, which is based on reproduced images, had self-consciously mimicked the impersonal surfaces of photography, but Photo-Realism re-jected this ironic distance and aped the documentary image without em-barrassment. In a brilliant analysis of the limitations of photography ("What's All This About Photography?" *ARTFORUM,* Vol. 17, No. 9, May, 1979), painter Richard Hennessy defines the crucial differences between photo-graphic and pictorial imagery. A devastating argument against photogra-phy ever being other than a minor art because of its intrinsic inability to transcend reality, no matter what its degree of abstraction, the article makes a compelling case for the necessity of painting, not only as an expressive human activity, but also as our only present hope for preserving major art, since the subjugation of sculpture and architecture to economic concerns leaves only painting genuinely "liberal" in the sense of free.

According to Hennessy, photography, and by inference, painting styles derived from it, lacks surface qualities, alienating it from sensuous expe-rience. More than any of the so-called optical painting styles, photography truly addresses itself to eyesight alone. Upon close inspection, the detail of photography breaks down into a uniform chemical film—that is, into some-thing other than the image it records—in a way that painterly detail, whether an autonomous abstract stroke, or a particle of legible representation as in the Old Masters, does not. Thus it is the visible record of the activity of the human hand, as it builds surfaces experienced as tactile, that differ-entiates painting from mechanically reproduced imagery. (Conversely, the call for styles that are exclusively *optical* may indicate a critical taste uncon-sciously influenced in its preference by daily commerce with the opticality of reproduced images.)

The absence of the marks of the human hand that characterizes the

detached automatic techniques of paint application with spraygun, sponge, spilling, mopping and screening typical of recent American painting, relates it to graphic art as well as to mechanical reproductions that are stamped and printed.

IV. EXAMPLE OF HOFMANN

Among the first painters to insist on a "maximal" art that is sensuous, tactile, imagistic, metaphorical and subjective, Hennessy himself painted in a variety of styles, examining the means and methods of the artists he most admired—Picasso, Matisse, Klee, Miró, and above all Hans Hofmann. The latter has come to symbolize for many younger painters the courage to experiment with different styles, to mature late, after a long career of assimilating elements from the modern movements in a synthesis that is inclusive and not reductive. Indeed, Hofmann's commitment to preserving all that remained alive in the Western tradition of painting, while rejecting all that was worn out by convention or superseded by more complex for- mulation, has become the goal of the courageous and ambitious painters today.

Who could have predicted in 1966, when Hofmann, teacher of the Abstract Expressionists, who brought Matisse's and Kandinsky's principles to New York, died in his eighties, that the late-blooming artist would become the model for those ready to stake their lives on the idea that painting had not died with him? Hofmann's example was important in many ways, for he had remained throughout his life an easel painter, untempted by the architectural aspirations of the "big picture" that dwarfed the viewer in its awesome environmental expanse. Conscious of allover design, Hofmann nevertheless chose to orient his paintings in one direction, almost always vertically, the position that parallels that of the viewer. The vertical ori- entation, which implies confrontation, rather than the domination of the viewer by the painting, is also typical of many of the artists of the eighties, who accept the conventions of easel painting as a discipline worthy of preservation. Moreover, Hofmann had also turned his back on pure au- tomatism, after early experiments with dripping. Like Hofmann, with few exceptions, the artists who follow his example maintain that painting is a matter of an image that is frontal and based on human scale relationships. They paint on the wall, on stretched canvases that are roughly life-size, working often from preliminary drawings, using brushes or palette knives that record the marks of personal involvement and hand craft, balancing out spatial tensions by carefully revising, as Hofmann did.

Of course, not all the artists I am speaking of have a specific debt to Hofmann. In fact, the serious painters of the eighties are an extremely heterogeneous group—some abstract, some representational. But they are united on a sufficient number of critical issues that it is possible to isolate them as a group. They are, in the first place, dedicated to the preservation

of painting as a transcendental high art, a major art, and an art of universal as opposed to local or topical significance. Their aesthetic, which synthesizes tactile with optical qualities, defines itself in conscious opposition to photography and all forms of mechanical reproduction which seek to deprive the art work of its unique "aura". It is, in fact, the enhancement of this aura, through a variety of means, that painting now self-consciously intends—either by emphasizing the involvement of the artist's hand, or by creating highly individual visionary images that cannot be confused either with reality itself or with one another. Such a commitment to unique images necessarily rejects seriality as well.

V. THE PAINTER AS IMAGE MAKER

These painters will probably find it odd, and perhaps even disagreeable, since they are individualists of the first order, to be spoken of as a group, especially since for the most part they are unknown to one another. However, all are equally committed to a distinctively humanistic art that defines itself in opposition to the *a priori* and the mechanical: A machine cannot do it, a computer cannot reproduce it, another artist cannot execute it. Nor does their painting in any way resemble prints, graphic art, advertising, billboards, etc. Highly and consciously structured in its final evolution (often after a long process of being refined in preliminary drawings and paper studies), these paintings are clearly the works of rational adult humans, not a monkey, a child, or a lunatic. Here it should be said that although there is a considerable amount of painting that continues Pop Art's mockery of reproduced images—some of it extremely well done—there is a level of cynicism, sarcasm and parody in such work that puts it outside the realm of high art, placing it more properly in the context of caricature and social satire.

The imagery of painters committed exclusively to a tradition of painting, an inner world of stored images ranging from Altamira to Pollock, is entirely invented; it is the product exclusively of the individual imagination rather than a mirror of the ephemeral external world of objective reality. Even when such images are strictly geometric, as in the case of artists like Susanna Tanger, Lenny Contino, Peter Pinchbeck, Elaine Cohen, Georges Noel and Robert Feero, they are quirky and sometimes eccentrically personal interpretations of geometry—always asymmetrical or skewed, implying a dynamic and precarious balance, the opposite of the static immobility of the centered icon, emblem or insignia. The rejection of symmetry and of literal interpretations of "allover" design, such as the repeated motifs of Pattern Painting, defines this art as exclusively *pictorial;* it is as unrelated to the repetitive motifs of the decorative arts and the static centeredness of ornament as it is to graphics and photography. For the rejection of the encroachments made on painting by the minor arts is another of the defining characteristics of the serious painting of the eighties.

Although these artists refuse to literalize any of the elements of paint-
ing, including that of "allover" design, some, like Howard Buchwald, Joan
Thorne, Nancy Graves and Mark Schlesinger are taking up the challenge
of Pollock's allover paintings in a variety of ways without imitating Pollock's
image. Buchwald, for example, builds up a strong rhythmic counterpoint
of curved strokes punctuated by linear slices and ovoid sections cut through
the canvas at angles and points determined by a system of perspective
projections referring to space in front of, rather than behind, the picture
plane. Thorne and Graves superimpose several different imagery systems,
corresponding to the layers of Pollock's interwoven skeins of paint, upon
one another. Schlesinger, on the other hand, refers to Pollock's antecedents
in the allover stippling of Neo-Impressionsim, which he converts into im-
ages of jagged-edged spiraling comets suggesting a plunge into deep space
while remaining clearly on the surface by eschewing any references to value
contrasts or sculptural modeling. These original and individual interpre-
tations of "allover" structure point to the wide number of choices still
available within pictorial as opposed to decorative art. For in submitting
itself to the supporting role that decorative styles inevitably play in rela-
tionship to architecture, painting renounces its claims to autonomy.

VI. THE LEGACY OF POLLOCK

To a large number of these artists, Pollock's heroism was not taking the
big risk of allowing much to chance, but his success in depicting a life-
affirming image in an apparent state of emergence, evolution and flux—
a flickering, dancing image that never permits the eye to come to rest on
a single focus. Like Pollock's inspired art, some of these paintings emphasize
images that seem to be in a state of evolution. Images of birth and growth
like Lois Lane's bulbs, buds and hands and Susan Rothenberg's desperate
animals and figures that seem about to burst the membrane of the canvas
to be born before us, or Robert Moskowitz' boldly hieratic windmill that
stands erect in firm but unaggressive confrontation—a profound metaphor
of a man holding his ground—are powerful metaphors. In the works of
Lenny Contino and Dennis Ashbaugh, as well as in Carol Engelson's proces-
sional panels, a kind of surface dazzle and optical excitement recall the
energy and sheer physical exhilaration that proclaimed the underlying
image of Pollock's work as the life force itself. Because he was able to create
an image resonant with meaning and rich with emotional association with-
out resorting to the conventions of representational art, Pollock remains
the primary touchstone. The balance he achieved between abstract form
and allusive content now appears as a renewed goal more than twenty years
after Pollock's death.

As rich in its potential as Cubism, Abstract Expressionism is only now
beginning to be understood in a profound instead of a superficial way.
What is emerging from careful scrutiny of its achievements is that the major

areas of breakthrough of the New York School were not the "big picture", automatism, action painting, flatness, et al., but the synthesis of painting and drawing, and a new conception of figuration that freed the image from its roots in representational art. For Cubism, while fracturing, distorting and in other ways splintering the image (something neither Abstract Expressionism or the wholistic art that came from it did) could never free itself of the conventions of representational art to become fully abstract.

Drawing on discoveries that came after Pollock regarding the role of figuration in post-Cubist painting, artists today are at ease with a variety of representational possibilities that derive, not from Cubist figuration, but from the continuity of image with surface established by Still, Rothko, Newman and Reinhardt, who imbedded, so to speak, the figure in the carpet, in such a way as to make figure and field covalent and coextensive.

In the current climate of carefully considered re-evaluation, the rejection of figure-ground relationships, which artists of the sixties labelled as superannuated conventions inherited from Cubism, is being reviewed and reformulated in more subtle and less brutal terms. Cutting the figure out of the ground to eliminate the recession of shapes behind the plane was an instant short-cut solution to a complex problem. Ripping the figure from the ground eliminated figure-ground discontinuities in a typically Duchampesque solution of negating the problem. (Interestingly, Johns, usually considered Duchamp's direct heir, backed off from the objectness of the *Flag*, in which he identified image with field, and found another solution to reconciling representation with flatness by embedding the figure in the ground in later works such as *Flag on Orange Field*.)

Short-cuts, recipes, textbook theorizing and instant solutions to difficult problems are being rejected today as much as trademarks and the mass-produced implications of seriality. Today, subtler modes of dealing with the relationship between image and ground without evoking Cubist space are being evolved. Even artists like Carl Apfelschnitt, Sam Gilliam and Ron Gorchov, who alter the shape of the stretcher somewhat, do so not to identify their painting as virtual objects, but to amplify the meaning of imagery. Apfelschnitt and Gorchov, for example, make totemic images whose sense of presence relies on metaphorical associations with shields and archaic devices; Gilliam bevels the edge of his rectangular canvas to permit freer play to his landscape illusion, insuring that his dappled Impressionism cannot be interpreted as the naive illusion of a garden through a window.

VII. POST-CUBIST REPRESENTATION

The difficulties of reconciling figuration, the mode of depicting images whether abstract or representational, with post-Cubist space has been resolved by these painters in a variety of ways. Precedents for post-Cubist representation exist in Pollock's black-and-white paintings, and more re-

cently in Guston's figurative style. Drawing directly in paint, as opposed to using drawing as a means to contour shape, has given a new freedom to artists like Nancy Graves, Richard Hennessy, William Ridenhour, Anna Bialobroda, Steven Sloman and Luisa Chase. In that post-Cubist representation is not based on an abstraction from the external objective world, but on self-generated images, it is a mental construct as conceptual in origin as the loftiest non-objective painting. Lacking any horizon line, Susan Rothenberg's white-on-white horse, Lois Lane's black-on-black tulips, and Robert Moskowitz' red-on-red windmill, or Gary Stephan's brown-on-brown torso have more in common with Malevich's *White-on-White* or Reinhardt's black crosses in black fields than with any realist painting. Like Dubuffet's *Cows*—perhaps the first example of post-Cubist representation—and Johns' targets and numbers, these images are visually embedded in their fields, whose surface they continue. This contiguity between image and field, enhanced by an equivalence of facture in both, identifies image and field with the surface plane in a manner that is convincingly modernist.

The possibility of depicting an image without resorting to Cubist figure-ground relationships greatly enlarges the potential of modernist painting for the future. No longer does the painter who wishes to employ the full range of pictorial possibilities have to choose between a reductivist suicide or a retrenchment back to realism. By incorporating discoveries regarding the potential for figuration with an abstract space implicit in Monet, Matisse, and Miró, as this potential was refined by Pollock and the color-field painters, an artist may choose a representational style that is not realist.

Today, it is primarily in their pursuit of legible, stable, imagistic styles—both abstract and representational—structured as indivisible wholes (another legacy of color-field painting) rather than composed in the traditional Cubist manner of adding on parts that rhyme and echo one another that modernist painters are united. Even those who make use of loosely geometric structures for painterly brushwork like Mark Lancaster, Pete Omlor and Pierre Haubensak, do so in a highly equivocal way that does not allude to Cubic figure-ground inversions, but rather recalls Impressionist and Fauve integrations of the figure into the ground. Their images suggest poetic associations with the grid of windows, a play on the illusion of the picture as window; but they do not pretend in any way that the picture *is* in any way a window. Still others, like Thornton Willis, Vered Lieb, Susan Crile, and Frances Barth, are even freer in their use of geometry as a structuring container for color, rather than as a rigid *a priori* category of ideal forms.

In all of these cases, the representation of an image never invokes naive illusionism; to remain valid as a modernist concept, figuration is rendered compatible with flatness. This may mean nothing more radical than Clive Bell's assumption that a painting must proclaim itself as such

before it is a woman, a horse or a sunrise, or Serusier's definition of a painting as a flat surface covered with patches of color. However, it does necessitate conveying the information that the depicted image is incontrovertibly two-dimensional, that it lies on the plane, and not behind it. The contiguity of image with ground is established often as the Impressionists did, by an allover rhythmic stroking. All that in Cubism remained as vestigial references to the representational past of painting—value contrast, modeling, perspective, overlapping, receding planes, etc.—is eliminated so that the space of painting cannot be confused with real space. Once the truth of the illusion of painting is acknowledged—and *illusion, not flatness, is the essence of painting*—the artist is free to manipulate and transform imagery into all manner of illusions belonging exclusively to the realm of the pictorial, i.e., the realm of the imagination. Moreover, since the depicted illusions belong to the imagination, i.e., they are registered by the brain and the eye, surface, perceived as constituted of pigment on canvas, can be manipulated to evoke a tactile response that has nothing to do with the experience of a third dimension, but is entirely a matter of texture.

The difference between a painting that is composed, a process of addition and subtraction, and one that is constructed, through a structuring process that takes into consideration the architecture of the frame, continues to be a primary consideration. These artists take a responsibility to structure for granted, just as they reject the random, the chance and the automatic as categories of the irresponsible. In this sense, decision-making, the process of deliberation, becomes a moral as well as an aesthetic imperative.

Sifting through the modern movements, panning the gold and discarding the dross, the painters of the eighties, as we have seen, retain much from Abstract Expressionism. In many cases, there is a commitment to a kinetic or visceral metaphor. However, this appeal to empathy in the energetic and muscular images of Elizabeth Murray, Dennis Ashbaugh, Stewart Hitch, Georges Noel, Howard Buchwald, Robert Feero and Joan Thorne, or in the movement implied by Susan Rothenberg, Edward Youkilis and Joanna Mayor, has more in common with the "life-enhancing" quality Bernard Berenson identified as our empathic identification with Signorelli's nudes than with the documentary and autobiographical gestures of "action painting".

VIII. THE FUNCTION OF THE IMAGINATION

Today, the essence of painting is being redefined not as a narrow, arid and reductive anti-illusionism, but as a rich, varied capacity to birth new images into an old world. The new generation of painters who have matured slowly, skeptically, privately, and with great difficulty, have had to struggle to maintain conviction in an art that the media and the museums

said was dying. Today, it is not the literal material properties of painting as pigment on cloth, but its capacity to materialize an image, not behind the picture plane, which self-awareness proclaims inviolate, but behind the proverbial looking-glass of consciousness, where the depth of the imagination knows no limits. If an illusion of space is evoked, it is simultaneously rescinded. In one way or another, either in terms of Hofmann's "push–pull" balancing out of pictorial tensions, or by calling attention to the actual location of the plane by emphasizing the physical build-up of pigment on top of it, or by embedding the figure into its contiguous field, serious painting today does not ignore the fundamental assumptions of modernism, which precludes any regression to the conventions of realist representation.

Not innovation, but originality, individuality and synthesis are the marks of quality in art today, as they have always been. Not material flatness—in itself a contradiction, since even thin canvas has a third dimension and any mark on it creates space—but the capacity of painting to evoke, imply and conjure up magical illusions that exist in an imaginative mental space, which like the atmospheric space of a Miró, a Rothko or a Newman, or the cosmic space of a Kandinsky or a Pollock, cannot be confused with the tangible space outside the canvas, is that which differentiates painting from the other arts and from the everyday visual experiences of life itself.

The idea that painting is somehow a visionary and not a material art, and that the locus of its inspiration is in the artist's subjective unconscious was the crucial idea that Surrealism passed on to Abstract Expressionism. After two decades of the rejection of imaginative poetic fantasy for the purportedly greater "reality" of an objective art based exclusively on verifiable fact, the current rehabilitation of the metaphorical and metaphysical implications of imagery is a validation of a basic Surrealist insight. The liberating potential of art is not as literal reportage, but as a catharsis of the imagination.

The Surrealists believed, and no one has yet proved them wrong, that psychic liberation is the prerequisite of political liberation, and not vice-versa. For most of the twentieth century, the relationship between art and politics has been an absurd confusion, sometimes comic, sometimes tragic. The idea that to be valid or important art must be "radical" is at the heart of this confusion. By aspiring to power, specifically political power, art imitates the compromises of politics and renounces its essential role as moral example. By turning away from power and protest, by making of their art a moral example of mature responsibility and judicious reflection, a small group of painters "taking a stand within the self", as Ortega y Gasset described Goethe's morality, is redeeming for art a high place in culture that recent years have seen it voluntarily abdicate for the cheap thrill of instant impact.

Because the creation of individual, subjective images, ungoverned and

ungovernable by any system of public thought or political exigency, is *ipso facto* revolutionary and subversive of the status quo, it is a tautology that art must strive to be radical. On the contrary, that art which commits itself self-consciously to radicality—which usually means the technically and materially radical, since only technique and not the content of the mind advances—is a mirror of the world as it is and not a critique of it.

Even Herbert Marcuse was forced to revise the Marxist assumption that in the perfect Utopian society, art would disappear. In his last book, *The Aesthetic Dimension,* he concludes that even an unrepressed, unalienated world "would not signal the end of art, the overcoming of tragedy, the reconciliation of the Dionysian and the Apollonian. . . . In all its ideality, art bears witness to the truth of dialectical materialism—the permanent non-identity between subject and object, individual and individual." Marcuse identifies the only truly revolutionary art as the expression of subjectivity, the private vision:

> The *"flight into inwardness"* and the insistence on a private sphere may well serve as bulwarks against a society which administers all dimensions of human existence. Inwardness and subjectivity may well become the inner and outer space for the subversion of experience, for the emergence of another universe.

For art, the patricidal act of severing itself from tradition and convention is equally suicidal, the self-hatred of the artist expressed in eliminating the hand, typical of the art of the last two decades, can only lead to the death of painting. Such a powerful wish to annihilate personal expression implies that the artist does not love his creation. And it is obvious that an activity practiced not out of love, but out of competition, hatred, protest, the need to dominate materials, institutions or other people, or simply to gain social status in a world that canonizes as well as cannibalizes the artist, is not only alienated but doomed. For art is labor, physical human labor, the labor of birth, reflected in the many images that appear as in a process of emergence, as if taking form before us.

The renewed conviction in the future of painting on the part of a happy few signals a shift in values. Instead of trying to escape from history, there is a new generation of artists ready to confront the past without succumbing to nostalgia, ready to learn without imitating, courageous enough to create works for a future no one can be sure will come, ready to take their place, as Gorky put it, in the chain of continuity of "the great group dance."

This is a generation of hold-outs, a generation of survivors of catastrophes, both personal and historical, which are pointless to enumerate, since their art depends on transcending the petty personal soap opera in the service of the grand, universal statement. They have survived a drug culture that consumed many of the best talents of their time; they have lived through a crisis of disintegrating morality, social demoralization and

lack of conviction in all authority and tradition destroyed by cultural relativism and individual cynicism. And they have stood their ground, maintaining a conviction in quality and values, a belief in art as a mode of transcendence, a worldly incarnation of the ideal. Perhaps they, more than the generations who interpreted his lessons as license, have truly understood why Duchamp was obsessed by alchemy. Alchemy is the science of trans-substantiation; the tragedy of Duchamp's life was that he could only study alchemy because he could not practice it. To transform matter into some higher form, one must believe in transcendence. As a rationalist, a materialist and a positivist, Duchamp could not practice an art based on the transformation of physical matter into intangible energy and light. Those who perpetuate an art that filled him with ennui are the last of the true believers; their conviction in the future of painting is a courageous and constructive act of faith.

SUSAN ROTHENBERG, "Untitled #33" 1976 Acrylic on paper, 29½" × 41⅜"
Courtesy Margo Leavin Gallery, Los Angeles.

In 1979, Richard Marshall was the curator of an influential exhibition of paintings at the Whitney Museum of American Art that included the works of Nicholas Africano, Jennifer Bartlett, Denise Green, Michael Hurson, Neil Jenney, Lois Lane, Robert Moskowitz, Susan Rothenberg, David True, and Joe Zucker. The excerpt from his catalogue statement which is included here describes the use of ambiguous, manipulated, and isolated imagery in order to force viewers to engage their imaginations and give their own meanings to the paintings. Indeterminacy and pictorial illusion are seen as the key elements in depicting the complexities of contemporary experience—elements which were forbidden by modernist theory.

New Image Painting

Richard Marshall

Much of the art of the 1970s has been characterized by artists' inclination toward the use of recognizable images. This has occurred most readily and obviously in those disciplines predisposed to image-making—performance, video, film, photography—and has also become increasingly apparent in recent painting and sculpture. Although the use of imagery in painting and sculpture was often discredited and discouraged, a number of artists began to incorporate recognizable forms into their work in a way that is both opposed to and an assimilation of the predominant modes of abstraction and figuration of the '50s and '60s. This catalogue and the exhibition which it accompanies focus on the work of ten painters who utilize imagery in non-traditional and innovative ways, and make images the dominant feature of their paintings. The artists assembled here are related more in sensibility than in style, and an aim of this exhibition is to present their paintings with a view toward understanding them individually rather than collectively.

Although each artist's use and treatment of imagery is different, the conceptualization and function of the image is often similar. By exploring the choice and treatment of recognizable forms in painting, certain descriptive generalizations can be made about the work of these imagists. Familiar adjectives used to describe an artistic style—representational, figurative, realist—do not differentiate these artists' ways of using images nor adequately convey the distinct painterly qualities manifested in the work. Conversely, labels such as abstract, non-objective, and expressionistic do

Excerpted from Richard Marshall, "New Image Painting," catalogue essay, Whitney Museum of American Art, 1979.

not allow for the appearance of familiar shapes and forms. The type of painting discussed here draws upon and rejects aspects of each of these styles of painting. The images used fluctuate between abstract and real. They clearly represent things that are recognizable and familiar, yet they are presented as isolated and removed from associative backgrounds and environments. The paintings do not attempt to duplicate an object as it exists in nature or to interpret reality, but to depict an image that is drastically abbreviated or exaggerated, retaining only its most basic identifying qualities. The images are radically manipulated through scale, material, placement, and color. Because of their isolation and alteration, they create a distance between themselves and the viewer. This is confounded by the wavering equilibrium established between form and content—often weighted more toward form. The image becomes released from that which it is representing. The imagery is non-normative and often non-referential to specific interpretation. The paintings contain a narrative quality only to the extent that a narrative is implied or suggested—but not stated. When two or more images are used simultaneously, any narrative aspect present is non-linear and non-sequential, and therefore does not readily lend itself to simple, obvious explanation.

What becomes most apparent in these works is the interplay between the emotive content of the image and its formal structure and characteristics. The use of imagery brings into play the imagination and psychology of the viewer to a greater degree than the analytical and perceptual considerations encouraged by other work of the recent past. In some ways, imagistic painting confounds the viewer because expectations and associations with the suggested illusion are not readily discernible or explicable. A viewer's response is not made directly to an image but is based on the meanings that he attaches to such images. A viewer responds to meanings of objects that are defined within a cultural system and social organization and which are mediated by the use of symbols. Through classification of these symbols one carries with them the knowledge and associations experienced when encountering these images. The essence, value, or nature of an image resides not in the image but in the relation between it and the viewer. As a result of this, when an image is presented in an unusual, unexpected, or altered manner, its predictable or specific allusion is not elicited. When confronted with an illusion of an object that is devoid of the surroundings that provide clues and keys to its meaning, the viewer's interpretation becomes undefined and open-ended. Although broad and commonly held definitions are at hand, numerous variables are present. The viewer's participation in experiencing the work is enhanced to the extent that, when introduced to a new terminology, one must draw upon memory for possibly analogous experiences and conceptions. Even though these images are recognizable and contain many psychological associations, they become obtuse to rational explanation based on their content. The

paintings, then, are not reliant on the references inherent in the meanings attached to the image but can also bring into play formal, intellectual, and painterly factors. The image becomes neutralized and is freed from its usual functions; it can be used to expand into other capacities. The artist is free to manipulate the image on canvas so that it can be experienced as a physical object, an abstract configuration, a psychological associative, a receptacle for applied paint, an analytically systematized exercise, an ambiguous quasi-narrative, a specifically non-specific experience, a vehicle for formalist explorations, or combinations of any.

The meanings and associations applied to an image cannot be completely obliterated, nor is it advantageous that they be. The viewer attempts to find meaning in an image by correlating previously classified associations, and the lack of obvious meaning will consequently elicit the application of potential and possible meanings. Paired, multiple, or successive images will invariably educe a narrative or implied relationship between images. Because of this, the artist is able to either enhance, promote, or control this direction or attempt to further negate relationship and story. The artist will often encourage speculation on the relationship between images but control the external references and extraneous details to the point of keeping its reading immediate and specific. All additional clues and props for the development of a linear and sequential narrative are eliminated so that flexibility in interpretation is simultaneously restricted and yet activated.

Although the appearance of images in contemporary painting may seem reactionary and contrary to a viewer accustomed to the highly visible abstract presentations of recent American art, these image painters exhibit a closer affinity to Abstract Expressionist, Pop, Minimal, and Conceptual concerns than to traditional figurative and realist work. Pictorial illusion, previously considered a foe of contemporary sensibility, has emerged with new strength, vigor, and impact.

American art since the mid-'40s has been distinguished by a striving toward the reduction and clarification of all but the most essential qualities of art. Paring down to the most cogent aspects of visual, emotional, formal, and intellectual components has been a consistent objective of recent art. The Abstract Expressionists' preoccupation with the demands of paint and canvas in conjunction with its emotional and self-reflective characteristics; Pop Art's blatant and ironic use of disjointed and disparate public imagery with its instant cultural associations and meanings; and the emphasis of the Minimalist sensibility on perceptual phenomena and physicality, though seemingly dissimilar, share certain basic intentions. The imagists, toward the same end, have drawn from these varying features of recent art and have conjoined seemingly different attitudes and concerns. By acknowledging and assimilating the salient aspects of recent American art, these contemporary artists have been able effectively to employ, manipulate, and revitalize imagery. . . .

RICHARD DIEBENKORN, "Ocean Park #37" 1971 Oil on canvas, 50" × 50"
Courtesy collection of Robert A. Rowan.

Critic and painter Peter Plagens examines the formal strategies of
painting which, in Marcia Tucker's words, "defies, either deliber?
virtue of disinterest, the classic canon of good taste, draftsmanship, a
source material, rendering, or illusionistic representation." Plagens goes o
the ways in which one can make a "good" painting—ambitious, balanced,
learned, and skillful—without cliches. Drawing on popular cultural sources,
"bad" painting turns its awkwardness into an asset by its ability to defy pre-
dictability and to engage viewers' interest. Apparent ineptness and a "catalogue
of disguises" can make paintings more effective as art only if they are accom-
panied by aesthetic distance. In time, the genuine innovations of the "bad"
become integrated into, and serve to revitalize, "good" painting.

The Academy of the Bad

Peter Plagens

There is now a phenomenon abroad in the land called, among other
things, " 'bad' painting," "new image" painting, "new wave" painting, "punk
art" and "stupid" art. Although it takes many forms, it is primarily realized
in painting, where its trademarks are what looks like inept drawing, garish
or unschooled color, tasteless or trivial or bizarre imagery, odd and im-
practical assemblage, maniacally vigorous or disinterested paint application,
dubious craft and materials, and a general preference for squalor over
reason. Concurrent interpretations of its cause range from the end of
modern art itself, to simple spillover from the loudest rock music played
at the grungiest clubs. Most art world developments have, however, some-
thing to do with other art, and are most profitably illuminated by com-
parison. "Bad" painting is best seen next to "good" painting.

During Minimalism and its aftermath, painting was in a weak theo-
retical position because, being bound to the convention of that flat, static,
indoor rectangle, it didn't appear to do much to advance the precious
dialectic of modernism. That is, in the outward-bound imperative of con-
temporary art (i.e., the further from a conventional objet d'art the better,
whether it be in a mainstream straight line from grid to field to box to
blueprint to specifications to prose, or in the variegated hook rugs, laser
beams, rituals, huts and fences of "pluralism"), painting stayed home and
minded the store. Now that modernism has either pooped out because its
audience is more revolutionary than it is, or is just catching its wind in the
backstretch, painting breathes free of the avant garde, and is making a

Reprinted from Peter Plagens, "The Academy of the Bad," *Art in America* (November 1981).

comeback. In this artistic recession, conventions are being disinterred—reopened, like old gold mines.

Nevertheless, exhumed conventions can still be exhausted ones. The problem with painting, particularly abstract painting, is that by now all the possible significant variations on neat/messy, thick/thin, big/little, simple/complex, or circle/square have been done. You've got your basic Mondrian, basic Frankenthaler, basic Pollock, basic Reinhardt, basic Kline, and basic Pousette-Dart. (Granted, there are an infinite number of occupiable points between zero degrees and 180 degrees, but who really cares about that which comes along late in the day and blithely situates itself two degrees, 12 minutes down the dial from *perpendicular?*)

We all know by now what the deliberately "good" painting looks like: its scale is physically ambitious within a human limitation; its composition is interlocked and balanced; its color, whether loud or muted, displays a knowledge of key; and its paint handling evidences the presence of a nimble wrist. "Good" painting looks, at its most orthodox, like one of Richard Diebenkorn's *Ocean Park* pictures, at its most agitated like one of Joan Mitchell's works, or, at its most attenuated, like a Brice Marden triptych. The trouble with "good" painting, especially that by artists holding a reverse idea of the avant garde (i.e., in the face of pluralism, the closer to the most moribund late Cubist mannerism the better), is that it quickly becomes predictable and boring.

(Straight figurative painting is somewhat immune to all this. Since it's closely connected with the passing, visible, real world, it can float on iconography, with Robert Bechtle pursuing successive models of Chryslers at a constant time lag, or Jack Beal updating our sins with each new L.L. Bean catalogue. Yet straight figurative painting is also somewhat prey to all this, as the insistent timelessness of William Bailey or the aggressive tours de force of Al Leslie, each trying to deodorize the lingering scent of journalism, testify.)

Painters painting since the heyday of Abstract Expressionism have been aware of the pitfalls of deliberately "good" painting which hangs its hat on nothing but a manifest definition of "good" painting itself, and they have tried by various means to work through, or around, the dangers of staleness and cliché. One approach has been *elegance*, usually got by playing up one or two of "good" painting's properties while neutralizing or eliminating, as nearly as possible, the others. A vintage, ca. 1970 Ken Noland stripe painting, for instance, goes big in scale and juicy in color, while mechanizing paint handling and (almost) obviating composition. It looked fresh in its time (and still does), but the present-day strike-offs—all those paintings resembling off-the-rack Peruvian skirts—beggar our sensibilities and are about as interesting as four A.M. static on channel nine.

Another tack has been *straightforwardness*—painting so self-effacing and guileless that it charms us into forgetting this may be the umpteenth

footnote to a theme by earlier full-disclosure painters like Robert Moth-
erwell or Barnett Newman, or even a good recent one like Frances Barth.
Straightforwardness, however, subverts itself quite easily; it slips into either
pseudo-straightforwardness (an inside joke demanding an up-to-the-min-
ute knowledge of art world fashion in order to perceive why a particular
painting is innocent, that is, straightforward instead of trendy) or a form
of needlessly visual Conceptual art. (The "Painting of the Eighties" exhi-
bition was filled with such duplicitous or tactical paintings.)

A third approach simply and unabashedly celebrates painting's ability
(or, more accurately, *paint's* ability) to create illusion; without dipping back
into the fetid pot of figuration, it augments frothy impasto with low-angle
spray, masks out areas which end up looking like masking tape, and, as
seemingly necessary to an Abstract Illusionist work as an alligator to a polo
shirt, throws in airbrushed shadows under squiggles of paint to make them
appear to hover three inches off the picture's surface. It is ostensibly time-
honored (although the difference between the Abstract Illusionists and
William Harnett is that his devices didn't work *automatically*) and certainly
arresting (if the double-take is our most profound esthetic experience, then
these are the masterpieces of the '80s), but there is a great pitfall: the failure
to distinguish between a work of art and a stunt. The *everything-but-the-
kitchen-sink* gambit has no need for restraint; if a painting is a circus, three
rings must be ten times better than one. Ultimately, there is no need to
confine such compilations to paintings, especially when an artist like John
Okulick can make a sculpture look like a painting trying to look like a
sculpture.

One final way of attacking the problem of making a "good" painting
without succumbing to its manifest clichés might, for lack of a more precise
term, be called *fetish-ism*: adopting the look of obsessive, or ritualistic, or
simply non-Western art-making activity. It can remain close to the bone of
painting, restricting itself to the metronomically numbing task of applying,
in hundreds or thousands, the visceral *Om* of an identical dab of paint, or
roam as far afield as room-filling installation pieces flaunting beads, rib-
bons, feathers, stones, sticks and bones. Sometimes the conscious or semi-
conscious acquisition of primitive materials or devices to juice up urban art
(i.e., whenever either the artist or the intended audience lives in a big city)
doesn't seem expedient or exploitative; once in a while it results in a "good"
painting which slips around the rules. But stealing pictorial modes from
whole cultures or dressing up as a shaman is no more noble or insightful
than ripping off Malevich. A source is a source is a source.

Approaches like elegance, straightforwardness, everything-but-the-kitchen-
sink and fetishism work for a while, but they become increasingly ineffective
against the nagging doubt buzzing louder and louder in the painter's inner
ear: what's the point in trying to defy predictability and boredom by paint-

KAREN CARSON, "Doors and Targets" 1982 Acrylic on paper, 62½" × 95½"
Photograph by Douglas M. Parker. Photograph courtesy Rosamund Felsen Gallery, Los Angeles.

ing a "good" painting, when a satisfying feeling of expression, or attracting a lot of attention, can be had by painting an *effective* painting? ("Effective," here, is admittedly something of an umbrella term—it covers paintings which get attention by being other things than "good"—and something of a tautology, i.e. an "effective" painting is discerned as such simply by its causing the question of what an effective painting is to occur in the first place.) Against the ever-diminishing effectiveness of the "good," the great, tempting counterweight of the "bad" is too good to resist.

By the "bad," I mean something a little broader than the same quotation-barnacled word used in The New Museum's exhibition, "Bad Painting," of 1978, which was limited to painting based on inept-looking drawing: I mean all those qualities *not* usually associated with the "good." I mean the opposite of the elements of "good" painting sketched above: trivially small or uselessly large scale, graceless or inert or unbalanced composition, garish or sour or random-seeming color, and indifferent or seemingly out-of-control paint handling. And I also mean something a little more calculated than painting which inadvertently redefines "good" by (to use an inappropriate metaphor) marching to the sound of a different drummer. "Bad" painting is more strategy than obsession (more strategic, in fact, than the devices used to expand the parameters of "good" painting), and it is so because it takes into account, indeed depends upon, the probable inability of its audience's taste to accept it as an enlarged version of "good."

The real world, because it is the real raw world and not the filtered one of art, offers more cultural sources for "bad" painting than it does for "good" painting: everything from the tackiness of commercial art imitating clichéd forms of fine art (e.g., those emporia hawking portrait sculpture made by a mechanized carving process based on a sequence of photographs of the model), to the raw, untutored, spleenish imperatives of restroom graffiti; everything from junior high school study-hall drawing (e.g., the excruciatingly detailed but proportionately awry ballpoint pen drawing of a drag racer, bathing beauty or decapitation scene done by a restless 14-year-old who forgot his textbooks for the free period), to the T-square-less layouts of fan magazines and depilatory advertisements; everything from yard sales of blond motel furniture to the crude modeling of chewing tobacco barn signs. (One form of "bad" is curiously absent from art galleries hip enough to traffic in irony: misinformed or expedient pastiches of "good" painting which fail critically but succeed commercially. The reason is the difficulty in trying to outflank the debilities of overused "good" painting with painting which only exaggerates those flaws. How would the audience tell the difference among "good bad" painters, "bad good" painters, and the genuine article on both sides? On the other hand, a dose of Leonardo Nierman or Frank Gallo in some museum surveys of an even newer new wave might bring on a tide of revisionist sentiment for critically neglected masters like Fritz Scholder, M.C. Escher, Leroy Nieman and Yaacov Agam—

to equal the historical reappraisal of Bouguereau and Cabanel.)

The inclusion, or adoption, of the "bad" is not new with American artists like Julian Schnabel, David Salle, Donald Sultan, Jonathan Borofsky, Jedd Garet, Kim MacConnel, Fred Escher, Robert Colescott, or Charles Garabedian (who made people in Los Angeles wonder whether he could *really* paint if he wanted to way back in the '50s); nor is it new with Europeans like Georg Baselitz (expressionism turned literally on its head), Markus Lupertz (whose "badness" is more like studentness), Sandro Chia or K.H. Hödicke. Francis Picabia, probably the best "bad" painter who ever lived,

JONATHAN BOROFSKY, "I Dreamed I Found a Red Ruby" 2 color lithograph, 76″ × 39½″
© Gemini, G.E.L. 1982 Los Angeles, California.

tried to stuff a stuffed monkey still-life up the noses of Rembrandt, Renoir and Cézanne (three of the most notoriously "good" painters, and therefore the kind of anathema to Picabia that, say, Jake Berthot, Robert Motherwell or Sharon Gold represent to the present-day "bad" sensibility), and then went on through a few decades' worth of edgily clumsy mechanical semi-abstractions. The "bad" of Philip Guston's late paintings consists of his simple, awkward, psychologically charged figuration; though always, within the boundaries of his figural shapes, Guston's handling of paint is extremely "good," or decidedly accomplished. Larry Rivers, beginning in the late '50s, and Roy Lichtenstein, in the early '60s, made banality, the food of the "bad," a decisive part of their paintings, but Rivers artsified his French money and Camel packs with enough bits of "good" painterly business to satisfy the same Rembrandt he later parodied, and Lichtenstein edited, cropped, simplified and tightened the literal idiocies of *True Love* into one of the most durable approaches to "good" painting in the annals of modern art. And on the West Coast, there's been Joan Brown, whose work may prove how quickly what was once perceived as "bad" is critically assimilated and is now seen as charming and inventive.

Of the Pop artists, Andy Warhol looms as the most totally, deliciously "bad": wrinkled canvas stretching, clogged silkscreens, illegible *Daily News* photos, repugnant or corny or limp subject matter, and crass color. Warhol, however, suffuses the dish he cooks up with an unerring sense of graphic chic, and it is the Warhol of the slick shoe drawings, greeting cards and cookbooks, rather than Andy the neo-Dadaist, who emerges as the "good" chef. (Like Jim Dine, who started out more or less "bad," and has gotten more defiantly "good" with unmistakably old-masterish licks, Warhol's recent work is laden with a deftness unexpected by, and perhaps unavailable to, the wave of "bad" painters thrashing in his wake.)

Finally, there is the precedent of Chicago—Ivan Albright begetting H.C. Westermann begetting The Hairy Who begetting every third artist to show on Ontario Street: critic Peter Schjeldahl refers to the current "badding" of SoHo as "the Chicagoization of New York," and painter Frank Owen says wistfully that the Midwesterners have been "snookered again" (meaning The Big Apple has looked over the overlooked "bad," seen its market potential, and gone out and laid down its own pipeline instead of sending to Illinois for the methane of *malerisch*). Chicago's Imagism is, however, usually tightly rendered, where the new wave of New York "bad" is loosely, even wildly painted.

There is one thing which Schnabel, Garet, Rivers, Warhol and the Imagists have in common, and that is that their underlying purpose—to make "effective" modern art that looks like it was made by an artist with special talents—belies the look of the "bad," and vice versa. The undeniable purpose (attended by such giveaways as the art's participation in a sophisticated gallery system, slick kromecote announcements, and the artist's hav-

ing one or two degrees from an art school or university art department) most often turns a putative obsession into a strategy. What is supposed to look like a van Goghian, "I can't help it, in my emotional state I couldn't paint a cypress tree any other way even if I wanted to, and therein lies the power of my art," comes off more like the art director of *New York* magazine saying, "You know, instead of running a photograph, why don't we get one of those punkish magic-marker drawings to catch their eyes?" In principle, the adoption of the skin of the "bad" without actually being consumed by its guts is no more a hypocrisy than any other form of artifice in art. As "the willing suspension of disbelief" essential to our perceiving a bunch of actors prancing about on the stage as the court of Richard III is usually the result of the author's craft rather than his passion, it should be the visual artist's honorable prerogative to replicate dementia.

The big trouble with attempting to make significant painting via the "bad" is not that the "badness" is built rather than bled, but that it can at best only echo a real thing which exists outside not only the art world but sometimes art itself. Witness Henry Darger of Chicago, against whom "bad" artists like Fred Escher and Jedd Garet pale in comparison.

Darger died in 1973 at the age of 81, after a long and troubled life which included being sent to a home for feeble-minded boys and ending up washing dishes in a hospital. Discovered in the room in which he lived for 40 years were thousands of typewritten pages, single-spaced, and bound into 13 volumes, detailing *The Realms of the Unreal*, the saga of the seven "Vivian sisters" on a planet far from earth, their efforts to free thousands of child-slaves, and their sufferance of bondage, torture, even crucifixion at the hands of the "Glandelenians" and assorted other evil men. Recognized as a spiritual progenitor of the nastier aspects of Imagism, Darger's accompanying watercolors were given a posthumous exhibition at Chicago's Hyde Park Art Center, and chunks of his artistic estate were consigned to the dealer, Phyllis Kind, who has mounted two Darger shows. (Darger's pictures indicate about the same level of talent as his writing, that of a slightly precocious and wacko fifth grader—Darger's imaginative technique of working from actual newspaper and magazine imagery notwithstanding—and it's interesting to note that the literary world, apparently attaching less importance than the art world to the hipness of ineptitude, does not, to my knowledge, plan to publish the text.) Other examples abound: Lee Godie in Chicago, Elijah Pierce in Columbus, Ohio, and Ed Murphy (né Newell) and Lewis Palmer in California—*real* outside sensibilities who would do the work they do, no matter what (to the sophisticated artist) the perceived unviability of semi-exhausted "good" painting.

It is too simplistic to designate art-world strategy the sole, or even dominant, driving force behind the present surfeit of "bad" painting. Hilton Kramer opened an emphatically favorable *New York Times* review of shows

by Julian Schnabel and Malcolm Morley (a deftly painterly Photorealist gone loosely painterly Expressionist—whether that's "good" to "bad," I can't say) by noting:

> At the heart of every genuine change in taste there is, I suppose, a keen feeling of loss, an existential ache—a sense that something absolutely essential to the life of art has been allowed to fall into a state of unendurable atrophy. It is to the immediate repair of this perceived void that taste at its profoundest level addresses itself.

What has been allowed to atrophy is, of course, Expressionism. But there is a difference, say, between Nolde, with his attempt to reach a primal nerve, and David Salle, with his use of a recognizably debased source—i.e., pulp illustration. The reinfusion of gut, soul, pain, rage and plain ol' visual clout into an art form which, like painting, operates best with some esthetic distance (i.e., a screaming face painted in cadmium red light, with splatters, is not necessarily the best painterly equivalent of rage), and, if not esthetic distance, genuineness, is not well served by a catalogue of disguises lifted from the art of the insane, the untutored and the jejeune, then coyly plopped down south of Houston Street, east of Michigan Avenue, or a block away from Ocean Front Walk.

When Richard Diebenkorn attempts another "good" painting, it succeeds or fails on simply how *good* (without the quotes) he paints it. Diebenkorn may by now be a bit academic, and it may be painters like Ron Gorchov or Elizabeth Murray who will manage to revitalize "good" painting by distilling and distancing elements of the "bad" and integrating them as positive components against the excesses of elegance, straightforwardness, *tours de force* and fetishism. It may even be that Murray and Gorchov are, underneath, conservatives and that someone like Julian Schnabel (who is, on the basis of a wonderful red triptych called *Raped by a Zombie* in the Neumann Collection in Chicago, a very interesting painter) is rescuing painting from its doldrums. If he is, it will be for more permanent and less trendy, more thoughtful and less spleenish, and more fundamentally "good" and less superficially "bad" reasons, than the disingenuous dogma of the shadow Academy.

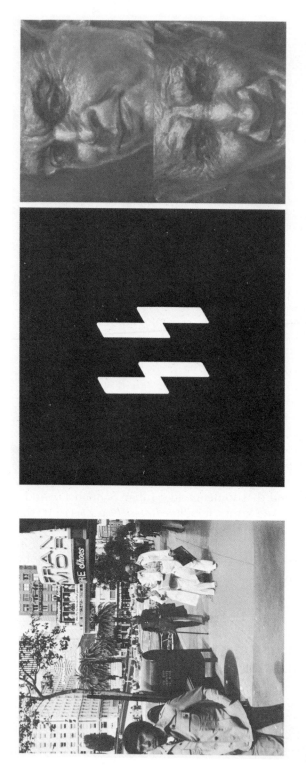

. . . S.S. General Otto Froesch was as hurt as he was angry. All around he was regarded as a good fellow. Cultured and witty. How could this man have stared into his face for so many hours without really seeing him?

DOUGLAS HUEBLER, "Crocodile Tears II" 1983 Photograph and painting, 120" × 40"
(Brief fictions re-sounding from the proposal in Variable Piece #70:1971 "to photographically document the existence of everyone alive.")
Photograph courtesy the Leo Castelli Gallery and the artist.

Artist and critic Joseph Kosuth is well known for advocating in the sixties that the function of the artist is to question the nature of art. He rejected painting on the grounds that "if you make painting you are already accepting (not questioning) the nature of art." For Kosuth neoexpressionist painting is un-critical—intentionally undermining earlier notions of quality, while working in a vacuum of meaning caused by the collapse of modernism. In this vacuum, the art market steps in as the only arbiter of value.

Necrophilia Mon Amour

Joseph Kosuth

(The comments I've written here were written in one sitting and basically as you find them. I've tried to be as chatty as possible; it seemed appropriate to the form of this project. Needless to say the excerpted portions of the conversation that accompany my text here become only a quasi-factual account; not that people didn't say what is attributed to them, but the transformation of all oral discussion into a written text is nothing less than radical. Often, because of multiple voice-overs, the transcriber is obliged to approximate or reconstruct with only parts of the dialogue. I've tried to leave such parts out, but it is always a pity: they tend to be the heated or excited parts of the conversation. Also, I've tried to choose portions in which people other than myself speak, since I have the last word here.)

I have friends, whose opinions I respect, who maintain that for me to consider the work that I discuss here is to lend credibility to it. They say if we all remain silent it will quietly disappear, like photo-realism or pattern painting. I disagree, for two reasons. First, the issues at stake have become too crucial to ignore any longer, and second, because I don't really think the, uh, 'shelf life' of weak work can be terribly extended by even reams of verbiage; but I do think that relevant work can suffer from a lack of a critical dialogue. Artists who don't risk asking themselves hard questions about what they are doing, and about what others are doing, can't grow. The dialogue is necessary in order to see the work, and find out its rela-tionship with the world. Simply looking at work won't do it; we're just too close to it.

We set up a discussion situation with people—other artists—who share a community and a problem. In some sense we are defined by our rela-tionship to that problem—the problem being, from my point of view, the aftermath of what is unhappily titled 'The End of Modernism,' or, to be more upbeat, 'The Beginning of Post-Modernism.' Some of us around

Reprinted from Joseph Kosuth, "Necrophilia Mon Amour," © *Artforum* (May 1982).

that table, I suppose, have been participants in one, the other, or both. But no one would want to press such claims; art historians jealously guard their preserve—when we're as 'smart' as they we just get called self-serving. What is more relevant is that we are functioning artists, now. And we know Ad Reinhardt had a point when he said, "In art, the end is always the beginning." The locus of the conversation was the effect we've had on each other's present work because of, rather than in spite of, the kind of baggage we brought with us to that table. This wasn't discussed, but it organized the discussion.

Anyway, as I have repeatedly said—and those who understand the value of hyperbole will appreciate it—artists work with meaning, not form (if such a separation were possible). To think the reverse is tantamount to saying that when you speak you think in terms of grammar (let's see: I need a noun, a verb, a subject) rather than in terms of what you want to express. The analogy, once stated, is limited; language functions instrumentally in a way art does not. In art, the tradition of organized meaning functions as authority; it speaks louder than any individual can. The individual artist must rupture the forms of that authority; that is, he or she makes meaning by canceling, redirecting or reorganizing the forms of meaning that have gone before. It is in this sense that the art of this century—the 'avant-garde' tradition—is associated with the political. Since the demise of that historicist discourse called Modernism, a kind of generalized vacuum of meaning has seemed to develop. The discourse previously framed and gave meaning to work, but it now appears to have disintegrated. The art of the late '60s bared the mechanism of Modernism, in a sense, and much of the self-reflexivity became, as a style, simply self-consciousness. Many younger artists, a couple of whom participated in the discussion which is the subject here, as art students naturally found some of us to be the representations of authority, and therefore of institutionalized meaning. The antithesis to what we appeared to represent, the rupture-device, seemed easy: use painting. To speak positively first, the better work in this category is more complicated than that; often it's not simply painting but a reference to painting, a kind of visual quotation, as if the artists are using the found fragments of a broken discourse. (One thinks of the beach scene in *Planet of the Apes*). Such work has critically internalized the issues of the late '60s and early '70s, and in some ways, even if through negation, is tied to that earlier work. (One of the more charitable things I could say is that when the best of the work of certain younger artists is compared with the worst of the art that preceded it, the latter could be described as a test posing as an illustration and the former as an illustration posing as a test.)

I'm often asked what I have to say about this 'rebirth' of painting, since I have always maintained that painting was dead. Actually, when I first

described it as dead I was a kid—and I was projecting into the future. Let's just say that it's dying—although a slower and more agonizing death than I at first thought. Of course, what one is talking about is the death of a particular belief-system, the death of certain meanings. In fact, this continuation of painting as a kind of 'painted device' is a necessary part of that 'dying' process. Work that had a critical relationship to painting *external* to it provided painting with a kind of meaning from the outside, as the other half of a dialectic. Obviously, such work couldn't directly eclipse it in any widespread or permanent way because the dynamic of painting, due to the power of its rich history, had been established as a cultural institution for too long; customs can live on as formal conventions long after they've lost their meaning. I think the work of this period that will remain with us will do so in spite of the fact it's painted. As for the rest, it continues the death of painting through its uncritical extolling of painting's past virtues while it simultaneously devalues those same traditional qualities through bad craft and an intentional undermining of an earlier era's concept of 'quality' through the confused identification of formal invention with the use of what becomes too simply 'what those other guys left behind.' In other words, such work devalues those same qualities that provide the authority from which it speaks—as a process it is in an entropic tailspin. Such work, unlike my generation's critique of painting, is neither reflexive nor external, but becomes naively internalized; in short, it becomes actualized in practice as a kind of terminal illness. It seems that many artists are cannibalistically revisiting the earlier art of this century and cancelling it through inflated but empty celebrations marketed as 'formal invention.' This erasing of earlier meaning seems destructive, rather than creative, precisely because the critical relationship is lacking. By using the earlier work as 'nature'—something found, to be used—and not 'culture,' it is being depoliticized as an institution with economic and social meaning. It is through that (missing) critique and reflexiveness that one historically locates oneself and takes responsibility for the meaning one makes, which is the consciousness one produces. It's that distancing that describes one's own historical location; self-knowledge and the production of knowledge itself is impossible without it. The power of the work we see in museums is exactly this. It is the authenticity of the cultural production of a human being connected to his or her historical moment so concretely that the work is experienced as real; it is the passion of a creative intelligence to the present, which informs both the past and the future. It is not that the meaning of a work of art can transcend its time, but that a work of art describes the maker's relationship to her or his context through the struggle to make meaning, and in so doing we get a glimpse of the life of the people who shared that meaning. (For this reason, one can never make 'authentic' art—in the sense given here—by simply attempting to replicate the forms of an earlier powerful art.)

In this sense *all* art is 'expressionist.' But one must understand the complexity, even delicacy, of the way in which a work of art must be so singularly the concrete expression of an individual (or individuals) that it is no longer simply about the individual, but rather, is about the culture that made such expression possible. Because of this, Expressionism, as an institutionalized style, but focusing on the individual artist in a generalized way (abstracting that which must remain concrete) has become the least expressive art of our time. It is the preferred art form for the artists who have the least to say, because they count on the institution of Expressionism to do their talking for them. The "Wild Ones" couldn't be tamer.

Let's talk about money. The art market, which by nature is conservative—particularly in this country—loves paintings. Every illiterate, uncultured dingbat (rich or not) knows that paintings are art, are great investments, and look swell over the couch. Forget whatever historical necessity was thoughtfully felt by some artists for a return to painting; the market is delighted to have paintings hip again; it can pretend that the last 20 years didn't happen, celebrating old hacks and new opportunists indiscriminately. How has this happened? That 'vacuum of meaning' caused by the collapse of the previous discourse (Modernism) and the, as yet, noticeable nonarrival of a replacement ('post-Modernism' is more of a notion than a discourse) has meant that new work is increasingly given its meaning by movement within the art market. Careers are made, not on new ideas, but new taste: as the cliché goes, art has begun to function in earnest as expensive fashion. Artists unheard of three years ago are commanding $40,000 a painting—prices it used to take artists a whole career to arrive at. Once, the idea of art historical importance stabilized the market value of an artist's work, but prices no longer reflect this—how could they? Now they reflect speculation on short-term market scarcity; and the mode of painting is ideally suited to marketing scarcity. However, there may be problems in paradise. Sales at those prices are either between dealers (who don't seem to keep the work for very long) or to, well, people who know little about art and take the dealers' advice on à la mode investments. At those prices people get nervous, and when somebody else becomes chic, the newly arrived will unload (since their relationship to the work is superficial to begin with) and prices will most probably come crashing down—something not unlike what happened to the Greenberg gang in the late '60s. The pity is that all this has very little to do with the art; certainly very little to do with the artist's relationship to his or her work. But in the end it does because such pressure makes it very difficult for artists to go in the direction that their work is taking them. In such a situation there isn't sufficient time for the work to be evaluated on its own terms and establish its own meaning. How many of us can be unaffected in our evaluation of work that got too hot too fast and then too cold too fast? When a work goes from $40,000 to, say, $8,000, will we still be able to see the ideas of

the artist, or will we be looking instead at lapels too wide—or simply at 'failure'? I think there is a certain responsibility of the artist to fight for the meaning of her or his work. It is as much a part of the making process as the manipulation of materials; without that struggle art becomes just another job.

The inarticulate murmurs of the art critical/historical establishment in the face of this market onslaught is noteworthy. Most of the 'criticism' is promotional, with the critics, like the dealers and collectors, trying to pick the 'winners.' Now this is certainly not new; some form of it is how careerism works. But with all the hoopla in the market and public media the dearth of analytical writing about this 'new art' isn't just appalling, it's frightening. I used to talk, in quasiconspiratorial terms, about an art critical/historical market complex (to mangle Eisenhower), but I'm willing to put that away in order to appeal to those critics (well, anyway, people who like to write about art) who fancy themselves as intellectuals (is that illegal yet?), to speak up. Sure, money talks, but it doesn't have to be a monologue. I used to complain that artists had to struggle with art historians and critics for control of the meaning of work, but at least they have a name, a face, and ideas for which they can be held accountable.

There is something going on in the art world; it's taking different forms in various countries, but its implications for this country are potentially profound. In America we tend to see cultural events in international terms: we can have no 'national' character yet, not in the profound sense, and so we made Modernism itself our culture. By exporting our provincialism we re-formed other cultures and made the mess look 'universal.' Our conception of Modernism spread with our economic and political power. Because our culture didn't evolve from one place on the globe, we increasingly saw our location as a place in time—this century—rather than a place on Earth. We have exported a synthetic culture without a history— McDonald's, Coca-Cola, Hilton Hotel environments, and so on. To the extent that local cultures gave up their culture for ours, they of course lost control over the meaning-making mechanisms within their lives, and became politically and economically dependent on us. But both here and abroad something happened in the late '60s—maybe the Vietnam war broke the bubble of our sales pitch. More and more, I think, artists in other countries began to re-examine the context of their life and their art—as the art we were making at the time necessitated—and they began to look less and less to America for 'guidance.' Nonetheless, experimental or 'advanced' art—the remains of what an earlier era called 'avant-garde'—in this country has been supported by Europeans for the past 20 years. But it's all rather paradoxical, at the least. While we were dependent on Europe for not just money but that discourse that provides meaning (the heavier intellectual production), they were dependent on that relationship to feel

anchored in the 20th century, at least this half of it. It seems to be changing. The significance of, uh, 'bye-bye to Modernism' is that the European can look to his or her own culture for a context in which to work, but the Americans, as usual, will have to start again from scratch. The alienation our popular culture breeds hasn't just turned off the Europeans, it's turned us off. Making art, even just being involved with it, is one of the least alienating activities in our society. If that is subsumed by the forces of our economy, it's a very bad sign—not just for our cultural life, but for our political life as well. Beyond the value of the work itself, the reason that Clemente and Chia will have an easier time of it than, say, Salle and Schnabel, is that even while addressing the issues of Modernism, the best contemporary Italian art has always indexed itself to its own history and culture. Contemporary Italian art never seemed to export well before; outside of Italy it always seemed less 'international' than the work of other countries. Some of the chauvinistic painting going on elsewhere in Europe is, of course, simplistic and vulgar, but whatever our judgment of it, one thing is certain: it will force a radical re-evaluation of American art, not just there, but here.

In our sociopolitical system, cultural engagement is expressed in economic terms; we can't get away from that. Thus it won't do to cast all art dealers and collectors as ogres. There have been great, creative dealers in this century who have been essential to the art being in the world; the warning being issued here is about the direction and character of a *system*, not a moralizing about individuals. (Regarding the moral problem, it is up to you, dear reader, to consider what your relationship is to the problem.) Beyond the obscenity of the present government administration, artists seem demoralized. I've seen, and I keep seeing, artists who have been working for years lose the personal meaning of their work as they begin to doubt their own history: it's as though the value of their work is only the commercial value set by the market (if that were the case LeRoy Neiman and Andrew Wyeth would be among the greatest artists of our age). Denied the historicism of Modernism, denied the culture and history of an older nation, how will artists in America—and those who care about art—resist the almost total eclipse of meaning? The art market has been there all along, as has criticism of it, but what I'm discussing is a significant change in the quality of the relationship younger, supposedly radical, artists have with it, and the effect it is having on their work. Who we are, both as individuals and as a people, is inseparable from what our art means to us.

RICHARD SERRA: It's interesting because in the '60s the definition of an artist was open. What's happened in the '80s is the definition is determined and the framework's determined, the galleries are determined, the institutions are determined. All you have to do [now] is satisfy the extension of what's meaningful within this framework, but the notion of challenging is over for these people, they don't

even know about it. . . . You can look at what the work [of the '60s] implies, right. Then you can look at the recoil, the reaction to that work. . . . So now we have Chagall.

DAVID SALLE: Looks good, he's very hot right now.

RICHARD SERRA: Yeah, Chagall's hot. What I'm saying is that this generation right now accepted all the structure of making painting. The structures were already determined. Symbol, sign, iconography is up for grabs. Who can do it better than whoever. Whether it's Keith Haring or David Salle or whatever. The movement will be as good as the people are to express it. . . . This movement is a little bit like the child of Pop Art dealing with the ethos of Abstract Expressionism, so there's a contradiction. How do you get your feeling out in terms of contemporary iconography? I mean how do you love Pollock and Warhol and make a connection? There are two mythological figures in the culture—Pollock and Warhol. You have a lot of young painters and a few sculptors actually, but you have Warhol and Pollock standing for enormous notions of model figures for young painters to come up to . . . I mean, that's what we're talking about. What do they do about that contradiction . . .

DAVID SALLE: Are you *asking* me who my mythological figures are or are you imposing them on me?

RICHARD SERRA: I'm not asking you, this thing is an accepted fact.

DAVID SALLE: Not to me.

SANDRO CHIA: Each artwork is a personal research for a certain identity. The work is the materialization of this research. Each painting, each sculpture is just a step that you reach in this opera, in all the work you do during your life and this is why art is more interesting than politics or society or anything else. Because this is the physical proof of metaphysical existence. This way is better than politics, because it doesn't make up your mind.

KATHY ACKER: What sort of tools and mechanics are you using now to keep on working?

SANDRO CHIA: I try to give as little importance to materials and tools as is possible. If I use brush and canvas and colors, I'm doing painting, and I find them to be the less paradoxical, the less sophisticated means of achieving my step in the big world because they are obvious and already assumed by the tradition in the work. So there is no investment in the materials. Don't be distracted from the real substance of the work, which is not in the materials you use. The materials must be very secondary and marginal.

KATHY ACKER: I was just asking David Salle how he worked—I was just saying I saw a painting of his that totally interested me. . . .

DAVID SALLE: On the most banal level it's just deciding to identify with a certain image, even if the image is something which is an abstraction. The image of abstract painting . . . and then reacting to it by putting something next to it or adding something. That's just the obvious. Now, I mean why that color bar? And the color bar came first. I had an idea that I wanted to make this painting that looked like a painting that you'd see in a movie, a kind of hip movie where the decor was from the '60s or the late '50s. That really was the starting point . . .

BARBARA KRUGER: When you said you identified with the image you didn't say you presented this specific image, you said you identified with it.

DAVID SALLE: I said, after I decided to do it, then it was a process of identification, and then wanting to in a sense make visible why I thought it might be of some good in the first place. Because by itself, somehow, it's not really visible . . .
LAWRENCE WEINER: We were just talking about Expressionism before you came in.
BARBARA KRUGER: Expressionism?
LAWRENCE WEINER: Yes, and what it constitutes. Joseph [Kosuth] was explaining what it constituted for him and I was questioning whether there was any way to say that the difference is that the Expressionism that I find a bit socially distasteful is the Expressionism that uses the idea of expression as the content rather than the context since all art is expressive and all art is a form of expression.

BARBARA KRUGER: Expressionism is identified with a history of work and to me that is the expression. It's the expression of where someone chooses to locate themselves within a particular practice more than it is a very valorized feeling.
RICHARD SERRA: I'm talking about the weight of the content on the money. I never thought of the copper penny as being political. It's got Lincoln's head on it. I never thought of it as being political.
BARBARA KRUGER: Well, I do. Just the placement of Lincoln's head is a specific indicator in terms of electoral processes, who we pick as our heroes, who we choose for our fathers.
RICHARD SERRA: If you want to make the copper penny political you can make every painting in every gallery political. I think there was probably art on the money before there was money on the art.
SANDRO CHIA: During the 1960s an implicit and often explicit declaration in works by artists was that politics was a universal critical method applicable to everything. Artists wanted to open up art and politics for everyone. So you had an inflation of art, as well as of political, production. The result was that the artists actually ended up depriving people of the specifics of art and confusing practical political action with ideology. I think art is useful, socially useful, only when it maintains distinct boundaries and intensifies itself rather than diffusing itself into everything.
BARBARA KRUGER: But what I'm saying is, what is that power that names the specific thing as a political event, rather than an ongoing sort of unraveling of events?
PHILIP GLASS: I had a piece in Stuttgart where people returned the tickets because it was written by an American. The piece had been staged by a director from East Berlin and he had highly politicized the content of the opera, which wasn't anything to do with me but that was the way he wanted to interpret it. That happens in the theater all the time, I had no objection to it but people didn't go. There were some people who turned the tickets back because it was written by an American. That had never happened to me before, it was bizarre.

KATHY ACKER: I know in France the publishers are cutting down on their publication of American authors. I've heard Mitterand has given some publishers money to publish French fiction and poetry.
PHILIP GLASS: A lot of the people here began working because of a kind of internationalism in art—it seemed to be great for a while.

JOSEPH KOSUTH: I think for a long time Europe was sending tickets for ex-
hibitions and supporting the art of American artists and it was not reciprocated at
all. I mean there were very few invitations to come here. Now, it's different. It was
really one way, one direction for a long time.

LAWRENCE WEINER: They've got national quotas in some of these big shows
now. They say no more than 6% American, no more than 2% American, no more
than 2% Canadian, no more than 3% Italian. It's not a joke. And I'm totally as-
tounded when I hear it and of course you can never get anybody to write it in
print. There is no proof.

DAVID SALLE, "The Author Through Long Telescope" 1981
Acrylic on canvas, 72" × 96"
Courtesy Larry Gagosian Gallery, Los Angeles.

Critic Donald Kuspit argues that, rather than Kosuth's self-reflexiveness, contemporary painting marks a return to what modernism had left out: symbols of psychological reality and lived experience. Kuspit believes that art should have a direct influence on human affairs, not merely on art theory, by creating awareness of the contemporary psyche. Kosuth's preoccupation with the intellect causes him to ignore the role of the imagination and the emotions.

Reply to Kosuth

Donald Kuspit

Joseph Kosuth's "Necrophilia Mon Amour" deserves comment, if only because, coming to us with an aura of radicality, it is in fact conservative in outlook—desperately concerned to preserve the status quo of Kosuth's own conceptualism. He wants to play both sides, to be an artist within the system and to be divinely above it. We can be sure that when one acts like a know-it-all about every art but one's own, one's own art is on the defensive; in such cases, a first-strike attack is regarded as the best defense. Kosuth's typical strategy, in use since *Art after Philosophy,* is insultingly to close down everybody else's position so that one's own seems open and truthful. (The alternative, critical approach would be to stop playing god and to regard oneself as also fallible.)

Kosuth clears the field without an examination of its details. He hollows discourse by denying the authenticity of his opponents; he appropriates all authenticity for himself. It is worth noting that he rarely names the artists and critics he dismisses as conceptually beside the point. This lack of specific example is a method of self-justification; Kosuth does not argue from evidence, but from the self-sufficiency of his own position. He operates in a classically prejudicial manner—in terms of polarization, creating a lower class of ineffective lumpen artists whose work is worth dealing with only as an example of what is not really art.

The more substantive parts of "Necrophilia Mon Amour" deal with the nature of art and with Kosuth's assertion that painting is dying (a modification, he admits, of his youthful belief that it was already dead). Kosuth loves the prophetic role; it's an easy one, since in prophecy the future is always more certain than the present is analyzable (prophecy replaces complex present with simple future). In his attack on the new Expressionism, which he sees as market motivated, Kosuth clearly sees himself as Christ clearing the temple of art of the moneylenders. But at

Reprinted from Donald Kuspit, "Letter to the Editor," © *Artforum* (December 1982).

the same time he does not want to be taken as one of what he calls "the representations of authority, and therefore of institutionalized meaning." He wants to retain the cachet of being critical. Younger artists, he believes, are using painting to critically reject the authority of his conceptual art, which they regard as another rigid, repressive formalism, as intellectualism cutting art off from its own imaginative powers; thus Kosuth, in danger of becoming outdated, must go after the younger generation of artists, turning the tables on them by showing that they, being painters, were outdated to begin with, dead on arrival.

Kosuth, then, sees the revival of painting as a direct threat to his stature as a Modernist critical thinker/artist. According to Kosuth, "since the demise of . . . Modernism, a . . . generalized vacuum of meaning has seemed to develop." But it may be that the "canceling, redirecting, or reorganizing" following Modernism's death was a return to what Kosuth's brand of self-reflexive Modernism repressed: the psychosocial roots of Modernism, its thrust as a world-alienating or world-disrupting passion. Painting may be a means of rearticulating this passion, but Kosuth can only speak positively of it by locating it in terms that his conceptualism can comprehend; the best of the new painting, Kosuth argues, finds new meanings in the dregs of a once-authoritative tradition of meaning. But these are not the "expressionist" terms in which the new painting presents itself. The "new criticality" sought by nominally "Expressionist" painting—one that seeks to supplant the sterile, epistemological criticality of Kosuth—is that articulated by Friedrich Nietzsche in *The Birth of Tragedy*.

> *The truth once seen, man is aware everywhere of the ghastly absurdity of existence, comprehends the symbolism of Ophelia's fate and the wisdom of the wood sprite Silenis: nausea invades him. Then, in this supreme jeopardy of the will, art, that sorceress expert in healing, approaches him; only she can turn his fits of nausea into imaginations with which it is possible to live. These are on the one hand the spirit of the* sublime, *which subjugates terror by means of art; on the other hand the* comic *spirit, which releases us, through art, from the tedium of absurdity.*

Kosuth's conceptualism shares in the destructive devolution that has pervaded philosophy in the Modern period, a near-suicidal self-abasement. Such conceptualism is a reign of terror masquerading as enlightenment, an exaggeratedly ascetic use of Occam's razor not simply to cut away "meaningless," "poetic" notions of philosophy and art but to cut into their flesh like a scalpel. In a nutshell, Kosuth's "objectivity" is a suppressive, anti-art position carried to the absurd extreme of regarding itself (mistakenly) as art's means of salvation through self-purification. In fact, it is an implicit acknowledgment of art's mismanagement of its own destiny in this century: of its working itself into a position of powerlessness in which it has no serious influence on human affairs.

Expressionism, on the other hand—to use the language Kosuth uses to dismiss it in *Art After Philosophy*—attempts to create "demonstrative symbols" of the psychological in order to steady the "orbit" of art within the " 'infinite space' of the human condition"—to give art a relatively clear and distinct path in that space in which, from its origin, it has found itself. Art is not self-invented, self-orbiting, self-justifying. The real question for the new as well as the old Expressionism is this: is a demonstrative symbol of psychological reality inappropriate in the context of art? There is a further question, crucial to Kosuth's reputation as a critical artist: can such a symbol function critically, "make meaning," in Kosuth's words, and especially help us "get a glimpse of the life of the people who shared that meaning"?

The answer is self-evident: the admission of intersubjectivity necessitates the psychological. And the best of the new Expressionists—from Francesco Clemente to A.R. Penck and, yes, to Julian Schnabel—attempt to

ROGER HERMAN, "Vater, Mutter, Heidelberg" 1982 Oil on canvas, 48" × 51"
Photograph courtesy Ulrike Kantor Gallery.

to create not only symbols of psychological reality (sometimes very obscure psychological reality) but to establish such symbols in critical relationship to art. It is already a difficult task to create these symbols while avoiding the pitfalls of conventional demonstrativeness; the critical task is doubled when there is an attempt to show that art achieves criticality through its psychological effect, through its power over the psyche. What Kosuth calls "the found fragments of a broken discourse" are only the manifest content of the new Expressionism, which attempts to give that discourse new meaning by using it in a kind of visual utopian fantasy; pushed to the limits of the demonstrative, the "broken discourse" may come to bespeak a meaning that is not original to it or even conceivable to it. Its resources stretched, it may come to express the subjectivity that is as constitutive of meaning as is Kosuth's objectivity.

Kosuth's conceptualism operates out of an economy of scarcity, but criticality must have a lavish relationship with its object. It must know all the conventions well in order to conceive of unconventionality, and of the reason and need for it. With Kosuth, self-criticality, and its larger critical relationship to life, have become overintellectualized, overexposed; art here is no longer subversive, except perhaps to itself. But by exploring a new demonstrativeness, by manipulating symbols both familiar and archaic, the new Expressionism seeks new possibilities for itself and for criticality. It is an opportunity in the dead end represented by Kosuth's version of Modernism. It may fake its passion, and it may never realize the symbolic— may never learn the symbols it seeks, or may unwittingly articulate—but the issue is beyond what is fake or not fake, sincere or insincere. The new art has to do with an effort born of desperation, with an attempt to give criticality a new grounding, and with a sense that one cannot step in the same stream twice—which does not mean that the new Expressionists are original, only that the psychic flow is, for all its containment between familiar banks.

Writing in a seamless and subjective prose, poet Rene Ricard draws on his personal experience to scrutinize graffiti artists and art that, initially, adorned public places and the trains of the New York Transit Authority. Ricard views graffiti as a native art, like the blues—at first anonymous and, later, when the styles and tags become familiar, a way of asserting the ego. Its commanding presence and immediacy provide direct information about contemporary consciousness, alienation, and race relations.

The Radiant Child

Rene Ricard

I remember the first Tags (where is *Taki?*), Breaking (where you spin on your head), Rapping (where I first heard it). I know the names, but are the names important? Where is *Taki?* Perhaps because I have seen graffiti, then seen something else, thrown myself on the dance floor, then gone on to dance another way, I say that the reason for abandoning so much during the '70s was that each fad became an institution. What we can finally see from the '70s buried among the revivals and now surfacing (Tagging, Breaking, Rapping) was at least one academy without program. Distinct to the '70s, graffiti, in particular, was the institutionalization of the idiosyncratic that has led to the need for individuation within this anonymous vernacular. This is why the individuals (*Crazy Legs*) must distinguish themselves.

Artists have a responsibility to their work to raise it above the vernacular. Perhaps it is the critic's job to sort out from the melee of popular style the individuals who define the style, who perhaps inaugurated it (where is *Taki?*) and to bring them to public attention. The communal exhibitions of the last year and a half or so, from the Times Square Show, the Mudd Club shows, the Monumental Show, to the New York/New Wave Show at P.S. 1, have made us accustomed to looking at art in a group, so much so that an exhibit of an individual's work seems almost antisocial. Colab, Fashion Moda, etc., have created a definite populist ambience, and like all such organizations, from the dawn of modern, have dug a base to launch new work. These are vast communal enterprises as amazing that they got off the ground as the space shuttle and even more, fly-by-night, that they landed on solid ground.

The most accessible and immediately contagious productions in these shows were those of the graffiti stylists. The graffiti style, so much a part

Excerpted from Rene Ricard, "The Radiant Child," © *Artforum* (December 1981.)

of this town, New York, is in our blood now. It's amazing that something so old can be made so new. There is an instant appeal in the way spray paint looks, ditto markers. Any Tag by any teenager on any train on any line is fairly heartbreaking. In these autographs is the inherent pathos of the archaeological site, the cry down the vast endless track of time that "I am somebody," on a wall in Pompeii, on a rock at Piraeus, in the subway graveyard at some future archaeological dig, we ask, "Who was *Taki*?"

Graffiti refutes the idea of anonymous art where we know everything about a work except who made it: who made it is the whole Tag. *Blade, Lady Pink, Pray, Sex, Taki, Cliff 159, Futura 2000, Dondi, Zephyr, Izzy, Haze, Daze, Fred, Kool, Stan 153, Samo, Crash. (Crash* is still bombing.) But trains get buffed (the *damnatio memoriae* of the Transit Authority), and with the need for identity comes the artist's need for identification with the work, and to support oneself by the work is the absolute distinction between the amateur and the pro. Therefore, the obvious was to raise oneself by the supreme effort of will from the block, from the subway, to the Mudd, to the relative safety and hygiene of the gallery. Because an artist is somebody. Say what you will about group shows and collaborative enterprise: *Das Kapital* was written by one man. This is no graffito, this is no train, this is a Jean-Michel Basquiat. This is a Keith Haring.

Both these artists are a success in the street where the most critical evaluation of a graffito takes place. Jean-Michel is proud of his large *Samo* Tag in a schoolyard, surrounded by other Tags on top of Tags, yet not marked over. This demonstrates respect for the artist as not just a graffitist but as an individual, the worth of whose Tag is recognized. There's prestige in not being bombed over. There are also fake *Samos* and Harings as well as a counter-Haring graffitist who goes around erasing him. The ubiquity of Jean-Michel's *Samo* and Haring's baby Tags has the same effect as advertising; so famous now is that baby button that Haring was mugged by four 13-year-olds for the buttons he was carrying (as well as for his Sony Walkman.) The Radiant Child on the button is Haring's Tag. It is a slick Madison Avenue colophon. It looks as if it's always been there. The greatest thing is to come up with something so good it seems as if it's always been there, like a proverb. Opposite the factory-fresh Keith Haring is Jean-Michel's abandoned cityscape. His prototype, the spontaneous collage of peeling posters, has been there for everyone's ripping off. His earlier paintings were the logical extension of what you could do with a city wall. (For the moment he's stopped the collage.) His is a literal case of bringing something in off the street but with the element of chance removed. I'm always amazed at how people come up with things. Like Jean-Michel. How did he come up with the words he puts all over everything, his way of making a point without overstating the case, using one or two words he reveals a political acuity, gets the viewer going in the direction he wants, the illusion of the bombed-over wall. One or two words containing a full

JEAN-MICHEL BASQUIAT, "Philistines" 1982 Acrylic and oilstick/canvas, 72" × 123"
Photograph courtesy Annina Nosei Gallery, New York.

body. One or two words on a Jean-Michel contain the entire history of graffiti. What he incorporates into his pictures, whether found or made, is specific and selective. He has a perfect idea of what he's getting across, using everything that collates to his vision. . . .

Where is *Taki*? We can't escape the etymology or genealogy of art. It's not coincidental that the time that saw the gestation of graffiti was the period of gallery-referential art that flourished ('wrong word) in the early '70s. During the era of the white wall, what would have the greater effect on us now was being produced by guerrilla artists bombing trains during their mechanical slumber in Queens. Those teenage prophets are lost in the mists of their own maturity, reminiscent of the way the origin of the blues is lost, the simple expression of the individual followed much later by full-scale commercial exploitation. Contrary to the rules of modern art that hallow the innovator, here is the second generation capitalizing on the innovations of the first. The commercial exploitation of innovation is, conversely, the primary logic of commercial art.

Even as I write, the Transit Authority has unleashed police dogs around the Corona yard, so perhaps there is still hope. Bombing will continue even with the dogs. When it stops you'll know it's played out. If it's still alive the autopsy will kill it. What would happen if subway graffiti were recognized as the native art it is? Would they find *Taki* and declare him a National Living Treasure as the Japanese do their keepers of the flame of native craft? Or if the TA legitimizes it, i.e. encourages it with NEA funding? What happens when the revolution is televised? It bombs out. Train painting has already been severely formalized almost to decadence. It has become historically self-conscious, the progression from expression to Pop; there is a Campbell's Soup can train; sophistication to boredom.

Looking through the Mailer book on graffiti from 1974, was it photographer's optical bias, editorial selectivity, or was the classic period of graffiti as "abstract expressionist," '50s, as the book makes it look when compared to the Pop psychedelic '60s of the train I was on today? It looks so much more severe in the book, metallic style, less balloon style: tougher, *muy switchblade, mas barrio*. But who remembers what it looked like? I remember that it was very sexy, the feeling; I don't remember the look. Eidetic overlays can't be trusted. What did it look like?

Jean-Michel's don't look like the others. His don't have that superbomb panache that is the first turn-on of the pop graffitist. Nor does his market have that tai-chi touch. He doesn't use spray but he's got the dope, and right now what we need is information; I want to know what is going on in people's minds and these pictures are useful. This article is about work that is information, not work that is about information. No matter what the envelope looks like to get it there, the dope's inside. Let the Parisians copy the athletic togs *le look américain jeune Puma sneakaires le graffiti mignon,*

style is spin-off; what the pictures are internally about is what matters. If you're going to stand up there with the big kids you've got to be heavy, got to sit on a wall next to Anselm Kiefer next to Jonathan Borofsky next to Julian Schnabel and these guys are tough they can make you look real sissy. There's only one place for a mindless cutie and it ain't the wall, Jack.

Judy Rifka and Jean-Michel Basquiat have both evolved a vocabulary, and so in his way has Keith Haring. In his gray eminence enterpreneurial capacity as director of the Mudd Club shows he was of particular importance in the general dissemination of work by other young artists, and not secondarily his own. His work is faux graphic and looks ready-made, like international road signs. This immediacy is his trump card. It is the already-existing quality of his characters that deceives one into accepting them as already there without the intervention of an individual will. But he did make them up. In their impersonal code they are transmitting a personal narrative. The code is here to be cracked. These poor little characters wigging out from the radioactive communications they are bombarded with are superslick icons of turmoil and confusion. They are without will, without protection from impulses of mysterious source. We can laugh at their involuntary couplings and tiny horrified runnings around because we see them as we cannot see, as the fish cannot see the water, ourselves.

Of course what artists see us as can tell us more about themselves than about us. The second-generation Pop artists who've been popping up behind their more innovative contemporaries show more interest in the(ir) poor victims of cocktail dresses, in the trials and tribulations of dressing up and going out, enchained by our fashion slavery, in Society, than in society. Chief of the Clubbists is Robert Longo who in his own way is concerned with our contemporary solipsism. As an undercover agent of the Fashion Police I am reluctantly placing him under arrest partly for being two years behind the times but really for forgetting that fashion imitates art, and that art that imitates fashion is two removes from the source. Art Deco comes after Cubism. On the subject of Troy Brauntuch, and the use of pictures, his work seems to have been anticipated by an Edwardian novelist: " 'That habit of putting glass over an oil painting,' she murmured, 'makes always such a good reflection particularly when the picture's *dark.* Many's the time I've run into the National Gallery on my way to the Savoy and tidied myself before the Virgin of the Rocks . . .' " (source available).

We need to see ourselves now but not this literally. For some reason we need recognizable evidence of our existence. Something has happened and we need, if not advice, at least a demonstration of the situation and many of our fears are in the words contained in Jean-Michel's pictures— Tar, Oil, Old Tin, Gold—we don't need a lexicon to know what these mean. These morphemes are self-evident.

PHAEDRUS: Whom do you mean and what is his origin?

SOCRATES: I mean an intelligent word graven on the soul of the learner, which can defend itself, and who knows when to speak and when to be silent.
PHAEDRUS: You mean the living word of knowledge which has a soul, and of which the written word is no more than an image?
SOCRATES: Yes, of course that is what I mean

<div align="right">——source available</div>

I'm always amazed by how people come up with things. Like Jean-Michel. How did he come up with those words he puts all over everything? Their aggressively handmade look fits his peculiarly political sensibility. He seems to have become the gutter and his world view very much that of the downtrodden and dispossessed. Here the possession of almost anything of even marginal value becomes a token of corrupt materialism. This is the bum coveting a pair of Guston's shoes. When Jean-Michel writes in almost subliterate scrawl "Safe plush he think" it is not on a Park Avenue facade that would be totally outside the beggar's venue but on a rusted-out door in a godforsaken neighborhood. Plush to whom safe from what? His is also the elegance of the clochard who lights up a megot with his pinkie raised. If Cy Twombly and Jean Dubuffet had a baby and gave it up for adoption, it would be Jean-Michel. The elegance of Twombly is there but from the same source (graffiti) and so is the brut of the young Dubuffet. Except the politics of Dubuffet needed a lecture to show, needed a separate text, whereas in Jean-Michel they are integrated by the picture's necessity. I'd rather have a Jean-Michel than a Cy Twombly. I do not live in the classical city. My neighborhood is unsafe. Also, I want my home to look like a pile of junk to burglars.

Politics can come up by inference in a work, without pointing, without overt dialectic, by the simplest depiction (as in the case of John Ahearn) of an individual. When one looks at Ahearn's pieces, the sensibility is so specific and acute that we feel we would get the same feeling even if it looked entirely different. And his people are about feelings. I don't know how anyone who could afford them would put them in their homes. "Why would the boss want to be reminded at home of the people who keep asking him for a raise?" (source available). They are objects of devotion, of love and its ennobling ability, and are among the rarest and most moving in the history of art. They will command and dominate wherever they are hung and make all art that is anterior to it or that bears a resemblance seem like it was just leading up to Ahearn. They wipe out Segal. They make Duane Hanson seem like a snob and an insensitive jerk. When we look at Hanson's lumpen proles and their dazed stupefaction we feel superior. Ahearns, like most physically dominant art, don't reproduce well. The actual confrontation with the work is overwhelming. They are made to be seen from quite specific angles. Ahearn's work is hung high, and these people up against the white wall of a gallery are looking down at the

viewer with dignity, sobriety, querulousness, perfectly precise and specific expressions, fleeting and miraculously caught. The man seems to be looking into the future with intense responsibility as the woman, with her arms around his neck, trusts his ability to confront the world. I am that woman. Ahearn works in the South Bronx the way Caravaggio probably would. He gives his models the first cast. They're poor and they're owed the grace of their image. This is no exploitation and yet I have heard him referred to (by an artist) as a racist, exploiter of his sitters. If going into the ghetto and commemorating its inhabitants is racist, then what do you call people who segregate themselves and plot genocide?

To Whites every Black holds a potential knife behind the back, and to every Black the White is concealing a whip. We were born into this dialogue and to deny it is fatuous. Our responsibility is to overcome the sins and fears of our ancestors and drop the whip, drop the knife. In Izhar Patkin's parable of racial cannibalism we see that when a man with a .45 meets a man with a shotgun I guess the man with the pistol is a dead man.

Where is *Taki?*

I think now about Anya Phillips who so briefly illuminated this fleeting world. I think about clothes worn by people so recently and yet how long ago it all seems that Anya would show up in those cocktail dresses and of all things, a Chinese girl in a blonde wig. And now all the girls in their cocktail dresses who never heard of Anya and how quickly each generation catches the look of its creators and forgets the moral underneath. I think about how one must become the iconic representation of oneself if one is to outlast the vague definite indifference of the world. I think about how every bleach blonde is called Blondie in the street and Deborah Harry's refutation of her iconic responsibility to reify her name as a brunette. We are that radiant child and have spent our lives defending that little baby, constructing an adult around it to protect it from the unlisted signals of forces we have no control over. We are that little baby, the radiant child, and our name, what we are to become, is outside us and we must become "Judy Rifka" or "Jean-Michel" the way I became "Rene Ricard."

JULIAN SCHNABEL, "Some Bullfighters get Closer to the Horns II" 1982
Oil, plates, and bondo on wood, 108" × 84"
Courtesy Mr. William J. Hokin, Chicago,
and Margo Leavin Gallery, Los Angeles.

Curator, critic, and collector Henry Geldzahler grapples with the question of evaluating new and unfamiliar art—neoexpressionist painting, for example. Geldzahler's criteria for good art have nothing to do with modernism's insistence on purification and self-definition; nor do they involve overt analysis of politics, culture, and the media. He prescribes a firm grasp of art history and an understanding of oneself and one's times as necessary prerequisites for intelligent judgment. This general background makes it possible to judge the value of a specific work by its memorability, its ability to reveal new qualities over time, and the pleasure it gives day after day. For Geldzahler, quality in art is an experiential judgment and not based on *a priori* standards; one must employ one's own visual capacities.

Determining Aesthetic Values

Henry Geldzahler

Let me explain to you why I am addressing this subject. I was sitting in my office a few months ago and I received a call asking if I would give a lecture on a Sunday afternoon, because the lecture I had delivered in 1976 met with some success. I said, "Gee, I'll do that. It's months off, it'll never happen."—a very dangerous thing to say. I asked myself, "What is the question I am asked most often?" And that is, "What is Andy Warhol really like?" I couldn't possibly talk about that for two hours. So, barring, "What is Andy Warhol really like?" the question I am asked second most often is, "How can you tell if it's any good?"

Art historians taught me a long time ago that if you want to make a point forcefully, don't illustrate it. So what I will do is talk at a little distance; I'm going to try to enunciate some principles; I'm going to get bogged down in anecdote and autobiography, and at the end, I'm going to indicate that it's all anecdote and autobiography, and the principles have to be arrived at individually. I will try to tell you, not what I know about looking at pictures, but what I can verbalize. Some of this will sound very pedestrian and some of it might even sound insightful. I'm not going to make any distinction.

There are two prerequisites for having any sense of what is of value and quality in your own time. The first is a firm grasp of the history of art. The firmer the grasp you have and the better grounded you are in every conceivable period, the less shocked or thrown off base you're going

Reprinted from Henry Geldzahler, "Determining Aesthetic Values," *Interview* (November 1982). (*This is an edited transcript of a lecture delivered at the Yale University Art Gallery in January 1982.*)

to be by something that appears to be new but *isn't* or that is meretricious in any of a dozen ways. A grounding in the best art that's ever been done, hitting your head against the concrete wall of achievement, there's absolutely no substitute for it. It means living in or visiting metropolitan centers. You can not learn this from slides; slides are the history of images, not the history of art. The history of art is contained in works of art, which are unique. Such things as texture, condition, the presence of a work of art, its size (all slides are the same size), the scale of the work, the *presence*—the physicality of it on the one hand and the aura on the other—these things are transmitted only in a one-to-one relationship with the work itself.

The other prerequisite you must have in order to come to terms with contemporary art is a thorough sense of who *you* are in your own time. And to combine those two attributes in one person is not easy. The greatest poetry available to us at any given time, from the point of view of relevance, is probably the poetry written that day, because it speaks to our own condition most intimately and proceeds from common presuppositions. It might be very difficult to come to terms with it, it might even be difficult to find it. What magazine is it in? Who's going to point me in that direction?

But it is to the music of our time, the art of our time, that our greatest responsibility lies. Now in order to be a sensitive barometer of recent art, in taste and in experience, you've got to be pretty tough on yourself. You can't let yourself get away with too much psychological flimflam. The terror, the fear, the exaltation (in a drug culture, sometimes even the use of drugs; in a culture that's heavily psychoanalyzed, perhaps a dose of psychoanalysis)—there are all kinds of doors through which one has to go in order to have the "contemporary" experience, if you will, and this has been true of every period.

The best summing up of what in the contemporary art of any period that's so exciting is the Ezra Pound paraphrase of Confucius, *Make it new*. *Make* is to fashion. *It* is tradition, or the craft, the history. And *new* is . . . Make it new, constantly make it new. If the artist makes it too new, then we're going to have to chase to catch up with it, or, it may be mere novelty. If the *it*, the craft, dominates to such an extent that it makes it difficult to see the contemporary content, then it might take a while longer to catch up. But make it new. I sometimes call it "Tickle the Sleeping Giant." The Giant is the history of art, the canon that we've inherited. The Sleeping Giant is the Metropolitan Museum of Art collection; the *tickle* is the contemporary art section.

To make it new one must be in touch with a tradition while, at the same time, knowing exactly who you are and what your own time is about. Those are the beginnings, and they're not easy. They're the hard part. Now come a couple of rather more pleasant rules because they can be easily encapsulated.

How do you tell the value of contemporary art? One of the ways I've discovered is memorability. If you look and can remember, a month, a week, a day later, the way it's made, the way the forms fit, the color-message of the picture, then it's probably good. It's a little like leaving *Traviata* or *La Boheme* whistling the tunes. They're memorable. If a work calls itself to memory without your asking it, if it insists, if it comes back like a melody, then that's quite serious and you probably have to buy it. Memorability is very important. If you're impressed with a work of art on the spot, and it leaves you with nothing when you're gone, chances are it's not very good.

On the other side of the coin is what Clement Greenberg calls the *narrative* element in art and this principle holds true for the most abstract painting as well as the most representational. The work of art must continue to reveal new messages and images on subsequent viewings, and not exhaust itself in what I call the Big Bang, revealing everything to you the first time you see it and then having a lessened impact each time subsequent. The narrative, or the story, is how a picture reveals itself to you through time. The story is in *you*. It's an internal story and only you can judge it. A Kenneth Noland, for instance, has a rather simple geometric layout which could probably even be explained over the telephone to someone; and yet there's an awful lot about a Kenneth Noland that *can't* be explained over the telephone, an awful lot that grows on you on subsequent viewings.

Another helpful thing to remember, and this comes again from an intimate knowledge of the history of art, and also from a knowledge of your own time, is to recognize the cycles, the swing of the pendulum. It's no accident that taste in art changes. This happens on a rhythmic basis, but not in a predictable way. One can't construct a *Farmer's Almanac* calendar to say that in the fourth decade of the 21st century we'll be back to the figure, or classicism, or something like that. But if you look back through the history of art, you begin to see the ways in which the cycle exists in time. Some cycles take in fifty years, others ten or fifteen years. If you understand the necessity and inevitability of these cycles, you won't be terribly surprised when something happens, yet it's foolish to predict, and critics who try to predict are, I think, in up to their eyeballs. Because it is only the genius, the artist in the studio, who is creating the new rules of his or her generation. And even *he* can't tell you what he's going to be doing three days from now. He (de Kooning, Pollock, or whomever), at the time he is creating, will, in spite of a grasp of his own intention, in spite of the fact that his hand and mind and eye are in perfect control, will surprise himself, will find that there is more happening on the canvas than he knew he was putting in. There are more gestures, more references: he has ingested the history of art more thoroughly than he has realized. And for the critic to say, "It's time to return to the figure," or "It's time to do this," or "The next thing is going to be that," is completely off the wall, I

think. Samuel Butler said that the history of art is the history of revivals. That's a rather sophisticated remark. It's not quite true—it borders on Oscar Wilde—but there is some truth to it.

The idea is not to anticipate the new, because we've just decided one can't do that. Instead, one should endeavor to recognize the inevitability of the new once it occurs. This is inevitability after the fact. The quicker you can do this, the more in touch you are with what's going on. To rear back and say, "No, no, this can't be art!" is something you have to live through a few times, until your skin is formed and your eyes are renewed in such a way that you can deal with it. But try to shorten that time, because it's fruitless. The art won't go away. Once it's there, it's up to you to catch up with it. It doesn't mean that everything that's touted as new is going to be first-rate, either. To anticipate is impossible. To be able to fit it into the history of art, recent and past, once you've seen it, is what I call Retrospective Inevitability.

There is another exercise if you want to judge the quality of a work of art. It's terribly expensive and very few of us can do it: buy the art and live with it. If you're not sure about something and it hangs in your bedroom or it's on the way to the kitchen and you see it every day, consciously or not, it will either disappear and you'll never see it again or it will impose

LAURENCE DREIBAND, "Dog Drawing #15" 1983 Charcoal on rag paper, 63" × 87"
Photograph courtesy Janus Gallery.

itself on you. For about fifteen years, I had a painting by Hans Hoffman in my bedroom. It was over the mantle and—I mean this literally—it was like getting fresh flowers every day. It had a continuing presence, a continuing growth and importance in the world of images that I carried around with me. Something we find people doing increasingly, is buying what they can afford—the decorative arts. Decorative art, the occasional piece—the vase, the ashtray, the doorknob, whatever it is that attracts your attention— if you're not sure about it and you're in a position to do so, buy it for ten or twenty dollars and leave it on the table. Your sense of quality in that area will speed up very quickly. Your ability to zero in on that which is cute and burns itself out quickly, or that which has what Clive Bell calls significant form, will be a very useful lesson.

The one thing you must never fear is, if a work of art gives you pleasure, that it must be soft, it must not be good. There is nothing wrong with pleasure. That a beautifully colored Rothko gives us more pleasure than one of the late dark ones doesn't automatically make the late ones better, although there's a lurking suspicion in our minds the more austere Rothko should be liked better. One thing you musn't do is fall for the artist's trick of saying, "Love me, love me, I need you." That's a kind of false pleasure. It's where the color becomes so lush and so soft, so *overdone*, that you realize the artist is crying out in his loneliness for some relationship with you, and there you have to spurn him or her.

The single-bang art work is the titillator. I also call it the one-joke work. Beware of the new that is new by virture of only one characteristic. A Lowell Nesbitt painting of a Georgia O'Keeffe-like flower blown up to ten by eight feet—sure it's new; no one's done a Georgia O'Keeffe ten by eight feet before. But is that enough? Another example is the famous *Time* magazine invention of Op Art (which followed Pop Art), that never happened. It never existed. It was a question of visual titillation, an abstract version of the Christ portrait blinking at you as you cross the room.

Another big-bang aspect of a work of art can be the high-tech finish. No one's ever been as shiny as a Trova, but is that shininess enough? If you want to think in an art historical way, think about a Trova standing next to a sculpture by Oskar Schlemmer. In thinking about Schlemmer's complexity of forms, the Trova disappears.

Just now, at Grand Central Station, I saw an enormous billboard for a Kodak photograph; it was very exciting—a red farmhouse in the snow. I got a bang out of it. I thought to myself, "I'm giving this lecture, let me test this picture." I looked away and kept looking back. I found that, technologically, to be given the sense of an enhanced ability to see, that alone can give you an aesthetic chill: but it doesn't last. What can give you an aesthetic chill that lasts is the Flemish, the Van Eyck idea of reality, lending people the ability to see in sharp focus the distance, the middle ground and the foreground all at the same time. That, combined with the subject

matter, with the quality of the paint, the way it's put down—all contributes to the greatness of Flemish painting. A huge and very beautifully photographed and reproduced shot of a farmhouse in the snow doesn't continue to reveal. It doesn't have a story in time. As a matter of fact, it rapidly wears itself out. An original is Dubuffet, for instance; it was both new subject matter at the time it was done, and presented in a way that was new formally. I don't know how Dubuffet looked when he first appeared in 1945; I would think rather shocking. But the thing that's so extraordinary is that there is no art that remains shocking for more than ten or twelve years. There is no shocking art that doesn't reduce itself either to triviality or to beauty. The apocalyptic wallpaper, which was the impression people had of Pollock, now becomes the rather lacelike, choreographic painting to which the history of art gives its imprimatur of high achievement. This makes some artists furious, because they would like to be a termagant, an angry interpreter for all eternity. Time has a way of calming things down.

Some of the most challenging hours I had as a student were in a connoisseurship course at Harvard with a man named Jacob Rosenberg. Jacob Rosenberg was the curator of prints at the Berlin Museum up to 1937, or however late Hitler allowed him to hold that position. He then went to England and from there came to Harvard. His two volume Rembrandt biography remains the finest. Rosenberg's connoisseurship course consisted of an hour of slides, five minute viewings of a Rubens drawing alongside a Rubens copy, a Rembrandt drawing and a "school of Rembrandt." You never knew which slide would be on which screen. After an hour of writing down your impressions, you spent the next two hours discussing what it was that led you to think the one was a Rembrandt, and the other the school of Rembrandt. It was one of the most useful exercises I've ever had. Rosenberg was able, in his Cuddles Slezak accent and manner (the jovial waiter in Casablanca), to speak about things like linear variety, and the many other categories that animate works of art, and that have to be present in every work for it to be first-rate. His writings on connoisseurship are indispensable, and I highly recommend them. It doesn't help when you're confronted with a new work to force yourself to think about rhythm and variety, because your mind quickly turns to mush that way. But as a way of rationalizing after the fact what it is that attracts you to something, these methods truly work.

The Fogg Art Museum at Harvard keeps a large collection of fakes. It's a fascinating subject, and it taught me a great deal about the complexity of esthetic values in great works of art. No matter how good a fake might be on the day it is made, it is quite easy to spot 25 years later because forgers always assume the presupposition of their own time. Rembrandt is far more complicated than any faker can possibly recreate; therefore, an 18th century forgery of a Rembrandt and a 19th century forgery of a Rembrandt look very different, because one is done from the point of view

of Boucher and Fragonard, and the other from the point of view of De-
lacroix. In other words, there's enough in Rembrandt to allow the copier
to move around and find what it is that will appeal to his generation. One
doesn't do this consciously, but because it's the only thing one *can* do—see
it in one's own time.

The truth is—and all of us know this—one gets so much more in-
formation in the blink of an eye than one can verbalize in hours and hours.
You have to learn to trust that totally systemic way of looking. It may take
weeks for the elements that make up a work to shake down to the point
where they can be verbalized, to where you can be persuasive (first of all
to yourself, and then to a neighbor) about what it is you like in a work of
art. But there is no substitute for what we were talking about in the first
place, which is the intimate knowledge of the history of art and the constant
renewal of one's mind and eye through looking at works of art in the great
museums.

A frequent question I am asked is "Can a sense of quality be transferred
from one area to another?" I think it can. It's hard to talk about, but I
have a wonderful example. I helped assemble the Woodward Family Col-
lection in Washington, D.C.; they hired me in 1962, when Mrs. Woodward
was 62 years old. She had a wonderful collection of 18th century French
drawings and furniture. They wanted to collect American art to lend to
embassies abroad. They knew there was something new going on; they
didn't understand it, but they wanted to learn. I would bring them Raus-
chenbergs and Gottliebs and Stellas back in 1962 and 1963. And Mrs.
Woodward was able to abstract something that had to do with consistency—
with a feeling of authority in an important work of art—some series of
intimations she was able to transfer from her impeccable knowledge of
18th century French furniture, that enabled her to say, yes, yes, yes, and
occasionally, no. I was very impressed with her. That was the most vivid
example I've seen of someone who was able to transfer a sense of quality.

Are critics a help? One of the most shocking things I hear is, "Did you
see So-and-so got a wonderful review?" Reviews are written by reviewers.
A reviewer is just you or me having an opinion; it can be more or less
articulate. We don't live in a culture where our reviewers have the ability
to stand on our shoulders and see further than we can. We're not talking
about Baudelaire or Apollinaire, we're talking about somebody on the local
paper who equally might be writing about fashion or movies. Here's a
review of the first *La Boheme,* in 1894, written by a man named Carlo
Bersezio, the foremost Turin critic of the time:

> *Just as it makes only a slight impression on the spirit of its listeners,* La Boheme
> *will leave only a slight trace in the history of opera. The composer would be wise
> to consider it a momentary mistake and continue boldly on the right path.*

Another reviewer was a man named Wolf, who wrote about a Degas ex-

hibition: "Does Mr. Degas know *nothing* about drawing?"— which is something David Hockney likes to quote whenever he gets a bad review. *"Does Mr. Degas know nothing about drawing?"* So much for reviewers.

John Canaday (he preceded Hilton Kramer as a critic at *The New York Times*) wrote about my *New York Painting and Sculpture 1940–1970* show, the week before it opened, "Rumor has it that Henry Geldzahler's *New York Painting* show is the biggest booboo of the year." A critic who says "rumor has it" is somebody in a very special category. John Canaday used to fulminate in articles against curators and critics who actually know artists. He felt you should not know artists because that's going to prejudice you in some way. The critic should be Jovian, above in a helicopter, never on the ground, seeing things only from a great distance. I feel exactly the opposite. It's the artist who teaches you. When somebody said to me, "Why does Frank Stella have more space than any other artist in the *New York Painting and Sculpture* show?" I said, "Why shouldn't he? He's my best friend." That was a joke. But what it means, in part, is he's my best friend because he teaches me the most; he teaches me the most, therefore I respect him the most.

In the early 1960s, there was a New Zealand artist called Billy Apple. Billy Apple's real name is Barry Bates. He took the name Billy Apple because it was such a fascinating name. He came to New York in 1961. Pop Art was first shown at the Sidney Janis Gallery in early 1962. In the second or third month of '62, Billy Apple came to my office at the Metropolitan Museum and said, "Do you think Sidney Janis would like a painting about eight by ten feet of rows of 7-Up bottles?" I said, "Why? Do you think it's not worth making without knowing in advance whether Sidney Janis will like it? By the way, Andy Warhol has done the same thing with Coke bottles." "That's totally different," he said, "that's *Coke* bottles." He also once told me he turned down a studio in the same building as Jasper Johns because he didn't want Jasper "traipsing through his studio stealing his ideas." What could have happened to a genius of that quality I don't know, but I'll never forget him. I told that story to Frank Stella, at the time, in 1962, and Frank said, "There are no good ideas for paintings, there are only good paintings." The datum is the work of art.

The enormous luck I had in coming to New York in the summer of 1960 was in what George Kubler in his great book, *The Shape of Time*, calls "the happy entrance." I made a happy entrance. It was at a moment when the ground rules were changing. Just when it looked like abstract art was going to go on forever, when it looked like de Kooning was going to dominate forever, Frank Stella was laying down new rules and Helen Frankenthaler was putting color down in a new way and Andy Warhol and Roy Lichtenstein were opening other horizons. If I'd come in three or four years earlier I'd have identified myself with the older generation and I would have been as shocked by the new as anybody else. As it was, I came

CLAES OLDENBURG, "Symbolic Self Portrait With Equals" 1969 Ink, color pen, spray lacquer, watercolor, and collage on paper, 19¾" × 15"
Photograph courtesy of the artist.

in with no prejudices, as a *tabula rasa*, a blackboard ready to be written on. It was a happy entrance because the guys with the chalk happened to be making good images and inventing new rules. That's also in the Kubler book: if you think of the history of art in terms of game theory, then it's extremely exciting to be in a place where the old game is exhausted—you can't make any moves because they've all been made before—and a genius comes along, clears the board and says, "Now we're going to play the game *this* way." That's what happened in 1959–60. It took fifteen or eighteen years to exhaust that game.

The first audience for art is clearly the artist who creates it. Then it's his intimate friends and the other artists who are near him. It usually takes two or three years for the work to trickle out of the studio into the public arena. With Pop Art it took about a year and a half, and that was with the high-geared engine that is the New York City art world and the international art world training full view. Virtually the whole thing happened under the television cameras. It's quite amazing. When I first met the various Pop artists in the summer of 1960 they didn't know each other. I was able to introduce Lichtenstein to Rosenquist; Warhol didn't know Wesselman. It was a very exciting moment. And within a year and a half there was a symposium at the Museum of Modern Art and I was defending Pop Art, a young curator from the Metropolitan Museum going down to the Modern. That's when I knew something was wrong—when the Musem of Modern Art set up a symposium to try to tear down this new Pop Art, which Hilton Kramer and Dore Ashton and Peter Selz all said had no merit. I said, "Look, it's definitely art. Time will judge whether it's good art or not. There's no point in going crazy over it." The real anger was in Peter Selz because Peter is a German art historian who wrote a good book on German Expressionism. Peter's point in the late Fifties was, "We must return to humanism. We must have the new content of the agony of today in the works of art." The next thing would be no more abstraction. You have to remember that in '55, '56, '57, it looked like Pollock and de Kooning and Kline were going to dominate forever, that we were in a tunnel and there was no way out. The second generation Abstract Expressionists were the only answer. For Jasper Johns and Rauschenberg, Frank Stella and Helen Frankenthaler to come up with *their* option, and the Pop Artists with the other, was very disorienting to a good fellow like Peter Selz who wanted something else. He wanted Leon Golub and the new humanism to triumph.

It turned out that Peter was right. We *did* need a new figurative painting. But it was what he hated most in the world. It looked like a celebration of what was most banal and second-rate in America: the poster, the billboard, television. Jim Rosenquist, Lichtenstein. Horrors! We did have new figuration, but it was as antihumanist as the abstraction was. That new humanism was on the way but it only arrived recently.

In both Germany and Italy in the late Sixties and Seventies a figurative

movement has been building. In Italy the artists who are best known and are beginning to have shows in New York galleries are Clemente, Cucchi, Chia and Palladino. The Germans include Lupertz, Penck and Baselitz. They're fascinating artists and they've taken a long time to get to New York. This relates to the quality of the subject once again. These are the artists I've been seeing in the last couple of years who have challenged me most, who have made it most difficult for me to continue saying the same things I've been saying about today's art. It has changed the ground we stand on. And this is the most you can ask from new art, that it force you to rethink your presuppositions. The idea that America, which has dominated the visual arts since the 1940s, should have a reverse river flowing from Germany and Italy (particularly those two countries), went against the grain of the preconceptions we were living with from the Forties through the Seventies. It's quite helpful, even salubrious, to be brought up short that way. These are artists you're going to be hearing more about. Robert Hughes in *Time* magazine fulminated against them a few months ago with such anger and passion and with such an excellently honed scalpel, I think it's possible he might turn around and embrace them in a year or two. In order to have put them down so exquisitely, he must really have thought about them. And the odd thing about the art you hate is sometimes you can begin to love it.

What I find so exciting about the Italians and Germans is that it's as if their art skips over the war generation, back to their grandfathers. It's as if these German Expressionists are continuing what Nolde and Schiele and others were doing in the Twenties and Thirties before Hitler came along. It's as if they are the conscience of their age, wiping out the 40 years they hate. The same is true with the Italians who look to the metaphysical paintings of the Teens and Twenties—not only de Chirico, but di Pisis and Carra and Savinio.

It is often the artists themselves who reveal to us what we've been missing. A famous example is Mendelssohn, who revived Johann Sebastian Bach because he needed him. Mendelssohn was inspired by Bach. The *St. Matthew Passion* wasn't played from 1750, when Bach died, until 1829, when Mendelssohn conducted it exactly one hundred years after it was written. Mendelssohn needed it to justify *Elijah* and *St. Paul*, his great oratorios. And it was Cezanne who was partly responsible for bringing us to Poussin again. Artists are extremely good at pointing us in a fertile direction. Sometimes the new is not really new at all, but the old seen in a new way.

Ellsworth Kelly, who couldn't be more of an artist in a different tradition, helped me to see the German Expressionists in a new way, and prepare me for what was coming. I was never a Max Beckmann fan, but one night a few years ago, Ellsworth sat me down with a 300 page drawing catalog of Beckmann and we looked at every single drawing. I was looking at Max Beckmann through Ellsworth Kelly's eyes. He lent me his eyes for

the evening, truly. And in a way it prepared me for these German artists—these new Expressionists.

I think we're in the throes of writing a new game. These German and Italian artists have their equivalent in New York—Julian Schnabel and David Salle, both of whom are showing at Mary Boone and Leo Castelli. They are young artists, and each is bringing a sense of complexity and texture out of the Western tradition of figurative painting and are putting it back into their work in new ways. They look a little vulgar, a little off-putting now, in a way that is challenging. I know I started off with Julian Schnabel with the same resistance I had for Frank Stella's Black paintings: I said, "Uh-uh, uh-uh. I know a lot about art, and one of them is that you can't break plates or paint on velvet." It turns out you *can*.

One of the reasons I left the Metropolitan Museum after 17 years was that I wasn't in touch with the art of the Seventies as I had been with the art of the Sixties. I didn't feel that the art that was being made was something I vibrated with in a very elemental way. As a matter of fact, I realized after I put up my *New York Painting and Sculpture 1940–1970* show that an epoch was over. While Olitski and Motherwell and others continued to paint wonderful paintings in the Seventies, their styles had been posited earlier. I wasn't quite in sync with what the Minimalists were doing, or the earth artists or the various other movements of the Seventies. And I wasn't going to be the curator of 20th century art at the Met who went around bad-mouthing American art. So when Ed Koch asked me to move over to city government, I knew it was time to do something else. When asked by the news media how it felt to be entering politics after 18 years in the ivory tower of the Metropolitan Museum, I replied that after 18 years in politics, it felt good to be entering government.

Imagine, then, my gratitude to a young curator named Diego Cortez when he assembled a show in 1981 at P.S. 1 in Queens, called *New York/New Wave*. He's a good twelve years younger than I am, and he's a good twelve years older than the artists he's shown. Diego's real name is James Curtis; he's an Episcopalian boy from Illinois who couldn't get anywhere in New York as James Curtis, so he changed his name and doors swung open: that's a 1980's success story. I purchased several works out of his show, and now have hanging in my apartment paintings (and sculpture) by many of these young artists. I'm using my test of How do you live with them? The answer is they jolt me; every time I see them I get a shock. It's a shock of newness, a shock of quality, but also one of recognition. I don't say that they are the greatest artists who ever lived, but they have plugged me into a contemporary ethos I wasn't aware of.

We are living in an exciting and formative period. I call this a Golden Age. Let's not make the mistake of missing it.

For painter and critic Jeremy Gilbert-Rolfe, modernist art functioned as a
gation of the assumptions characteristic of a society. The contemporary u
popular imagery—imagery produced originally by the advertising and enter-
tainment industry—has for the most part been uncritical because it does not
serve to defamiliarize and transform consciousness. It merely reaffirms, rather
than questions, the values of conspicuous consumption and monetary gain as
the supreme values of contemporary life.

Popular Imagery

Jeremy Gilbert-Rolfe

Modern art has persistently exhibited a fascination with, and in many
instances a dependence upon, popular culture. Indeed, it is possible to say
that modernism's history is in many instances the history of an art involved
with the procedures and materials of everyday life. When one thinks of
the nineteenth century, for example, one thinks of Courbet's use of a style
of drawing derived from the illustrations on wine bottles. Or of Mallarmé
taking the newspaper as an organizational model for writing as such. And
we might also think of Champfleury's recommendation in his book on
popular images of 1869 that the art of the future should devote itself to
the preservation of popular imagery as a conservative didactic instrument,
conciliation for him being the supreme goal of art.

Champfleury's recommendation, it seems to me, is an extremely pres-
cient one. For one thing it is precise in recognizing the fundamental con-
servatism of popular culture. For another it is accurate in anticipating the
use to which popular imagery will be put in late capitalist societies, such as
our own—and of course also in communist and fascist societies. And for
another which is more directly pertinent to my own interests—which is to
say art specifically rather than culture in general—there do seem to be a
number of artists at present who are engaged in a species of conciliation
of a rather obvious sort.

Popular imagery may be formulated by people genuinely represen-
tative of what is sometimes called the masses, but its relationship to the
community as a whole is no longer in any sense direct. For us, that is to
say, popular imagery is not produced by peasants singing topical folk songs
in provincial French taverns, but is rather given to us by bourgeois who
live in Beverly Hills and work in advertising and the entertainment industry.

Reprinted from Jeremy Gilbert-Rolfe, "Popular Imagery," *Journal of the Los Angeles Institute of Contemporary
Art* (Summer 1982).

Popular imagery, then, is the imagery of conciliation by definition. It presents themes or subjects which are generally held to be ahistorical insofar as they refer to what one might call fundamental human values or ambitions or proclivities—such as sex, wealth, individualism, spontaneity—but presents them in a context which reconciles them with the demands and preferences of the dominant ideology. Popular imagery as we encounter it in 1982 is a mechanism for converting human interests in general into advertisements for capitalism in particular.

As such, it is a mechanism which converts the conservative—in the sense of being slow to change and conscious of a desire to maintain some continuity with the past—aspirations of ordinary people into aspirations actually opposed to that conservatism and instead consistent with the demands of a radically reactionary economic doctrine, a doctrine which calls itself conservative but which in fact persistently demands enormous and rapid change on the part of the population at large, in the interests of what is ludicrously referred to as economic growth or well-being. Popular imagery, then, comes to us as a subversion, by those in power, of the values of the people at large. Popular imagery *is* popular because it deals with things that everybody thinks about. But in dealing with those things, popular imagery typically seeks to present them in terms which propagandize for the *status quo* of constant change that is central to the consumerism on which liberal democracy may be said to depend.

Now, given this characterization of popular imagery as the *locus* for a reconciliation between the aspirations of the people as a whole and the ambitions of the economic oligarchy, let me say a couple of things about popular imagery and the production of works of art.

I have said that modernism in general has often exhibited an interest in popular culture, the culture of the everyday. I mentioned Courbet and Mallarmé, two artists who in fact have almost nothing in common. Their mutual use of ingredients drawn from the everyday is one of the very few assumptions they *can* be said to share. In nineteenth century modernism, materials and procedures drawn from the everyday world are typically used to defamiliarize and demystify art itself, albeit from widely disparate points of view, and to equally divergent ends. As I have said elsewhere, modernist notions of the purity of artistic enunciation are always self-contradictory insofar as modernist art always functions through negation of the assumptions characteristic of life as a whole, while at the same time invoking those assumptions and associations in the interests of what is ultimately an extremely *im*pure notion of the art as a self-transcending object. I have discussed the role of association and memory in the subject matter of Matisse's paintings in the 1920s and 30s—his use of subjects already associated with charm and pleasure: the Mediterranean, the *haute bourgeois* interior, fashionably dressed women—and we could point in this same regard to more recent examples of invocations of the familiar which serve, through the

associations inherent in them, to undermine and qualify the simultaneity and thus the implicit artistic purity of the work of art in such instances as Pollock's use of automobile lacquer and also in the case of Lichtenstein's reconsideration of problems of composition through resources derived from the world of newsprint. Modernist works, then, typically contradict the everyday world even while contradicting themselves by re-introducing aspects of the everyday as material or technique, or indeed, as subject matter in the ordinary sense. In such works the transformational capacity of art, its ability to propose a way of seeing, which defamiliarizes by negation the way we see and think in the world, is itself qualified and contextualized by those materials and techniques which it extracts from the world.

In which connection I should also want to note that the work of art's capacity to function as a negation, as a reordering of the perceptual and cognitive assumptions which carry one through life in general, has been central to the success of the most explicitly political modernism: that it is the work's articulation as art, by which I mean the work's identity as a series of formal relationships, which makes it possible for Eisenstein or Brecht or Straub to produce works which are politically powerful.

In conclusion, then, over the past several years we have seen the emergence of a great deal of work which is indeed preoccupied with popular imagery but which is not, or so it seems to me, particularly ambitious when considered as art. In general such work is indebted to the work and career of Andy Warhol, who as Matei Calinescu has pointed out, is the artist who, more than anyone else, adapted Duchamp's notion of the ready-made to ends which are exactly the opposite of what Duchamp seems to have had in mind. Warhol's use of popular imagery is uncritical, completely acquiescent in that imagery's implications and actual function, and it is my opinion that the same charge should be levelled at most of his followers. As such, theirs is not so much art as a substitute for art which reassures its public on a number of levels, all philistine, by suggesting that the crass predictability typical of popular culture can, for us, bear the burden of that extrapersonal communicability which is aesthetic experience. In the wake of this Warholian plague, the much-vaunted historical consciousness of our century has been turned into a curious kind of consumerist relationship with modernist history, where styles—German Expressionism, Italian Metaphysical painting, etc., etc.—are picked up at will as one might choose a variety of cheese in a supermarket. By no means are we, here, in the presence of that resuscitation of what was peripheral to the art of the previous generation which Viktor Shklovsky proposed to be characteristic of the evolution of artistic style, because such selections from the past are in no way transformed so as to defamiliarize our own present, excepting insofar that they are being done now. And the fact that they are being done now means nothing at all, unless one is to take seriously a view of art which would have art production be a kind of theater in which the work

of art itself exists as a kind of prop for the artist's good intentions—a view which I cannot take seriously because as far as I am concerned a work which doesn't go beyond its author's intentions is probably no work at all. Acquiescence or intervention? It is my impression that much of the work we see which proposes to use popular imagery is entirely acquiescent in the dominant ideology, not least in its implicitly ahistorical attitude to history itself, and that it is merely typical of contemporary life that, with characteristic Warholian drollery, such an art of acquiescence should want me to believe that it is in fact adopting a critical posture towards that to which it has in actuality wholly surrendered.

Critic Craig Owens regards neoexpressionist painting not as spontaneous expression but as self-conscious utilization of the codified techniques of expression necessary in order to gain acceptance in the art market. Rather than expressing a commitment to negating the authority of dominant cultural institutions, neoexpressionism functions as an escape from social and economic realities. Rejecting the modernist belief in science and technology, it is characterized as a retreat to fantasy rather than an examination of what Owens believes is the proper subject matter of contemporary art: power, authority, and domination.

Honor, Power, and the Love of Women

Craig Owens

In 1911, just as the Expressionist movement was gaining momentum in German-speaking countries, Freud speculated that the origin of the creative impulse lies in frustration, a sense that reality is impervious to desire:

> The artist is originally a man [and we will soon discover why, for Freud, the role of artist is invariably masculine] who turns away from reality because he cannot come to terms with the demand for the renunciation of instinctual satisfaction as it is first made, and who then in phantasy-life allows full play to his erotic and ambitious wishes. But he finds a way of return from this world of phantasy back to reality; with his special gifts he moulds his phantasies into a new kind of reality, and men [the spectator posited here is also masculine] concede them a justification as valuable reflections of actual life. Thus by a certain path he actually becomes the hero, king, creator, favourite he desired to be, without pursuing the circuitous course of creating real alterations in the outer world.[1]

When he assigns art a compensatory role, Freud appears merely to repeat the basic error of Western art theory (Hegel: "The necessity of the esthetically beautiful [derives from] the deficiencies of immediate reality").[2] Why must art always be defined as an *alternative* to reality? Sometimes art is a *recognition* of reality, a mode of apprehending and of representing it. And why do we tend to neglect the fact that works of art always exist as *part of* the material world? Thus, Freud's treatment of the artist could easily be indicted for complicity with philosophical esthetics. Such an in-

Reprinted from Craig Owens, "Honor, Power and the Love of Women," Art in America (January 1983).
This text is a revised version of a speech delivered on September 22, 1982 to the Society for Contemporary Art, the Art Institute of Chicago. I would like to thank Courtney Donnell for inviting me to address that audience. I would also like to thank Barbara Kruger, without whose work and conversation parts of this discussion would not have been possible.
C.O.

dictment, however, would have to overlook what is truly original here: Freud—like the Expressionists—situates art not in relation to reality, but in relation to *desire*. Even more importantly, he locates it in relation not only to the artist's desire, but to the spectator's desire as well. The work of art is the token of an intersubjective relation between artist and spectator; the investigation of this relation is the task of a properly psychoanalytic esthetics.[3]

However, the desire that Freud attributes to the artist and the source of the pleasure he attributes to the spectator are by no means unproblematic. Both are motivated, he proposes, by a (masculine) desire to be a hero. The artist's hopes of royalty and of mastery were explicitly stated in 1911 ("hero, king, creator, favourite"). Six years later, when he reiterates this definition in the *Introductory Lectures on Psychoanalysis*, Freud will have more to say about the spectator's pleasure; in Lecture 23 he writes, "[The artist] makes it possible for other people once more to derive consolation and alleviation from their own sources of pleasure in their unconscious which have become inaccessible to them." That is, the spectator recognizes the desire of the artist represented in the work as his own (repressed) desire, and the lifting of repression is invariably accompanied by a sensation of pleasure. Esthetic pleasure, then, is essentially narcissistic: it arises from the viewer's identification of his own desire with the desire of the other (in this case, of the artist). (Elsewhere, Freud writes of the spectator of *Hamlet*: "The precondition of enjoyment is that the spectator should himself be a neurotic.")[4]

Since the desire to be a hero is shared by artist and spectator alike, it is tempting to regard it as innate and immutable—to posit a universal human desire for mastery. There is, however, an alternative to this essentialist reading; for it is Freud who has taught us (through Lacan) that desire is a *social* product, that it comes into the world because of our relations with others. What is the source of the artist's desire, then, if not the sense of frustration that Freud locates at the origin of the work of art, his sense of powerlessness to achieve in reality what he desires in his fantasy? His desire to be a hero, then—"to feel and to act and to arrange things according to his desires"[5]—arises only because he believes he *lacks* this power. (Lacan: Desire is lack.) And when this lack is represented within works of art, it will tend to be confirmed, that is, posited as (the) truth. Such works will also tend to reinforce the spectator's sense of his own impotence, *his* inability to create real alterations in the world.

We are all familiar with the popular diagnosis of Hitler as a frustrated artist (*verhinderter Künstler*): had he been able to sublimate in art his desire for power, the world might have been spared much anguish. Recently, this conceit has "inspired" a number of art works, most ostentatiously, Hans-Jürgen Syberberg's epic film *Our Hitler*, in which the führer is represented as history's greatest *filmmaker*.[6] (As I have argued elsewhere, Syberberg's

work has much in common with that of the German "Neo-Expressionists.")[7] Such works estheticize, and thereby neutralize, the machinations of power; they also invert Freud's formula. For in the passage cited above, art is treated not as a sublimation of, but as a *realization* of desire; thus, the twenty-third lecture on psychoanalysis concludes: "[The artist] has thus achieved *through* his phantasy what previously he had achieved only *in* his phantasy— honour, power, and the love of women."

Sandro Chia's *The Idleness of Sisyphus* (1981) appears to confirm Freud's speculations on the artist. Not only does the painter's recourse to classical myth testify to his withdrawal from reality into a realm of subjective fantasy (the language of depth psychology is also the language of myth); what is more, Chia clearly identifies his own activity with that of a classical *hero*— Sisyphus, the Corinthian *king* condemned to eternal repetition. For it is not difficult to recognize in Chia's protagonist, as he struggles with a mass of inert, recalcitrant material, a displaced representation of the heroic male artist—a role Chia himself has rather pretentiously assumed, at least in interviews and public appearances.

Remember Sisyphus's crime and punishment: for (twice) rebelling against Death, he was sentenced eternally to push a giant boulder up the side of a mountain, only to have it roll back down again as he approached the summit, to the great amusement of the gods. Thus, if the Sisyphus myth can be said to represent Chia's own desire for royalty and for mastery, it also represents the sphere of perpetual frustration in which that desire is operative.

In Albert Camus's *The Myth of Sisyphus,* an extended philosophical argument against suicide composed in 1940 (that is, in the same year that France surrendered to Germany), Sisyphus is treated as the perfect embodiment of the modern (i.e., Existentialist) hero, who confronts without flinching the absurdity of his existence. Yet Camus's recourse to classical myth works to transform his hero's inability to change the world from a historical into a metaphysical condition, the origins of which remain shrouded in mystery. In the same way, Chia's invocation of Sisyphus projects frustration as a permanent state. In both Camus and Chia, then, myth objectifies psychology, while psychology validates myth; both exist, however, in relation to an evacuated historical dimension.

This reading of Chia's painting is complicated, however, by the fact that his Sisyphus is a comic rather than tragic figure. Camus interpreted Sisyphus as an image of hope beyond hopelessness, of comfort and security in desolation. Such pathos is totally absent from Chia's treatment of the same myth; with his silly grin, business suit and diminutive fedora, his Sisyphus combines the physiognomy of the clown with that of the petty bureaucrat. Thus, Chia does not defend his hero but ridicules his blind

obedience; the artist sides not with the suffering of the victim, but with the laughter of the gods.

Chia appears to ridicule the artist-hero in the same breath that he proclaims his resurrection. Here, we encounter the fundamental ambivalence that sustains the current revival of large-scale figurative easel painting, its perpetual oscillation between mutually incompatible attitudes or theories. Interpreted as irony, this ambivalence is sometimes summoned as evidence to support the thesis that painters like Chia are engaged in a genuinely critical activity; thus, *The Idleness of Sisyphus* has been interpreted as a "Dada cartoon designed to subvert the conventional mythic image."[8] Maybe I am taking Chia's painting too seriously, then; it is, after all, only a joke. Perhaps—*but at whose expense?* (Freud: Jokes are historically a contract of *mastery* at the expense of a third person.)[9]

In *The Idleness of Sisyphus* Chia debunks the (modernist) belief in progress in art—a belief which he and his colleagues emphatically repudiate. It must be stressed, however, that Chia is not critical but merely contemptuous of the ideology of progress; thus, he simply substitutes repetition (Sisyphus) for progress. If the social program of modernity can be defined, following Max Weber, as the progressive disenchantment of the world by instrumental reason, cultural modernism was also a demystification—a progressive laying bare of esthetic codes and conventions. In *The Idleness of Sisyphus,* however, Chia counters modernist *de*mystification with an antimodernist *re*mystification. Progress is exploded as (a) myth; Chia's painting is a joke, then, at the modernist painter's expense.

But because he identifies himself with Sisyphus, Chia seems to be indulging in *self*-mockery as well. Either way, *The Idleness of Sisyphus* testifies to the painter's ambivalence about his own activity, to a lack of conviction in painting—a lack Chia shares with most artists of his generation. (This is what links him with painting's supposed "deconstructors"—Salle, Lawson, et al.) And once we have acknowledged the prevalence of this attitude, how long can we continue to account for Chia and his colleagues' extraordinary prosperity—for these artists have indeed won "honour, power, wealth, fame . . ."—simply by positing some insatiable "hunger for pictures"?[10] Must we not speak instead of a more fundamental *contempt for painting*— a contempt which is shared by artists and audience alike?

The Idleness of Sisyphus alerts us, then, to what is at stake in the current revival of so-called Expressionist painting and its widespread institutional and critical acceptance. (Chia's painting was immediately acquired by the Museum of Modern Art; this is not only a measure of his success, but also an indication that the institutions—and the critics—that support this kind of work must be named as its collaborators.) Artists like Chia construct their works as pastiches derived, more often than not, from the "heroic" period of modernism. Chia favors Boccioni's dynamic Futurist line in par-

ticular, but he plunders a wide range of antimodernist sources as well—late Chagall, reactionary Italian painting of the '30s. The modern and the antimodern exist side by side in his work; as a result, they are reduced to absolute equivalence.

In Chia's work, then, quotation functions not as respectful *hommage*, but as an agent of mutilation. What Russian formalist critic Boris Tomashevsky wrote of the epigone seems applicable to the pasticheur as well:

> *The epigones repeat a worn-out combination of processes and, as original and revolutionary as it once was, this combination becomes stereotypical and traditional. Thus the epigones kill, sometimes for a long time, the aptitude of their contemporaries to sense the esthetic force of the examples they imitate; they discredit their masters.*[11]

Chia, Cucchi, Clemente, Mariani, Baselitz, Lüpertz, Middendorf, Fetting, Penck, Kiefer, Schnabel . . .—these and other artists are engaged *not* (as is frequently claimed by critics who find mirrored in this art their own frustration with the radical art of the present) in the recovery and reinvestment of tradition, but rather in declaring its bankruptcy—specifically, the bankruptcy of the modernist tradition. Everywhere we turn today the radical impulse that motivated modernism—its commitment to transgression—is treated as the object of parody and insult. What we are witnessing, then, is the wholesale liquidation of the entire modernist legacy.

Expressionism was an attack on convention (this is what characterizes it as a modernist movement), specifically, on those conventions which subject unconscious impulses to the laws of form and thereby rationalize them, transform them into images. (Here, convention plays a role roughly analogous to the censorship which the ego exercises over the unconscious.) Prior to Expressionism, human passions might be represented by, but could have no immediate presence or reality within, works of art. The Expressionists, however, abandoned the simulation of emotion in favor of its seismographic registration. They were determined to register unconscious affects—trauma, shock—without disguise through the medium of art; with Freud, they fully appreciated the *disruptive* potential of desire. Whatever we may think of this project today—whether we find its claims to spontaneity and immediacy hopelessly naive, or whether we believe that the Expressionists actually tapped a prelinguistic reserve of libidinal impulses—we should not overlook its radical ambition.[12]

In "Neo-Expressionism," however—but this is why this designation must be rejected—Expressionism is reduced to convention, to a standard repertoire of abstract, strictly codified signs for expression. Everything is bracketed in quotation marks; as a result, what was (supposedly) spontaneous congeals into a signifier: "spontaneity," "immediacy." (Think of Schnabel's "violent" brushwork.) The pseudo-Expressionists retreat to the pre-Expressionist simulation of passion; they create illusions of spontaneity

and immediacy, or rather expose the spontaneity and immediacy sought by the Expressionists as illusions, as a construct of preexisting forms.

In all discourse, quotation represents authority. Modernism—Expressionism included—represents a challenge to authority, specifically to the authority vested in dominant cultural modes and conventions. Today, however, modernism has itself become a dominant cultural mode, as the quotation of modernist conventions in pseudo-Expressionism testifies. Transgression has become the norm in a society that stages its own scandals (Abscam). Thus, the contemporary artist is trapped in a double bind: if the modernist imperative is obeyed, then the norm is simultaneously upheld; if the modernist imperative is rejected, it is simultaneously confirmed.

In other words, today the modernist imperative to transgression can be neither embraced nor rejected. Caught in this untenable situation, the pseudo-Expressionists substitute an abstract revenge against modernism for its radical impulse. Modernist strategies are used against themselves: thus, the antiauthoritarian stance of the modernist artist is attacked as authoritarian, and anyone who argues for the continuing necessity of antiauthoritarian critique thereby opens him or herself to charges of authoritarianism.[13]

What we are witnessing, then, is the emergence of a new—or renewed—authoritarianism masquerading as antiauthoritarian. Today, acquiescence to authority is proclaimed as a radical act (Donald Kuspit on David Salle).[14] The celebration of "traditional values"—the hallmark of authoritarian discourse—becomes the agenda of a supposedly politically motivated art (Syberberg, Anselm Kiefer, but also Gilbert & George). More often than not, however, the pseudo-Expressionist artist claims to have withdrawn from any conscious political engagement, and this estheticist isolationism is celebrated as a return to the "essence" of art. (This is the basis for Achille Bonito Oliva's championing of the Italian "trans-avant-garde.")

Authoritarianism proclaimed as antiauthoritarian, antiauthoritarian critique stigmatized as authoritarian: this is one manifestation of what Jean Baudrillard diagnoses as a generalized cultural *implosion*.[15] Everything reverses into its opposite; opposites reveal mirrored identities. The imploded state of pseudo-Expressionist art would seem, therefore, to *preclude* irony. For irony is essentially a *negative* trope calculated to expose false consciousness; the coexistence, in pseudo-Expressionist work, of mutually incompatible attitudes suggests instead the *loss* of the capacity for negation, which Lacan locates at the origin of the schizophrenic breakdown.[16] Schizophrenic discourse is paralogical; it does not recognize the law of contradiction. Thus, the schizophrenic will be obliged *to say the opposite of what he means in order to mean the opposite of what he says.*[17]

Although most of the major symptoms of schizophrenia are to be found

in pseudo-Expressionist painting—hebephrenia, catatonia, ambivalence—
I am not proposing that we diagnose contemporary artists, on the basis of
their work, as schizophrenics. Nor would I proclaim schizophrenia, as some
have, as a new emancipatory principle.[18] Still, my argument is more than
descriptive; it seems to me that contemporary artists *simulate* schizophrenia
as a mimetic defense against increasingly contradictory demands—on the
one hand, to be as innovative and original as possible; on the other, to
conform to established norms and conventions.

What we see reflected, then, in supposedly "revivalist" painting is the
widespread antimodernist sentiment that everywhere appears to have gripped
the contemporary imagination. This sentiment is hardly limited to art, but
manifests itself at every level of intellectual, cultural, and political life at
present. Antimodernism is primarily a disaffection with the terms and
conditions of *social* modernity, specifically, with the modernist belief in
science and technology as the key to the liberation of humankind from
necessity. Fears of ecological catastrophe, and of the increasing penetration
of industrialization into previously exempt spheres of human activity, give
rise to a blanket rejection of the ideology of progress. Responsibility for
the crisis in social modernity is, however, often displaced onto its cultural
program—especially the visual arts. Thus, the antiauthoritarian stance of
the modernist artist—in particular, the Expressionist valorization of human
desire—is often blamed for the much-discussed "crisis of authority" in
advanced industrial nations.[19]

Antimodernism is one manifestation of what Belgian political econo-
mist Ernest Mandel identifies as the "neo-fatalist" ideology specific to late
capitalist society—a belief that science and technology have coalesced into
an autonomous power of invincible force. In his book *Late Capitalism*, Man-
del traces its effects in detail:

> *To the captive individual, whose entire life is subordinated to the laws of the
> market—not only (as in the 19th century) in the sphere of production, but also
> in the spheres of consumption, recreation, culture, art, education and personal
> relations, it appears impossible to break out of the social prison. "Every-day
> experience" reinforces the neo-fatalist ideology of the immutable nature of the
> late capitalist social order. All that is left is the dream of escape—through sex
> and drugs, which are in their turn promptly industrialized.[20]*

Sex, drugs, rock and roll—there is, as we know, another traditional
means of escape (although this function has largely been assumed by the
mass media): Art. And it is this route—blocked by the avant-garde's am-
bition to intervene, whether directly or indirectly, in the historical process—
that pseudo-Expressionist artists are attempting to force open once again.
But in offering the spectator an escape from increasing economic and social
pressures, they reinforce the neofatalist ideology of late capitalism. Theirs

is an "official" art which provides an apology for the existing social order; collaboration with power replaces the oppositional stance of the modernist artist.

Have we not finally uncovered the source of the sense of frustration that Freud located at the origin of the work of art—namely, a belief in the opacity and omnipotence of the social process? It is not surprising, then, that the current "revival" of figurative modes of expression should be sustained everywhere by artists' desires to be heroes. The desire for mastery is nowhere more apparent than in that rapidly proliferating genre of art works that can only be called the "artificial masterpiece." *Artificial*, because genuine masterpiece status can accrue to a work of art only after the fact; *masterpiece*, because such works, whether executed by men or women, are motivated by a masculine desire for mastery, specifically, a desire to triumph over time.

When the historical conditions surrounding a work's production and reception by the artist's contemporaries have been superseded, and yet the work appears to continue to speak to us in the present *as if it had been made in the present,* we elevate the work to the status of a classic.[21] What this view of the work of art represses is the successive reappropriation and reinterpretation of works of art by each successive generation. A classic certainly did not appear to be a classic at the time of its first appearance, and it is naive to assume that it meant the same thing to the artist's contemporaries as it does to us. Nevertheless, the survival of works of art gives rise to the illusion that timeless metaphysical truths express themselves through them.

The artificial masterpiece inverts this situation: it speaks in the present as if it had been made in the past. As such, it testifies primarily to our impatience, our demand for instant gratification and, most importantly, the spectator's desire to see (his sense of) his own identity confirmed by the work of art. The extraordinary speed with which the pseudo-Expressionists have risen to prominence indicates that their work, rather than creating new expectations, merely conforms to existing ones; when "the fulfilled expectation becomes the norm of the product," however, we have entered the territory of *kitsch*.[22]

Throughout the history of art, style has been one of the most effective indices to the existence of a timeless truth in the work of art. Thus, Carlo Maria Mariani resurrects 19th-century Neoclassicism—a style which, in its own time, was calculated to provide an ascendent bourgeoisie with an idealized image of its own class aspirations and past struggles—an image transposed, however, from the plane of history to that of myth.[23] Mariani's Neo-Neoclassicism indicates that the academic project of sublimating history into form and universality—a project that was abandoned by the earliest modernists—has returned.

Although it may appear to occupy the opposite end of the stylistic

spectrum, A.R. Penck's cultivated neoprimitivist technique performs exactly the same function. Penck's work derives directly from American painting of the 1940s—specifically, from the Abstract Expressionist's early involvement with myth and primitive symbolism (early Gottlieb, Pollock, etc.). These artists were interested in such emblematic imagery primarily as a bearer of cultural information; Penck, however, uses it to express a heroic affinity with the precultural—with the barbaric, the wild, the uncultivated. It also gives his work the appearance of having been around since the beginning of time.[24]

Artificial masterpieces are also manufactured today through the revival of outmoded artistic materials and production procedures, thereby denying the fundamental historicity of those materials and techniques.[25] Although the entire revival of easel painting must be evaluated in these terms, Francesco Clemente's resurrection of fresco is a particularly blatant denial of history, as are Jorg Immendorff's, Markus Lüpertz's and, now, Chia's return to monumental, cast-bronze sculpture. Other artists resuscitate discarded iconographic conventions: Louis Cane, for example, paints Annunciations. Here, Catholic subject matter indicates a desire for catholicity; but it also reads as a reference to Cane's recent "conversion" from modernist abstraction to antimodernist figuration.

Perhaps the most transparent strategy for simulating a masterpiece is that of antiquing the canvas itself. Thus, Gérard Garouste's neo-Baroque allegories—which, the artist insists, "stage the battle of the forces of order and disorder, of the rational and the irrational"—are dimly perceived through what appear to be layers of yellowed varnish. But Ansel Kiefer also "antiques" his canvases. Not only has he returned to landscape painting; he also attempts, through the implicit equation of the barren fields he depicts with the burnt and scarred surfaces of his own canvases, to impart to his paintings something of the desolation and exhaustion of the earth itself. (What is more, Kiefer attributes this desolation to mythical rather than historical forces. His "Waterloo" paintings bear a legend from Victor Hugo: "The earth still trembles/from the footsteps of giants.") Thus, Kiefer's art insists that it is only the faithful reflection of (its own) shattered depletion.

In the 1970s, as is well known, several writers—Richard Sennett and Christopher Lasch among them—diagnosed the collective Narcissism that appeared to have infected an entire society. It is tempting, on the basis of the phenomena discussed above, to describe our own decade as Sisyphean, referring, of course, to the widespread "compulsion to repeat" in which we appear to be deadlocked. It is, however, precisely this tendency to treat contemporary reality in mythological terms that is at issue here. When the critic diagnoses a collective neurosis, does he not also betray his own desire for (intellectual) mastery? In the eighth chapter of *Civilization and Its Dis-*

contents Freud addressed the question of intellectual mastery, significantly, in the context of a discussion of the possibility of psychoanalyzing entire societies: "And as regards the therapeutic application of our knowledge," Freud writes, "what would be the use of the most correct analysis of social neurosis, since no one possesses authority to impose such a therapy on the group?"

Yet everywhere we turn today we encounter therapeutic programs for the amelioration of our collective "illness"—nowhere more blatantly than in the authoritarian call for a return to traditional values which, we are told, will resolve the crisis of authority in advanced industrial nations. Perhaps, then, it is to the issue of mastery—of power, authority, domination—that both art and criticism must turn if we are to emerge from our current impasse.

NOTES

[1] Sigmund Freud, "Formulations Regarding the Two Principles in Mental Functioning," *General Psychological Theory*, ed. Philip Rieff, New York, 1963, pp. 26–7, my italics.

[2] On art as supplement, see Jacques Derrida, "The *Parergon*," *October* 9 (Summer 1979), 3–41, as well as my afterword, "Detachment/from the *parergon*," 42–9.

[3] Psychoanalytic discussions of the work of art's relation to its spectator occur mainly in film theory and criticism; see in particular the work of Christian Metz (*The Imaginary Signifier*) and Stephen Heath (*Questions of Cinema*).

[4] Freud, "Psychopathic Characters on the Stage," *Standard Edition*, vol. 7, p. 308.

[5] Ibid., p. 305. The entire passage reads as follows: "The spectator is a person who experiences too little, who feels that he is a 'poor wretch to whom nothing of importance can happen,' who has long been obliged to damp down, or rather displace, his ambition to stand in his own person at the hub of world affairs; he longs to feel and to act and to arrange things according to his desires—in short, to be a hero."

[6] On *Our Hitler*, see Fredric Jameson, "In the Destructive Element Immerse," *October* 17 (Summer 1981), 99–118, and Thomas Elsaesser, "Myth as the phantasmagoria of History...," *New German Critique* 24–5 (Fall/Winter 1981–82), 108–54. I disagree with Elsaesser's defense of Syberberg's practice, but I am indebted to his insights on the modern functions of myth.

[7] "Bayreuth '82," *A.i.A.*, Sept. '82, p. 135.

[8] Michael Krugman, "Sandro Chia at Sperone Westwater Fischer," *A.i.A.*, Oct. '81, p. 144.

[9] See Freud, *Jokes and Their Relation to the Unconscious*. This particular formulation of Freud's thesis is from Jane Weinstock, "She Who Laughs First Laughs Last," *Camera Obscura* 5, p. 107.

[10] This is the title of Wolfgang Max Faust's recent book on contemporary German painting (*Hunger nach Bildern*).

[11] Quoted in Hans Robert Jauss, *Toward an Aesthetic of Reception*, Minneapolis, '82, p. 197.

[12] See Theodor Adorno's discussion of Schoenberg's Expressionism in *Philosophy of Modern Music*, New York, 1980, esp. pp. 38–9.

[13] This is the thrust of attacks launched recently by Peter Schjeldahl, who has increasingly been gravitating towards a Neoconservative position, against myself and other writers—ironically, from the pages of the *Village Voice*, supposedly the last bastion of '60s-style radicalism.

[14] "Salle, then, offers us an explicitly conformist art—an art in perfect harmony with its world. . . . Its attempt at maximalizing its resources is nothing but an acceptance of—submission to—the totality of its world." It is not that I disagree with Kuspit's description of Salle's enterprise; rather, I find no cause for celebration. "David Salle at Boone and Castelli," *Art in America*, Summer '82, p. 142.

[15] Jean Baudrillard, *L'Echange symbolique et la mort*, Paris, 1975, passim. For an English text, see Baudrillard's "The Beaubourg Effect," *October* 20 (Spring 1982).

[16] See in particular Lacan's "On a question preliminary to any possible treatment of psychosis" in *Ecrits: A Selection*, New York, 1977.

[17] This formulation is Gregory Bateson's. See Anthony Wilden, *System and Structure*, London, 1972, pp. 56–62.

[18] Gilles Deleuze and Félix Guattari, for example. See their *Anti-Oedipus*, New York, 1977.

[19] This is the argument of Neoconservative Daniel Bell in *The Cultural Contradictions of Capitalism*, New York, 1976, esp. pp. 85–119. For a rebuttal, see Jürgen Habermas, "Modernity versus Postmodernity," *New German Critique* 22 (Winter 1981), 3–14.

[20] Ernest Mandel, *Late Capitalism*, London, Verso, 1978, p. 502. Mandel, of course, is indebted here to Lukács's *History and Class Consciousness*.

[21] Jauss, pp. 28–32.

[22] This definition is Wolfgang Iser's. Quoted in Jauss, p. 197.

[23] Elsaesser, pp. 132–33.

[24] Thus, Penck tends to project violence as part of some essential "human nature." But we can treat violence as innate only at the risk of overlooking its specific *social* determinants: its origins in frustration provoked by an opaque, omnipotent social process.

[25] On the historicity of artistic materials and production techniques, see Benjamin Buchloh, "Michael Asher and the Conclusion of Modernist Sculpture," *Performance, Text(e)s & Documents*, ed. C. Pontbriand, Montreal, 1981, pp. 55–65, reprinted in this volume.

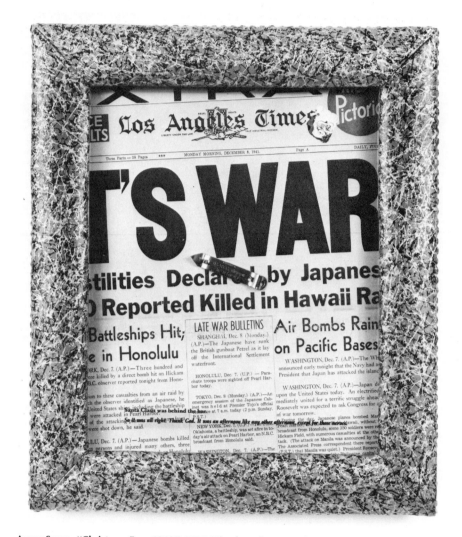

ALEXIS SMITH, "Christmas Eve, 1943" 1982 Mixed media 21⅜" × 18½"
Courtesy Margo Leavin Gallery, Los Angeles. ©Douglas M. Parker

Modernism's pretentious desire for eternal values is viewed by critic and painter Thomas Lawson as symbolic of its surrender to the social structure it had originally sought to subvert. Neither modernism's ahistorical stance nor a fashionable and calculated neoexpressionism are adequate strategies for the radical artist. Lawson advocates critical subversion, deconstruction on canvas of the illusions of real life as represented in the mass media. Painting is the perfect vehicle for raising "troubling doubt" about the ideas and methods of the media precisely because it is situated at the center and not the periphery of the art marketplace.

Last Exit: Painting

Thomas Lawson

The paintings have to be dead; that is, from life but not a part of it, in order to show how a painting can be said to have anything to do with life in the first place.
———David Salle, *Cover*, May 1979

It all boils down to a question of faith. Young artists concerned with pictures and picture-making, rather than sculpture and the lively arts, are faced now with a bewildering choice. They can continue to believe in the traditional institutions of culture, most conveniently identified with easel painting, and in effect register a blind contentment with the way things are. They can dabble in "pluralism," that last holdout of an exhausted modernism, choosing from an assortment of attractive labels—Narrative Art, Pattern and Decoration, New Image, New Wave, Naive Nouveau, Energism—the style most suited to their own, self-referential purposes. Or, more frankly engaged in exploiting the last manneristic twitches of modernism, they can resuscitate the idea of abstract painting. Or, taking a more critical stance, they can invest their faith in the subversive potential of those radical manifestations of modernist art labelled Minimalism and Conceptualism. But what if these, too, appear hopelessly compromised, mired in the predictability of their conventions, subject to an academicism or a sentimentality every bit as regressive as that adhering to the idea of Fine Art?

Such is the confused situation today, and everyone seems to be getting rather shrill about it. At one extreme, Rene Ricard, writing in *Artforum* on Julian Schnabel, has offered petulant self-advertisement in the name of a

Reprinted from Thomas Lawson, "Last Exit: Painting," *Artforum* (October 1981).

reactionary expressionism, an endless celebration of the author's importance as a champion of the debasement of art to kitsch, fearful that anything more demanding might be no fun. The writing was mostly frivolous, but noisy, and must be considered a serious apologia for a certain anti-intellectual elite. On the other hand the periodical *October* has been publishing swingeing jeremiads condemning, at least by implication, all art produced since the late '60s, save what the editors consider to be permissible, which is to say art that owes a clear and demonstrable debt to the handful of Minimal and Conceptual artists they lionize as the true guardians of the faith. From a position of high moral superiority these elitists of another sort, intellectual but antiesthetic, condemn the practice of "incorrect" art altogether, as an irredeemably bourgeois activity that remains largely beneath their notice. Both approaches, of the esthete and the moralist, leave distinctions blurred, and art itself is conveniently relegated to an insignificant position as background material serving only to peg the display of self or of theory. From both sides we receive the same hopeless message: that there is no point in continuing to make art since it can only exist insulated from the real world or as an irresponsible bauble. This is only a partial truth. It would be more accurate, although a good deal more complicated, to argue that while there may be no point in continuing to make certain kinds of art, art as a mode of cultural discourse has not yet been rendered completely irrelevant.

> *Today . . . modern art is beginning to lose its powers of negation. For some years now its rejections have been ritual repetitions: rebellion has turned into procedure, criticism into rhetoric, transgression into ceremony. Negation is no longer creative. I am not saying that we are living the end of art: we are living the end of the* idea of modern art.
> ——Octavio Paz, *Children of the Mire: Modern Poetry from Romanticism to the Avant-Garde*

Despite the brouhaha, the numerous painting revivals of the latter part of the '70s, from New Abstraction to Pattern and Decoration, proved to be little more than the last gasps of a long overworked idiom, modernist painting. (The diversionary tactics of so many bemused critics hid this truth under a blanket eventually labelled "pluralism," but as the decade closed that blanket became more and more of a shroud.) These revivals were embalmed and laid to rest in Barbara Rose's poignantly inappropriately titled show "American Painting: The Eighties." That exhibition, presented in 1979, made the situation abundantly clear, and for that we should be thankful. Painter after painter included there had done his or her best to reinvest the basic tenets of modernist painting with some spark of life, while staying firmly within the safe bounds of dogma. The result was predictably depressing, a funereal procession of tired cliches paraded as if still fresh; a corpse made up to look forever young.

While it was still a creative force modernism worked by taking a pro-grammatic, adversary stance toward the dominant culture. It raged against order, and particularly bourgeois order. To this end it developed a rhetoric of immediacy, eschewing not only the mimetic tradition of Western art, but also the esthetic distance implied by the structure of representation— the distance necessarily built into anything that is to be understood as a picture of something else, a distance that sanctions the idea of art as a discursive practice. With modernism, art became declarative, we moved into the era of the manifesto and the artist's statement, justifications which brook no dissent.

Modernism's insistence on immediacy and the foreclosure of distance inevitably resulted in a denial of history, in an ever greater emphasis on not just the present, but the presence of the artist. Expressive symbolism gave way to self-expression; art history developed into autobiography. Van-guard art became a practice concerned only with itself, its own rules and procedures. The most startling result was the liberation of technique; the least useful result was the pursuit of novelty. As the modernist idea became debased, its deliberate sparseness worn through overuse, the acting-out of impulse, rather than the reflective discipline of the imagination, became the measure of satisfaction and value. As a result the modernist insistence on an essential meaninglessness at the center of artistic practice came ac-tually to mean less and less. From being a statement of existential despair it degenerated into an empty, self-pitying, but sensationalist, mannerism. From being concerned with nothingness, it became nothing. The repudia-tion of mimesis, and the escalating demands for impact, for new experience beyond traditional limits, inevitably loosened the connections between ar-tistic discourse and everyday life. Art became an abstraction, something of meaning only to its practitioners. On the whole modernist artists acted as though alienated from bourgeois society—it was the only posture that gave their work a significance transcending its own interiority. But for the most part this remained only a posture, rarely developing into a deeper com-mitment to social change. In a manner that foretold the final decline of the moral authority of modernism, radically individualist artists all too often found comfortable niches in the society they professed to despise, becoming little more than anxious apologists for the system.

Of course there had been one important moment that saw a possibility for a more truly revolutionary activity, and that was in Moscow in the years immediately following the Russian Revolution. This period not only pushed modernism to its logical expression in abstraction, but turned that abstrac-tion away from the personal toward a more significant critique of produc-tion. Developing implications nascent in the work of Cézanne and the Cubists, it concentrated on the basic ingredients, ideological and material, involved in the production of art. This moment, abandoned by the artists themselves (only partly because of political pressures) in favor of a totally

reactionary antimodernism, saw the first stirrings of a seed that, when later conjoined with the very different, but equally radical, activity of Marcel Duchamp, came to fruition just as the modernist hegemony seemed unassailable—demonstrating that it was not.

That fruition has been called Minimalism, and the Mimimalist artists subverted modernist theory, at that time most ably articulated by the followers of Clement Greenberg, simply by taking it literally. If modernist art sought to concern itself with its own structures, then the Minimalists would have objects made that could refer to nothing but their own making. This absurdist extremism worked by dramatizing the situation, which in turn reinjected a sense of distance, and a critical discourse was once again possible. (It is no accident that it was this generation of artists—Donald Judd, Robert Morris, Robert Smithson, Art & Language, Joseph Kosuth, and Mel Bochner—who reintroduced the idea that an artist might be more than a sensitive person with talent, might in fact be both intelligent and articulate, might have something to say.)

All the while, countless other artists continued as if the ground had not been opened up in front of them, even adopting some of the superficial characteristics of the very modes that were rendering their practice obsolete and moribund. Some, of course, continued to paint, and it was those whom Rose chose to celebrate in her exhibition. And if that show seemed to lack all conviction, Rose's catalogue essay more than compensated with the vehemence of its language. Defending a denatured modernism that had become so divorced from historical reality that it could pretend to celebrate "eternal values," she lashed into Minimalism and Conceptualism as though they were the agents of the Anti-Christ. Which, for the true believer, they are.

Rose made it clear that procedure had indeed become ritual, and criticism mere rhetoric. Modernism has been totally coopted by its original antagonist, the bourgeoisie. From adversary to prop, from subversion to bastion of the status quo, it has become a mere sign of individual liberty and enterprise, freed entirely from the particular history that once gave it meaning. It is not just that its tactics and procedures have been borrowed by the propaganda industries—advertising, television, and the movies—it has become a part of them, lending authority and authenticity to the corporate structures that insistently form so much of our daily lives.

> We need change, we need it fast
> Before rock's just part of the past
> 'Cause lately it all sounds the same to me
> Oh-oh . . .
> It's the end, the end of the 70's
> It's the end, the end of the century
> ——The Ramones, from the song,
> "Do you remember Rock 'n' Roll Radio?"
> 1979

The end of the century. If modernist formalism seems finally discredited, hopelessly coopted by the social structures it purportedly sought to subvert, its bastard progeny continue to fill the galleries. We all want to see something new, but it is by no means clear that what we have been getting so far has any merit beyond a certain novelty. As Antonio Gramsci so presciently observed in his prison notebooks, a period lacking certainty is bedeviled by a plethora of morbid symptoms. Following the lead of architectural critics these symptoms have been hailed, rather carelessly, as "post-modern," with that term standing for a nostalgic desire to recover an undifferentiated past. According to this understanding any art that appropriates styles and imagery from other epochs, other cultures, qualifies as "post-modern." Ironically, the group that has been enjoying the most success, to date, as the exemplification of this notion is made up of pseudoexpressionists like Jonathan Borofsky, Luciano Castelli, Sandro Chia, Francesco Clemente, Enzo Cucchi, Rainer Fetting, Salomé, and Julian Schnabel. Despite the woolly thinking behind this usage, the claim does have some merit, but in the end the work of these artists must be considered part of a last, decadent flowering of the modernist spirit. The reasons for this initial success are quite straightforward. The work of these artists looks very different from the severe respectability of recent modernist production in New York, yet it is filled with images and procedures that are easily recognized as belonging to art, or at least to art history. As their champions are quick to point out, their work can be keyed, at least superficially, to a strain of activity that stretches from Conceptual art back to Dada. And on top of that they appear personal, idiosyncratic in a period during which lip service has been paid to the idea of individual liberty, even as that liberty is being systematically narrowed by the constraints of law and commerce.

These young painters ingratiate themselves by pretending to be in awe of history. Their enterprise is distinguished by an homage to the past, and in particular by a nostalgia for the early days of modernism. But what they give us is a pastiche of historical consciousness, an exercise in bad faith. (Even Borofsky's integrity becomes implicated here as a result of his relentless mystification.) For by decontextualizing their sources and refusing to provide a new, suitably critical frame for them, they dismiss the particularities of history in favor of a generalizing mythology, and thus succumb to sentimentality.

Chia and Cucchi hanker after the excitements of neoprimitivism, especially as understood by the likes of Marc Chagall, nurturing a taste for assumed naiveté. Castelli, Fetting, and Salomé hark back to the same period, favoring instead the putative boldness of style and content of German Expressionism. But whatever their sources, these artists want to make paintings that look fresh, but not too alienating, so they take recognizable styles and make them over, on a larger scale, with brighter color and more pizzazz. Their work may look brash and simple, but it is meant to, and it is altogether too calculated to be as anarchistic as they pretend.

Clemente and Schnabel are both more ambitious, seeking to accommodate a much broader range of references in their work. Both pick up on the neoromantic, pseudosurreal aspects of fashionable French and Italian art of the '30s and '40s, and make a great fuss about their wickedly outrageous taste in so doing. But that is only a starting point, albeit one that, with its emphasis on additive collage, sanctions an uncontrolled annexation of material. Renaissance and Baroque painting, Indian miniatures, cheap religious artifacts, a certain type of anything is fair game. And whatever is accepted becomes equivalent to everything else, all distinctions are merged as styles, images, methods, and materials proliferate in a torrent of stuff that is supposedly poetic, and thus removed from mere criticism.

This wider cultural cannibalism is the topic of another essay; the annexation of wide areas of modern art is problematic enough for my purposes here. Concentrating on that alone we have a surfeit of evidence, showing an historicism that pays court to a strain of 20th-century art that can, superficially, be identified as antimodern. Superficially, because any work produced in a certain period must share essential characteristics with other work of the same period; antimodern, because I am talking about the production of artists of the '30s and '40s who openly rebelled against the mainstream of radical modernism. In other words, the sophisticated if often rather mild-mannered art that was recently gathered together as part of the Beaubourg's *Les Réalismes* exposition. The same material also served as an introduction to the revisionist history presented at Westkunst. This was art that was difficult only in the sense that a naughty child is difficult; that is, art that misbehaved within a strictly defined and protected set of conventions. Art that misbehaved to demonstrate the need for discipline. Art that advocated a forced return to "eternal values," in both the esthetic and political realms. Art that often declared itself nationalist, always traditionalist. It is possible that recent work appropriating this art could have a critical import. The work of the pseudoexpressionists does play on a sense of contrariness, consistently matching elements and attitudes that do not match, but it goes no further. A *retardataire* mimeticism is presented with expressionist immediacy. The work claims to be personal, but borrows devices and images from others. There is a camp acknowledgment that what was once considered bad art can now be fun: however, that acknowledgment is couched in self-important terms that for the most part steer clear of humor. Appropriation becomes ceremonial, an accommodation in which collage is understood not as a disruptive agent, a device to question perception—but as a machine to foster unlimited growth.

This marriage of early modernism and a fashionable antimodernism can be characterized as camp, and there is definitely a strain of Warholism about the work. It is cynical work with a marketing strategy, and therefore extremely fashion-conscious. It is work that relies on arch innuendo and tailored guest lists—a perfect example is provided by Clemente's series of

frescoed portraits of a chic demimonde, although the Germans' concentration on gay subject matter works in an equivalent manner.

But to dismiss this work as belonging to camp is too easy, for something more sinister is at hand. The forced unification of opposites is a well-established rhetorical tactic for rendering discourse immune from criticism. The capacity to assimilate anything and everything offers the prospect of combining the greatest possible tolerance with the greatest possible unity, which becomes a repressive unity. With this art we are presented with what amounts to a caricature of dialectics, in which the telescoping of elements cuts off the development of meaning, creating instead fixed images—cliches— which we are expected to associate with the proper attitudes and institutions (high art fit for museums). With great cynicism this work stands the modernist enterprise on its head, removing the anxious perception of nothingness at the heart of modernist expression, and replacing it with the smug acknowledgment that if the art means nothing it will be all the more acceptable to those who seek only entertainment. Such a debased version of modernist practice is vigorously opposed to the very idea of critical analysis since it is simply a declaration of presence signifying only the ambition of the artist to be noticed.

> *Being in love is dangerous because you talk yourself into thinking you've never had it so good.*
> ——David Salle, *ArtRite*, Winter 1976/77.

David Salle makes tremendously stylish paintings, paintings that will look good in the most elegant of rooms. His choice of color is brilliant— pale, stained fields, highlighted with bright, contrasting lines and areas of paint. A look of high fashion. And yet the images he presents this way are emotionally and intellectually disturbing. Often his subjects are naked women, presented as objects. Occasionally they are men. At best these representations of humanity are cursory, offhand; at worst they are brutal, disfigured. The images are laid next to one another, or placed on top of one another. These juxtapositions prime us to understand the work metaphorically, as does the diptych format Salle favors, but in the end the metaphors refuse to gel. Meaning is intimated but tantalizingly withheld. It appears to be on the surface, but as soon as it is approached it disappears, provoking the viewer into a deeper examination of prejudices bound inextricably with the conventional representations that express them. Salle's work is seductive and obscure, and this obscurity is its source of strength, for when we attempt to bring light to the darkness, we illuminate much else as well. Salle follows a strategy of infiltration and sabotage, using established conventions against themselves in the hope of exposing cultural repression.

Salle occupies a central position in this polemic, for he appears to be

balancing precariously between an empty formalism of the sort practiced by Clemente and Schnabel, and a critical subversion of such formalism. His work has long shared certain characteristics with the work of these artists, particularly in the deliberately problematic juxtaposition of heterogeneous styles and images. But whereas the worth of Clemente and Schnabel remains narcissistic at base, Salle's has always appeared more distant, a calculated infiltration aimed at deconstructing prevalent esthetic myths. Only now there seems to be a danger that the infiltration has become too complete; the seducer finds himself in love with his intended victim.

This infatuation has become more evident in the months following the so-called collaboration between Salle and Schnabel. This was a collaboration by fiat, a self-conscious gesture on the part of Schnabel (who had been given the painting in an exchange) in which he reversed the order of one of Salle's diptychs and partly covered one panel with a large, roughly painted portrait of Salle. The fabric of the original Salle was metaphorically ripped apart, literally wiped out, its meaning not so much altered as denied. The painting in fact became a Schnabel, a demonstration of the superior power of cannibalism over sabotage as a means of gaining control over one's subject. Lately Salle's paint has become thicker and more freely applied, some of the images clearly recognizable as taken from other art. In short, the ensembles seem less threatening.

Nevertheless, Salle's paintings remain significant pointers indicating the last exit for the radical artist. He makes paintings, but they are dead, inert representations of the impossibility of passion in a culture that has institutionalized self-expression. They take the most compelling sign for personal authenticity that our culture can provide, and attempt to stop it, to reveal its falseness. The paintings look real, but they are fake. They operate by stealth, insinuating a crippling doubt into the faith that supports and binds our ideological institutions.

> *Nothing is more unfitting for an intellectual resolved on practicing what was earlier called philosophy, than to wish...to be right. The very wish to be right, down to its subtlest form of logical reflection, is an expression of that spirit of self-preservation which philosophy is precisely concerned to break down.*
> ——Theodor Adorno, *Minima Moralia*, 1951

I believe that most of the serious critics who are at all interested in the problem of defining that clumsy term "post-modernism" would agree with the gist of my argument so far, would agree that, in the current situation, not only is the viability of any particular medium suspect, but that esthetic experience itself has been rendered doubtful. But it is precisely here that we begin to drift apart in the face of the unreconcilable difference. Basically it is a conflict between a certain logical, even doctrinaire, purity and the

impurity of real life; a disagreement over what to do about the gap between what ought to be and what is.

A recent and succinct statement of the idealist position is Douglas Crimp's essay "The End of Painting," which appeared in *October* 16 (Spring 1981). Crimp describes the ennervation of modernist painting in terms similar to those I have used, but then attempts to close the argument, by demonstrating "the end." For this purpose he chooses to isolate the work of Daniel Buren as exemplary of the Conceptualism that ten years ago sought to contest the myths of fine art. Crimp allows that Buren's work runs the risk of invisibility, that since it is intentionally meaningless in a formal sense, it might fail to operate on a critical level. And indeed it is a problem that the work needs an explanatory text, a handbook of the issues raised, a guide to one's approach. But that is the least of it, for what Crimp fails to acknowledge is that Buren's strategy has, by this time, degenerated into little more than an elegant device, naturalized by the forces it sought to undermine. Worse than looking like decor, the photographic record of his activity makes his work now look very much like the art he despises, recalling as it does the kind of *decollage* popular in Paris in the '50s. So Buren actually finds himself in a quandary similar to that faced by Salle, but since he deliberately reduced his means so severely in the beginning, he now has less to work with, and so has less hope of escaping either failure or cooptation. As a result of this inevitable impasse a good deal of Conceptual art has lost its conviction, and thus its ability to provoke thought.

One simply does not believe repeated warnings that the end is nigh, particularly when those issuing the warnings are comfortably settling down as institutions in their own right. Much activity that was once considered potentially subversive, mostly because it held out the promise of an art that could not be made into a commodity, is now as thoroughly academic as painting and sculpture, as a visit to any art school in North America will quickly reveal. And not only academic, but marketable, with "documentation" serving as the token of exchange, substituting for the real thing in a cynical duplication of the larger capitalist marketplace.

In recognition of this state of affairs Sherrie Levine has decided to simply represent the idea of creativity, re-presenting someone else's work as her own in an attempt to sabotage a system that places value on the privileged production of individual talent. In doing so she finalizes Crimp's argument more conclusively than Buren, but that finality is unrealistic. It is also desperate. She articulates the realization that, given a certain set of constraints, those imposed by an understanding of the current situation as much as those imposed by a desire to appear "correct" in a theoretical and political sense, there is nothing to be done, that creative activity is rendered impossible. And so, like any dispossessed victim she simply steals what she needs. Levine's appropriations are the underside of Schnabel's misappro-

priations, and the two find themselves in a perverse lockstep. The extremity of her position doubles back on her, infecting her work with an almost romantic poignancy as resistant to interpretation as the frank romanticism of her nemesis.

So what is a radical artist to do in the current situation if he or she wants to avoid instant cooptation or enforced inactivity? A clue, paradoxically, is to be found in one of Crimp's passages on Buren: "It is fundamental to Buren's work that it act in complicity with those very institutions that it seeks to make visible as the necessary conditions of the art work's intelligibility. That is the reason not only that his work appears in museums and galleries, but that it poses as painting." It is painting itself, that last refuge of the mythology of individuality, which can be seized to deconstruct the illusions of the present. For since painting is intimately concerned with illusion, what better vehicle for subversion?

> *Cultivated philistines are in the habit of requiring that a work of art "give" them something. They no longer take umbrage at works that are radical, but fall back on the shamelessly modest assertion that they do not understand.*
> ——Theodor Adorno, *Minima Moralia*

Given the accuracy of Adorno's observation it is clearly necessary to use trickery to pry open that understanding, for the main problem today is to open the channels of critical discourse to a healthy skepticism. Established avenues of protest, the disturbances that are the usual remedies of the disenfranchised and the disenchanted are no longer effective. They are too easily neutralized or bought off by an official "inquiry." But by resorting to subterfuge, using an unsuspecting vehicle as camouflage, the radical artist can manipulate the viewer's faith to dislodge his or her certainty. The intention of that artist must therefore be to unsettle conventional thought from within, to cast doubt on the normalized perception of the "natural," by destabilizing the means used to represent it, even in the knowledge that this, too, must ultimately lead to certain defeat. For in the end some action must be taken, however hopeless, however temporary. The alternative is the irresponsible acquiescence of despairing apathy.

To an unprecedented degree the perception of the "natural" is mediated these days. We know real life as it is represented on film or tape. We are all implicated in an unfolding spectacle of fulfillment, rendered passive by inordinate display and multiplicity of choice, made numb with variety: a spectacle that provides the illusion of contentment while slowly creating a debilitating sense of alienation. The camera, in all its manifestations, is our god, dispensing what we mistakenly take to be truth. The photograph *is* the modern world. We are given little choice: accept the picture and live as shadow, as insubstantial as the image on a television screen, or feel left out, dissatisfied, but unable to do anything about it. We

know about the appearance of everything, but from a great distance. And yet even as photography holds reality distant from us, it also makes it seem more immediate, by enabling us to "catch the moment." Right now a truly conscious practice is one concerned above all with the implications of that paradox. Such a practice might be called "post-modern" in a strict etymological sense because it is interested in continuing modernism's adversary stance, interested in the possibilities of immediate action, yet aware of the closure that that immediacy has imposed, in time, on genuine discourse. It is art that reintroduces the idea of esthetic distance as a thing of value, as something that will allow that discourse to open. It is art that pays attention to the workings of received ideas and methods, and in particular to those of the dominant media, in the hope of demonstrating the rigid, if often hidden, ideology that gives shape to our experience.

The most obvious procedure for this art that plumbs the dark secrets of the photographic question, the public trace of a submerged memory, would be to make use of the photographic media themselves, isolating pieces of information, repeating them, changing their scale, altering or highlighting color, and in so doing revealing the hidden structures of desire that persuade our thoughts. And indeed, it has been this kind of practice, the practice of such artists as Dara Birnbaum, Barbara Bloom, Richard Prince, and Cindy Sherman, working with video, film, and fashion photography, that has received the most considered attention from critics like Crimp and Craig Owens. And yet despite the success of this approach, it remains, in the end, too straightforwardly declarative. What ambiguity there exists in the work is a given of its own inner workings and can do little to stimulate the growth of a really troubling doubt. The representation remains safe, and the work too easily dismissed as yet another avant-garde art strategy, commentary too easily recognized.

More compelling, because more perverse, is the idea of tackling the problem with what appears to be the least suitable vehicle available, painting. It is perfect camouflage, and it must be remembered that Picasso considered Cubism and camouflage to be one and the same, a device of misrepresentation, a deconstructive tool designed to undermine the certainty of appearances. The appropriation of painting as a subversive method allows one to place critical esthetic activity at the center of the marketplace, where it can cause the most trouble. For as too many Conceptual artists discovered, art made on the peripheries of the market remains marginal. To reopen debate, get people thinking, one must be there, and one must be heard. One of the most important of Duchamp's lessons was that the artist who wishes to create a critical disturbance in the calm waters of acceptable, unthinking taste, must act in as perverse a way as possible, even to the point of seeming to endanger his or her own position. And it seems at this point, when there is a growing lack of faith in the ability of artists

Thomas Lawson, "Saved" 1983 Oil on canvas, 48" × 96"
Photograph courtesy Metro Pictures, New York.

to continue as anything more than plagiaristic stylists, that a recognition of this state of affairs can only be adequately expressed through the medium that requires the greatest amount of faith.

For it is this question of faith that is central. We are living in an age of skepticism and as a result the practice of art is inevitably crippled by the suspension of belief. The artist can continue as though this were not true, in the naive hope that it will all work out in the end. But given the situation, a more considered position implies the adoption of an ironic mode. However, one of the most troubling results of the cooptation of modernism by mainstream bourgeois culture is that to a certain degree irony has also been subsumed. A vaguely ironic, slightly sarcastic response to the world has now become a cliched, unthinking one. From being a method that could shatter conventional ideas, it has become a convention for establishing complicity. From being a way of coming to terms with lack of faith, it has become a screen for bad faith. In this latter sense popular movies and television shows are ironic, newscasters are ironic, Julian Schnabel is ironic. Which is to say that irony is no longer easily identified as a liberating mode, but is at times a repressive one, and in art one that is all too often synonymous with camp. The complexity of this situation demands a complex response. We are inundated with information, to the point where it becomes meaningless to us. We can shrug it off, make a joke, confess bewilderment. But our very liberty is at stake, and we are bamboozled into not paying attention.

The most challenging contemporary work using photography and photographic imagery remains illustrative. There is an indication of what might be considered, but no more; our understanding of the reverberations of the camera's picture-making is not advanced in a cohesive and compound form. Important issues are singled out, but they remain singular, strangely disconnected.

Radical artists now are faced with a choice—despair, or the last exit: painting. The discursive nature of painting is persuasively useful, due to its characteristic of being a never-ending web of representations. It does often share the irony implicit in any conscious endeavor these days, but can transcend it, to represent it. Many artists have decided to present work that can be classified as painting, or as related to painting, but that must be seen as something other: a desperate gesture, an uneasy attempt to address the many contradictions of current art production by focusing on the heart of the problem—that continuing debate between the "moderns" and the "post-moderns" that is so often couched in terms of the life and death of painting.

JOHN BALDESSARI, "Soldier and Starving Person" 1984
Black and white photographs, 60" × 40"
Photograph courtesy Sonnabend Gallery, New York.

When Robert Rauschenberg reproduced photographic images from other sources onto his canvases, his paintings became more like bulletin boards than illusionistic windows, thereby breaking down the presumed autonomy of modernist painting. Critic Douglas Crimp discusses examples of appropriated imagery in recent art and architecture. He argues that some appropriations serve to question, while others merely reassert, modernism's emphasis on style, originality, and universality.

Appropriating Appropriation

Douglas Crimp

Over the past few years it has become increasingly clear that the strategy of appropriation no longer attests to a particular stance toward the conditions of contemporary culture. To say this is both to suggest that appropriation *did* at first seem to entail a critical position and to admit that such a reading was altogether too simple. For appropriation, pastiche, quotation—these methods can now be seen to extend to virtually every aspect of our culture, from the most cynically calculated products of the fashion and entertainment industries to the most committed critical activities of artists, from the most clearly retrograde works (Michael Graves' buildings, Hans Jurgen Syberberg's films, Robert Mapplethorpe's photographs, David Salle's paintings) to the most seemingly progressive practices (Frank Gehry's architecture, Jean-Marie Straub and Danièle Huillet's cinema, Sherrie Levine's photography, Roland Barthes' texts). And if all aspects of the culture use this new operational mode, then the mode itself cannot articulate a specific reflection upon that culture.

On the other hand, the very ubiquity of a new mode of cultural production does underscore the fact that there has been an important cultural shift in recent years, a shift that I still want to designate as that between modernism and postmodernism, even if the latter term is utterly confusing in its current usages. *Postmodernism* will perhaps begin to acquire meaning beyond the simple naming of a *Zeitgeist* when we are able to employ it to make distinctions within all the various practices of appropriation. What I would like to do here, then, is to suggest some ways in which these distinctions might be approached.

To begin, I should perhaps look more closely at the assertions of the regressive/progressive character of the uses of appropriation by the artists

Reprinted from Douglas Crimp, "Appropriating Appropriation," catalogue essay for *Image Scavengers: Photography*, Institute of Contemporary Art, University of Pennsylvania, 1983.

157

named above. How, for example, can we distinguish Graves' use of pastiche from that of Gehry? For the sake of convenience, let's take the most famous building by each architect—Graves' recently completed Portland Public Services Building and Gehry's own house in Santa Monica. The Portland building displays an eclectic mix of past architectural styles drawn generally from the orbit of classicism. But it is a particular brand of classicism, an already eclectic classicism, to which Graves turns—the neo-classicism of Boullée and Ledoux, the pseudo-classicism of Art Deco public buildings, occasional flourishes of Beaux-Arts pomp. Gehry's house, by contrast, appropriates only a single element from the past. It is not, however, an element of style; it is an already-existing 1920s house. This house is then collaged with (surrounded by, shot through with) mass-produced, from-the-catalogue materials of the construction industry—corrugated iron, chain-link fence, plywood, asphalt.

Differences between these two practices are, then, immediately obvious: Graves appropriates from the architectural past; Gehry appropriates laterally, from the present. Graves appropriates style; Gehry, material. In what different readings do these two modes of appropriation result? Graves' approach to architecture returns to a premodernist understanding of the art as a creative combination of elements derived from a historically given vocabulary (they are also said to derive from nature, but nature as understood in the nineteenth century). Graves' approach is thus equivalent to that of the Beaux-Arts architect, against which the modernists would react. Although there can be no illusion that the elements of style are originated by the architect himself, there is a very strong illusion indeed of the wholeness of the end product and of the architect's creative contribution to the uninterrupted, ongoing tradition of architecture. Graves' eclecticism thus maintains the integrity of a self-enclosed history of architectural style, a pseudo-history immune to problematic incursions from real historical developments (one of which would be modern architecture itself if considered as more than merely another style).

Gehry's practice, by contrast, retains the historical lessons of modernism even as it criticizes its idealist dimension from a postmodernist perspective. Gehry's house takes from history an actual object (the existing house), not an abstracted style. The present-day products of the building trade reflect nothing other than the material conditions of the present moment in history. Unlike the marble that Graves uses, Gehry's materials cannot pretend to a timeless universality. Moreover, the individual elements of Gehry's house resolutely maintain their identities. They do not combine into an illusion of a seamless whole. The house remains a collage of fragments, declaring its contingency as would a movie set seen on a sound stage (a comparison which this house directly solicits), and these fragments do not add up to a style. Gehry's house is a unique response to a particular architectural program; it cannot be indiscriminately reapplied to another

situation. Graves' vocabulary, on the other hand, will seem to him as appropriate to a teapot or a line of fabrics as to a showroom or a skyscraper.

What, then, becomes of these differences when applied to photography? Can analogous distinctions be made between the photographic borrowings of Robert Mapplethorpe, on the one hand, and Sherrie Levine, on the other? Mapplethorpe's photographs, whether portraits, nudes or still lifes (and it is not coincidental that they fall so neatly into these traditional artistic genres), appropriate the stylistics of prewar studio photography. Their compositions, poses, lighting, and even their subjects (*mondain* personalities, glacial nudes, tulips) recall *Vanity Fair* and *Vogue* at that historical juncture when such "artists" as Edward Steichen and Man Ray contributed to those publications their intimate knowledge of international art photography. Mapplethorpe's abstraction and fetishization of objects thus refer, through the mediation of the fashion industry, to Edward Weston, while his abstraction of the *subject* refers to the neoclassical pretenses of George Platt Lynes. Just as Graves finds his style in a few carefully selected moments of architectural history, so Mapplethorpe constructs from his historical sources a synthetic "personal" vision that is yet another creative link in photographic history's endless chain of possibilities.

When Levine wished to make reference to Edward Weston and to the photographic variant of the neoclassical nude, she did so by simply rephotographing Weston's pictures of his young son Neil—no combinations, no transformations, no additions, no synthesis. Like the 1920s house that forms the core of Gehry's house, Weston's nudes were appropriated whole. In such an undisguised theft of already existing images, Levine lays no claim to conventional notions of artistic creativity. She makes use of the images, but not to constitute a style of her own. Her appropriations have only functional value for the particular historical discourses into which they are inserted. In the case of the Weston nudes, that discourse is the very one in which Mapplethorpe's photographs naively participate. In this respect, Levine's appropriation reflects upon the strategy of appropriation itself— the appropriation by Weston of classical sculptural style; the appropriation by Mapplethorpe of Weston's style; the appropriation by the institutions of high art of both Weston and Mapplethorpe, indeed of photography in general; and finally, photography as a tool of appropriation. Using photography instrumentally as Levine does, she is not confined to the specific medium of photography. She can also appropriate paintings (or reproductions of paintings). It is, by contrast, the rejection of photography as a tool that guarantees the atavism of the painters' recent pastiches, since they remain dependent upon modes of imitation/transformation that are no different from those practiced by nineteenth-century academicians. Like Graves and Mapplethorpe, such painters appropriate style, not material,

SHERRIE LEVINE, detail from "After Vincent Van Gogh" 1983 Collage, 14″ × 17″
Photograph courtesy of Richard Kuhlenschmidt Gallery.

except when they use the traditional form of collage. Only Levine herself has been canny enough to appropriate painting whole, in its material form, by staging an exhibition at/of the studio of the late painter Dimitri Merinoff.

The centrality of photography within the current range of practices makes it crucial to a theoretical distinction between modernism and post-modernism. Not only has photography so thoroughly saturated our visual environment as to make the invention of visual images seem an archaic

idea, but it is clear that photography is too multiple, too useful to other discourses, ever to be wholly contained within traditional definitions of art. Photography will always exceed the institutions of art, always participate in nonart practices, always threaten the insularity of art's discourse. In this regard, I want to return to the context in which photography first suggested to me the moment of transition to postmodernism:

> *While it was only with slight discomfort that Rauschenberg was called a painter throughout the first decade of his career, when he systematically embraced photographic images in the early '60s it became less and less possible to think of his work as* painting. *It was instead a hybrid form of* printing. *Rauschenberg had moved definitively from techniques of* production *(combines, assemblages) to techniques of* reproduction *(silkscreens, transfer drawings). And it is this move that requires us to think of Rauschenberg's art as postmodernist. Through reproductive technology postmodernist art dispenses with the aura. The fantasy of the creating subject gives way to the frank confiscation, quotation, excerptation, accumulation, and repetition of already existing images. Notions of originality, authenticity, and presence, essential to the ordered discourse of the museum, are undermined.*

When I wrote that paragraph two and a half years ago, what had struck me as crucial about Rauschenberg's early '60s works was their destruction of the guarded autonomy of modernist painting through the introduction of photography onto the surface of the canvas. This was important not only because it threatened the extinction of the traditional production mode, but also because it questioned all the claims to authenticity according to which the major social institution of art—the museum—determined its body of objects and its field of knowledge. When the determinants of a field of knowledge begin to be broken down, a whole range of new possibilities for knowledge opens up, a range that could not even have been foreseen from within the former field. And in the years following Rauschenberg's appropriation of photographic images—his very real disintegration of the boundaries between art and nonart—a whole new set of esthetic operations and activities *did* take place.

These activities could not be contained within the space of the museum or accounted for by the museum's system of knowledge. The crisis thus precipitated was met, of course, by all manner of attempts to deny that any significant change had occurred and to recuperate traditional forms. A whole new set of appropriations aided this recuperation: appropriations of long-outmoded techniques such as painting *al fresco* (albeit on portable panels, of course) and casting sculpture in bronze, rehabilitations of *retardataire* and reactionary artists such as nineteenth-century *pompiers* and between-the-wars realists; and reevaluations of hitherto secondary products such as architects' drawings and commercial photography.

It was in relation to this last response to the museum's crisis—the wholesale acceptance of photography as a museum art—that it seemed to

me a number of recent photographic practices using the strategy of appropriation functioned. Thus, Richard Prince's appropriation of advertising images, his thrusting of unaltered pictures into the context of the art gallery, exactly duplicated—but in a determinedly degraded manner—the appropriation by art institutions of earlier commercial photography. In like fashion, it appeared that the so-called directorial mode of art photography (which I prefer to call *auteur* photography) was wryly mocked by Laurie Simmons' setup shots of dollhouses and plastic cowboys. Or by Cindy Sherman's ersatz film stills, which implicitly attacked auteurism by equating the known artifice of the actress in front of the camera with the supposed authenticity of the director behind it.

Certainly I did not expect this work simply to function instrumentally or even didactically in its response to the institutional force of the museum. Like Rauschenberg's works, all works made within the compass of the present art institutions will inevitably find their life and their resting place within those institutions. But when those practices begin, even if very subtly, to accommodate themselves to the desires of the institutional discourse— as in the case of Prince's extreme mediation of the advertising image or Sherman's abandonment of the movie still's mise-en-scène in favor of close-ups of the "star"—they allow themselves simply to enter that discourse (rather than to intervene within it) on a par with the very objects they had once appeared ready to displace. And in this way the strategy of appropriation becomes just another academic category—a thematic—through which the museum organizes its objects.

A particularly illuminating example of the current conditions of art is provided again by the work of Rauschenberg. In his latest work he has returned to one of his early interests—photography. But not photography as a reproductive technology through which images can be transferred from one place in the culture to another—from, say, the daily newspaper to the surface of a painting—but rather photography as an art medium traditionally conceived. Rauschenberg has become, in short, a photographer. And what does he find with his camera, what does he see through his lens, but all those objects in the world that look like passages from his own art. Rauschenberg thus appropriates his own work, converts it from material to style, and delivers it up in this new form to satisfy the museum's desire for appropriated photographic images.

Arguing that modernism proclaimed a bogus neutrality, photographer Allan Sekula urges artists to become involved with the practical struggle to establish a more egalitarian society. Rather than engaging in media hype and self-promotion, artists should conduct an intensive investigation of the "authoritarian monologues of school and mass media."

Dismantling Modernism

Allan Sekula

Suppose we regard art as a mode of human communication, as a discourse anchored in concrete social relations, rather than as a mystified, vaporous, and ahistorical realm of purely affective expression and experience. Art, like speech, is both symbolic exchange and material practice, involving the production of both meaning and physical presence. Meaning, as an understanding of that presence, emerges from an interpretive act. Interpretation is ideologically constrained. Our readings of past culture are subject to the covert demands of the historical present. Mystified interpretation universalizes the act of reading, lifting it above history.

The meaning of an artwork ought to be regarded, then, as *contingent*, rather than as immanent, universally given, or fixed. The Kantian separation of cognitive and affective faculties, which provided the philosophical basis for Romanticism, must likewise be critically superseded. This argument, then, calls for a fundamental break with idealist aesthetics, a break with the notion of genius both in its original form and in its debased neo-romantic appearance at the center of the mythology of mass culture, where "genius" assumes the trappings of a charismatic stardom.

I'm not suggesting that we ignore or suppress the creative, affective, and expressive aspects of cultural activity, to do so would be to play into the hands of the ongoing technocratic obliteration of human creativity. What I am arguing is that we understand the extent to which art *redeems* a repressive social order by offering a wholly imaginary transcendence, a false harmony, to docile and isolated spectators. The cult of private experience, of the entirely affective relation to culture demanded by a consumerist economy, serves to obliterate momentarily, on weekends, knowledge of the fragmentation, boredom, and routinization of labor, knowledge of the self as a commodity.

In capitalist society, artists are represented as possessing a privileged

Excerpted from Allan Sekula, "Dismantling Modernism: Reinventing Documentary." Reprinted from *The Massachusetts Review*, © 1979 The Massachusetts Review, Inc.

subjectivity, gifted with an uncommon unity of self and labor. Artists are the bearers of an autonomy that is systematically and covertly denied the economically objectified mass spectator, the wage-worker and the woman who works without wages in the home. Even the apparatus of mass culture itself can be bent to this elitist logic. "Artists" are the people who stare out, accusingly and seductively, from billboards and magazine advertisements. A glamorous young couple can be seen lounging in what looks like a Soho loft; they tell us of the secret of white rum, effortlessly gleaned from Liza Minelli at an Andy Warhol party. Richard Avedon is offered to us as an almost impossible ideal: bohemian as well as his "own Guggenheim Foundation." Artist and patron coalesce in a petit bourgeois dream fleshed-out in the realm of a self-valorizing mass culture. Further, the recent efforts to unequivocally elevate photography to the status of high art by transforming the photographic print into a privileged commodity, and the photographer, regardless of working context, into an autonomous *auteur* with a capacity for genius, have the effect of restoring the "aura," to use Walter Benjamin's term, to a mass-communications technology. At the same time, the camera hobbyist, the consumer of leisure technology, is invited to participate in a delimited and therefore illusory and pathetic creativity, in an advertising-induced fantasy of self-authorship fed by power over the image machine, and through it, over its prey.

The crisis of contemporary art involves more than a lack of "unifying" metacritical thought, nor can it be resolved by expensive "interdisciplinary" organ transplants. The problems of art are refractions of a larger cultural and ideological crisis, stemming from the declining legitimacy of the liberal capitalist worldview. Putting it bluntly, these crises are rooted in the materially dictated inequalities of advanced capitalism and will only be resolved *practically*, by the struggle for an authentic socialism.

Artists and writers who move toward an openly political cultural practice need to educate themselves out of their own professional elitism and narrowness of concern. A theoretical grasp of modernism and its pitfalls might be useful in this regard. The problem of modernist closure, of an "immanent critique" which, failing to logically overcome the paradigm within which it begins, ultimately reduces every practice to a formalism, is larger than any one intellectual discipline and yet infects them all. Modernist practice is organized professionally and shielded by a bogus ideology of neutrality. (Even academic thuggeries like Dr. Milton Friedman's overtly instrumentalist "free market" economics employ the neutrality gambit.) In political-economic terms, modernism stems from the fundamental division of "mental" and "manual" labor under advanced capitalism. The former is further specialized and accorded certain privileges, as well as a managerial relation to the latter, which is fragmented and degraded. An ideology of separation, of petit bourgeois upward aspiration, induces the intellectual

worker to view the "working class" with superiority, cynicism, contempt, and glimmers of fear. Artists, despite their romanticism and propensity for slumming, are no exception.

The ideological confusions of current art, euphemistically labeled a "healthy pluralism" by art promoters, stem from the collapsed authority of the modernist paradigm. "Pure" artistic modernism collapses because it is ultimately a self-annihilating project, narrowing the field of art's concerns with scientific rigor, dead-ending in alternating appeals to taste, science and metaphysics. Over the past five years, a rather cynical and self-referential mannerism, partially based on Pop art, has rolled out of this cul-de-sac. Some people call this phenomenon "post-modernism." (Already, a so-called "political art" has been used as an end-game modernist bludgeon, as a chic vanguardism, by artists who suffer from a very real isolation from larger social issues. This would be bad enough if it weren't for the fact that the art-promotional system converts everything it handles into "fashion," while dishing out a good quantity of liberal obfuscation.) These developments demonstrate that the only necessary rigor in a commodified cultural environment is that of incessant artistic self-promotion. Here elite culture becomes a parasitical "mannerist" representation of mass culture, a private-party sideshow, with its own photojournalism, gossip column reviews, promoters, celebrity pantheon, and narcissistic stellar-bound performers. The charisma of the art star is subject to an overdeveloped bureaucratism. Careers are "managed." Innovation is regularized, adjusted to the demands of the market. Modernism, per se, (as well as the lingering ghost of bohemianism) is transformed into farce, into a professionalism based on academic appointments, periodic exposure, lofty real estate speculation in the former factory districts of decaying cites, massive state funding, jet travel, and increasingly ostentatious corporate patronage of the arts. This last development represents an attempt by monopoly capital to "humanize" its image for the middle-managerial and professional subclasses (the vicarious consumers of high culture, the museum audience) in the face of an escalating legitimation crisis. High art is rapidly becoming a specialized colony of the monopoly capitalist media.

Political domination, especially in the advanced capitalist countries and the more developed neo-colonies, depends on an exaggerated symbolic apparatus, on pedagogy and spectacle, on the authoritarian monologues of school and mass media. These are the main agents of working-class obedience and docility; these are the main promoters of phony consumer options, of "lifestyle," and increasingly, of political reaction, nihilism, and sadomasochism. Any effective political art will have to be grounded in work *against* these institutions. We need a political economy, a sociology, and a nonformalist semiotics of media. We need to comprehend advertising as the fundamental discourse of capitalism, exposing the link between the language of manufactured needs and commodity fetishism. From this basis,

a critical representational art, an art that points openly to the social world and to possibilities of concrete social transformation, could develop. But we will also have to work toward a redefined *pragmatics*, toward modes of address based on a dialogical pedagogy, and toward a different and significantly wider notion of audience, one that engages with ongoing progressive struggles against the established order. Without a coherent oppositional politics, though, an oppositional culture remains tentative and isolated. Obviously, a great deal needs to be done. . . .

Photographer John Brumfield addresses the responsibility of art programs to do more than merely assimilate students into the art subculture. Brumfield urges that in addition to teaching art mores and manners, instructors initiate serious critical examination of values beyond prevailing fashion—in particular the function of art in contemporary society and the processes for determining its meaning and truth.

On the Question of
Teaching a Dentist to Shave

John Brumfield

Generally speaking, most art programs emphasize either commercial or fine art: there's lots of overlapping of course, but the range of current practice is pretty well defined within the extremes implied by those two categories. At one end of a hypothetical continuum you have the School of the Art Institute of Chicago, or the San Francisco Art Institute or CalArts— schools that are devoted almost exclusively to high art concerns, and, at the other pole, you have such institutions as Parsons, the Art Institute of Houston, the Rochester Institute of Technology, and even the Brooks Institute, A School of Photographic Arts and Sciences—high-tech training centers into which kids enroll, fresh out of high school, wanting to be Frank Frazetta or Calvin Klein, wanting to make $10,000 a minute or become the design head at General Motors or do a lot of slurp-flash album covers and be—if you will—the Queen of the Now. When they get to a place like that, a place whose curriculum and track record promises a legitimate shot at that kind of box office, what they are indeed taught is how to *do* that. The mechanics, of course. And of course also, the post-puberty socialization required of all initiates entering a professional fraternity.

Classes are so structured that they are not exposed to much else. Certainly not to ideas. One learns when to use a blue marker and what to do with an airbrush and precisely how to handle a full range of filters and gels—all the latest techniques for making candies or cars or contraceptives more beautiful than real, how to improve on a model's drape or a president's underbite—for the core of the curriculum is based on the practical necessity of mastering a technology to perfection.

Isn't there a de facto philosophy of art buried here? Sure. But it's incidental to the more pervasive ideology of superficial professionalism;

Excerpted from John Brumfield, "On the Question of Teaching a Dentist to Shave," *Afterimage* (November 1982).

for these are, all of them, training camps to which come an apparently endless wave of recruits equipped, often enough, with little more than a shapeless ambition, and it is the function of the school to provide the appropriate shape. Given the society, that's an imperative of survival, the necessary *modus operandi* of access.

Nor should we be too quick to condemn, for it's awfully hard—speaking of the bitch and moan theory that Paul Berger alludes to—to find a place in our society where you don't have to go to bed with grimy hands. All of us are involved in something that is paid for by money that originates—that enters the market—elsewhere; the Sancta Sanctora of High Art are no exception. We are all familiar with the image from *The Americans*, the school of art captioned *Salt Lake Cty, Utah*, perhaps by implication itself a temple of salvation, surely of truth and beauty; but positioned as precisely as it is in Frank's carefully constructed sequence, the school is also a specifically stratified element of the socio-political hierarchy. It is embedded in the support system of prestige and privilege.

And it is specific. Like every other trade, professional, or business school, the fine arts programs of all western societies operate in response to a client-market base, for which the "art world," an essentially mediating superstructure, is, in this respect, an organically fluid service community. Functioning to signal, accommodate, and rationalize the expectations of the client class, the art world is the model against whose various sub-categories the fine arts institution judges itself. Thus the art curriculum of any given school is a mirror, not of the incremental nature of art, nor—as is popularly supposed—of the market, but rather of one or more administrator's perceptions of the dynamics of the current complex *in which* the market system finds itself. Essentially sociological, these need not be especially analytical perceptions. For the task is simply to see where one fits in the scheme of things. Within the dominant culture.

In this milieu an art of rigorous discourse, of exposition, of issues scrupulously examined, is simply unwelcome, and it is not surprising that in most art schools it is a commonplace that such art either cannot exist or must be propaganda. And insofar as our educations have been limited to fine arts curricula, this seems likely to be the case. Because like dentists, we have been *professionally educated*. We are narrowly well-informed, acculturated, and appropriately superficial; and while our fine arts educations have failed—at every juncture—to address even the rudiments of intellectual discipline or critical integrity, they have, at all the better schools, provided us with an abundance of professionally acceptable response patterns. For a typical fine arts curriculum is comprised, usually, of about one-third of the craft content of the trade school to two-thirds catechism: critique "situations" in which the matriculating neophyte adopts a vocabulary and a rhetorical stance signifying the attainment of true seriousness. Indeed, what our students are really learning from the profoundly educa-

tional process that might be called the deep syntax of the art school is how to fit. How to fit. How to be an acceptable—preferably esteemed—member of a fringe mandarin elite: how to assimilate into the behavioral modalities modeled before them by their teachers great and small. How to fit. How to move, how to dress, how to talk, how to think, and of course how to make an image that is patently within the canons of the high art sub-culture. If the essential bourgeois illusion is freedom, the essential illusion of the artist is significant self-expression. Because the choices by which art is made are far more arbitrary than is commonly pretended. We conform. We no longer do street photography, carve in blue marble, paint religious subjects in cathedral settings, or model cowboys in red bronze because these are all passé—for a variety of reasons. They are tired, trite, out of touch, corny, irrelevant, limited, and dated; and so, of course, is the imagery of last year's *Artforum*. There is, as we all know, nothing so retrograde as being merely recent. One must be on the money.

That's why it's important to recognize that there's a lot of teaching going on that goes on underneath the surface, and that teaching is really about assimilation into a sub-cultural value system: about the techniques and modalities of fraternal acculturation, not how to examine, analyze, or even evaluate beyond the clearly cued parameters of prevailing fashion. And while I doubt that one M.F.A. in 20 (50) can outline a set of criteria leading to a definition of "good art" that is sensible to anyone not already conversant with the jargon, my more emphatic point is that the structure—the system—of contemporary art education, fine and applied, simply cannot tolerate the introduction of critical discourse on any but the most parochially academic levels of sophistication.

To seriously examine art making as a pre-eminently behavioral activity, to rigorously consider the relative significance of art as an ongoing aspect of intellectual history, or to ask that the visual arts compete, *for serious attention*, in the world of ideas—such expectations are unbearable.

For while we may indeed pay enormous lip service to the litany that art is the means by which culture perpetuates its deepest values and transmits its subtlest insights, we are so far from truly believing this that it plays no active part in our private or professional assessments, our critical literature, or even in those magazine and newspaper reviews through which we daily translate the latest developments in art into the language of the presumably educated layman. Moreover, to ask what it is we know when we have ostensibly enjoyed the opportunity to draw upon the new insights and perceptions of a fresh work of art or, further, to ask what an image means, is often to do no more than be awkwardly embarrassing. For in most cases we really don't know. The work of art—by Joel Witkin, Bart Parker, or Patrick Nagatani—may indeed suggest, point, connote, or imply in all kinds of relatively specific directions, but as to what it actually signifies, most of us really can't say. We may talk about the high seriousness of art,

and cluck proudly at the superiority of sensibility that its apprehension represents, but exactly how to bring that superiority out of the ideal world of the ineffable and into the arena of knowledge and communicable meaning so that it may have something of a truly visceral significance, that is a problem for which we have developed too few tools.

Artists Leslie Labowitz and Suzanne Lacy examine in detail the depiction of women as victims of violence, in both the media and the fine arts—a representation which reinforces the conception of women as powerless. They urge artists to use their insights into visual imagery to reshape public consciousness, make people aware of the values of the media, and become a positive counterforce to commercial exploitation in whatever form it may take.

Mass Media, Popular Culture, and Fine Art

Leslie Labowitz and Suzanne Lacy

It is impossible to ignore the effects of mass communication on our social environment. For the first time in history millions of people commonly experience the same images and information. Within our "popular culture," we are constantly presented with images of women as victims. Along with feminist activists, women artists are exploring how these images affect our lives and how we can create alternatives.

While art in every form makes tangible some experience of the individual artist, our art focuses on those experiences which also have reference to one's political position in the culture. Educational in nature, it offers information on social issues and the possibility of individual and collective action. Our work combines performance and conceptual art ideas with community organization, political strategy, and media analysis. These performances involve not only artists but individuals from the community as performer/creators.

From this work we formed *Ariadne/A Social Art Network,* an affiliation of women in the arts, media, government and feminist community. Together we have produced a series of collaborative events on specific social issues, such as rape, incest, and violent images of women in the media. These issues are particularly critical at a time when violence against women is dramatically on the increase.

This article describes our view of the relationship of mass media to the fine arts shown through the current use of violent images of women. Our opinions, as women who feel ourselves potential victims, are biased. What we hope to point out is that the creation of violent images by artists

Reprinted from Leslie Labowitz and Suzanne Lacy, "Mass Media, Popular Culture, and Fine Art: Images of Violence Against Women," in catalogue, "Social Works," Los Angeles Institute of Contemporary Art, 1979.

Thanks to Linda Palumbo and Linda Macaluso for editing assistance. L.L. and S.L.

or media-makers reflects another bias; and that beyond either viewpoint there is an urgent need for artists to develop a political perspective on media and its relationship to their own work.

IMAGES OF WOMEN IN THE MEDIA

Images of women being physically abused are increasingly common. A woman's seductively exposed neck is encircled with a blood-red ribbon to simulate throat slashing in the widespread advertisement for the movie, *Bloodline*. *Vogue* magazine published a set of photographs by Richard Avedon showing a man caressing, then beating, a woman who appeared to enjoy it. In Cambridge, The Camel's Hump Boutique displayed a mannequin dumped from a garbage can, blood running from her mouth and men's shoes on her head and neck. Record album advertisements and covers feature chained, raped and murdered women.

The causes of this increase in media sex-violence are complex. The vogue in violence is seen by some as a result of a demand for attention by media-makers who find their audiences increasingly hard to shock. Others feel such violent images serve as an outlet for many kinds of social and work-related tensions. Feminists see in these images a backlash to the shifting power relationship between men and women: violence, whether implied through media symbols or acted out in rape, intimidates and controls women. Whatever the causes for these images, they present a current trend expressed through several media forms:

a. *Advertising* The female body has embodied the ideas, values and experiences of the artist throughout fine art history. Likewise, commercial art uses the images of women, in this case to make products desirable. Other media (television, film, even the news) ape the methods of advertising, using the research into the manipulation of consciousness which underlies the industry's financial success. Advertising does not purport to be an art, but reserves for itself the techniques of science: they want us to buy and they'll spend millions on empirical research to see what motivates us.

Since men own and control the media, the prevailing cultural notion of reality is based on male experience. Advertisers dig deeply into male mythology for images which create a powerful resonance with the viewer. Sexual images of women appear to motivate, so these have been manipulated extensively to create the novelty that attracts attention. More frequently now, the trend is toward images incorporating violence with sexuality.[1]

The sophistication of the advertising industry makes its increased use of violence potentially devastating. In the past two decades, we have seen evolving images of women in media fit the mandate for visual novelty. From the slightly naughty bikinied goddess to the large-bosomed sex queen

to the completely nude libertine, each image was discarded when its value for attracting attention wore off. The female victim in today's advertising is yet another escalation to create a novel and attention-riveting shock. Violence is a valuable tool in the advertiser's arsenal, because the length of time needed to cause an impact on the viewer is small yet the result is powerful.

Violence in advertising is cheerfully explained by a recording industry publicity director, "If a group wants a gorilla on the cover, they get a gorilla on the cover, unless it's illegal or there's a marketing reason why gorillas aren't a good idea."[2] Violence against women is neither illegal nor ineffective in the market. Commercial artists and directors consistently rationalize these images with complete indifference to their content. One advertiser decided to bolster lagging sales in men's pants by creating an ad campaign depicting violence against men, explaining "I don't think women deserve to be beaten any more than men."[3] Paradoxically and with the same apparent objectivity, this advertiser explained an earlier advertisement featuring violence to women, "We decided to develop a campaign men could really identify with. We really wanted to give it to women."[4] Evidenced not in the advertisers' rationalizations but in the images themselves, woman-hating finds contemporary and influential expression in the desire to sell products. The entertainment and news industries follow suit, competing with advertising and each other for viewer attention.

b. *Entertainment: Television and Film* Images of women in television and film often appeal to the pornographic sensibility, i.e., the portrait of sexuality preoccupied with domination and power. Movie one-sheets and newspaper advertisements frequently depict the most violent images in the film, seeking to seduce the viewers' interest by exploiting response patterns set up by product advertising. The entertainment industry manipulates not only brief violent flashes (as in advertising), but develops narratives that depend almost exclusively on violence. It is a formula followed by many producers and directors, justified as giving the public what it wants. It accomplishes a ceaseless indoctrination of media ideology, a survey of the possibilities for violent behavior. When these possibilities include an escalation of violence toward women (and, increasingly, children), it becomes impossible to ignore their effects in real life.

c. *The News Media* The news media, carrying a stamp of objectivity and reality, is itself part of the communication industry's portrayal of violence. As in entertainment and advertising, news depends upon strong, often sensational images to capture its audience. Front page photographs and television lead-ins are offered as enticements to the audience, following the prescription that we take for granted by now—violent drama sells, so use it.

Violence is presented as a series of fantastic events which happen

without logical explanation (by implication we are powerless to stop it). Social, economic, or political analysis is ignored as these would be counter to the sacred "objectivity" of the news.

Calling the images or information objective belies what every artist knows: how an image is framed, edited, manipulated and worded affects the viewer's perception of its message. A front page photo of a nude body on a hillside conveys much more than a simple reporting of the incident. It tells you what kind of people make plausible victims and demonstrates the potentially erotic elements in violence by its visual associations with both entertainment and pornography. News images, with more believability than entertainment, graphically demonstrate the realm of possibilities of human behavior.

d. *Pornography* Pornography is experiencing a renaissance in popularity among media-makers and artists alike. In the violent fantasies that fill pornographic magazines, films and audiotapes, women and children's victimization is increasingly explicit.

Pornography expresses a clear and virulent hatred of women that has a demonstrable effect on viewers: it reinforces male bonding, arouses sexuality, and makes viewers more receptive to whatever they've just seen. Images of violence desensitize the audience, and sex and violence together condition a response of arousal. For anyone who has not seen hard core pornography during the last five years, a visit to a porn shop can enlighten you quickly: happy, tender sex is difficult to find. Violence is everywhere, and the market for such fantasies flourishes. A woman might be tied up in various painful and degrading postures (whole magazines are dedicated to various forms of knots and bindings); threatened with insects, animals or reptiles; gang raped; tortured; mutilated; disemboweled; and killed. Passion is curiously absent. It is left for the viewer to interpret his—and the audience is clearly male—visceral response as passion. Pornography serves as an affordable ego boost for those who can own little from the array of power symbols in our culture. It is the desire to own, control, and destroy, encouraged by the advertising industry, which has been packaged as a model of possession itself.

Some argue that sex-violent images are only entertainment. But people spend a great deal of energy and money pursuing entertainment, suggesting it has a considerable motivating influence on our actions. Even so, this appears a rather thin argument when set in a climate of increasing violence against women. The rate of violent crimes involving rape and mutilation continues to climb rapidly, with Los Angeles, one of the media centers, leading in the United States.

It is no longer possible to ignore the influence of media violence on physical violence. Dozens of specific cases that substantiate this relationship have been cited.[5] Victimization images establish the roles through which we perceive ourselves in relationship to others, making it normal to abuse

women and children. Media is a powerful educational tool, teaching men how to kill and women how to be victims.

SOCIAL RELEVANCE OF ART IN A MEDIA CULTURE

It may appear ironic to include the fine art profession in a discussion of the effects of media images on the public, given that we don't often concern ourselves with that audience. But mass communication techniques have moved into the art profession, and the possibilities presented by this technology change the relationship of the artist to his/her culture.

Contrary to common myths about the differences between fine artists and commercial artists, there are significant parallels with respect to their depiction of women. Similar to media-makers, fine artists have stepped up their production of violent images. These images, distributed through the traditional art system of galleries, museums and art magazines, are finding their way into mainstream media as well. Conversely, one can observe artists borrowing *from* media images in the creation of their work. The interrelationship between art and media, particularly with respect to mutually-used representations of women, suggests art may be inadvertently in collusion with the goals and values of those who control the media. Three points seem crucial:

a. *Artists increasingly draw inspiration from mass media.* One trained in art skills inevitably recognizes the tremendous potential of mass media. Artists borrow from media, adopt those concepts and images that attract popular interest, and cloak these in art language. They experiment with detective stories, soap operas, documentary reporting, and news broadcasting. They get their videotapes on television, print their own books, make movies, publish posters, paint billboards, and even make the news.

Some artists appeal directly to the mass audience for support of their ideas, Judy Chicago created a media event around *The Dinner Party* to communicate feminist perceptions not accepted by an indifferent or even antagonistic art world. Others are intrigued with the forms of mass communication, as was Lowell Darling when he ran for Governor of California. Our work involves a critique of media applications, to put forth political ideas regarding social change. The net effect of this and other variously motivated activity has been to enhance the art profession's awareness of its potential contribution to a highly technologized visual environment.

b. *Artists are not independent of the shaping influence of the media.* Art education does not support an understanding of the politics of images. It does, however, provide analytical skills to dissect images and to observe the effects of these images on their viewers. It is with fascination that contemporary artists watch the sophisticated and purposeful manipulation of audience response by commercial image-makers, learning as they do so.

Once seen as the vanguard of society's cultural evolution, the heralders of innovation through the visual experience, today's artists appear inef-

fectual compared to the media power structure. Many artists have themselves become indoctrinated by that power structure, recreating images from the media in their own work without questioning either the inventiveness or the morality of their actions. Inviolate behind the myth that art is a unique and singular expression of the artist's personal vision (and therefore above moral or political judgment), some artists purport to be exploring their relationship to women through violent images. In fact, these images attract attention, are economically profitable, and create a notoriety that has little to do with the work itself.

Even among artists who decry social violence, incorporation of media's influence into their work produces reactions contrary to their intentions. In Chicago recently, Joy Poe staged her own rape in a surprise performance at Artemesia Gallery. Poe stated her purpose was to "change society's complacent attitude toward rape";[6] in fact, she presented another, more immediate, picture of a woman inevitably victimized, reinforcing her audience's feelings of horror and helplessness.

Likewise Darryl Sapien, in *Crime in the Streets* (a performance in San Francisco's tenderloin district), attempted to critique social violence. His graphic images of that violence were far stronger than his solution, a "bridge of human kindness" that stretched across the alley. With both artists, their political analysis, informed perhaps by their own fear, helplessness or outrage, did not extend far enough to avoid recreating these feelings in their audience. In understanding how images of violence reinforce powerlessness, these artists might have concluded their works with a way for the audience to interact positively in creating solutions to the problems presented.

c. *The continued use of popular media images in fine art legitimates their existence outside of social or political criticism.* Helmut Newton is but one of many fashion photographers now recognized as an art figure. As early as 1975, his commercial displays in *Vogue* magazine included shots of a woman wincing in pain as a man bites her ear, a man hitting a woman in the breast, and, most revealing, a women's head being forced into a toilet bowl. Four years later, similar work of Newton's was displayed in a San Francisco art gallery along with that of painter David Hockney. Critic Hal Fischer described his photographs of women as "allowing us to indulge ourselves in their imagery without feeling that we have completely dispensed with our own social consciousness."[7]

In a more revealing statement of the transformations brought about by the designation of fine art, he continues "In magazine form interspersed with fashion imagery, Newton's pictures have seemed one more tedious attempt at shock value. However, in the gallery format, larger and fewer in number, they operate with far more ambiguity and within a framework of eclectic antecedents."[8] Meaning, now that it is *art*, its violence is no longer tedious but ambiguous.

Elevation of such images to "high art" serves the most insidious function of all: the support of values that appear as personal expression but which are actually derived from a programmed reality.

OUTSIDE THE MYTHS: THE ROLE OF ARTIST IN CONTEMPORARY SOCIETY

All images are political in that they portray a set of values and attitudes about how the world is or could be. It is not the content of any single image but rather the sum of these and their constancy which shapes their audience. Whether contending with or agreeing with the flow of media images, the artist in the technological society must be cognizant as never before of the way in which his or her visual product hits its audience.

Trained to analyze the structure and to manipulate the content of imagery, artists are a potentially radical force. We can restructure visual reality. By formulating and sharing information, artists can begin to demystify image-making, helping the mass audience to understand media's impact on their lives and identities. To learn how images are made, even to learn to make them oneself, can be a most powerful affirmation.

Granted, to create images which reflect a reality different than that of our own media-derived consciousness is an arduous task. Alternatives are hard to develop and often not as interesting as those we have been trained to expect. Images of solutions are not likely to be popular among advocates who label art with an informed social consciousness as "propaganda." As we have seen, however, most art carries its propaganda; it is only when the ideas run dramatically counter to accepted reality that they are labeled as such.

We are not suggesting that artists run their images through a political system to come up with acceptable visual representations of a new social order. Rather, we would have members of the profession understand their work is not without social consequences, and that there exists a political value system behind the production of images in the media. We are suggesting, as well, that we regain our ability to think independently within the culture, to question what we read, see, or hear from mass media, and, most importantly, to formulate through our work our own visions of the future.

We think the questions one should ask of art are: Who (how many) will see it, and what will its effect on these viewers be? Does the structure of the work invite dialogue, exchange, and growth from its audience? What images of ourselves and our society does it ultimately support? And finally, what is its vision of the future, and how does it support action in that direction?

In answering these questions, we open the discussion of new roles for artists in our highly technological society. Now artists exist, barely supported, on the fringes of that society. By looking at our relationship to the

audience and the popular culture which that technology creates, artists can formulate a vital and responsible position within society.

NOTES

[1] Increased violence has stimulated sales even within a predominantly female market. Since most women do not question that social symbols are more controlled by one sex than the other, they are subject to the same conditioning as men, with one difference: they see themselves, reflected in the media, as the victims.

[2] Quotes from advertising executives from "Really Socking It to Women," *Time Magazine,* February 7, 1977, p. 14.

[3] Ibid.

[4] Ibid.

[5] Both individual incidents and sociological research demonstrate a direct link between media and actual violence.

A bizarre broomstick rape was shown on television, and shortly afterward a man copied this crime. In another of several examples, a woman was burned in Boston after television had graphically portrayed this crime.

Social scientists have demonstrated the instigative nature of media violence repeatedly over the past few years, seriously questioning the still widely-held catharsis hypothesis developed by psychoanalytic theory. "The implications of these research findings for the impact of television on its viewers is obvious. Given the salience of violence in commercial television . . . there is every reason to believe that this mass medium is playing a significant role in generating and maintaining a high level of violence in American society." Urie and Bronfenbrenner, *Two Worlds of Childhood: U.S. and USSR* (New York: Russell Sage Foundation, 1970), pp. 109–115.

[6] Cindy Lyle, "Chicago Rape Performance," *Women Artists News,* June-Summer 1979.

[7] Darryl Sapien, "Crime in the Streets," High Performance, Vol. 2, No. 2, p. 39.

[8] Hal Fischer, "A Taste of Decadence," *Artweek,* March 10, 1979, p. 11.

Critic Hal Foster examines in detail the appropriations and deconstructions of Barbara Kruger and Jenny Holzer, artists who manipulate signs in order to disorient language and, ultimately, displace ideology. Kruger combines visual material—non-narrative photographs—with aphorisms—texts, often in accusative form—in order to question and open up social stereotypes. Holzer lists "truths" of social discourse in order to cast doubt on what passes for accepted knowledge. Both unmask the ways in which impersonal language can be vehicles for desire and power.

Subversive Signs

Hal Foster

Both Barbara Kruger (37) and Jenny Holzer (32) are of a generation of artists whose images are as likely to derive from the media as from art history, and whose context is as likely to be a street wall as an exhibition space.

A stress on art as information is natural to Kruger: for 11 years she was a designer and photo editor at Condé Nast. In her panels and posters, she takes emblematic images (of objects or people) from old films and photo annuals; these she blows up and crops severely, then poses with short texts of her own. Often Kruger draws on media formats: Her first series of reproduced images alternates photos and texts in four panels, in a way reminiscent of old photo-stories. A second series, often of images of women collaged with words and bars of color, parodies display ads. And her latest series, which combines sensational photos and assaultive captions, plays upon newspaper headlines.

Ironically, Holzer is now known for her anonymous posters of "Truisms" and "Inflammatory Essays," first seen on Lower Manhattan walls in 1977. Printed messages set in black italic type usually on white paper, they seem to offer information, but the "Truisms" are mostly opinions, and the "Essays" mostly demands. Conflicted and cogent by turns, they intend everything and nothing—verbal anarchy in the street.

> *A writer—by which I mean not the possessor of a function or the servant of an art, but the subject of a praxis—must have the persistence of the watcher who stands at the crossroads of all other discourses* (trivialis *is the etymological attribute of the prostitute who waits at the intersection of three roads).*
> ——Roland Barthes

Reprinted from Hal Foster, "Subversive Signs," *Art in America* (November 1982).

The work of Kruger and Holzer is situated at just such a crossing—of languages of the self, of art and of social life. Both artists treat these languages at once as targets and as weapons—and are able to do so because the work of both mixes promiscuously with signs of all sorts. Indeed, Kruger and Holzer are manipulators of signs more than makers of art objects—a shift in practice that renders the viewer an active reader of messages more than a contemplator of the esthetic. This shift is not new, yet it remains strategic—if only because few of us are able to accept the status of art as a social sign entangled with other such signs. This status is the very subject of Kruger's art, this entangling the very operation of Holzer's.[1]

Such concerns relate these artists to many others at work today—Kruger to those who appropriate media imagery, Holzer to those who, like the graffitists, work in the street. But the antecedents of both artists are certain Conceptual artists (Joseph Kosuth, Lawrence Weiner, Douglas Huebler, John Baldessari) and site-specific artists (Daniel Buren, Michael Asher, Dan Graham). Kruger and Holzer inherit the varied critique of the given conditions of art production and reception worked out by these artists—but not uncritically. Holzer: "As far as the systematic exploration of context is concerned at that time [ca. 1977] that point had been made."[2] And made perhaps too definitively: both Kruger and Holzer doubt that an ideology can be reduced to one language, then critiqued—or an institution to one space, then charted. Both, instead, reflect critically on discourses outside the art world. From there, they turn back to address discourses within the art world.[3]

> . . . in writing of speech (on the subject of speech) I am condemned to the following aporia: denounce the imaginary of speech through the irreality of writing.
>
> ——Barthes

In her latest work Barbara Kruger may re-present a photo of a coin minted with two noble heads, with a caption like: "Charisma is the perfume of your gods." Together, the photo and caption convoke two discourses that are usually kept apart: the official rhetoric of the state and the public cult of personality. These discourses call up others: the function of "aura" and "genius," for example, in the art market. Another recent work (shown at Documenta) re-presents a photo of a marble bust of a woman; the caption reads: "Your gaze hits the side of my face." Here, an equation is made between esthetic reflection and the alienation of the gaze: both reify.

Kruger makes a similar equation in her text in the Documenta catalogue[4]—an allegory in which we are led by a sort of antimuse to a place adorned with a "masterly" painting and a "classic" statue. "Through your worshipful response," she tells us, "these objets d'art become much like the insistent sun and safe breezes that caress them: they seem to be nature." Here, esthetic reflection is seen to naturalize art, render it absolute. "(Y)ou

recoil from both our suggestion and our touch," we are told. "You have an investment in their adoration"—an investment that is both libidinal and economic. Finally, this antimuse reveals her own strategy:

> We loiter outside of trade and speech and are obliged to steal language. We are very good mimics. We replicate certain words and pictures and watch them stray from or coincide with your notions of fact and fiction.

This last well describes Kruger's own artistic practice.

It was not always so. Kruger was once a painter (of large, abstract canvases), and a designer at *Mademoiselle* and *Vogue*. In a sense, then, she was trained in the very spheres of high art and media production which she now critically probes. Her critique is not simple sabotage; it is dialectical (or at least double-edged): with images from the mass media she questions the discourses of high art, and vice versa.

Her turn from art "proper" dates from 1975 when she quit painting and temporarily left New York to teach. Provoked by Conceptual art, Kruger had written before; but now, under the influence of film and feminist criticism (as well as Brecht, Benjamin, Barthes . . .), she began to use her texts in her art. In 1978 she published a book called *Picture/Readings* which juxtaposes simple photos of banal California homes with short fictions about what may go on inside. These "readings" are like grim soap operas—true enough, perhaps, but still excessive. Here, the two levels of narrative—the literal photos and the figurative fictions—invest one another, and one becomes aware of the often "perverse" relationship between desire and representation.

By 1978 Kruger had found her mode, one which would draw on her skill as both a manipulator of images and a reader of social signs. In the same year she began a series of 14 four-panel works (each 30 by 96 inches) which alternate photos and texts. From left to right the panels contain: 1) A photographic detail of a stark social space—a hospital room. 2) A "litany" of thoughts, set in small type and photoprinted. 3) A severely cropped reproduction of a melodramatic illustration of the type that used to run with stories in, say, *The Ladies' Home Journal*. And 4) A panel with a caption, a simple command such as "Wait" or "Please Don't." Taken together, the first two panels pose the partial perspective of us all as social subjects. The third panel is open to interpretation—many social meanings are possible. But in the fourth panel, interpretation is suddenly suspended, and we are left to wonder by what authority.

In these works, truth is a mix of personal metaphor and social stereotype. This recalls Nietzsche, for whom "Truths are illusions whose illusionary nature has been forgotten, metaphors that have been used up and have lost their imprint and that now operate as mere metal, no longer as coins."[5]

After 1978 Kruger proceeded to two series in which a photo and a text are collaged in a single image. In the first series, a photo of a stereotype (e.g., the suburban housewife) is stamped with a word (e.g., "deluded") that renders it invalid—takes it out of circulation, in effect. In the second, more subtle series, this same type of photo (e.g., fraternity men at play) is "reminted" with an ambiguous caption; then, its value altered, the image is set back into circulation.

The photos in the first collages are slightly dated; most are taken from annuals that range from the 1920s to the '60s. Kruger blew up these images, cropped and colored them with overlays, then stamped them with one or more words, usually in large red letters. Often this word simply labels that rhetoric of the image as false. One work represents a photo of a woman cropped at the chin and elbows: hands clasped in prayer, she wears a prim wool sweater; below appears the word PERFECT. Is it the stereotype of the devout young woman that is blasted here? Or is it the society which deems such an appearance perfect? In either case, the verbal blast seems too easy (indeed, too perfect). Often in these series, stereotypes are set up only to be condemned—a closure of thought that implies that 1) the artist is somehow free of ideology—a mystification of its own, and that 2) stereotypes, so flatly contradicted, are more absolute than they are.

Kruger is aware of these problems. In a text called " ' Taking ' Pictures" (published in the English film journal *Screen*), she writes that the idea of appropriation, in her and others' work, is to question "the 'original' use and exchange value" of images—to contradict "the surety of our initial readings" and to strain "the appearance of naturalism." But she notes two traps: "(T)he implicit critique within the work might easily be subsumed by the power granted its 'original.' " (This problem menaces the work of many "appropriators.") And: "The negativity of this work, located in its humour, can merely serve to congratulate its viewers on their own contemptuous acuity." ("Demystification" now often serves as correct rather than critical thought.)

In her most recent series of collages, Kruger evades both traps. The photos here are less stereotypical of people, more emblematic of situations, and the address of each work implicates us all. Though still enlarged, then cropped, the photos are now captioned "in the accusative" (in black-and-white type like the New York *Post*'s). In each work, Kruger re-presents an image of control that is then contested (e.g., in one photo one looks down through bars at a dark figure; the caption reads: "You molest from afar"), or an image implicit of an ideology that is then indicated (e.g., across a detail of the Sistine Chapel "Creation" are the words: "You invest in the divinity of the masterpiece"). Again, the captions expose or counter the images; but here, an alternation "from implicit to explicit, from [the] inference [of the photos] to [the] declaration [of the texts]" upsets any closure

of thought. For in this series, neither photo nor text is privileged as truth: what truth there is, is an effect of the dialectical revision of one by the other.

There remains the problem of address. Almost every text poses a You: a Big Brother who rules but is mystified ("Your manias become science" reads the caption of a photo of a nuclear blast): and a ruled I who is *not* mystified. This is problematic, as is the apparent belief that power can be named, located. But Kruger does not in fact imply this: the place of the You and I is unsure. (For example, over a photo of a shadowy man appear the words: "Your comfort is my silence." What comfort, what silence—and *whose?*) In linguistics the pronouns "you" and "I" are known as "shifters": in speech they continually change places and referents.[6] As does power, as, for that matter, does desire. And this is the interest of these works: how they get at the motions of power and desire. For power and desire are not fixed things "out there"; they exist, they hide, in representations. This is why Kruger reworks her images—to see who works through them, and to

BARBARA KRUGER, "Untitled" 1981 Photograph, 40" × 50"
Photograph courtesy Annina Nosei Gallery, New York.

reverse the order of the speaker "I," the subject "you." It is in the language of social images that such power must be contested. Kruger knows this; and so does Jenny Holzer.

> . . . *it is within speech that speech must be fought, led astray—not by the message of which it is the instrument, but by the play of words of which it is the theater.*
>
> ——Barthes

If Kruger is concerned with power and the rhetoric of images, Holzer is concerned with the Babel of social discourses. For Holzer this babble is by no means innocent: in her work language is the site of pure conflict. On the one hand, there is a utopian proposition, "the plurality of desire," and on the other, the social censure that acts via language. To Barthes

> *Language is legislation, speech is its code. . . .To utter a discourse is not, as is too often repeated, to communicate; it is to subjugate. . . .Language—the performance of a language system—is neither reactionary nor progressive; it is quite simply fascist.*[7]

How does Holzer treat this "fascism" of language? If in Kruger address is ambiguous, in Holzer it is anarchic: in her work we see not only how language subjects *us* but also how *we* may disarm it.

This is clearest in her "Truisms," a list of several hundred statements first seen as posters and photostats on Lower Manhattan walls. (Though complete by 1979, they continue to appear: last March single Truisms were seen on the Spectacolor sign above Times Square, and at Documenta a selection of Truisms, translated into German, covered the side of a Kassel house.) As posters, they are set as official information in black italic type (like the *Times*'s headlines). Listed alphabetically, they have no discursive order (indeed, they suggest how the arbitrary lurks beneath the conventional). The first Truism reads: A LITTLE KNOWLEDGE GOES A LONG WAY; the last: YOUR OLDEST FEARS ARE THE WORST ONES. Somewhere in between come:

MORALS ARE FOR LITTLE PEOPLE
MURDER HAS ITS SEXUAL SIDE
MYTHS MAKE REALITY MORE INTELLIGIBLE
NOISE CAN BE HOSTILE
NOTHING UPSETS THE BALANCE OF GOOD AND EVIL
OCCASIONALLY PRINCIPLES ARE MORE VALUABLE THAN PEOPLE
OFTEN YOU SHOULD ACT LIKE YOU ARE SEXLESS

Beliefs and biases, the Truisms are hardly truistic. Rather, "such statements place in contradiction certain ideological structures that are usually kept apart."[8] Contradiction here is both internal and contextual, for the

Truisms contest the bad faith of the ads on the street—and, implicitly, the "false homogeneity" of all signs. Not only do they present truths in conflict, they also imply that under each truth lies a contradiction.

Though "site-specific," the Truisms are oddly atopic: internally, they collide discourses of all sorts (e.g., proverbs and politics). The reader seems to be in the midst of *open* ideological warfare—but oddly, the result is a feeling of release.[9] For coercive languages are usually hidden, at work everywhere and nowhere: when they are exposed, they look ridiculous. And the Truisms do read like a dictionary of such languages, robbed of the "fascist" power to compel.

That all truths are arbitrary, that language is true *and* false, is Truistic (WORDS TEND TO BE INADEQUATE). Is there (only) choice? (A Truism too: REMEMBER YOU ALWAYS HAVE FREEDOM OF CHOICE.) One can say that all truths are subjective and/or equal—but that is the problem, not a solution. Is there no escape from this abyss? Actually, the Truisms as a whole express a simple truth: that truth is created through contradiction. (This truth, that of dialectics, denies its own closure as a truth: this is what makes it true.) Only through contradiction can one construct a self that is not entirely subjected.

Although a militant tone prevails, no one voice speaks in the Truisms. Indeed, each voice, when not menaced by rote speech, is lost in a plurality of public voices, and all the I's are "nothing other than the instance saying 'I' " (Barthes). In the end, then, an encounter with the Truisms is like an encounter with the Sphinx; though one is given answers, not asked questions, initiation into our Theban society is much the same: entanglement in discourse.

Holzer treated this entanglement early on in *Diagrams* (1977), a little book which combines phrases about moods and events with drawings from science books, sociology texts, etc. The mapping of the subjective onto the scientific is often ironic (e.g., under a mess of lines and equations one reads: "Conditions for signalling to one's past"). It is also provocative: for each language questions the adequacy of the other. In the end, "subjectivity" and "scientificity" become relative terms.

Entanglement in discourse is most extreme in Holzer's "Inflammatory Essays" (1979–82). In effect, the Essays heat up and expand upon the Truisms. Set in similar type, they appeared first as small posters, then colored ones, then as a book (*The Black Book*—a pun on the manuals favored by messianic leaders?). The Essays are arguments, not statements: they work within a few types of discourse—ones so militant that leftist and rightist all but meet. In short, the Essays are concerned with the *force* of language rather than its truth value: they exhibit its complicity with power— how one perverts the other.

Again, the voices are provocative. Imperative commands and sub-

junctive desires mix seductively with the impersonal mode of truth. Some voices insinuate, others demand. A few almost convince (of outlandish things: e.g., castration for child molesters?), but finally it is each voice that is convinced, conquered by its own discourse. This closure is of the kind evident in political language, for, as Barthes noted, reality in such language is prejudged, naming and condemning are one. "A history of political modes of writing would therefore be the best of social phenomenologies."[10] Together, the Truisms and Inflammatory Essays evoke such a phenomenology.

In 1980 and '81 Holzer worked with the artist Peter Nadin on the "Living" series, a series that, in the form of signs, plaques and exhibitions, continues to the present. *Eating Through Living*, a book published by Tanam Press, presents the basic vocabulary: 150 or so texts punctuated by four repeated images (three of them by Nadin)—four fingers, schematic heads of a young man and woman, and an arm, hand and hammer all as one form (an emblem of man defined by function?). The images act as empty signs, thoroughly inflected by the language of the texts.

In this series, Holzer works more than before in given art spaces; at the same time, her signs and plaques draw on common discourses more than ever. Indeed, the language of the "Living" series is omnivorous: living, one feels, *is* eating—consuming and being consumed by speech (teen fiction, government rhetoric, etc.). Again, society is a tooth-and-nail struggle, but now Holzer is more playful with language and so, in a way, more subversive.

Here too, there is no one voice, and the meanings of the self are debunked. Emotion may be confused with a faulty tear duct:

> MORE THAN ONCE I'VE WAKENED
> WITH TEARS RUNNING DOWN MY
> CHEEKS. I HAVE HAD TO THINK
> WHETHER I WAS CRYING OR
> WHETHER IT WAS INVOLUNTARY
> LIKE DROOLING.

A Skinnerian psychology that is cast—hilariously—as social policy:

> EXERCISE BREAKS AT STRATEGIC
> POINTS DURING THE DAY EN-
> HANCE PRODUCTIVITY AND PRO-
> VIDE SIMULTANEOUS SENSATIONS
> OF RELIEF AND JUVENATION.

A stereotypical discourse that is its own parody:

ONCE YOU KNOW HOW TO DO
SOMETHING YOU'RE PRONE TO
TRY IT AGAIN. AN UNHAPPY EX-
AMPLE IS COMPULSIVE MURDER.
THIS IS NOT TO BE CONFUSED
WITH USEFUL SKILLS ACQUIRED
THROUGH YEARS OF HARD WORK.

In each text the speaker distorts or is distorted by this "official-ese"—which is really our social discourse of efficacy and etiquette. In "Living" more than in the Truisms or Essays, Holzer meets the repression therein with subterfuge—with wit and play. That is, she leads language astray.

She most beguiles officialdom in her metal signs and cast-bronze plaques (adapted from "Living" texts). A sign is usually a directive (a prohibition, say, or an enticement), or the site of simple information. The plaque is *the* form of administrative truth: it commemorates a place, celebrates a man, and thereby exalts a piece of property or a proper name as the very presence of history. Holzer's signs and plaques foil this marking. Rather than present a public place, they may pose a subversively private one:

THE MOUTH IS INTERESTING BE-
CAUSE IT IS ONE OF THOSE PLACES
WHERE THE DRY OUTSIDE MOVES
TOWARD THE SLIPPERY INSIDE.

Or, rather than announce "George Washington Slept Here," they may offer you this:

IT TAKES A WHILE BEFORE YOU
CAN STEP OVER INERT BODIES
AND GO AHEAD WITH WHAT YOU
WERE WANTING TO DO.

They may even contest the very idea of private space:

I NEED MORE FREEDOM. THEN
YOU SHOULD LEAVE. BUT THIS
PLACE IS AS MUCH MINE AS
YOURS.

Generally, the signs and plaques traduce official language, which, like an old male chauvinist in the hands of a supple feminist, undoes itself.

The work of both Jenny Holzer and Barbara Kruger displaces lan-

guage, disorients the law. This is what ideology in general cannot afford, for it tends to work through language that denies its own status as such: stereotypical language. Holzer and Kruger question stereotypes in work that, though it does not conform to political art conventions, is acutely critical, i.e., political. For "setting the stereotype at a distance is not a political task, inasmuch as political language is itself made up of stereotypes, but a critical task, one, that is, which aims to call language into crisis."[11]

NOTES

[1] This promiscuity of signs was the subject of "Pictures and Promises," a show curated by Kruger at The Kitchen in January 1981, in which ads, logos and art works were placed together and the separate status of each cast in doubt.

[2] Quoted in Rex Reason, "Democratism," *Real Life* No. 8, Spring/Summer 1982.

[3] For more on the relationship between these artists, see Benjamin Buchloh, "Allegorical Procedures: Appropriation and Montage in Contemporary Art," *Artforum*, September 1982, pp. 43–56.

[4] This text was written, in part, as a parodic counter to the letter sent to Documenta artists by its "artistic director," Rudi Fuchs.

[5] Friedrich Nietzsche, *On Truth and Lie in an Extramoral Sense*, quoted in Paul de Man, *Allegories of Reading*, New Haven, 1979, p. 111.

[6] For a discussion of the shifter and of the index in relation to recent art, see Rosalind Krauss, "Notes on the Index: Seventies Art in America," *October* 3 and 4, Summer and Fall 1977. As regards the relation of power and speech, see this note of Jean Baudrillard's: " 'Circular' discourse is to be taken literally: that is to say that it no longer passes from one point to another but that it describes a circle which *indistinctly* encompasses the positions of transmitter and receiver, now unlocatable as such. Thus there is no longer any instance of power, any transmitting instance—power is something that circulates and whose source is no longer marked, a cycle in which the positions of dominator and dominated interchange in an endless reversion that is also the end of power in its classical definition." *Simulacres et Simulation*, Paris, Edition Galilée, 1981, p. 52.

[7] Roland Barthes, "Lecture in Inauguration of the Chair of Literary Semiology, College de France," *October* 8, Spring 1979, trans. Richard Howard, p. 5.

[8] Dan Graham, "Signs," *Artforum*, April 1981, p. 39.

[9] Not for everyone. An installation of Truisms at a Marine Midland Bank office at 140 Broadway in Lower Manhattan was cancelled last February after one week. Apparently, the Truism, IT'S NOT GOOD TO OPERATE ON CREDIT, disagreed with bank officials.

[10] Roland Barthes, *Writing Degree Zero*, New York, 1978, p. 25.

[11] Roland Barthes, "Writers, Intellectuals, Teachers," *Image-Music-Text*, New York, 1979, p. 199.

In his influential work and writing, artist Daniel Buren has directed attention to the institutional framework within which artworks are displayed—a framework obscured by modernism's emphasis on the self-sufficiency of the artwork. The museum preserves art, reinforcing the idea of the masterpiece; the museum collects work, thereby making an economically motivated distinction between work which is and is not successful. The museum also serves as a refuge, isolating work and placing it in an idealistic and illusory removal from actual political and economic conditions.

Function of the Museum

Daniel Buren

Privileged place with a triple role:

1. *Aesthetic.* The Museum is the frame and effective support upon which the work is inscribed/composed. It is at once the centre in which the action takes place and the single (topographical and cultural) viewpoint for the work.

2. *Economic.* The Museum gives a sales value to what it exhibits, has privileged/selected. By preserving or extracting it from the commonplace, the Museum promotes the work socially, thereby assuring its exposure and consumption.

3. *Mystical.* The Museum/Gallery instantly promotes to "Art" status what it exhibits with conviction, i.e. habit, thus diverting in advance any attempt to question the foundations of art without taking into consideration the place from which the question is put. The Museum (the Gallery) constitutes the mystical body of Art.

It is clear that the above three points are only there to give a general idea of the Museum's role. It must be understood that these roles differ in intensity depending on the Museums (Galleries) considered, for sociopolitical reasons (relating to art or more generally to the system).[1]

I. PRESERVATION

One of the initial (technical) functions of the Museum (or Gallery) is preservation. (Here a distinction can be made between the Museum and

This statement is an extract from a text written in October, 1970. It was to be the third part—"Le Donne"—of the text "Position—Proposition" published by the Museum of Mönchen-Gladbach in January 1971, the two others being "Standpoints" and "Critical Limits." This was first published by the Museum of Modern Art, Oxford, England for Buren's show, March 31–April 15, 1973. Reprinted by permission of the author.

the Gallery although the distinction seems to be becoming less clear-cut: the former generally buys, preserves, collects, in order to exhibit; the latter does the same in view of resale.) This function of preservation perpetuates the idealistic nature of all art since it claims that art is (could be) eternal. This idea, among others, dominated the 19th century, when public museums were created approximately as they are still known today.

Painted things are generally attitudes, gestures, memories, copies, imitations, transpositions, dreams, symbols . . . set/fixed on the canvas arbitrarily for an indefinite period of time. To emphasize this illusion of eternity or timelessness, one has to preserve the work itself (physically fragile: canvas, stretcher, pigments etc.) from wear. The Museum was designed to assume this task, and by appropriate artificial means to preserve the work, as much as possible, from the effects of time—work which would otherwise perish far more rapidly. It was/is a way—another—of obviating the temporality/fragility of a work of art by artificially keeping it "alive," thereby granting it an appearance of immortality which serves remarkably well the discourse which the prevalent bourgeois ideology attaches to it. This takes place, it should be added, with the author's, i.e., the artist's delighted approval.

Moreover, this conservatory function of the Museum, which reached its highest point during the 19th century and with Romanticism, is still generally accepted today, adding yet another paralysing factor. In fact nothing is more readily preserved than a work of art. And this is why 20th century art is still so dependent on 19th century art since it has accepted, without a break, its system, its mechanisms and its function (including Cézanne and Duchamp) without revealing one of its main alibis, and furthermore accepting the exhibition framework as self-evident. We can once again declare that the Museum makes its "mark," imposes its "frame" (physical and moral) on everything that is exhibited in it, in a deep and indelible way. It does this all the more easily since *everything that the Museum shows is only considered and produced in view of being set in it.*

Every work of art already bears, implicitly or not, the trace of a gesture, an image, a portrait, a period, a history, an idea . . . and is subsequently preserved (as a souvenir) by the Museum.

II. COLLECTION

The Museum not only preserves and therefore perpetuates, but also collects. The aesthetic role of the Museum is thus enhanced since it becomes the single viewpoint (cultural and visual) from which works can be considered, an enclosure where art is born and buried, crushed by the very frame which presents and constitutes it. Indeed, collecting makes simplifications possible and guarantees historical and psychological weight which reinforces the predominance of the support (Museum/Gallery) inasmuch as the latter is ignored. In fact, the Museum/Gallery has a history, a volume,

a physical presence, a cultural weight quite as important as the support on which one paints, draws. (By extension, this naturally applies to any sculpted material, transported object or discourse inscribed in the Museum.) On another level, let us say social, collecting services to display different works together, often very unalike, from different artists. This results in creating or opposing different "schools"/"movements" thereby cancelling certain interesting questions lost in an exaggerated mass of answers. The collection can also be used to show a single artist's work, thus producing a "flattening" effect to which the work aspired anyway, having been exclusively conceived—willingly or not—in view of the final collection.

In summary, the collection in a Museum operates in two different but parallel ways, depending on whether one considers a group or a one-man show.[2]

A) In the case of a confrontation of works by different artists the Museum imposes an amalgam of unrelated things among which chosen works are emphasized. These chosen works are given an impact which is only due to their context—collection. Let it be clear that the collection we are speaking of and the selection it leads to are obviously economically motivated. The Museum collects the better to isolate. But this distinction is false as the collection forces into comparison things that are often incomparable, consequently producing a discourse which is warped from the start, and to which no one pays attention (cf. "Beware!" Introduction).

B) In collecting and presenting the work of a single artist (one-man show) the Museum stresses differences within a single body of work and insists (economically) on (presumed) successful works and (presumed) failures. As a result, such shows set off the "miraculous" aspect of "successful" works. And the latter therefore also give a better sales value to juxtaposed weaker works. This is the "flattening" effect we mentioned above, the aim of which is both cultural and commercial.

III. REFUGE

The above considerations quite naturally lead to the idea, close to the truth, that the Museum acts as a refuge. And that without this refuge, no work can "exist." The Museum is an asylum. The work set in it is sheltered from the weather and all sorts of dangers, and most of all protected from any kind of questioning. The Museum selects, collects and protects. All works of art are made in order to be selected, collected and protected (*among other things from other works which are, for whatever reasons, excluded from the Museum*). If the work takes shelter in the Museum-refuge, it is because it finds there its comfort and its frame; a frame which one considers as natural, while it is merely historical. That is to say, a frame necessary to the works set in it (necessary to their very existence). This frame does not seem to worry artists who exhibit continually without ever considering the problem of the place in which they exhibit.

Whether the place in which the work is shown imprints and marks this work, whatever it may be, or whether the work itself is directly—consciously or not—produced for the Museum, any work presented in that framework, if it does not explicitly examine the influence of the framework upon itself, falls into the illusion of self-sufficiency—or idealism. This idealism (which could be compared to Art for Art's sake) shelters and prevents any kind of break.[3]

. . . .In fact every work of art inevitably possesses one or several extremely precise frames. The work is always limited in time as well as in space. By forgetting (purposefully) these essential facts one can pretend that there exists an immortal art, an eternal work. . . . And one can see how this concept and the mechanisms used to produce it—among other things the function of the Museum as we have very rapidly examined it— place the work of art once and for all above all classes and ideologies. The same idealism also points to the eternal and apolitical Man which the prevalent bourgeois ideology would like us to believe in and preserve.

The non-visibility or (deliberate) non-indication/revelation of the various supports of any work (the work's stretcher, the work's location, the work's frame, the work's stand, the work's price, the work's verso or back etc. . . .) are therefore neither fortuitous nor accidental as one would like us to think.

What we have here is a careful camouflage undertaken by the prevalent bourgeois ideology, assisted by the artists themselves. A camouflage which has until now made it possible to transform "the reality of the world into an image of the world, and History into Nature."

NOTES

[1] It must be quite clear that when we speak of "the Museum" we are also referring to all types of "galleries" in existence and all other places which claim to be cultural centres. A certain distinction between "museum" and "gallery" will be made below. However the impossibility of escaping the concept of cultural location must also be stressed.

[2] We are here referring more particularly to contemporary art and its profusion of exhibitions.

[3] A detailed demonstration of the various limits and frames which generally constitute a work of art—painting, sculpture, object, ready-made, concept . . .—has been removed for technical reasons from the original text. However this subject matter can be found in other texts already published, such as: "Critical Limits," Paris, October 1970; "Around and about," *Studio International*, June, 1971; "Beware," *Studio International*, March, 1970; "Standpoints," *Studio International*, April, 1971; "Exposition d' une exposition," *Documenta V catalogue*.

Philosopher David Carrier analyzes the economic conditions surrounding art-making, its distribution, and criticism. He takes painting as his example, viewing it as a system of pre-industrial production for private consumers. Despite the idealized vision of artists as unalienated workers, Carrier views artists as conditioned by the art market and facing very tangible economic constraints which art dealers must face as well. Art criticism creates aesthetic value by persuading people that work is good; if enough people are persuaded, then the work *is* good. Carrier's pragmatic theory of truth complements his pragmatic analysis of the art market as it now exists.

Art and Its Market

David Carrier

for JM

Most contemporary art critics who have any political interests are sympathetic to Marxism; so much criticism is involved in discussions of the ways in which artists' imagery or technique may be "progressive" or "reactionary." Paintings are said in some way to express the spirit of our times, and the critic seeks to determine what in fact a painting does express. A real Marxist criticism would, I think, approach art in a different way, and leaving aside the political issues I here offer such an account. Artworks are commodities in our culture, high-priced things for sale in the galleries; and we need to understand how these objects are made by artists, merchandised by critics, and purchased by collectors. How does this art market function, and how does the structure of that market influence our thoughts about art itself? I consider first the role of the artist, then that of the art dealer, and finally the position in this market system of those who write about art.

I

The problems of making art are, first, questions about the system of production in the most literal sense, about the work of the artist in his loft. Artmaking is an old-fashioned kind of manufacturing, one which the world of mass production, of the subdivision of labor in the factory, has hardly touched. In Hogarth's England everything was made in small shops, the individual craftsman making, essentially, the entire object. Of course what the industrial revolution meant was that commodities were made in more

Written for this volume, printed with permission of the author.

efficient ways. That making paintings has in this way remained traditional is what makes it both attractive and in many ways a problematic activity. Artists see themselves as unalienated workers, who choose to do what they will, how they wish; they control the making of their work like, for Marxists, all workers will in the ideal, unalienated society of the future. The problem with a system of handmade production is that it is terribly inefficient. Automobiles or furniture could not practically be made in this way.

Because paintings are made in this pre-industrial fashion, producing them is expensive. For artists to pay for supplies, and the costs of a small factory space (their lofts), each painting must cost more than most people interested in art can afford to pay. Here are very rough calculations: An artist would do well to have a one-person show every year, and a show with ten paintings would be large. To sell all ten paintings would be exceptional. Assume that this artist sells an equal number of works elsewhere, through friends or in group shows. For works sold in galleries the artist will receive about half the dealer's price. So we are imagining a highly successful and productive artist effectively selling ten to fifteen paintings a year. If these sales are to pay for materials and the cost of a working space, which today in Manhattan is a few tens of thousands of dollars a year, then we can see that each painting will have to cost a few thousand dollars to manufacture. And the price at the dealer will be double that. Here we have not yet imagined the artist making any profit. Such income is not, as in an indus-trialized workshop, money going to the stockholders; it is, simply, money needed to pay for the artist's food, museum visits and art catalogues.

This calculation may be in some ways too optimistic, in others too pessimistic. It assumes that the artist sells more than most artists in New York now showing at good galleries sell. Of course, Kelly or Johns sell as much as they choose to produce, and at much higher prices than I have here imagined. But once we consider artworks selling for more than a hundred thousand dollars we really are talking about blue-chip invest-ments; even people who like these works a lot buy them, I would think, rather in the spirit in which they purchase stocks or houses. And there are only a handful of such artists among the tens of thousands in New York. My calculation may be pessimistic in that an artist painting relatively small works might work in a cheaper space and produce more art in a year. Furthermore, choosing to be in Manhattan is itself a problem; an equivalent space in Pittsburgh would be very much cheaper. Finally, I imagine the artist living from the sale of work, and relatively few artists can do that.

But smaller works are not necessarily easier to sell than large ones; and all things being equal, selling one twelve thousand dollar painting is perhaps easier than selling four at three thousand each. Whether living outside Manhattan is a viable option for an artist seeking commercial success is unclear. New York is the center of the market, not only because so many galleries are there but also because only showing in New York establishes

a reputation which makes possible shows elsewhere. There may be a market for serious art in Pittsburgh, but showing there won't get you known elsewhere. Even were great work shown in Pittsburgh, few people would know about it, and if work doesn't get talked about, written about, and looked at in New York it's unlikely to have a very wide impact. A reputation is established not just by having a show but, before that, by having dealers, critics and collectors be able to see and talk about your work. And since such people are concentrated in Manhattan, and go there to look for art, being there is important for establishing a position. Finally, although teaching provides an artist with a stable income, it takes lots of time and energy; and so the time left for the artist's own work is correspondingly reduced. I don't know of any very successful artists who continue to teach when they can live from sales of their work.

Treating teaching about painting as a branch of higher education raises some interesting issues. Some branches of the university justify themselves by preparing students for the job market; other departments are valued because they teach skills which we think every educated person should know. Electrical engineering teaches a marketable skill, and these engineers should know something about philosophy. But where does painting stand within the university? Is painting a kind of skill taught to prepare students to be professional painters? Alternatively, is doing painting something which every cultured person should know something about? Clearly we think of painting in the first way. Non-painters are not normally expected to learn about painting; and painters learn their craft as if they were preparing for careers as artists. In principle this is fine. Making art is a serious and often all-absorbing activity, and so deserves to be studied in this way. But the difficulty in practice is that very many students are being prepared for an almost nonexistent occupation. They are learning a skill which cannot provide them with a reasonable chance of earning a living. And then we move in a kind of circle. The artist's profession is very difficult, so many artists support themselves by teaching; in teaching, they produce more artists who will, in their turn, face the same problem. My aim is not to moralize about this situation, but to describe it. Compare painting with a purely academic field like philosophy. Because teaching philosophy is thought valuable, there are some few jobs for philosophers. Furthermore, philosophers justify themselves by doing research, which we think is a good thing. Philosophers produce no commodities, and so can survive only by such support. Painting, by contrast, is an activity which would survive even if it had no place at all in the university. Perhaps there is nothing tragic in this situation, since art students inevitably find that they cannot support themselves as artists; meanwhile, they have at least chosen to study what interests them. Perhaps, however, if they understood the art market better, fewer students would choose such a career. Given its tangential relation to the art market, being in the university is in itself not likely to give students such an understanding.

II

Faced with these difficulties, it is perhaps natural for artists to feel critical of art dealers. The artist, they think, is the creative personality, the dealer merely the salesperson; artists make, and dealers just manipulate the market. An authentic style, Richard Wollheim says, is not formed on the time-scale "of the avant-garde dealer or his clients greedy for profit or power."[1] Certainly there is no reason to celebrate the clear enough links between art marketing and economic power. Artworks often are status symbols, valued because they are very expensive and hard to get. Mere money isn't enough to get a work by one of our superstars; to purchase one, you must be a desirable collector, one with status. But a way to understand this situation is to ask what alternatives are available.

Dealers provide a selection mechanism, a way of conveniently letting us see work which perhaps is good. Like any such mechanism, this one has costs which must ultimately be absorbed by the consumer. Someone might visit artists in their lofts to look for work, trying to keep one step ahead of the dealers. Were art thus sold without middlemen, it would be both cheaper and harder to find. To look at art only in galleries is to trust the dealer's taste. But there is much competition between dealers, and if Castelli has great power now, that is because in the past his judgments have often been thought good. So, from the viewpoint of the public or the collector, what's valuable about such dealers is that they make it easier to find what often is very good art. But dealers too must support themselves, and *as the art world is now arranged* the dealer's costs are high. If we balance rent, publicity and insurance costs against the profits from selling work in one show per month, then it is clear that individual works must be relatively expensive. A few thousand dollars seems a low figure. Here, as in my discussion of artists' costs, the estimates may be either too optimistic or too pessimistic. Even the best dealers are unlikely to sell out every show. Were dealers located in lower rent districts than mid-Manhattan or Soho, prices would be lower. But then it would be correspondingly more difficult to see easily the range of contemporary art. If dealers did not advertise in journals, their costs would also be reduced. But without those advertisements, art journals could not exist in their present form.

The gallery has become a small-scale, dispersed salon. Instead of seeing everything for sale under one roof, we must go to a number of smaller spaces. Such a display system has both advantages and disadvantages. Power is concentrated in the hands of a few influential dealers who, because they are powerful, continue to attract the best artists. This system gives power to the curators who select the works. As long as there are more artists than can be displayed, there will always be debates about how to select. What the market guarantees, at least, is that there is an economic rationale to that selection. An artist's works are valued if there is a market for them,

and dealers become important if they can create and sustain such a market. In practice, probably the showing of not-yet-established artists in good galleries is either a gamble on the dealer's part—an expectation that these people might become better known—or a kind of pleasurable hobby, the small sales from such new figures being supported by higher-paying sales of better-known work. Certainly art dealers would be happy to find more markets for contemporary art. But obviously dealers alone cannot create such a market, and it is absurd to blame them for working within a larger system which they have not created.

My account may seem so far insufficiently radical. I assume that the art market is a market of private consumers, and so these problems arise just because few potentially interested people can afford art. An obvious alternative is some system of public or corporate patronage. Whether that will solve the problems of the contemporary artist is unclear. Someone or some group will have to determine which artists to employ, and these critics will have a power like that now exerted by private collectors. In one way, the situation of such experts will be different. Today, a painting by Clemente is valuable because some very rich people desire it, and what others think about that choice is, all things being equal, a matter of indifference. (Of course, all things may not be equal once we consider how the art market is linked with gifts to museums, and to tax write-offs promoted by foundations.) But when we consider public patronage, expenditures on art need justification. This will be difficult, for the public is not sympathetic to contemporary art. This was not a problem at earlier times; the people who paid for Borromini's work didn't care what the masses thought about this great art. But today, if we take the notion of public art seriously, we must consider the tastes of the general public.

Perhaps if public consciousness were raised, more people would care for serious art. I have noted how art prices have a certain logic; how they are constrained by the artist's manufacturing costs and the dealer's costs of exhibiting. Nothing in this situation is inevitable, and the word "logic" does not mean that there are no other possibilities. The result is that artworks are financially out of reach for most people. But this need not be so. Did most people want art, perhaps we would find some way of manufacturing it that was more efficient. In our society, commodities which are desired by the majority of the population are efficiently produced.

There are two ways of thinking about such commodities. Maybe what we desire is mostly determined by false consciousness, by how advertisers convince us to buy all kinds of rubbish which, in the ideal society of the future, people will see to be rubbish. Then people will be amazed that once there was a demand for video games, pornographic movies, and the music of Blondie. Nobody really needs designer jeans, and if people think they need such things it is only because they have failed to grasp their real needs. But how are such authentic needs to be determined? I don't care much

for popular culture but that is because I have a place in the art world. The claim that in an unalienated society most people would prefer Marden to LeRoy Neiman just asserts that our tastes are superior. How to justify that assertion is far from clear. Designer jeans are sold by advertising, because people are persuaded that tight, expensive trousers are better than cheaper, more comfortable ones. But art-world people too are persuaded, perhaps by more subtle means. We read art criticism. Imagining a world in which tastes in clothing or painting are not determined by some kind of advertising is difficult. Were there such a world, then we could find what kinds of clothing and art people genuinely prefer; we could find what is genuine in human nature, before we are corrupted by advertising. I suggest that such a view of human nature is very implausible. For tastes are always a cultural product, and so imagining a taste uncorrupted by society is impossible. Since it is usually conservatives who believe in such a fixed human nature, it would be highly ironical for leftists to criticize the art market by claiming that such an ideal will emerge someday in the future.

III

We thus come to the third part of the art world: art writing. Like all commodities, artworks must be not only made and sold, but also advertised; and the critic's role in the present art world system is to promote artworks, to persuade people to buy them.

In the more stable art world of the past, where stylistic changes were relatively slow and prices for contemporary work relatively low, it was possible to think of critics as acute observers of the works, people whose judgments were valued because they were good at pointing out the features of excellent work. Eighteenth-century connoisseurs could debate the relative merits of Michelangelo and Raphael, and whether Rubens was as great as Poussin. Because tastes in that world were relatively stable it was natural to think that aesthetic judgments were determined by human nature, or even by reason itself. There was some broad agreement in judgments—nobody was urging the merits of Giotto, or of Islamic art—and the standards didn't change too quickly, Reynolds' late-18th-century viewpoint not differing that much from Vasari's mid-16th-century analysis. Now, when we believe in the greatness of Giotto, Raphael and Pollock, and, soon, Johns as well, we start to see how taste is a social creation, a product of the activity of successive generations of critics. "Jasper Johns is a great painter" is true, I am suggesting, because today most art-world people think he is great. To ask, "but is he really that good?" is to pose a meaningless question. This does not mean that future tastes could not be different. Perhaps then he will stand to our great artists as for us Gerome stands to Manet, such a now-unimaginable change showing merely that tastes can

change as much in the next century as they have in the last.

How does art advertising function? Consider first the physical forms of art writing. In the journals there are three kinds of materials: purchased advertising; short reviews; and the longer articles. So, *Artforum* prints the reviews in small type after the articles, and *Arts Magazine* segregates reviews from the main body of articles with an interposed section of advertising. Five journals circulate widely, and with only a dozen or two reviews in each journal, even a critical review provides some visibility for an artist. The number of longer articles is very limited, and not all are about contemporary figures; so being the subject of such an article already implies that an artist is a serious figure. Finally, the ultimate achievement is a retrospective with accompanying catalogue. The text discusses the artist's career, offers a theory of the work, and notes the artist's influence. Compared with journal articles, catalogues may achieve limited circulation; they become widely known and are reprinted only when, as was the case with Michael Fried's great *Three American Painters*, the text itself becomes widely discussed. But what such a catalogue implies is that an artist's work deserves such a permanent record.

In some ways these forms of art writing are new. Greenberg's accounts of Pollock's career published in the 1940's in *The Nation* were brief and not illustrated; unlike criticism now, his had no footnoted references. These accounts could not have meant much to people who had not already seen Pollock's art, while today everyone knows what the new art looks like, and students who never visit New York can produce New York-style art. Today a few journals are influential because they carry advertising and so can afford color reproductions and can pay their contributors (though very modestly). Even feature articles in these journals don't often produce much commercial success; but what must frustrate many artists is that their work does not achieve even that minimal visibility produced by reviews. Still, the effects of more art reviewing, or of more journals, are hard to predict. If the actual size of the art market is fixed, the result might be like grade inflation in the academic world, where a "C" once was respectable and now is below average. Alternatively, the art market might become larger, or the art-world hierarchy—with a few superstars, some artists with modest commercial success, and many unknown artists—might change.

Our conception of the art world as such a hierarchy is in part a natural product of our contemporary theories of art. I want to mention the three most prominent accounts without here disputing their truth or falsity. Let us think of these as marketing strategies, as ways of advertising art.

Art as a form of personal expression. Student works amalgamate different influences—Bacon's figures in Pearlstein's poses, or Dine's hearts with Schnabel's plates—while mature artists' works are distinctive, a genuine Warhol, early or recent, being marketable as self-evidently his work. Com-

mercial success thus requires that artists both change their style and make their works identifiably their own, just as the new Mercedes models both look new and relate to their earlier models.

Art as a kind of social expression. Artists in their studios are a highly sensitive barometer; for example, Pollock's turn towards abstraction reflected the cold war, and some figurative painting shows our collective sexual and political anxieties. Art is significant because it explains our society, condensing into one image observations which a sociologist would take pages to explain. As the recent retrospective illustrated, even Morandi can be treated in this fashion. Some writers saw in his arranged bottles resistance to fascism, while others criticized him for failing to be a more political artist.

Art as a form of problem solving. Lichtenstein's distanced images answer the dilemma posed by too much abstract expressionism. There is a logic to art history, and the significant new figures are those who see how that history can be taken further. Of course, what problems a work thus solves depends upon how we view art history; if Cubism leads towards a modernist flattened picture space, early Chagall and Balthus lead in other directions, and a skillful critic might point to contemporary works which solve the problems they pose.

These three approaches have interestingly different implications for the art market. The number of possible individual styles, or ways we think of the problems posed by earlier art, are probably relatively few. So theories of personal expression imply that there can be only a few interesting artists today, and all the others are doomed as mere imitators. Art as social expression allows for more artists, but excludes from consideration artists expressing the wrong feelings. A Schnabel-imitator's art on that account is more interesting than the unanxious works of Thomas Nozkowski. Some activities are valued even when not performed superbly well, and we need many cooks, French teachers and plumbers, even though few of them are virtuosos. The tendency of art theory is to imply that only the highest achievements are worthwhile, and good imitations of great work have, therefore, little value. So, to envy artists because they are unalienated workers is not really to take account of the art market, it being one thing to work freely in the studio and quite another to sell the products of that labor. Except for famous, crazy, or exceptionally independent figures, everyone is aware of what succeeds in that market. For example, some artists previously known for "good" painting introduce garish color and leaping Germanic nudes into their grids and tasteful color fields. Everyone's awareness of what is possible is colored by seeing what other artists are making and selling. In that situation, the possibilities of individual expression themselves are a social creation, and art as social expression becomes expression of widely accepted values.

The critic uses these theories to persuade us of an artist's importance.

A cynic might take that to mean that critics persuade us to value things not really valuable. What we want to know, the cynic might say, is the truth about the work, not what the critic persuades us to believe. I am arguing that this is an impossible demand. For if aesthetic judgments are just statements of art-world consensus, then asking whether they are really true is meaningless. A successful critic is one who convinces us to accept his or her claims. Initially, such a critic's statements are less true statements about the art-work than arguments for how we ought to see the work. Here a general contrast between knowledge and action is relevant. When we know, we know how the world is; when we act, we change the world to suit us. The list "bananas, coffee, muffins" may describe what is *in* my kitchen or it may remind me of what I *intend* to put in my kitchen. Art criticism is better treated as a form of action than as a description of what we already know. The critic's rhetoric is a way of inducing beliefs in art-world people, and when critics succeed, most people come to believe their claims, which therefore are true. This account may seem outrageous to those who believe that critics merely draw attention to significant features of artworks. But an important and very influential essay like Leo Steinberg's account of Jasper Johns's early work would not make the works it describes seem significant merely by describing them. Steinberg persuades us that the features of Johns's art he describes make that art important.[2]

We can respond to such rhetoric in two ways. We may just be moved by the rhetoric, and we can seek to critically understand how it does move us. Sometimes knowing how rhetoric functions undermines its effect, as when we realize how advertisements for expensive clothing make the glamour of those garments rub off on their wearers. In other cases the relation between the beliefs produced by visual rhetoric and how we think of those beliefs is more complex. Pornographic images may play with assumptions thought sexist by a viewer who is, still, aroused by what is seen. By contrast, Bernini's masterpiece *The Ecstasy of St. Teresa* uses visual rhetoric to produce beliefs which for the believer are true. Just as one task for the art historian is to help us understand how such visual rhetoric "works," so now one goal of a theory of art criticism is to grasp the structure of the rhetoric employed in writing about contemporary art.

That criticism today has this openly rhetorical structure tells us something about the works it describes. We understand traditional visual artworks in part by studying their use of visual metaphors. Such works do not just assert facts, the philosopher Arthur Danto has argued at length, but present them "in a way intended to transform the way in which an audience receives those facts."[3] This rhetoric is embedded in the work itself, as when a baroque altar makes us revere the saint it represents, or when the mirror reflection in Manet's *Bar aux Folies-Bergères* draws us into the erotic drama of that image. The critic describing these works wants us to see them properly, and to be moved by their rhetoric as the artists intended.

202 Art and Its Market

That rhetoric may be obscured by time, if Bernini's sculpture seems merely erotic, or lost by a spectator's misunderstanding, if we think that the apparent spatial inconsistencies in the Manet are just due to ineptness. But in describing much contemporary art the critic is not just explaining how the work uses such rhetoric. Brice Marden has painted an *Annunciation Series*, but seeing his weighty canvases as being "about" stages in the Annunciation is different from seeing those stages depicted by Fra Angelico. A historian of Renaissance art teaches us to read the Virgin's gestures; but though Marden too is interested in incarnation, his literal use of color relates to that doctrine in a very different way. Now we need a theory of abstract painting even to understand what the paintings have to do with an Annunciation.[4]

The claim that abstract painting is therefore essentially a literary art, one dependent for its meaning on the texts which accompany it, is familiar. Works like Marden's are artworks only when we relate them to texts, the work of art being not just what Marden makes but that object plus the writing surrounding it. What I am adding is a point about how that art writing is essentially rhetorical. The rhetoric is now not so much in the work, requiring writing just to point it out, as, rather, what criticism imposes on the work. What transforms the way the audience receives the work is how the critic talks about it. This change in the nature of artistic rhetoric is important. Michelangelo could "with the terrible power of his art," Vasari says, "move the hearts not only of those who [had knowledge of painting]. . .but even those who had none."[5] The Renaissance viewer was moved by seeing the work. Nowadays, responding to the rhetoric of a work requires explicit awareness of some art theory. So, the artwork is more esoteric, and the critic's role different. Everyone in the art world thinks that Noland is, or was, important; but only the academically minded can repeat the marvellously complex details of Fried's account of deductive structure, that rhetoric which helped to establish Noland's importance. Of course art writing has always had its technical side, and few of Piero's contemporaries knew about the mathematics of perspective. They didn't need to know those details to see in his work the illusionistic deep space. By contrast, someone who doesn't know or accept Fried's theory may see the Noland as just a pretty decoration.

Today, interpretation of a work involves a three-way collaboration between the artist who makes it, the critic who describes it, and the audience who by accepting the critic's description makes it true. For aesthetic judgments directly imply economic judgments. To persuade us that a work is good, and so convince the art world that it is valuable, are two descriptions of one and the same action. The work is valuable because it is thought to be good.

Some accounts of rhetoric in art writing imply that the works praised by critics are not really good; Stella perhaps is not good, though we have been falsely persuaded that he is good. Such an account suggests that we can talk about artistic value independent of social agreement, as if the real value of the work could be known independently of what people thought about that work. Once we see that tastes are a social product, we can understand why that kind of skepticism about artistic value is mistaken. This certainly is not to imply that anything goes. Indeed, insofar as I myself try to change the judgments of others, by championing artists who are not yet well known, I am acknowledging that tastes are socially created. Sean Scully is better than the new-wave painters, I might say; and I then would offer an argument showing why you should believe that claim.

Understanding criticism in this way may help us grasp its recent history. Just as in art itself, in criticism we have had a succession of very different approaches, the establishment of one account itself being sufficient reason for it soon to be rejected. In painting such changes may pose no problems, since admiring Johns does not necessarily mean that I cannot also appreciate Rothko, and liking both of them is compatible with appreciating Balthus. But criticism aims to be truthful and so, to put it crudely, if Fried is correct, then Rosalind Krauss cannot be right, and if Joseph Masheck has the correct analysis then both of them, it would seem, must be mistaken. Balthus's paintings do not contradict Rothko's in the way that the claims of one theory of art critique those of another account. But once we adopt a pragmatic theory of truth, this situation will become clearer.

Critics who are more than journalists establish their identity by championing something new, which means that they must reject the accepted art theories. Critics thus make assertions which, if they are good rhetoricians, come to be widely believed, and so then are true. This is why we value novelty in criticism, for only when critics say something incompatible with our accepted beliefs is it possible for them, by convincing us, to make interestingly true claims. If they fail to convince us, their account is false, and so therefore uninteresting. But if they do convince, rather soon newer critics will want to challenge them. Successful theories very quickly become of merely academic interest; today criticizing Fried is a bit like pointing out Roger Fry's errors, just as in twenty years more Rosalind Krauss's account of the end of painting, or Joseph Masheck's theory of iconicity, will be part of art history, no longer active concerns of the critic. Of course, these critics may continue to write; but just as now de Kooning continues to paint in his fashion, while influencing younger artists only in the way in which Rembrandt or any other old master may be an influence, so eventually a successful critic, just because his or her ideas become widely accepted, ceases to be a person who is challenged by newer writers.

This situation raises different problems for critics and painters. How established critics may respond to new work becomes difficult. Either they continually find new movements to like, in which case we wonder about the sturdiness of their beliefs (eclecticism not being a virtue in criticism) or, increasingly, they come to reject everything new, and so eventually become irrelevant. In the 1960s and 1970s, Harold Rosenberg continued to be preoccupied with de Kooning and Barnett Newman; Clement Greenberg admired Louis and Noland, but few people since; and Fried has apparently not supported any new figures since the mid-1960s—so these people are now figures in the history of criticism. By turning to 18th-century French art, Fried probably enhanced his reputation, this refusal to change his youthful position marking a contrast to the approach of someone like Rosalind Krauss, who started out as a formalist and now has developed a very different theory. She, like Fried, opposes most contemporary painting; but unlike him she continues to articulate her opposition, and that is not likely to give her a position of influence in the contemporary art world.

How such a pragmatic notion of truth is exemplified in my own account is interesting. Truth of criticism is relative to what art-world people believe, I have said, a theory becoming true when enough of these people believe it. What are the implications for my account? A truthful account of rhetoric must aim for truth by the standards it defines, so the claim that aesthetic judgments are rhetorically true is itself true only if convincing.

When criticism was believed to point out the properties of the artworks it described, an account such as mine might have seemed merely of sociological interest. But now we can see that to discuss art-world institutions is to explain a theory of art. Such an awareness of the rhetorical function of criticism itself can undermine taking that rhetoric at face value. We become preoccupied with techniques of persuasion, and doing that makes for both more skillful rhetoricians and an awareness of why such rhetoric has a certain arbitrariness. To become aware of the persuasive power of criticism, then, is to see why understanding art-world sociology and reflecting on the art critics' arguments are one and the same activity. Raised to self-consciousness, critics see their own role in the art system; they then turn to describe that system itself. Just as we can move from naively using rhetoric to understanding its effects, and from there to reflection on the nature of that understanding itself (the study of rhetoric thus becoming a study in how to use rhetoric in describing rhetoric), so here the critic who grasps the role of criticism can write about how criticism creates aesthetic value. The pursuit of criticism naturally ends in the self-conscious awareness of how criticism itself functions. An era, the era of criticism, has come to an end, and now we can analyze that period, while recognizing that nothing in an account of that time can let us anticipate what will happen next.

NOTES

[1] Richard Wollheim, "Style Now," in *Concerning Contemporary Art*, ed. Bernard Smith (Oxford: Clarendon Press, 1975), 152.

[2] Leo Steinberg, "Jasper Johns: The First Seven Years of His Art," reprinted in his *Other Criteria* (New York: Oxford University Press, 1972), 17–54.

[3] Arthur C. Danto, *The Transfiguration of the Commonplace* (Cambridge, Mass.: Harvard University Press, 1981), 166.

[4] Such an account is provided by Stephen Bann, "Brice Marden: From the Material to the Immaterial," in *Brice Marden: Paintings, Drawings and Prints 1975–80* (London: Whitechapel Art Gallery, 1981), 6–14.

[5] Giorgio Vasari, *Lives of the Most Eminent Painters, Sculptors, and Architects*, trans. G.D. Devere, ed. R.N. Linscott (New York: Random House, 1959), 364.

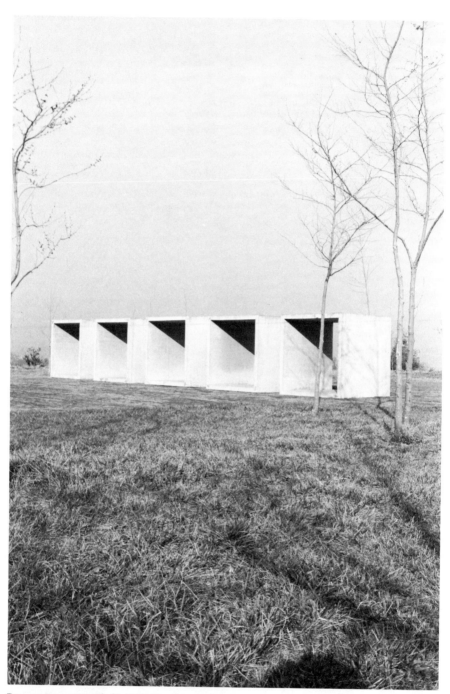

DONALD JUDD, "Untitled" 1977 Concrete, 84″ × 84″ × 89″
*Courtesy Art Center College of Design. Collection of the Los Angeles County Museum of Art.
Photograph by John Vince.*

In her essay for a 1968 exhibition of "primary structures," critic Lucy Lippard describes the works as inspired by an admiration for mass production and interchangeable parts; like machines, they were designed in a studio and manufactured elsewhere. The self-contained forms occupy and conquer space while the dematerialized forms disperse, deny, or incorporate space. They are not formal but anti-formal, having neutralized composition, color, and history in order to create a new landscape, not merely decorate one.

10 Structurists in 20 Paragraphs

Lucy Lippard

1

The works shown here are sculptures, or *primary structures* (a term I originally coined for use in a highly restrictive sense, but which was later adopted far more inclusively). The term *minimal* by which this idiom is journalistically designated means little, and what meaning it has is rather insulting, as it implies esthetic attrition. These artists are not less esthetically ambitious or esthetically successful than anyone else; certainly their work is not literally smaller. On the contrary, they are approaching the concept of art on the most basic and therefore most difficult level. They are trying to focus on the essential or the necessary in art; they have rejected aspects of sculpture that had become traditionally expected, sensing, perhaps, that the words *traitor* and *tradition* have the same Latin root. A traditionalist can be seen as one who has surrendered to his ancestors and betrayed his contemporaries. According to the painter Frank Stella, whose work around 1960 was most important to many of these sculptors: "It's just that you can't go back. It's not a question of destroying anything. If something's used up, something's done, something's over with, what's the point of getting involved with it?" Don Judd puts it more bluntly: "I consider the Bauhaus too long ago to think about it, and I never thought about it much."

2

There is more advanced sculpture than painting in America today. One reason is that sculpture, or in some cases a three-dimensional anti-sculpture, or structure, has provided an escape for those who feel the limitations of a pictorial idiom and an illusionary surface are too great to be overcome,

Reprinted from Lucy Lippard, "10 Structurists in 20 Paragraphs," catalogue essay, Gemeentemuseum, The Hague, 1968.

who share Judd's conviction that "the main thing wrong with painting is that it is a rectangular plane placed flat against the wall. A rectangle is a shape itself; it is obviously the whole shape; it determines and limits the arrangements of whatever is on or inside of it." Painters do not agree. Jo Baer, whose work is always grouped with the sculptors shown here, has written: "Painters discarded the teleology of distance and pictorial depth when they discarded the ground altogether, and paintings became objects altogether. This happened some time before they were inflated into wall objects, up-to-ceiling objects, and down-to-floor objects."

3

Most of these artists began as painters and moved into three-dimensions directly, bypassing sculptural training and tradition. They do not usually pay previous sculpture—American or European—the compliment of re-action; it is ignored. Most of this work is deliberately anti-sculptural in that it rejects the process of ordering parts, balancing or relating areas or forms. Most of these artists eschew the play of part against part aiming at a new spatial complexity by the single form—the space around, above, below, or within that form. They are opposed to fragmentation that stresses individual shapes and offer two alternatives among them: a radically self-contained form or an increasingly open and dematerialized form. Carl Andre requires "things in their elements, not in their relations."

4

When an absolutely symmetrical, repetitive, single, or serial scheme is employed, no one part is given precedence over another. The work becomes a whole rather than several different forms on a surface. It becomes non-relational, and is thus an heir to Jackson Pollock's (or Claude Monet's) allover paintings. The historical precedents for a primary art are mostly found in the 1920s and 1930s. The Russian constructivists or suprematists, de Stijl, the Bauhaus, even certain dadaists, envisioned a tabula rasa as the way to change art's course, and used geometric frameworks in which to make these changes. But the modular and conceptual schemes so favored by the primary structurists have mainly emerged from the innovations made in the last decade of American painting, the work of Barnett Newman, Ad Reinhardt and Mark Rothko and, later, of Frank Stella and Kenneth Noland. The youngest exhibitors here have more direct roots in the achievement of Judd, Morris, Andre, and LeWitt.

5

The steadfast denials of anything but the recent past, and the rejection of European influence, are not to be dismissed simply as chauvinism. They have to do with a conviction that the new and the difficult are the only goals worth attempting, that ideas as well as styles can be exhausted. An

integral element of advanced art in America is a disaffection with "easy art" that unites the most stylistically various artists who have come into prominence since 1945. The most obvious manifestation of this disaffection is the Oedipal ritual of action and reaction inherited from art history. The ruling genre, the most seen and thus most imitable style, becomes "easy" and must be renounced for a more advanced, difficult art. Baudelaire's "I have a horror of being easily understood" has been echoed by artists widely ranging in style. *Beauty, prettiness,* and *subtlety* have become suspect words in their suggestion of a facile hedonism.

6

Hilton Kramer has located David Smith's contribution to American art (and not incidentally to the primary structure; for he is the sole sculptor to have an effect on its evolution) in Smith's submission of "the rhetoric of the School of Paris to the vernacular of the American machine shop." Like many artists in America and in Europe, the sculptors in this exhibition admire the technological advances of the commercial and engineering world. They find in modern industrial techniques an admirable disassociation from sentimentality, from the pretty, the petty, the decadent "sensitivity" and "good taste" of much informal abstraction. But their construction is workmanlike and unobstrusive rather than detailed or overpolished. Technology is only a tool; they have no desire to imitate it, and they steadfastly try to avoid the pitfalls of dazzling new materials that tend to overshadow all other qualities in the work. Purged by Pop art, no longer veiled in myth or sociological baggage, the machine and the materials of modern technology can finally be taken for granted. Perhaps the most outstanding effect industrial society has had on primary art is the wholly absorbed principle of mass production and the principle of interchangeable parts which lies at the heart of American industrialism.

7

Moholy-Nagy's famous gesture of ordering a group of paintings by telephone from a sign painter has now become a matter of fact. Tony Smith ordered one of his first works the same way. Most of the structurists have their pieces made by professional industrial fabricators, men who have at their disposal the skills and equipment for making that particular form or surface, equipment no artist could possibly afford; in most cases it is difficult enough to afford the materials themselves. The fabrication process is a practical rather than an esthetic solution, and should not be overestimated as a factor in the artmaking process itself. While emphasis on the artist's mind rather than the artist's hand can be seen as a rejection of the expressionist 1950s, it does not rule out the expressive element.

Ronald Bladen, for example, does not consider himself in any way associated with those generally known as "minimal artists" because he em-

ploys a greater simplicity or reduction in order to achieve more drama. Tony Smith also views art as something vast and mysterious, whereas Judd, LeWitt, or Smithson look with great disfavor on anything that is not strictly factual or conceptual.

8

Primary structures may look alike at times, such as when several artists work with a cube or a free-standing box shape. But the motivations and attitudes behind these superficially similar works differ enormously. Robert Morris and Don Judd, for instance, have been mentioned in the same breath ever since they were the first to show aloof, single shapes. Morris is a cerebral and intellectual gymnast in the Duchampian tradition; in this group, the metaphysical complexity of his concepts is equaled (not paralleled) only by Carl Andre. Compared to Morris's ideational approach, Judd's is factual. In his own writings he stresses singlemindedness, physicality, wholeness, and direct confrontational experience. Morris says, "Unitary forms do not reduce relationships. They order them." Judd considers the primary structure "a vehicle for the fusion of distinct parts into an indivisible whole, for the incorporation of order and disorder, or the replacement of a rational geometric art with an alogical one."

9

Smith and Bladen are older than the others. Both had underground reputations before their work was seen, relatively late. Both consider themselves sculptors rather than anti-sculptors, both retain the "romantic" values of a previous art superimposed on an understatement and structural clarity furthered by single or modular forms. Neither makes fully resolved models; they work intuitively on the basis of an idea. "My view is let's make it and see what the hell it is," says Smith. Bladen is concerned with "that area of excitement belonging to natural phenomena such as a gigantic wave poised before it makes its fall, or man-made phenomena such as the high bridge spanning two distant points." Smith's view of nature is removed to the structural or organic plane rather than being based on visible phenomena. Seen in particular, his and Bladen's work is as different as Judd's and Morris's. Where Bladen enjoys the drama of precarious stance, of immense forms tipped out of their expected axes, Smith demands stability: "I don't want to be involved in muscle, in feats of engineering. I don't want the facades to be deductible. I want my work inscrutable throughout; if you can see how it's made then it loses its mystery." And Morris, in turn, opposes Smith, asserting shapes that can be censored logically and immediately by the viewer, that create strong single gestalt sensations. Grosvenor, whose background in naval engineering has perhaps been overemphasized, seeks a dynamic effect like Bladen, but in a more extended form. He thinks of

his work not as sculpture, but as "ideas which operate in the space between floor and ceiling."

10

A distinction could be made between structures that occupy space (Judd, Morris, Smithson), those that conquer space aggressively (Bladen, Smith, Grosvenor), those that deny or disperse it (Andre, Flavin) or those that incorporate it (LeWitt, and Smith's recent piece, *Smoke*). Obviously none of the generalizations in this text apply to all of the exhibitors, and almost none apply to Michael Steiner, whose polychromed relational sculptures have only the most tenuous connection with those of his colleagues, even within the uncategorized context of this exhibition.

11

Several of these artists hold that the idea is paramount and almost entirely eschew any preoccupation with physical scale, volume, mass, presence or expressiveness. For them, the making of the object is merely a traditional, expected step unnecessary to the esthetic. Andre and Smithson would probably agree with LeWitt that "the idea is the machine that makes the work." His aim is "not to instruct the viewer, but to give him information. Whether the viewer understands this information is incidental to the artist . . . he would follow his predetermined premise to its conclusion avoiding subjectivity. Chance, taste or unconsciously remembered forms would play no part in the outcome. The serial artist does not attempt to produce a beautiful or mysterious object but functions merely as a clerk cataloguing the results of his premise." As more and more sculpture is designed in the studio but executed elsewhere, the object becomes merely an end product. A number of still younger artists than those represented here are losing interest in any of the physical aspects of the work of art. Such a trend is provoking a profound dematerialization of art, especially of art as object. If it continues to prevail it may result in the object's becoming wholly obsolete.

12

Highly conceptual art supersedes the "formalism" found in the paintings of Noland and Stella or the sculpture of David Smith and Anthony Caro. Like the black paintings of Ad Reinhardt, it is anti-formal, for it has neutralized composition, color, and history. Dan Flavin, whose fluorescent light systems reiterate the lines of his interior spaces at the same time as they destroy their physicality, sees his work synonomizing "its past, present and future states without incurring a loss of relevance . . . I believe that art is shedding its vaunted mystery for a common sense of keenly realized dec-

oration . . . we are pressing downward toward no art—a mutual sense of psychologically indifferent decoration—a neutral pleasure of seeing known to everyone."

13

The formless forms or neutral units used by these men (bricks, grids, square plaques, tetrahedra, progressions) do not draw attention to themselves as form so much as they add up to a whole form that is a shape rather than an image. The modules are the real materials, the building blocks. Often there is a scientific or mathematical basis or metaphor underlying their arrangement, but it tends to be very simple. None of this work, with the exception of Smithson's, can be seen as an illustration of scientific ideas. Crystallography, with its systematic clarity of dimension and allowance for disorder within the network of physical interactions, has offered fertile ground; its systems are variously applied. Judd was one of the first to cite its relationship to the new art, but his work bears no resemblance to Tony Smith's. Smith, who sees all science as science fiction ("I read it like romance and can't believe it") uses a space lattice because of its infinite flexibility. A similar grid is also used by LeWitt as a vehicle for a totally finite, self-completing scheme.

14

The determined stasis, inertia and "deadness" of some of these works relates them to the history and aims of the monument. The public aspect of this art has been much discussed recently. In his article, "Entropy and the New Monuments," Smithson adopted a literary application of the Second Law of Thermodynamics to the visual arts and related an energy drain to a timeless science-fictional art predicted by primary structures. Monumental analogues can be found not only in the future but in the past. A deliberately static primitivism is asserting itself in the midst of a simultaneously active "electric" world. Several artists have cited the pyramids, obelisks, ziggurats, and mounds of ancient cultures as more interesting than any twentieth century prototypes. Their interest is experiential and not nostalgic: "Grid patterns show up in Magdelanian cave painting. Context, intention, and organization focus the differences. The similarity of specific forms is irrelevant" (Morris).

15

The presence of industrial monuments such as gas or oil drums, water tanks, windowless buildings, concrete pillboxes, airports, highways, parking lots, and housing projects have inspired a certain envy on the part of the artists who have aspirations to immense scale but little chance of being able

to work in such dimensions. (Frederick Kiesler wrote about the direct influence of the mountain landscape on the architectural forms of Machu Picchu.) The artists' attempts to improve upon and compete visually with their non-art surroundings have contributed to the new concern with public art. Morris, Smithson, Andre, among others, have plans for immense earth mounds, trenches and walls, a "City of Sand" and a "City of Ice," that would be experienced like landscape rather than optically isolated as art. Ideally, some of their projects would in fact create a new landscape made of sculpture rather than decorated by sculpture, along the lines of Tony Smith's long visualized "artificial landscape without cultural precedent."

16

Such projects are obviously public not only in scale but in scope. Governmental or corporate assistance is necessary for their realization. A pilot project is planned at the moment for a Texas airport which would employ earth as the medium for the four sculptures to be made in the clear zones at the beginning of the landing strips. This past fall, Claes Oldenburg made his Placid City Monument for the New York City sculpture show; it consisted of a trench dug between the Metropolitan Museum and Cleopatra's Needle (an obelisk). The pit was dug and then filled again by union gravediggers. As a monument, it probably attracted more public attention than all of the equestrian statues in Central Park. Its invisibility made it all the more visualizable. A still more conceptual monument was "made" years ago by Marcel Duchamp with the note: "Find inscription for Woolworth Building as a readymade."

17

Morris has projected a sculpture of steam jets; Andre made a "monument" out of sand dropped into a conical pile from one floor above; LeWitt has hidden elements of his serial projects within other elements where their existence must be taken completely on faith, as will his buried cube at the airport mentioned above. Hermeticism, dematerialization, total intellectualization has an increasing appeal. The complex concept buried in an impressive mass of purely physical bulk or else dispersed into thin air, but remembered, relates to the idea of archeology itself. The pyramids started out as architecture, but once the tombs were closed, they became sculpture. Over the ages they have become objects rather than functional enclosures, but a part of their fascination lies in their unseen cores, in the uses for which they were originally intended. Someone defined the major characteristic of sculpture as "just being there," a statement also made by Robbe-Grillet about Samuel Beckett's plays.

18

By its very restrictiveness, a primary art opens new areas of esthetic experience. It even tends to be over-stimulating. Above all, it has to be considered, not only seen but looked at or not only acknowledged but thought about. It will not provide instant departures for the familiar picture-finding, landscape-spotting, memory-inducing that often passes for enjoyment of abstract art. Many viewers are lost without these crutches of associative relationship to other objects or sights, so the new art is often called "boring" or said to test the spectator's commitment. The fact is that the process of conquering boredom can be boring. Most people prefer to stay with the viewer's digest. ("Honi soit qui mal y pense.")

19

Good art is never boring no matter how spare it is. This art is as committed as any other idiom. When it fails, it is as boring as any other kind. Its frequently cited impersonalism is just a new kind of personalism. It challenges the concept of boredom, monotony, and repetition by ruling out hitherto considered essentials and demonstrating that intensity does not have to be melodramatic.

20

"No formal sequence is ever really closed out by the exhaustion of all its possibilities in a connected series of solutions. The revalidation of old problems in new circumstances is always possible and sometimes actual." (George Kubler, *The Shape of Time.*) "Many machines grow more complex as they develop, because their functions and powers increase. But as each kind of machine approaches the limits of its inherent possibilities as a type, it tends to revert to simplicity, to emphasize economy of means, and to achieve what engineer and artist would agree in calling beauty of design and function." (A. L. Kroeber, *Anthropology: Cultural Patterns and Processes.*)

While the logic of pre-modernist sculpture was linked to the logic of the monument, modernist sculpture absorbed the pedestal, could be located anywhere, and so became, according to critic Rosalind Krauss, "functionally placeless and largely self-referential." Krauss describes developments in the sixties, when artists began to explore the concept of sculpture as defined by what it is not: not-landscape and not-architecture. In the expanded field of seventies' postmodernist sculpture, Krauss defines "marked sites," "site construction," "axiomatic structures," and "sculpture" by their relationship to and operations on landscape and architecture, as well as their negations. She thereby provides a critical framework capable of encompassing the rich diversity of work which was previously simply categorized as "sculpture."

Sculpture in the Expanded Field

Rosalind Krauss

Toward the center of the field there is a slight mound, a swelling in the earth, which is the only warning given for the presence of the work. Closer to it, the large square face of the pit can be seen, as can the ends of the ladder that is needed to descend into the excavation. The work itself is thus entirely below grade: half atrium, half tunnel, the boundary between outside and in, a delicate structure of wooden posts and beams. The work, *Perimeters/Pavilions/Decoys,* 1978, by Mary Miss, is of course a sculpture or, more precisely, an earthwork.

Over the last ten years rather surprising things have come to be called sculpture: narrow corridors with TV monitors at the ends; large photographs documenting country hikes; mirrors placed at strange angles in ordinary rooms; temporary lines cut into the floor of the desert. Nothing, it would seem, could possibly give to such a motley of effort the right to lay claim to whatever one might mean by the category of sculpture. Unless, that is, the category can be made to become almost infinitely malleable.

The critical operations that have accompanied postwar American art have largely worked in the service of this manipulation. In the hands of this criticism categories like sculpture and painting have been kneaded and stretched and twisted in an extraordinary demonstration of elasticity, a display of the way a cultural term can be extended to include just about anything. And though this pulling and stretching of a term such as sculpture is overtly performed in the name of vanguard aesthetics—the ideology of the new—its covert message is that of historicism. The new is made

Reprinted from Rosalind Krauss, "Sculpture in the Expanded Field," *October* 8 (Spring 1979).

comfortable by being made familiar, since it is seen as having gradually evolved from the forms of the past. Historicism works on the new and different to diminish newness and mitigate difference. It makes a place for change in our experience by evoking the model of evolution, so that the man who now is can be accepted as being different from the child he once was, by simultaneously being seen—through the unseeable action of the telos—as the same. And we are comforted by this perception of sameness, this strategy for reducing anything foreign in either time or space, to what we already know and are.

No sooner had minimal sculpture appeared on the horizon of the aesthetic experience of the 1960s, than criticism began to construct a paternity for this work, a set of constructivist fathers who could legitimize and thereby authenticate the strangeness of these objects. Plastic? inert geometries? factory production?—none of this was *really* strange, as the ghosts of Gabo and Tatlin and Lissitzky could be called in to testify. Never mind that the content of the one had nothing to do with, was in fact the exact opposite of, the content of the other. Never mind that Gabo's celluloid was the sign of lucidity and intellection, while Judd's plastic-tinged-with-dayglo spoke the hip patois of California. It did not matter that constructivist forms were intended as visual proof of the immutable logic and coherence of universal geometries, while their seeming counterparts in minimalism were demonstrably contingent—denoting a universe held together not by Mind but by guy wires, or glue, or the accidents of gravity. The rage to historicize simply swept these differences aside.

Of course, with the passing of time these sweeping operations got a little harder to perform. As the 1960s began to lengthen into the 1970s and "sculpture" began to be piles of thread waste on the floor, or sawed redwood timbers rolled into the gallery, or tons of earth excavated from the desert, or stockades of logs surrounded by firepits, the word *sculpture* became harder to pronounce—but not really that much harder. The historian/critic simply performed a more extended sleight-of-hand and began to construct his genealogies out of the data of millenia rather than decades. Stonehenge, the Nazca lines, the Toltec ballcourts, Indian burial mounds— anything at all could be hauled into court to bear witness to this work's connection to history and thereby to legitimize its status as sculpture. Of course Stonehenge and the Toltec ballcourts were just exactly *not* sculpture, and so their role as historicist precedent becomes somewhat suspect in this particular . . . demonstration. But never mind. The trick can still be done by calling upon a . . . variety of primitivizing work from the earlier part of the century—Brancusi's *Endless Column* will do—to mediate between extreme past and present.

But in doing all of this, the very term we had thought we were saving— *sculpture*—has begun to be somewhat obscured. We had thought to use a universal category to authenticate a group of particulars, but the category

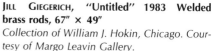

JILL GIEGERICH, "Untitled" 1983 Welded brass rods, 67" × 49" Collection of William J. Hokin, Chicago. Courtesy of Margo Leavin Gallery.

has now been forced to cover such a heterogeneity that it is, itself, in danger of collapsing. And so we stare at the pit in the earth and think we both do and don't know what sculpture is.

Yet I would submit that we know very well what sculpture is. And one of the things we know is that it is a historically bounded category and not a universal one. As is true of any other convention, sculpture has its own internal logic, its own set of rules, which, though they can be applied to a variety of situations, are not themselves open to very much change. The logic of sculpture, it would seem, is inseparable from the logic of the monument. By virtue of this logic a sculpture is a commemorative representation. It sits in a particular place and speaks in a symbolical tongue about the meaning or use of that place. The equestrian statue of Marcus Aurelius is such a monument, set in the center of the Campidoglio to represent by its symbolical presence the relationship between ancient, Imperial Rome and the seat of government of modern, Renaissance Rome. Bernini's statue of the *Conversion of Constantine*, placed at the foot of the Vatican stairway connecting the Basilica of St. Peter to the heart of the papacy is another such monument, a marker at a particular place for a specific meaning/ event. Because they thus function in relation to the logic of representation

and marking, sculptures are normally figurative and vertical, their pedestals an important part of the structure since they mediate between actual site and representational sign. There is nothing very mysterious about this logic; understood and inhabited, it was the source of a tremendous production of sculpture during centuries of Western art.

But the convention is not immutable and there came a time when the logic began to fail. Late in the nineteenth century we witnessed the fading of the logic of the monument. It happened rather gradually. But two cases come to mind, both bearing the marks of their own transitional status. Rodin's *Gates of Hell* and his statue of *Balzac* were both conceived as monuments. The first were commissioned in 1880 as the doors to a projected museum of decorative arts; the second was commissioned in 1891 as a memorial to literary genius to be set up at a specific site in Paris. The failure of these two works as monuments is signaled not only by the fact that multiple versions can be found in a variety of museums in various countries, while no version exists on the original sites—both commissions having eventually collapsed. Their failure is also encoded onto the very surfaces of these works: the doors having been gouged away and anti-structurally encrusted to the point where they bear their inoperative condition on their face; the *Balzac* executed with such a degree of subjectivity that not even Rodin believed (as letters by him attest) that the work would ever be accepted.

With these two sculptural projects, I would say, one crosses the threshold of the logic of the monument, entering the space of what could be called its negative condition—a kind of sitelessness, or homelessness, an absolute loss of place. Which is to say one enters modernism, since it is the modernist period of sculptural production that operates in relation to this loss of site, producing the monument as abstraction, the monument as pure marker or base, functionally placeless and largely self-referential.

It is these two characteristics of modernist sculpture that declare its status, and therefore its meaning and function, as essentially nomadic. Through its fetishization of the base, the sculpture reaches downward to absorb the pedestal into itself and away from actual place; and through the representation of its own materials or the process of its construction, the sculpture depicts its own autonomy. Brancusi's art is an extraordinary instance of the way this happens. The base becomes, in a work like the *Cock,* the morphological generator of the figurative part of the object; in the *Caryatids* and *Endless Column,* the sculpture is all base; while in *Adam and Eve,* the sculpture is in a reciprocal relation to its base. The base is thus defined as essentially transportable, the marker of the work's homelessness integrated into the very fiber of the sculpture. And Brancusi's interest in expressing parts of the body as fragments that tend toward radical abstractness also testifies to a loss of site, in this case the site of the rest of

the body, the skeletal support that would give to one of the bronze or marble heads a home.

In being the negative condition of the monument, modernist sculpture had a kind of idealist space to explore, a domain cut off from the project of temporal and spatial representation, a vein that was rich and new and could for a while be profitably mined. But it was a limited vein and, having been opened in the early part of the century, it began by about 1950 to be exhausted. It began, that is, to be experienced more and more as pure negativity. At this point modernist sculpture appeared as a kind of black hole in the space of consciousness, something whose positive content was increasingly difficult to define, something that was possible to locate only in terms of what it was not. "Sculpture is what you bump into when you back up to see a painting," Barnett Newman said in the fifties. But it would probably be more accurate to say of the work that one found in the early sixties that sculpture had entered a categorical no-man's-land: it was what was on or in front of a building that was not the building, or what was in the landscape that was not the landscape.

The purest examples that come to mind from the early 1960s are both by Robert Morris. One is the work exhibited in 1964 in the Green Gallery— quasi-architectural integers whose status as sculpture reduces almost completely to the simple determination that it is what is in the room that is not really the room; the other is the outdoor exhibition of the mirrored boxes— forms which are distinct from the setting only because, though visually continuous with grass and trees, they are not in fact part of the landscape.

In this sense sculpture had entered the full condition of its inverse logic and had become pure negativity: the combination of exclusions. Sculpture, it could be said, had ceased being a positivity, and was now the category that resulted from the addition of the *not-landscape* to the *not-architecture*. Diagrammatically expressed, the limit of modernist sculpture, the addition of the neither/nor, looks like this:

Now, if sculpture itself had become a kind of ontological absence, the combination of exclusions, the sum of the neither/nor, that does not mean that the terms themselves from which it was built—the *not-landscape* and the *not-architecture*—did not have a certain interest. This is because these terms express a strict opposition between the built and the not-built, the cultural and the natural, between which the production of sculptural art appeared to be suspended. And what began to happen in the career of

one sculptor after another, beginning at the end of the 1960s, is that attention began to focus on the outer limits of those terms of exclusion. For, if those terms are the expression of a logical opposition stated as a pair of negatives, they can be transformed by a simple inversion into the same polar opposites but expressed positively. That is, the *not-architecture* is, according to the logic of a certain kind of expansion, just another way of expressing the term *landscape,* and the *not-landscape* is, simply, *architecture.* The expansion to which I am referring is called a Klein group when employed mathematically and has various other designations, among them the Piaget group, when used by structuralists involved in mapping operations within the human sciences.* By means of this logical expansion a set of binaries is transformed into a quaternary field which both mirrors the original opposition and at the same time opens it. It becomes a logically expanded field which looks like this:

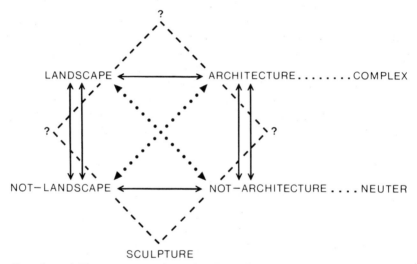

The dimensions of this structure may be analyzed as follows: 1) there are two relationships of pure contradiction which are termed *axes* (and further differentiated into the *complex axis* and the *neuter axis*) and are designated by the solid arrows (see diagram); 2) there are two relationships of contradiction, expressed as involution, which are called *schemas* and are designated by the double arrows; and 3) there are two relationships of implication which are called *deixes* and are designated by the broken arrows.

Another way of saying this is that even though *sculpture* may be reduced to what is in the Klein group the neuter term of the *not-landscape* plus the *not-architecture,* there is no reason not to imagine an opposite term—one

* For a discussion of the Klein group, see Marc Barbut, "On the Meaning of the Word 'Structure' in Mathematics," in Michael Lane, ed., *Introduction to Structuralism,* New York, Basic Books, 1970; for an application of the Piaget group, see A.-J. Greimas and F. Rastier, "The Interaction of Semiotic Constraints," *Yale French Studies,* no. 41 (1968), 86–105.

that would be both *landscape* and *architecture*—which within this schema is called the *complex*. But to think the complex is to admit into the realm of art two terms that had formerly been prohibited from it: *landscape* and *architecture*—terms that could function to define the sculptural (as they had begun to do in modernism) only in their negative or neuter condition. Because it was ideologically prohibited, the complex had remained excluded from what might be called the closure of post-Renaissance art. Our culture had not before been able to think the complex, although other cultures have thought this term with great ease. Labyrinths and mazes are *both* landscape and architecture; Japanese gardens are *both* landscape and architecture; the ritual playing fields and processionals of ancient civilizations were all in this sense the unquestioned occupants of the complex. Which is *not* to say that they were an early, or a degenerate, or a variant form of sculpture. They were part of a universe or cultural space in which sculpture was simply another part—not somehow, as our historicist minds would have it, the same. Their purpose and pleasure is exactly that they are opposite and different.

The expanded field is thus generated by problematizing the set of oppositions between which the modernist category *sculpture* is suspended. And once this has happened, once one is able to think one's way into this expansion, there are—logically—three other categories that one can envision, all of them a condition of the field itself, and none of them assimilable to *sculpture*. Because as we can see, *sculpture* is no longer the privileged middle term between two things that it isn't. *Sculpture* is rather only one term on the periphery of a field in which there are other, differently structured possibilities. And one has thereby gained the "permission" to think these other forms. So our diagram is filled in as follows:

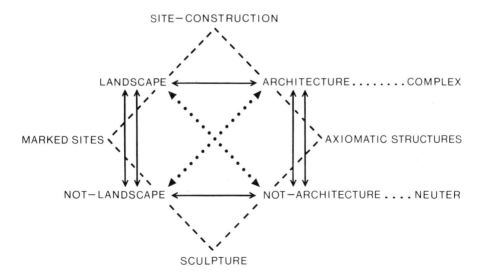

It seems fairly clear that this permission (or pressure) to think the expanded field was felt by a number of artists at about the same time, roughly between the years 1968 and 1970. For, one after another Robert Morris, Robert Smithson, Michael Heizer, Richard Serra, Walter De Maria, Robert Irwin, Sol LeWitt, Bruce Nauman . . . had entered a situation the logical conditions of which can no longer be described as modernist. In order to name this historical rupture and the structural transformation of the cultural field that characterizes it, one must have recourse to another term. The one already in use in other areas of criticism is postmodernism. There seems no reason not to use it.

But whatever term one uses, the evidence is already in. By 1970, with the *Partially Buried Woodshed* at Kent State University, in Ohio, Robert Smithson had begun to occupy the complex axis, which for ease of reference I am calling *site construction*. In 1971 with the observatory he built in wood and sod in Holland, Robert Morris had joined him. Since that time, many other artists—Robert Irwin, Alice Aycock, John Mason, Michael Heizer, Mary Miss, Charles Simonds—have operated within this new set of possibilities.

Similarly, the possible combination of *landscape* and *not-landscape* began to be explored in the late 1960s. The term *marked sites* is used to identify work like Smithson's *Spiral Jetty* (1970) and Heizer's *Double Negative* (1969), as it also describes some of the work in the seventies by Serra, Morris, Carl Andre, Dennis Oppenheim, Nancy Holt, George Trakis, and many others. But in addition to actual physical manipulations of sites, this term also refers to other forms of marking. These might operate through the application of impermanent marks—Heizer's *Depressions*, Oppenheim's *Time Lines*, or De Maria's *Mile Long Drawing*, for example—or through the use of photography. Smithson's *Mirror Displacements in the Yucatan* were probably the first widely known instances of this, but since then the work of Richard Long and Hamish Fulton has focused on the photographic experience of marking. Christo's *Running Fence* might be said to be an impermanent, photographic, and political instance of marking a site.

The first artists to explore the possibilities of *architecture* plus *not-architecture* were Robert Irwin, Sol LeWitt, Bruce Nauman, Richard Serra, and Christo. In every case of these *axiomatic structures*, there is some kind of intervention into the real space of architecture, sometimes through partial reconstruction, sometimes through drawing, or as in the recent works of Morris, through the use of mirrors. As was true of the category of the *marked site*, photography can be used for this purpose; I am thinking here of the video corridors by Nauman. But whatever the medium employed, the possibility explored in this category is a process of mapping the axiomatic features of the architectural experience—the abstract conditions of openness and closure—onto the reality of a given space.

The expanded field which characterizes this domain of postmodernism possesses two features that are already implicit in the above description.

One of these concerns the practice of individual artists; the other has to do with the question of medium. At both these points the bounded conditions of modernism have suffered a logically determined rupture.

With regard to individual practice, it is easy to see that many of the artists in question have found themselves occupying, successively, different places within the expanded field. And though the experience of the field suggests that this continual relocation of one's energies is entirely logical, an art criticism still in the thrall of a modernist ethos has been largely suspicious of such movement, calling it eclectic. This suspicion of a career that moves continually and erratically beyond the domain of sculpture obviously derives from the modernist demand for the purity and separateness of the various mediums (and thus the necessary specialization of a practitioner within a given medium). But what appears as eclectic from one point of view can be seen as rigorously logical from another. For, within the situation of postmodernism, practice is not defined in relation to a given medium—sculpture—but rather in relation to the logical operations on a set of cultural terms, for which any medium—photography, books, lines on walls, mirrors, or sculpture itself—might be used.

Thus the field provides both for an expanded but finite set of related

LITA ALBUQUERQUE, "Washington Monument Project" 1980
Photograph courtesy the Janus Gallery.

positions for a given artist to occupy and explore, and for an organization
of work that is not dictated by the conditions of a particular medium. From
the structure laid out above, it is obvious that the logic of the space of
postmodernist practice is no longer organized around the definition of a
given medium on the grounds of material, or, for that matter, the percep-
tion of material. It is organized instead through the universe of terms that
are felt to be in opposition within a cultural situation. (The postmodernist
space of painting would obviously involve a similar expansion around a
different set of terms from the pair *architecture/landscape*—a set that would
probably turn on the opposition *uniqueness/reproducibility*.) It follows, then,
that within any one of the positions generated by the given logical space,
many different mediums might be employed. It follows as well that any
single artist might occupy, successively, any one of the positions. And it
also seems the case that within the limited position of sculpture itself the
organization and content of much of the strongest work will reflect the
condition of the logical space. I am thinking here of the sculpture of Joel
Shapiro, which, though it positions itself in the neuter term, is involved in
the setting of images of architecture within relatively vast fields (landscapes)
of space. (These considerations apply, obviously, to other work as well—
Charles Simonds, for example, or Ann and Patrick Poirier.)

I have been insisting that the expanded field of postmodernism occurs
at a specific moment in the recent history of art. It is a historical event with
a determinant structure. It seems to me extremely important to map that
structure and that is what I have begun to do here. But clearly, since this
is a matter of history, it is also important to explore a deeper set of questions
which pertain to something more than mapping and involve instead the
problem of explanation. These address the root cause—the conditions of
possibility—that brought about the shift into postmodernism, as they also
address the cultural determinants of the opposition through which a given
field is structured. This is obviously a different approach to thinking about
the history of form from that of historicist criticism's constructions of elab-
orate genealogical trees. It presupposes the acceptance of definitive rup-
tures and the possibility of looking at historical process from the point of
view of logical structure.

Surveying the history of sculpture in the 20th century, critic Benjamin Buchloh views sculpture as alternating its identity. Sometimes it is used as a functional object—a model for architecture and design—and sometimes as an aesthetic object, investigating the conditions of aesthetic production. According to Buchloh, the use of prefabricated elements and the construction of sculpture outside of the studio led to the mechanically reproduced object and the demythification of the artist and the artwork. Progressive sculptors analyze the elements and fabrication procedures of their craft, as well as the relationship between their work and the perceiving subject. Buchloh argues that Michael Asher's work represents one culmination of this process because of the way it analyzes the historical and contextual determination of materials and spectators. Sculpture is defined by Buchloh to include perceptual and conceptual interactions between perceivers and objects within an institutional framework—interactions which serve the ideological purpose of clarifying the relationship between art and the socioeconomic conditions of its production and distribution.

Michael Asher and the

Conclusion of Modernist Sculpture

Benjamin H. D. Buchloh

Concrete material reality and social meaning should always be the primary criteria of specification. Before all else, we see in ideological objects various connections between meaning and its material body. This connection may be more or less deep and organic. For instance the meaning of art is completely inseparable from all the details of its material body. The work of art is meaningful in its entirety. The very constructing of the body-sign has a primary importance in this instance. Technically auxiliary and therefore replaceable elements are held to a minimum. The individual reality of the object, with all the uniqueness of its features, acquires artistic meaning here.[1]

Sculpture traditionally differed from painting through its seemingly unquestionable three-dimensionality, its physical and physiological corporeality. Sculpture was defined almost as literal embodiment of the artist's subjective plastic concerns, determined by the objective aesthetical and practical conditions of the sculptural discourse at hand to implement and concretize these concerns, and the spectator's (often the patron's) willing-

Reprinted from Benjamin H.D. Buchloh, "Michael Asher and the Conclusion of Modernist Sculpture," *Performance, Text(e)s & Documents,* edited by Chantal Pontbriand, les éditions Parachute, Montreal, 1981. Parts of the essay were originally delivered at the Centennial Lecture at the Art Institute of Chicago in November 1979. This revised and enlarged version was first presented at the Conference on Postmodernism and Multidisciplinarity, Montreal, October 1980.

ness and ability to recognize their existential being-in-the-world in the sculptural embodiment and representation. Or, as Rosalind Krauss recently stated in an appropriate academic definition: "The logic of sculpture, it would seem, is inseparable from the logic of the monument. By virtue of this logic a sculpture is a commemorative representation. It sits in a particular place and speaks in a symbolical tongue about the meaning and the use of that place."[2]

As we will be dealing in the following with some historical aspects of contemporary sculptural works in general, and with two works that were executed by Michael Asher in 1979 for two museums in Chicago in particular, it seems appropriate to consider these works in sculptural terms as they do in fact "sit in a particular place and speak in a symbolical tongue about the meaning and the use of that place." To achieve, however, an adequate reading of the complexity of the works in question, and the material and procedural transformations that have taken place in the evolution of contemporary sculpture, and to come to an understanding of the consequences and repercussions following from these works, it is necessary to recapitulate briefly some of the crucial changes that define sculpture in the history of modernism.

Looking at the concrete material reality of modernist sculpture (that is: its materials, and its procedures of production) as well as looking at its rapidly changing history of appreciation and reception, one could almost come to the conclusion that sculpture, due to its plastic and concrete 'nature' more than any other art practice, seems to lend itself to a particularly obdurate discourse of aesthetic ideology: how to maintain and continue atavistic production modes (modeling, carving, casting, cutting, welding) and apply them convincingly to semi-precious or so-called 'natural' materials (bronze, marble, wood) under the conditions of a highly industrialized society. Only twenty years ago (if not more recently) the works of Alberto Giacometti and Henry Moore could still pass as the epitome of the sculptural, where in fact their archaic iconography and plastic appearance revealed hardly more (but also no less) than the author's (and the public's) ossified insistence on maintaining a discourse that had lost its historic authenticity and credibility in the first decade of this century.

Even a practicing academic sculptor and sculpture/historian, William Tucker, seems to acknowledge the specific dilemma of his own discipline without, however, coming to an adequate understanding of the historical conditions that determine the dilemma of that category, when commenting on Rodin as follows:

> *Thus Rodin's mature sculpture follows the effective emergence of modern painting, moreover, in comparison with the directness, simplicity and objectivity of the new painting. The statement in sculpture seems tentative, half-formed and weighed down by a burden of romantic and dramatic subject matter of moral and public 'function' which the Impressionists had been able to jettison from the*

first. The reasons for the late arrival and confused intentions of the new sculpture lie partly in the physical character of sculpture and painting, partly in the relative development in Europe since the Renaissance, partly in the specific conditions of patronage and public taste which obtained in 19th century France (. . .). Sculpture became an art in which the taste and ambition of the public patron became the determining factor, and virtuosity and craftsmanship the criterion of artistic achievement.[3]

A more rigorously analytical reading of the history of modernist sculpture would have to acknowledge that most of its seemingly eternal paradigms, which had been valid to some extent in late 19th century sculpture (i.e., the representation of individual, anthropomorphic, wholistic bodies in space, made of inert, but lasting, if not eternal matter and imbued with illusionary moments of spurious life), had been definitely abolished by 1913. Tatlin's corner-counter relief and his subsequent *Monument for the Third International* and Duchamp's readymades, both springing off the height of synthetic Cubism, constitute the extremes of an axis on which sculpture has been resting ever since (knowingly or not): the dialectics of sculpture between its function as a model for the aesthetic production of reality (e.g., its transition into architecture and design) or serving as a model investigating and contemplating the reality of aesthetic production (the readymade, the allegory). Or, more precisely: architecture on the one hand and epistemological model on the other are the two poles toward which relevant sculpture since then has tended to develop, both implying the eventual dissolution of its own discourse as *sculpture*. This ambiguous transition and eventual withering away of the discipline had been sensed as early as 1903 by the conservative poet Rilke in his Rodin-study, but of course his sense was conveyed in a tone of deploration and lament as the withering artistic category was indicative of vanishing privileges and esoteric experiences, which he perceived as being incorporated in the wholistic, autonomous art object:

Sculpture was a separate thing, as was the easel picture, but it did not require a wall like the picture. It did not even need a roof. It was an object that could exist for itself alone, and it was well to give it entirely the character of a complete thing about which one could walk, and which one could look at from all sides. And yet it had to distinguish itself somehow from other things, the ordinary things which everyone could touch.[4]

The threshold between symbolic space and actual space, the ambiguous shift between functional object and aesthetic object, demonstrate the lines between which Michael Asher's works operate with increasingly analytical precision, deconstructing our notions of the sculptural as though they would want to prove that sculpture as a category has lost its material and historical legitimacy.

ON THE HISTORICITY OF SCULPTURAL MATERIALS AND PROCEDURES

Sculptural materiality before or beyond its iconic, formal or procedural definitions has to be considered as a symbolic system that is highly over-determined: for example we cannot help but suspect that the "nobility" of bronze and marble in the late 19th century work of Rodin was at least in part resulting from his dependence on the class of bourgeois fin de siècle *nouveaux riches* that supported him and that these materials fulfilled this audience's desire for 'nobilization' of the material world as much as they fulfilled Rodin's "aesthetic" needs: if the interests of a society at a given historical moment are based on the speculation with real estate, heavy industry and the founding of canons, then the aesthetic sculptural representation that would best and necessarily function as the "disinterested" and "purposeless as such" might well turn out to be luscious white marble and bronze. Therefore the symbolic determinations of the sculptural materials do not only result from the author's professional idiosyncrasies, whether his individual psychosexual organization tends more towards modeling soft and palpable masses (like clay) or whether he feels like cutting stone or carving wood, but they equally result from the audience's expectations—whether the specific material and the procedures of its production do attract and allow for a projective identification and seem in fact to embody the viewer's physical being in the world. Quite obviously then this being in the world in the material terms of three-dimensional representation of voluminous masses and bodies would refract and reflect in various manners the means and procedures of production of this material world itself inasmuch as they condition author and audience of sculpture alike.

In contradistinction to Rodin, to give another example, the truly radical modernity of Medardo Rosso's sculptures resisted this incorporation into bronze in most of his works and the sculptural production process itself was arrested and fragmented at the level of the wax and plaster model: materials which by their very nature quite explicitly reject any heroic or sublime connotations. Rosso often said that he wanted the materials of his sculptures to pass unnoticed because they were meant to blend with the unity of the world that surrounded them. The actual fragmentation of the sculptural procedure—whether deliberate or due to "circumstances"—corresponds as a plastic and historical fact to Rosso's fragmentation of the sculptural representations themselves. The reluctance or incapacity to fulfill all the requirements of the traditional sculptural production process, from modeling to casting, indicates an essential critical shift of attitude. It reveals the increasing doubts about the ability of a practice of artisan/oriented sculpture to come to terms with its historic reality: the completion of various steps and sequences of production activities, pretending to be conceived and executed by one individual, had become obsolete. Concomitant with the fragmentation of the sculptural procedures appears the phenomenon

of a heterogenous materiality: prefabricated elements, alien to the craft of nineteenth century sculpture, are introduced or intrude into the conventionally unitary sculptural body. Degas' only sculpture that was publicly exhibited during his lifetime and cast in bronze posthumously produces this modernist scandal for the first time: the *Little Dancer of Fourteen* (1876). When it was exhibited at the Exposition des Indépendants in 1881, Joris Huysmans hailed it as follows:

> At the same time refined and barbaric with her industrious costume and her coloured flesh which palpitates furrowed by the work of the muscles, this statue is the only truly modern attempt which I know in sculpture.[5]

Both phenomena, the fragmentation of representation and that of the production process as well as the assembling of heterogenous materials, at first gradual and tentative, as in the case of Degas, and then later in Cubism and Futurism, increasing and systematic in the combination and juxtaposition of mechanically produced anonymous objects and materials from reality-contexts with the individually produced aesthetic signs by the artist, up to the final and total take-over by the mechanically reproduced object, in Duchamp's readymade, find a meticulous description and precise historical analysis in Georg Lukács' attempt to define the conditions of reification in 1923:

> Rationalization in the sense of being able to predict with ever greater precision all the results to be achieved is only to be acquired by the exact breakdown of every complex into its elements and by the study of the special laws governing production. Accordingly it must declare war on the organic manufacture of whole products based on the traditional amalgam of empirical experiences of work (. . .). The finished article ceases to be the object of the work process (. . .). This destroys the organic necessity with which interrelated special operations are unified in the end product. (. . .) Neither objectively nor in his relation to his work does man appear as the authentic master of the process: on the contrary he is a mechanical part incorporated into a mechanical system. He finds it already pre-existent and self-sufficient, it functions independently of him and he has to conform to its laws whether he likes it or not. As labour is progressively rationalized and mechanized, his lack of will is reinforced by the way in which his activity becomes less and less active and more and more contemplative. The contemplative stance adopted toward a process mechanically conforming to fixed laws and enacted independently of man's consciousness and impervious to human intervention, i.e., a perfectly closed system, must likewise transform the basic categories of man's immediate attitude to the world: it reduces space and time to a common denominator and degrades time to the dimension of space.[6]

The intrusion of those alien materials in Degas' sculpture established a very precarious balance between the subjective aesthetic creation and the factors of given objective reality along the lines pointed out by Lukács. Ever since, and most definitely since Duchamp's readymades, these historical conditions have been forced to their most logical and radical ex-

treme. Duchamp's work features most prominently that contemplative character of spatialized time in the object that Lukács talks about. Quite amazingly, a totally opposite reading of Duchamp as the artist that continues and accomplishes the 19th century tradition of the dandy, the artist that refuses participation in the collective production process and inverts his role as procreator into that of the divine *blasé*, the *flâneur* that simply walks around the world and designates found objects as art, this reading converges precisely with the above observation, as spatialized time and passive contemplation are the modes in which melancholy perceives the world and the increasing estrangement from it.

Inevitably, at this point, Walter Benjamin's observation on the interaction between allegory and commodity has to be quoted:

> *The devaluation of the world of objects by the allegory is exceeded within the world of objects itself by the commodity.*[7]

Ever since the first decade of this century has this precarious ambiguity between the sculptural self and the material other, between aesthetic object and symbolic space on the one hand, and real object and actual space on the other, determined the practice of sculpture.

Not always, however, does aesthetic production evolve logically according to its own inherent necessities and external principles which are obviously asking for radical paradigmatical change: quite to the contrary, it seems that one of the essential features of aesthetic production—at least in 20th century art history—is the constant reiteration of the same problems and contradictions according to the law of compulsive repetition:[8] as the contradictions, which are objectively anchored in the organization of the means of production, obviously cannot be resolved aesthetically, every generational or period stratum within the continuity of an obsolete form of production assumes increasingly mythical and ideological qualities and functions as opposed to the truly aesthetic.

The history of post-second World War sculpture is particularly rich with these myths, and only one of the most spectacular ones should be briefly discussed as an example and historic link: that in which the issues of constructivism and Dada's attitude towards the mass produced object seem to coalesce, as, for example, in the work of David Smith, John Chamberlain and Anthony Caro. If anything, their work, welded metal and junk sculpture, seems to resolve in a most comforting manner that blatant contradiction between individual aesthetic production and collective social production, that between construction and found object. In fact, however, this contradiction is mythified in the work's semblance of synthesizing the heroic gesture of construction and creation and the melancholic gesture of denial and negation. In the same way, these artists, as public figures and biographical myths, combine the image of the proletarian producer, taming

the elements and extracting wealth from the furnace, with that of the melancholic stroller in the junk yards of capitalist technology—an image that has persisted right into the present. The necessarily fetishistic character of this work had been adequately diagnosed in the twenties by the Russian productivist artist and theoretician Boris Arvatov who wrote in *Art and Production*:

> While the totality of capitalist technology is based on the highest and latest achievements and represents a technique of mass production (industry, radio, transport, newspaper, scientific laboratory) bourgeois art in principle has remained on the level of individual crafts and therefore has been isolated increasingly from the collective social practice of mankind, has entered the realm of pure aesthetics (. . .). The lonely master—that is the only type in capitalist society, the type of specialist of "pure art"—who can work outside of an immediately utilitarian practice, because it is based on machine technology. From here originates the total illusion of art's purposelessness and autonomy, from here art's bourgeois fetishistic nature.[9]

As for the mythology and meaning of materials and production procedures, the scrap-metal/assemblage sculpture and the welding technique concretize the historic dilemma between obsolescent means of aesthetic production and their romanticization (i.e., fetishization) on the one hand and the advanced means of social production on the other as well as they embody the attempt to solve this historical dilemma. The failure of that attempt, inasmuch as it becomes evident in the work itself, is then the work's *historic* and *aesthetic* authenticity. Julio Gonzalez, who had been trained as a stone cutter, learned welding in the French Renault car factories during World War I and integrated his enforced experience from alienated labour in social production into his individual aesthetic production, or, from a different point of view one could argue that he adapted his aesthetic procedures to the experience of collective production procedures. This 'modernization' of the sculptural discourse was instantly successful because it seemed to respond to and fulfill the needs of a disposition within artist and public at the moment to achieve at least a symbolic reconciliation of the increasingly apparent contradictions. Picasso adopted this technique in the early twenties and a new sculptural category and production technique was born. When David Smith "discovered" Gonzalez and Picasso's work through the mediation of the art magazine *Cahiers d'Art* and imported the technique to North America, a further crucial step in the mythification of that simple sculptural procedure that had originated from Cubism's necessity to assemble planes in various spatial positions and directions, had taken place. Smith, more than Gonzalez, propounded the image of the proletarian producer linking it with the mythical Hephaistos/Vulcan figure. On frequent occasions did he point to the immensely important experiences of factory/production-labour that shaped and determined his work, in particular his experience as a welder in a World War II tank factory, and he

referred to his welded sculptures as constructions of the same historical order as locomotives. To what degree that self-image of the welding-mask-wearing proletarian producer and 20th century Vulcan possessed mythical attraction for David Smith is hinted at by the fact that his widow revealed that most of Smith's claims for severe and enduring experiences as a factory welder were in fact exaggerated and that they boasted a few, limited occasional jobs.

The next step of aesthetic removal and mythification occurred when this modernized sculptural production procedure was 'rediscovered' and 'reimported' to Europe by Anthony Caro in 1960 upon his first visit to North America and his encounter with David Smith. His radically superficial overnight shift (as in the radical superficiality of changes in the discourse of fashion) from his figurative bronze casting to the non-representational welded assemblage sculptures, made of scrap metal, and his subsequent step to investigate the decorative potential of gaudily painted arrangements of metal work samples, accomplished historically the aesthetic falsification and 'cultural' inversion of everything that constructivist ideas had originally intended and achieved within their limited political possibilities.

It took artists of the minimal and post-minimal generation like Carl Andre and Richard Serra in the mid- and late sixties to literally "decompose" these mythified construction techniques; materials and production procedures and the aesthetic shock and subsequent relief that their work might have caused originally resulted precisely from their deconstruction of sculpture, their perseverance of singularized, particular elements, clarification of the constituent forces within the sculptural construct and the transparence of the production procedures. It is symptomatic in that context that Richard Serra referred to the technique of welding as "stitching" during the sixties and that he readopted that very same technique when his work in the seventies returned to the mythification of the constructivist legacy to allow for a pretense to public monumental sculpture.

Ever since the first decade has radical sculpture increased the fragmentation of the sculptural production process itself as well as it has intensified the reflection on the constituent factors determining this process. Internally, the material elements assembling the sculptural phenomenon have become increasingly isolated, singularized and specific and the procedures of its fabrication as well as the physical laws and forces allowing or generating its appearance in space have become more and more the center of the sculptural investigation. Externally, an analysis of the perceptual relations that connect the sculptural object with the perceptual acts of the subject is incorporated into the very conception and formation of the sculpture. Necessarily resulting from this is an increased and systematic reflection of the interdependence and interrelationships of the sculpture and its surrounding spatial/architectural container.

The emergence of minimal and post-minimal aesthetics in the Sixties' sculpture, which form the historical context out of which Michael Asher's work developed, constitutes a major period of modernist sculptural history. In spite of numerous and reiterated affirmations, namely by American critics and historians, that minimal and post-minimal works are not to be seen in the historical context of modernist sculpture pointed out above, the contrary holds true: too frequent are the references by the artists themselves, implicitly and explicitly, given in works and statements, that acknowledge the rediscovery of plastic principles and theoretical positions which had been articulated in Duchamp's work on the one, and the constructivists on the other hand (for example: Andre on Rodchenko, Judd on Duchamp and Malevich, Flavin on Tatlin and Morris on Duchamp). This was precisely the part of the modernist tradition that had been ignored and rejected by the normative aesthetics of Greenberg's formalist "new criticism," which, even though debated and questioned, provided another essential element of the critical foundation against which the new sculptural work could be defined. In addition to that new positivist approach and the discovery of Merleau-Ponty's recently (1962) translated *Phenomenology of Perception,* we see a laconic pragmatism, resulting from what has been called appropriately *The Aesthetics of Indifference,* and a skeptical investigation into the epistemology of painterly and sculptural signs, partly the result of the artist's discovery of logical positivism and semiology, partly the result of an ideology of anti-expression, questioning subjective meaning, or existential meaning in general, that seemed to have dominated the preceding decade. Stella's famous statement "What you see is what you see" is a lapidary condensation of all these elements.

The formalist concept of "self-referentiality" is the more theoretical prescription to which art until around 1965 had to abide. What in fact amounted to a pictorial or sculptural analogy to the semiological understanding of the sign, its state of being constituted by two different elements, signifier and signified, that were arbitrarily connected, as Saussure had claimed, and the self-reflexivity resulting from that analogy in artistic production, again in principle, if not in explicit theoretical reflections, had been achieved by both Duchamp and Malevich in 1913. One of the first minimal works that expanded this notion of self-referentiality to a considerable degree was Robert Morris' *Mirrored Cubes* (1964–65) and it found its parallel on the West Coast in the early mirrored cubes by Larry Bell. Both refer explicitly to an unexecuted project by Duchamp,[10] defined in the *Green Box,* suggesting the placement of mirrored cubes on the floor of a room.

Asher went to New York for a year in 1963–64 and became very interested in Dan Flavin's and Judd's work, and constructed tapered wedge pieces in 1966 that follow a similar logic. They were installed flush against the wall and painted over with a color identical to the wall that supported

them. As in Morris' early work and Bell's mirrored cubes the most prominent characteristic of the work is its analytical approach towards the actual nature of the plastic phenomenon in its triadic context: to be aesthetical/spatial sign by itself, to be relating to a larger comprehensive spatial, i.e., architectural phenomenon, which may or may not purport its own and different order of signs and to be embedded, constituted and activated only through the individual act of perception that the spectator introduces into the interdependence of those two systems. The sign itself, at least in Morris' early work and in Asher's wedge pieces, is clearly determined by an attitude of negating its own importance, and significance, other than that of distinction and demarcation between the two dimensions of individual subjective perception and objective spatial condition, is denied. Dan Graham, later to become a close friend of Michael Asher, underwent a similar development in his work, leading gradually out of formalist and minimal aesthetics. He described his conception of an aesthetic structure as follows:

> There is a "shell" placed between the external "empty" material of place and the interior, empty material of language: systems of information exist halfway between material and concept without being either one.[11]

The overcoming of the formalist notion of self-referentiality in favor of an increasingly complex system of analysis in which the aesthetic work would obtain a more operative, functional dimension of use value (as opposed to the "merely" esthetic, disinterested structures) within the various parameters of historical determination that the work was simultaneously subjected to and incorporated in its analytical process, had been inherent within the formal attitude itself[12] and had already been true for the original development of formalist methodology.

Three concepts were of crucial importance for this transgression: the notion of specificity, the notion of place and that of presence. Donald Judd defined his understanding of *specificity* in regard to sculptural materials still with a clear innuendo towards positivist pragmatism by almost literally transferring a key term of Russian formalist criticism towards sculpture. We read in his essay "Specific Objects" in 1965:

> Materials vary greatly and are simply materials—formica, aluminum, cold-rolled steel, plexiglass, red and common brass and so forth. They are specific. Also they are usually aggressive.[13]

Shortly afterwards, Michael Asher and a whole generation of artists would embark on proving that materials are not simply materials, but that they are procedurally and contextually determined.

As Beveridge and Burn argued against Judd:

Aren't you saying you want the association to be restricted or localized to the object or its immediate (i.e., architectural) environment? Along with an autonomous form of art, you wanted a more autonomous art object, what you would call "more objective" (. . .) traditionally art objects are associated with other art and art history by way of their materials and by being a conventional type of art object. Such associations would, I suppose, in your words, be specific. But this was the last thing you wanted. The "autonomy" you developed for your objects had to function in respect to your presupposition of an art (historical) context and hence you still needed a means of associating the object with that context. Since the object itself denied any associations, the physical situation became a more important vehicle. That is to say, the object had to be circumstantially associated with its art context.[14]

The second concept, *place*,[15] was mainly developed by Carl Andre and Dan Flavin. Andre defined sculpture as place (as opposed to object or anthropomorphic representation). Other than pointing to the spatial specificity of the sculptural work (as opposed to its material specificity that Judd talked about), Andre's definition implied also originally (as did Flavin's practice) a subversive assault on the commodity status of artworks (given with the fact that they were moveable objects, contextless, offering themselves to every kind of transaction). Sculpture as *place* was supposed to integrate into its actual formation the spatial conditions into which it inscribed itself as constituent elements. Dan Graham again observed and described this with lucidity:

I liked that as a side effect of Flavin's fluorescents the gallery walls became a canvas. The lights dramatized the people (like spotlights) in a gallery, throwing the content of the exhibition out to the people in the process of perceiving; the gallery interior cube itself became the real framework. . .[16]

Quite independently, the French artist Daniel Buren had written in 1969 (published in English in 1973) an extraordinarily perspicacious critique of Duchamp's Readymade Concept which reveals, if we read it along with Dan Graham's description of Flavin's work, the unreflected and problematic points of the minimalist concept of place, its unconscious indebtedness to Duchamp, and it refers to precisely those points that Michael Asher's work will focus on:

The Museum/Gallery for lack of being taken into consideration is the framework, the habit, . . . the inescapable "support" on which art history is painted. Wishing to eliminate the tableau/support, on the pretext that what is painted can only be illusion, Duchamp introduced into a new framework/tableau a real object, which, at the same time, becomes artificial, motiveless, i.e. artistic.[17]

The almost literal congruence of Graham's and Buren's statements points to the objective nature of these artistic concerns of the post-minimal generation.

Temporal specificity is defined in the third term: *presence,* that is closely interrelated with its spatial and material counterparts. The term implies not only that the sculptural installation is determined by the specific temporal circumstances into which it is introduced, but moreover that it obtains within these circumstances a specific, temporally limited function and is disposable after its usage in time. Again Graham had pointed this out in looking at Flavin's work when it was shown in Chicago in 1967:

> The components of a particular exhibition upon its termination are replaced in another situation—perhaps put to a non-art use as part of a different whole in a different future.[18]

Asher later started using the term "situational aesthetics" in which both spatial and temporal specificity are combined.

By 1968, it had become fairly clear that the generation of minimal artists had either abandoned the original implications of those aesthetic strategies in increasingly adapting their work again to the offers and needs of the art market—or that these aesthetic strategies in themselves had to be radically modified to maintain their status as a functional tool in aesthetic inquiry of the historical conditions determining the work of art. Michael Asher's first major individual exhibition in 1969 at the San Francisco Art Institute applied the minimal principles of self-referentiality and specificity in spatial and temporal terms with a vigorous directness and analytic immediacy that revealed the unreflected formalist heritage in minimalism as much as it determined a new understanding of sculptural materiality.

He divided the allocated exhibition space at the San Francisco Art Institute into two halves by constructing a wall by means of assembling the given exhibition panels that normally would serve as additional support surfaces in exhibition spaces for the installation of paintings, etc. One half of the room contained an entry/exit door and was fairly dark as the wall construction prevented the light flooding into the other half of the room through windows and a skylight from being diffused in the room. The other half of the room was accessible only by a passage left open between the constructed wall and the given wall, but was very brightly lit.

Asher described this work as follows:

> The presentation at San Francisco was clearly dictated by every element which was available and it suggested a way of working for the future: using just elements which already existed without a great modification to the space.[19]

The very same year, in Europe, a hitherto almost totally unknown artist, Marcel Broodthaers, embarked on, as it seemed at the time, a fairly eccentric adventure: he had a well-designed letter head printed that announced in conservative typography the foundation of a new museum in

Brussels: *le Musée d'Art Moderne (Section XIX Siècle) Département des Aigles* and appointed himself to be director of this museum. The guests—among them Daniel Buren—that were invited for an official opening (the official opening speech was being delivered by a "real" museum director of a "real" museum) found themselves in a room (Broodthaers' former "studio") filled with empty wooden picture crates that museum institutions use for the transport of works of art, a number of art picture post-cards installed on the walls and installation equipment. Broodthaers as well had quite clearly developed an awareness of the Duchampian dilemma and his seemingly eccentric activity turned out to be the beginning of a systematic analysis of the myth of the museum, its transforming capacities in the process of acculturation. As early as 1966 did he point to the various hidden frames that determine the art object, when saying:

> *Every object is a victim of its nature: even in a transparent painting the color still hides the canvas and the moulding hides the frame.*[20]

As much as these two works on first observation seem to be incompatible and opposed—which is ultimately explained by the fact that both originate from opposite sources—as much do they reveal upon close analysis their actual historic connection—despite the major morphological and stylistic differences that had developed between European and American art since the Forties.

To the same degree that Asher's work overcomes the neo-positivist formalism that had marked the work of the preceding generation and that had—however vulgarized and falsified—its origins partly in Constructivism, to the same degree does Broodthaers' work surmount the trap of Duchamp's readymade concept that had kept almost all object-oriented art in its spell. Both positions—the constructive and the allegorical—seem to coalesce and henceforth determine the historically relevant work in contemporary art production.

It is crucial to comprehend the installations of Michael Asher in the historical perspective of sculpture (as opposed to a conceptual definition or gesture or, which would be even a graver misunderstanding, to align this work with a Neo-Dada-environment tradition, as has been done). Only then do these works reveal all their ramifications. As usual, a detailed and accurate formal analysis of the sculptural phenomena yields access to the work's more general historical repercussions. As it seems, Asher's sculptural installations are only constituted, however, by conceptual gestures, directions, decisions and by "found" or "given" objects and materials, or more correctly: conditions and circumstances of a particular situation in a museum/exhibition context. The material of a sculptural production process in both cases is totally negated, to a degree that surpasses even the most radical conceptual definition of a sculptural process like, for example, Law-

Michael Asher, Installation at the Art Institute of Chicago 1979. The replica in bronze of George Washington, 1788, by Jean Antoine Houdon, originally in front of the Michigan Avenue Entrance, can be seen in the foreground of this gallery. It was installed in an 18th Century context by Michael Asher as his work in the *73rd American Exhibition.*
Photograph by Rusty Culp. Photograph courtesy of the artist and the Art Institute of Chicago.

rence Weiner's statements from 1968: "A field cratered by structured simultaneous TNT explosions" (from *Statements*). The works inscribe themselves functionally into their own historical-spatial context, the museum, and they become the dialectical counterpart of their actual historical time, the exhibition period. It becomes apparent that their functional presence and the precision of their function is highly dependent on their actual negation of their own material presence as sculpture.

What, then, are the materials of Asher's installations? Should they actually be called "sculptural" at all or should they much rather be considered as an application of an academic discipline—the criticism of ideology—within the field of the visual arts? Is the necessity to look at the work in sculptural terms inherent in our own system of description and classification in the traditional historical categories? We can see, however, once looking at the works in the terms of that category, to what extent they inscribe themselves into the tradition of the sculptural discourse as much as they integrate themselves into the actual historical, i.e., institutional practice that propounds that discourse.

Jack Burnham, in the context of Haacke's works which also deal with museums and their institutional practices, has described some of the necessities for this:

> . . . he sees the museum and gallery context as an absolutely necessary element for the meaning and functioning of his works; (. . .) The questions had to be asked in the galleries and the gallery public had to be confronted with its self-portrait in that same environment. The walls of the museum or gallery are as much a part of his work as the items displayed on them. These works also need the "impregnation" of the gallery to set them in opposition to other contemporary art.[21]

The situation, in the case of Asher's work, is, however, more complex: as a sculptural phenomenon these works talk in their own language about sculpture/to sculpture, thus redefining the terminology and commenting, as we saw, on the present situation of the discourse. Simultaneously, and paradoxically, the material terms in which Asher's work manifests itself concretely are as alien to the tradition of the sculptural discourse as they are essential to the actual constitution of the work. As we saw in the case of Degas' and Duchamp's sculptural works that shifted the paradigms of sculpture, it is precisely the degree of negation of the discipline that allows for the work's historical authenticity. Or, put differently: the almost total alienation from its conventions generates the work's identity, which in one act of double negation reveals and negates both, the historical determination of itself as discourse and the conditions of historic and material reality which determine that discourse.

Conditions of collective reification change gradually (or, under the particular circumstances of crisis, rapidly and drastically). Their aesthetic representations appear accordingly: no longer could any object, whether individually crafted or mass-produced, reflect appropriately the degree of abstraction on which collective reification is operating and institutionalized.

Art production itself has become an activity that shares the conditions of cultural industry on the one hand, embellishing the corporate image to the public, and cultural, civil services on the other hand—which, due to their dependence on an elaborate state support system, channel any attempt at critical negation into a hermetically sealed ideology of culture.

During periods of history in which the governing powers want to convey a sense of conclusion (more precisely that history as process and change has been concluded) this experience of subtle oppression and stagnation is extrapolated in monumental public structures. Amnesia, the loss of memory which is at the origin of the destruction of historical dialectics, tends to incorporate itself in false public commemorative representations. Their stability and weight seem to balance off the insecurity that individuals and society at large experience once they have been totally deprived from actively participating in the decision making process of history. At this point

in time sculptors seem to be tempted to offer their services for monumental public commissions which embody those latent tendencies; they fill the gaps of historic identity with gigantic monuments. The recent increase in public commissions for monumental sculpture confirms this hypothesis and the critics rhapsodize already in a new ideology of postmodernist populism:

The root of the difficulty would seem to lie back at the turn of the century with the disappearance of the monument. Avantgarde art in general with its oppressive neutrality of content, has a long history of being perceived by the public at large as irrelevant. Its abstractness, however, is not the problem as much as its failure to conduct a public dialogue. (. . .) Belief or conviction on the part of the artist, while perhaps the most important single ingredient of a great work of art, is not, as far as the public is concerned, a substitute for symbolic content. (. . .) The artists who succeed there . . . will be those who are willing to come to terms with the notion of public commitment, who realize that such a stance, far from compromising their work, can infuse it with non-aesthetic content which has absented itself from modernist art.[22]

NOTES

[1] Bakhtin/Medvedev, *The Formal Method in Literary Scholarship* (1928), Baltimore, 1978, p. 12.

[2] Krauss, Rosalind, "Sculpture in the Expanded Field," *October* 8, Cambridge/New York, 1979, p. 33 ff., reprinted in this volume.

[3] Tucker, William, *Early Modern Sculpture*, New York/London, 1974, p. 13.

[4] Quoted in Tucker, *loc. cit.*, p. 9.

[5] Huysmans, Joris, "L'Exposition des Indépendants en 1881", in *L'Art Moderne*, Paris 1888, p. 227.

[6] Lukács, Georg, "Reification and the Consciousness of the Proletariat," in *History and Class Consciousness*, Cambridge, 1971, p. 88f.

[7] Benjamin, Walter, "Zentralpark", in *Gesammelte Schriften*, Vol. 1, 2, Frankfurt 1974, p. 660.

[8] On the level of sculptural production materials and procedures on which we have tried to focus parts of the essay, it seems only a matter of time now that the return of bronze casting in sculpture will be celebrated as an innovative and courageous return to the essence and roots of sculpture. As an aesthetic equivalent to ruthless and outright political reaction, casted bronze sculpture offers the stubborn solidity and semblance of perpetuity with which the contemporaries can identify. It is noteworthy that even five years ago such a shift would have been almost inconceivable—which again proves to what extent those aspects of aesthetic production carry meaning. It is certainly also no accident that Michael Asher's installation at the Art Institute of Chicago integrates a bronze cast into his work, thus quite elliptically pointing to the imminent sculptural reactions without participating in them.

[9] Arvatov, Boris, *Kunst und Produktion* (1925), Muenchen 1972, p. 11.

[10] The actual notes of Duchamp in the *Green Box* read as follows: "Flat container in glass— holding all sorts of liquids. Colored pieces of wood, of iron, chemical reactions. Shake the container and look through it. Parts to look at crossed eyed, like a piece of slivered glass, in which are reflected the objects in a room." from: *The Bride Stripped Bare. . . (The Green Box)*, London/New York, 1960, s.p.

[11] Graham, Dan, "Other Observations", in *For Publication*, Otis Art Institute, Los Angeles, 1976, s.p.

[12] See for example the radical change in the thinking and writing of Ossip Brik, who shifted from a pure formalist position to that of a committed productivist position. More recently, however, it seems that critics, historians and artists have become reluctant to acknowledge the historical and aesthetical consequences that their own work generates.

[13] Judd, Donald, "Specific Objects" (1965), in *Complete Writings*, New York/Halifax, 1975, p. 123.

[14] Beveridge, Karl/Burn, Ian, "Donald Judd", in *Fox 2*, New York, 1975, p. 130.

[15] The notion of "place" in sculpture was originally coined by Barnett Newman in regard to his sculptural work *Here I* (1951). It can be assumed that both Andre and Flavin, fervent admirers of Barnett Newman's work, derived their concept of place in sculpture from Newman. For Newman's discussion of his understanding of sculptural place, see: Rosenberg, Harold, *Barnett Newman*, New York, 1979.

[16] Graham, Dan, letter to the author.

[17] Buren, Daniel, "Standpoints", in *Five Texts*, London/New York, 1973, p. 38.

[18] Graham, Dan, *Dan Flavin*, Exhibition Catalogue, Chicago, 1967, s.p.

[19] Asher, Michael, Unpublished notes.

[20] Broodthaers, Marcel, *Moules, Oeufs, Frites, Charbons*, Antwerp 1966.

[21] Burnham, Jack, in *Hans Haacke: Framing and Being Framed*, Halifax/New York, 1977, p. 137.

[22] Foote, Nancy, "Monument, Sculpture/Earthwork", in *Artforum*, October 1979, p. 32.

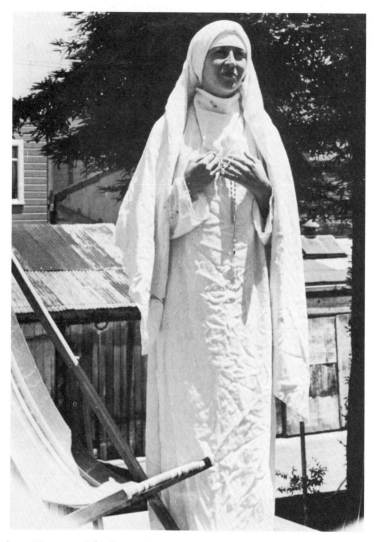

LINDA MONTANO, "The Screaming Nun" 1975
Embarcadero Plaza, San Francisco
Courtesy of the artist.

ART I dressed as a nun, danced, screamed, and heard confessions at Embarcadero Plaza.

LIFE Suzanne Hellmuth was teaching at San Francisco State and asked her students and friends to perform in the Plaza, so I did.

Steve Collins said that at one point I screamed uncontrollably and that the sound echoed throughout the entire space.

I don't remember doing this.

A few months later, I emotionally left my marriage.

The first "Happenings" of Allan Kaprow, Claes Oldenburg, Robert Whitman and others in the late fifties and early sixties appropriated the action from Action Painting to engage in direct confrontation with an audience which, ideally, became participants. In his book *Assemblage, Environments and Happenings*, from which this excerpt is taken, Kaprow outlines the informal rules for bypassing theatrical conventions which guided his early work. He consciously broke down modernism's rigid distinction between art and life by deriving the sources for his performances from any place except the arts. His rules disengage theatrical notions of space, time, and audience through the decreased use of physical frames—a stage, an announcement, a gallery—and the increased use of mental frames or attitudes to distinguish performances from other events. Kaprow's experiments with what he subsequently called "lifelike art" paralleled those of artists such as Dick Higgins, Alison Knowles, George Maciunas, and Wolf Vostell.

The Event

Allan Kaprow

It was repeatedly clear with each Happening that in spite of the unique imagery and vitality of its impulse, the traditional staging, if it did not suggest a "crude" version of the avant-garde Theater of the Absurd, at least smacked of night club acts, side shows, cock fights and bunkhouse skits. Audiences seemed to catch these probably unintended allusions and so took the Happenings for charming diversions, but hardly for art or even purposive activity. Night club acts can of course be more than merely diverting, but their structure or "grammar" is usually hackneyed and, as such, is detrimental to experimentation and change.

Unfortunately, the fact that there was a tough nut to crack in the Happenings seems to have struck very few of its practitioners. Even today, the majority continues to popularize an art of "acts" which often is well-done enough but fulfills neither its implications nor strikes out in uncharted territory.

But for those who sensed what was at stake, the issues began to appear. It would take a number of years to work them out by trial and error, for there is sometimes, though not always, a great gap between theory and production. But gradually a number of rules-of-thumb could be listed:

(A) *The line between art and life should be kept as fluid, and perhaps indistinct,*

Excerpted from Allan Kaprow, *Assemblage, Environments and Happenings* (New York: Harry N. Abrams, 1966).

as possible. The reciprocity between the man-made and the ready-made will be at its maximum potential this way. Something will always happen at this juncture, which, if it is not revelatory, will not be merely bad art—for no one can easily compare it with this or that accepted masterpiece. I would judge this a foundation upon which may be built the specific criteria of the Happenings.

(B) *Therefore, the source of themes, materials, actions, and the relationships between them are to be derived from any place or period* except *from the arts, their derivatives, and their milieu.* When innovations are taking place it often becomes necessary for those involved to treat their tasks with considerable severity. In order to keep their eyes fixed solely upon the essential problem, they will decide that there are certain "don'ts" which, as self-imposed rules, they will obey unswervingly. Arnold Schoenberg felt he had to abolish tonality in music composition and, for him at least, this was made possible by his evolving the twelve-tone series technique. Later on his more academic followers showed that it was very easy to write traditional harmonies with that technique. But still later, John Cage could permit a C major triad to exist next to the sound of a buzz saw, because by then the triad was thought of differently—not as a musical necessity but as a sound as interesting as any other sound. This sort of freedom to accept all kinds of subject matter will probably be possible in the Happenings of the future, but I think not for now. Artistic attachments are still so many window dressings, unconsciously held on to to legitimize an art that otherwise might go unrecognized.

Thus it is not that the known arts are "bad" that causes me to say "Don't get near them"; it is that they contain highly sophisticated habits. By avoiding the artistic modes there is the good chance that a new language will develop that has its own standards. The Happening is conceived as an art, certainly, but this is for lack of a better word, or one that would not cause endless discussion. I, personally, would not care if it were called a sport. But if it is going to be thought of in the context of art and artists, then let it be a distinct art which finds its way into the art category by realizing its species outside of "culture." A United States Marine Corps manual on jungle-fighting tactics, a tour of a laboratory where polyethylene kidneys are made, the daily traffic jams on the Long Island Expressway, are more useful than Beethoven, Racine, or Michelangelo.

(C) *The performance of a Happening should take place over several widely spaced, sometimes moving and changing locales.* A single performance space tends toward the static and, more significantly, resembles conventional theater practice. It is also like painting, for safety's sake, only in the center of a canvas. Later on, when we are used to a fluid space as painting has been for almost a century, we can return to concentrated areas, because

then they will not be considered exclusive. It is presently advantageous to experiment by gradually widening the distances between the events within a Happening. First along several points on a heavily trafficked avenue; then in several rooms and floors of an apartment house where some of the activities are out of touch with each other; then on more than one street; then in different but proximate cities; finally all around the globe. On the one hand, this will increase the tension between the parts, as a poet might by stretching the rhyme from two lines to ten. On the other, it permits the parts to exist more on their own, without the necessity of intensive coordination. Relationships cannot help being made and perceived in any human action, and here they may be of a new kind if tried-and-true methods are given up.

Even greater flexibility can be gotten by moving the locale itself. A Happening could be composed for a jetliner going from New York to Luxembourg with stopovers at Gander, Newfoundland, and Reykjavik, Iceland. Another Happening would take place up and down the elevators of five tall buildings in midtown Chicago.

The images in each situation can be quite disparate: a kitchen in Hoboken, a *pissoir* in Paris, a taxi garage in Leopoldville, and a bed in some small town in Turkey. Isolated points of contact may be maintained by telephone and letters, by a meeting on a highway, or by watching a certain television program at an appointed hour. Other parts of the work need only be related by theme, as when all locales perform an identical action which is disjoined in timing and space. But none of these planned ties are absolutely required, for preknowledge of the Happening's cluster of events by all participants will allow each one to make his own connections. This, however, is more the topic of form, and I shall speak further of this shortly.

(D) *Time, which follows closely on space considerations, should be variable and discontinuous.* It is only natural that if there are multiple spaces in which occurrences are scheduled, in sequence or even at random, time or "pacing" will acquire an order that is determined more by the character of movements within environments than by a fixed concept of regular development and conclusion. There need be no rhythmic coordination between the several parts of a Happening unless it is suggested by the event itself: such as when two persons must meet at a train departing at 5:47 P.M.

Above all, this is "real" or "experienced" time as distinct from conceptual time. If it conforms to the clock used in the Happening, as above, that is legitimate, but if it does not because a clock is not needed, that is equally legitimate. All of us know how, when we are busy, time accelerates, and how, conversely, when we are bored it can drag almost to a standstill. Real time is always connected with doing something, with an event of some kind, and so is bound up with things and spaces.

Imagine some evening when one has sat talking with friends, how as

the conversation became reflective the pace slowed, pauses became longer, and the speakers "felt" not only heavier but their distances from one another increased proportionately, as though each were surrounded by great areas commensurate with the voyaging of his mind. Time retarded as space extended. Suddenly, from out on the street, through the open window a police car, siren whining, was heard speeding by, *its* space moving as the source of sound moved from somewhere to the right of the window to somewhere farther to the left. Yet it also came spilling into the slowly spreading vastness of the talkers' space, invading the transformed room, partly shattering it, sliding shockingly in and about its envelope, nearly displacing it. And as in those cases where sirens are only sounded at crowded street corners to warn pedestrians, the police car and its noise at once ceased and the capsule of time and space it had become vanished as abruptly as it made itself felt. Once more the protracted picking of one's way through the extended reaches of mind resumed as the group of friends continued speaking.

Feeling this, why shouldn't an artist program a Happening over the course of several days, months, or years, slipping it in and out of the performers' daily lives. There is nothing esoteric in such a proposition, and it may have the distinct advantage of bringing into focus those things one ordinarily does every day without paying attention—like brushing one's teeth.

On the other hand, leaving taste and preference aside and relying solely on chance operations, a completely unforeseen schedule of events could result, not merely in the preparation but in the actual performance; or a simultaneously performed single moment; or none at all. (As for the last, the act of finding this out would become, by default, the "Happening.")

But an endless activity could also be decided upon, which would apparently transcend palpable time—such as the slow decomposition of a mountain of sandstone. . . . In this spirit some artists are earnestly proposing a lifetime Happening equivalent to Clarence Schmidt's lifetime Environment.

The common function of these alternatives is to release an artist from conventional notions of a detached, closed arrangement of time-space. A picture, a piece of music, a poem, a drama, each confined within its respective frame, fixed number of measures, stanzas, and stages, however great they may be in their own right, simply will not allow for breaking the barrier between art and life. And this is what the objective is.

(E) *Happenings should be performed once only.* At least for the time being, this restriction hardly needs emphasis, since it is in most cases the only course possible. Whether due to chance, or to the lifespan of the materials (especially the perishable ones), or to the changeableness of the events, it is highly unlikely that a Happening of the type I am outlining could ever

be repeated. Yet many of the Happenings have, in fact, been given four or five times, ostensibly to accommodate larger attendances, but this, I believe, was only a rationalization of the wish to hold on to theatrical customs. In my experience, I found the practice inadequate because I was always forced to do that which *could be repeated*, and had to discard countless situations which I felt were marvelous but performable only once. Aside from the fact that repetition is boring to a generation brought up on ideas of spontaneity and originality, to repeat a Happening at this time is to accede to a far more serious matter: compromise of the whole concept of Change. When the practical requirements of a situation serve only to kill what an artist has set out to do, then this is not a practical problem at all; one would be very practical to leave it for something else more liberating.

Nevertheless, there is a special instance of where more than one performance is entirely justified. This is the score or scenario which is designed to make every performance significantly different from the previous one. Superficially this has been true for the Happenings all along. Parts have been so roughly scored that there was bound to be some margin of imprecision from performance to performance. And, occasionally, sections of a work were left open for accidentals or improvisations. But since people are creatures of habit, performers always tended to fall into set patterns and stick to these no matter what leeway was given them in the original plan.

In the near future, plans may be developed which take their cue from games and athletics, where the regulations provide for a variety of moves that make the outcome always uncertain. A score might be written, so general in its instructions that it could be adapted to basic types of terrain such as oceans, woods, cities, farms; and to basic kinds of performers such as teenagers, old people, children, matrons, and so on, including insects, animals, and the weather. This could be printed and mail-ordered for use by anyone who wanted it. George Brecht has been interested in such possibilities for some time now. His sparse scores read like this:

DIRECTION

Arrange to observe a sign
indicating direction of travel.

· travel in the indicated direction

· travel in another direction

But so far they have been distributed to friends, who perform them at their discretion and without ceremony. Certainly they are aware of the

philosophic allusions to Zen Buddhism, of the subtle wit and childlike simplicity of the activities indicated. Most of all, they are aware of the responsibility it places on the performer to make something of the situation or not.

This implication is the most radical potential in all of the work discussed here. Beyond a small group of initiates, there are few who could appreciate the moral dignity of such scores, and fewer still who could derive pleasure from going ahead and doing them without self-consciousness. In the case of those Happenings with more detailed instructions or more expanded action, the artist must be present at every moment, directing and partici-pating, for the tradition is too young for the complete stranger to know what to do with such plans if he got them.

(F) *It follows that audiences should be eliminated entirely.* All the elements— people, space, the particular materials and character of the environment, time—can in this way be integrated. And the last shred of theatrical con-vention disappears. For anyone once involved in the painter's problem of unifying a field of divergent phenomena, a group of inactive people in the space of a Happening is just dead space. It is no different from a dead area of red paint on a canvas. Movements call up movements in response, whether on a canvas or in a Happening. A Happening with only an em-pathic response on the part of a seated audience is not a Happening but stage theater.

Then, on a human plane, to assemble people unprepared for an event and say that they are "participating" if apples are thrown at them or they are herded about is to ask very little of the whole notion of participation. Most of the time the response of such an audience is half-hearted or even reluctant, and sometimes the reaction is vicious and therefore destructive to the work (though I suspect that in numerous instances of violent reaction to such treatment it was caused by the latent sadism in the action, which they quite rightly resented). After a few years, in any case, "audience re-sponse" proves to be so predictably pure cliché that anyone serious about the problem should not tolerate it, any more than the painter should con-tinue the use of dripped paint as a stamp of modernity when it has been adopted by every lampshade and Formica manufacturer in the country.

I think that it is a mark of mutual respect that all persons involved in a Happening be willing and committed participants who have a clear idea what they are to do. This is simply accomplished by writing out the scenario or score for all and discussing it thoroughly with them beforehand. In this respect it is not different from the preparations for a parade, a football match, a wedding, or religious service. It is not even different from a play. The one big difference is that while knowledge of the scheme is necessary, professional talent is not; the situations in a Happening are lifelike or, if they are unusual, are so rudimentary that professionalism is actually un-

called for. Actors are stage-trained and bring over habits from their art that are hard to shake off; the same is true of any other kind of showman or trained athlete. The best participants have been persons not normally engaged in art or performance, but who are moved to take part in an activity that is at once meaningful to them in its ideas yet natural in its methods.

There is an exception, however, to restricting the Happening to participants only. When a work is performed on a busy avenue, passers-by will ordinarily stop and watch, just as they might watch the demolition of a building. These are not theater-goers and their attention is only temporarily caught in the course of their normal affairs. They might stay, perhaps become involved in some unexpected way, or they will more likely move on after a few minutes. Such persons are authentic parts of the environment.

A variant of this is the person who is engaged unwittingly with a performer in some planned action: a butcher will sell certain meats to a customer-performer without realizing that he is a part of a piece having to do with purchasing, cooking, and eating meat.

Finally, there is this additional exception to the rule. A Happening may be scored for *just watching*. Persons will do nothing else. They will watch things, each other, possibly actions not performed by themselves, such as a bus stopping to pick up commuters. This would not take place in a theater or arena, but anywhere else. It could be an extremely meditative occupation when done devotedly; just "cute" when done indifferently. In a more physical mood, the idea of called-for watching could be contrasted with periods of action. Both normal tendencies to observe and act would now be engaged in a responsible way. At those moments of relative quiet the observer would hardly be a passive member of an audience; he would be closer to the role of a Greek chorus, without its specific meaning necessarily, but with its required place in the overall scheme. At other moments the active and observing roles would be exchanged, so that by reciprocation the whole meaning of watching would be altered, away from something like spoon-feeding, toward something purposive, possibly intense. . . .

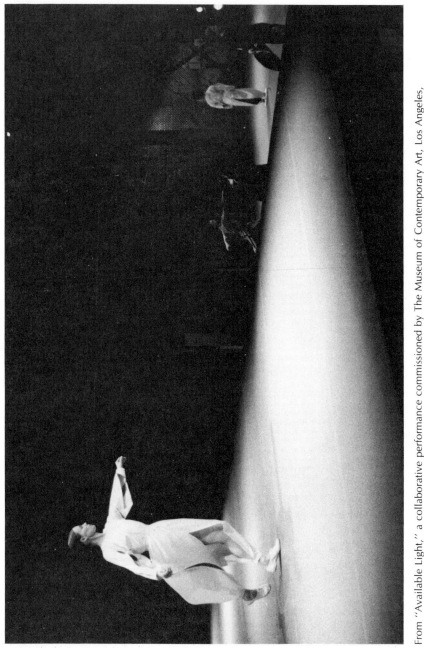

From "Available Light," a collaborative performance commissioned by The Museum of Contemporary Art, Los Angeles, premiered September 1983 at the Temporary Contemporary, Los Angeles, CA. Performed by The Lucinda Childs Dance Company. Music composed by John Adams. Choreography by Lucinda Childs. Stage design by Frank Gehry.

Critic RoseLee Goldberg presents an overview of different attitudes towards space by seventies' artists whose interest in the process of artmaking blurred distinctions between performance, sculpture, and conceptual art. Goldberg regards performance as the materialization of art theory, an arena for the body and subjective experience to test theoretical notions of space. Various conceptions of space are defined and exemplified in the work of conceptual artists, dancers, and performers. The mixture of media and attitudes marks a striking contrast to modernism's desire to maintain a rigid distinction between the various arts.

Space as Praxis

RoseLee Goldberg

INTRODUCTION

This article takes as its starting point the exhibition-publication *A Space: A Thousand Words* held at the Royal College of Art Gallery, London in February 1975. The exhibition comprised the work of thirty contributors on the 'production of space.' Those participating could professionally be categorized as artists, architects, musicians and filmmakers, but the intentions of the exhibition were to go beyond these categories and bring together different sensibilities and preoccupations, not in order to create false relationships between them, but to hold the ideas up to one another, as from a distance.[1]

Space became the common denominator after careful consideration of how this 'concept' is felt, not just in professional circles but as an obvious prime sensation that we all experience. In architecture, recent discussions were using as critical reference social, politico-economic and semiological yardsticks. Space, after all an inherent architectural principle, had however been reduced to a product of such discourses. Yet attempts were being made to question the nature of space itself, and we wished to make this work public.

In art, the lengthy debate on conceptual art seldom included specific reference to the perception of space. A symposium held on radio network WBAI-FM New York in 1969, moderated by Seth Siegelaub and entitled 'Art without Space',[2] began with the proposition by Siegelaub that they would discuss the "nature of the art whose primary existence in the world

Reprinted from RoseLee Goldberg, "Space as Praxis," *Studio International* (September 1975).

does not relate to space, not to its exhibition in space, not to its imposing things on the walls." None of the artists agreed.

> *Anything that exists has a certain space around it; even an idea exists within a certain space" (Lawrence Weiner).*
> *Maybe we are just dealing with a space that is different from the space that one experiences when confronting a traditional object (Robert Barry).*
> *I use the word space in two specific senses; one, as an interest or subject matter of the work and, two . . . the space as a condition for the awareness of the work . . . by space I refer to the lack of space (Robert Barry).*
> *I don't understand how you can think that something that is a fact of life is not germane . . . you may not consider space an art material, but the fact that you are occupying a certain amount of space in a pure physical sense means that you are dealing with space whether you want to or not (Lawrence Weiner).*
> *We all make objects that don't have any space around them except the personal experience of space . . . Music is a very spatial experience. I think we can experience space in a less physical way and that's the kind of space I'm talking about (Robert Barry).*

The discussion developed many themes, but mainly it confirmed that space is always inherent in art. Indeed, music, dance, gallery space, an exhibition on 'space' of two-dimensional propositions about space, increased the complexity of the subject. The response by contributors, and subsequent discussion of the exhibition, has led me to further investigate this notion. The following text, which does not refer to the exhibition, attempts to consider the way that our perception of space is challenged and altered. The references are to recent work of selected artists only, and not to architecture. For such a comparative exercise would necessitate a lengthy analysis of the ways in which space has been considered in architecture. Rather, I have sought to discuss the particular notion of 'Space as Praxis' as learnt from various activities of artists and performers working in what has come to be considered a 'conceptual art' framework. Hopefully those architects reading this piece will select for themselves the relevant comparisons.

THEORY AND PRAXIS

Although the notions of theory and practice have co-existed over the centuries, fluctuating in importance, sometimes dialectically opposed, sometimes both considered to be as general as one another, sometimes both equally indispensable for any activity, it was in a certain Anglo-Saxon framework that these two acquired delicate moral overtones. Theory pertained to Apollo, the god of intellect, while practice was symbolized by the wild festivities of Dionysus.

For someone like Oskar Schlemmer, working as painter and theatre director at the Bauhaus during the twenties, theory and practice reflected a puritan ethic. Schlemmer considered painting and drawing to be that

aspect of his work which was most rigorously intellectual, while the una-dulterated pleasure he obtained from his experiments in theatre was, he wrote in his diary, constantly suspect for this reason. The essential inves-tigation of his paintings, as in his theatrical experiments, was that of space: his paintings delineated the visual and two-dimensional elements of space, while theatre provided a place in which to 'experience' space. Although beset with doubts as to the specificity of the two media, theatre and painting, Schlemmer considered them as complementary activities: in his writings he clearly describes painting as theoretical research, while performance was the 'practice' of that classical equation.

Schlemmer's circumstances become an interesting pointer to present preoccupations in art, if one considers particularly recent events in New York. For the first time since the Bauhaus and the twenties, there has been a coming-together of dancers, musicians and artists; and the resulting cross-fertilization of concepts and sensibilities makes it difficult for those wishing to relocate the categories into either theatre, music auditorium or art gal-lery. For instance, the beginnings of an idea could sometimes be found in a John Cage piece, before it moved to other media; alternatively its origins could be found in the more formal enclaves of minimal sculpture, which was then transformed by some dancers into performance work. In other words, there seems to have been a general consensus of sensibility which links that work which is now considered 'conceptual' to performance art. This merging of related ideas allows performance to be considered the 'practice' of much theoretical and analytical work.

PERFORMANCE SPACE AND MATERIALIZATION OF CONCEPTS

But if we think of the ways in which much conceptual art and performance work are presented, it is clear that performance implies a different kind, i.e., quantity, of space, for its execution. Space becomes the medium for practice and actual experience. Put simply then, 'theory'—whether 'con-cepts,' 'drawing,' or 'documentation'—remains essentially two-dimensional, while 'practice/performance' implies a physical context, a space in which to experience the *materialization* of that theory. In this way recent art is to be looked at not only as the 'dematerialization of the art object' as it has been described by Lucy Lippard, but inversely as the materialization of the art concept.

Considering that "concept art is first of all an art of which the material is concepts,"[3] the materialization of these concepts beyond the realm of the mind has allowed for the inclusion of greatly varied art works, separately and conveniently named body art, land art, performance art, and so on. Although the form of each of these works and the medium used may differ considerably, the relationship between the intentions of the various artists is often quite an intimate one. What really alters the perception of the respective pieces is the *means* and *places* chosen for their execution. If we

'construct' a familiar example to illustrate this, we can see how intentions and preoccupations interact with means and places. Let us consider the following instructions:

'Take a book and lie for three hours in the sun, using the book to cover your bare chest.'

1. This statement may be produced in a book or framed and hung in a gallery. In this form it would be typical of many conceptual art instructions, where the execution or non-execution of the piece is irrelevant. The idea stands alone and the action is performed mentally.

2. These instructions may be executed by an artist on a lonely beach accompanied only by a photographer who documents the skin burning around the book, in detailed colour photographs. The photographs may then be exhibited in a gallery (with or without the original instructions), as a record of a live event. This would probably be discussed in relation to body art.

3. But it could also be presented as a piece of land art, if the indentations made by the artist's body in the land were recorded and this information presented in a gallery.

4. The piece could be differently constructed by dancers, using their bodies to suggest the feel of the action and so symbolically recall the body's relationship to the terrain. This could be performed in a gallery, and would be discussed under the general heading of 'performance art.'

From this exercise we can deduce that the attitudes of the various artists bear comparison while the actual works differ considerably. There is an overall insistence within these four possibilities on the experience of time, material and space rather than on a representation in formal terms.

So while some 'conceptual' artists were refuting the art object, others saw the experience of space and of their body as providing the most immediate and existentially real alternative. Much of conceptual art, when presented as either 'land,' 'body,' or 'performance' art, implied indirectly or directly a particular attitude to and investigation of the experience of space. This experience may seem to have little to do with the intentions or the meaning of a piece, but from the viewer's standpoint the experience of the piece sets up a new set of responses to the perception of space. Whereas earlier representations of space in art have been discussed variously from the simple planes of gothic paintings to the disappearing perspectives of early renaissance and renaissance art, or from the surfaces of Cubist painting to the enormous space obstructions of minimal sculpture, much recent art has insisted on the body as a direct measure of space. The relationship between the viewer, the artist and the art work then became an important one, since the viewer would have to put together the indeterminate elements of the space in order to fully perceive the piece.

This move from objective consideration of objects in the early sixties, to the mingling of experience, precepts and concepts generally conceded by the 'conceptual movement,' became a wave engulfing all kinds of creativity, not only those aspects of 'fine arts' where the anti-objectivity could be most specifically 'seen.' In music, too, space was the medium for less structured sound. John Cage referred to a 'diffuse acoustical space.' "In recent years my musical ideas have continued to move away from the object (a composition having a well-defined relationship of parts) into process (nonstructured activities, indeterminate in character)."[4]

Performance also reflected anti-object precepts. It moved away from "manipulating the body or sound as sculptural elements," as in the early works of Yvonne Rainer, Steve Paxton, Steve Reich, Trisha Brown and others, to less structured and exploratory work. Yvonne Rainer said of her work that she wished to use a different point of view about her body, so "that it could be handled like an object, picked up and carried, and so that objects and bodies could be interchangeable."[5] But to consider the body and object as interchangeable inevitably emphasized the body itself as the individual measure of space: as our first means of perceiving space.

SPACE AS PRAXIS

This recent insistence on the body as a means of experiencing space leads to spatial notions very different from the ones we have come to know through painting and sculpture. Rather than simply delineating the limits of spaces, 'space as praxis' extends our perception of space itself and body space. For it is in space that we experience the effects of these art propositions. For example, those artists who began with the premise of the 'artist-as-art' (Manzoni, Brus, Gilbert and George) focused on their own persons, so that the viewer could respond with a like body-awareness. But the private consciousness of the body, in these instances, had little to do with wider spatial experience.

Only subsequent works presented a new sense of space, which I shall attempt to describe under the following terms: *constructed space* and *powerfields* (Nauman, Acconci), *natural space* (Oppenheim), *body space* (Simone Forti, Trisha Brown, Yvonne Rainer), *spectator space* (Graham), or even work which was presented as a critique of the uses of *public and private space* (Buren, Dimitriejvic).

POWERFIELDS

In his early works Vito Acconci used his body to provide an alternative ground to the 'page ground' he had used as a poet. He described these initial attempts as very much oriented towards defining his body in space.

Rather than use the body as a narrative element or in order to 'go beyond the object,' he was concerned with describing an area which he calls

the 'powerfield.' This notion, taken from Kurt Lewin's three-part principle elaborated in *The Principle of Topological Psychology*, assumed a circle or a power-field which included all possible interaction in physical space.[6] In this sense his pieces were less concerned with locating his body in space, but rather with implicating people in the space through their own, and his, actions. He did not wish the audience to merely empathize with him, but was concerned with "setting up a field in which the audience was, so that they became a part of what I was doing . . . they became part of the physical space in which I move."[7] In *Seedbed*, therefore, when Acconci masturbated under a ramp built into a gallery over which passers-by walked, there occurred a curious interaction between him and his audience. Because he was constantly physically present (even though the evidence of this was only through his masturbating being audible) the audience were implicated in an act which would normally be performed more privately, and which in public would normally be considered 'distasteful.' He relied on the foot-steps of his potential voyeurs to provide the fantasy necessary to keep him at his task for hours on end. Being 'underground,' the pun on 'seedbed' created not only an awareness of place for both him and the audience but also the implied sense of 'growth' which the title inferred. But the wish to create a powerfield—where the audience could experience a new percep-tion of space and their movement in it—could also be created by construc-tion, through the use of model, rather than through direct physical con-frontation with the artists.

> There has been this urge recently to find an alternative to live performance, because it seems that a power field can probably exist without my physical presence. One way that this can occur is if a space is designed, directly oriented for my potential use so that when a person came into the space he would still be involved in my presence . . . this interest hasn't been totally devoid of an art context. It's always been how to make an exhibition area viable . . . to make those spatial concerns "hard."[8]

NATURAL SPACE

Dennis Oppenheim on the other hand used 'natural space' (beach, moun-tain side, ploughed field) to make direct correlations between the body and the space surrounding the body, rather than constructions or directly in-terpersonal performance as Acconci did.

> The body as place is a common condition of body works. Oppenheim's 1969 earth works extended Carl Andre's conception of "sculpture as place" to the point where as he said "a work is not put in a place, it is that place." This sentiment applies equally to Oppenheim's body works. In several works his body is treated as place. Generally the body as place acts as a ground which is marked in ways quite similar to those employed in earthworks.[9]

In an interview with Willoughby Sharp, Oppenheim emphasized that his concern for the body came from constant physical contact with large bodies of land. He also said that working with the land "demands an echo from the artist's body." His *Reading Position for a Second Degree Burn* (1970) illustrated these complementary sensibilities, while pointing also to a very different kind of body art, less concerned with space or place, but with inflicting marks and weals on the body as affirmation of a deeply personal physical consciousness of the body as matter.

CONSTRUCTED SPACE

However this shift from object to place was, ironically, finding its final form as a photograph in a gallery. The photograph (the pornography of art, according to Andre[10]) reduced the emphatic experiential quality of the work to a mere record of the experience. Documentation became the obverse of conceptual art. Initial anti-object motives and direct experience criteria of such pieces were absorbed and muted by the medium of 'documentation.'

The documented projects transmitted an idea of space by suggestion, projection or model only; the information on space was acquired passively. But the passive role of the viewer could be changed to an active one if the experience of the constructed space was the experience of the piece. Unlike the quasi-theatrical interventions of Acconci, many of Bruce Nauman's pieces relied on a more formal definition of space. Specifically constructed environments were built so that a particular feeling of space was designed into each work. In May 1970, five years after his first body work at the University of California at Davis, Nauman made a V-shaped corridor at San Jose State College. The two corridors were made of specially sound-proofed material, causing pressure changes in the corridors.

> When you were at the open end of the V there was not much effect. But as you walked into the V the pressure increased quite a bit. It was very claustrophobic. The corridors were two feet wide at the beginning and narrowed down to about sixteen inches. The walls became closer and slowly forced you to be aware of your body. It could be a very self-conscious kind of experience.[11]

Nauman insisted that many of the pieces were to do with creating a strict environment so that "even if the performer didn't know anything about me or the work that went into the piece, he would still be able to do something similar to what I would have done." In the piece described above, a mirror threw the spectator back on himself, dislocating his own image through unexpected confrontation in unfamiliar places. Nauman's comments were important in that they outlined that the specific intention of each piece was to change the viewers' perception of space. As in *Coloured*

Light Corridor, presented at the Hayward Gallery in 1971, or in pieces which combined the distancing use of video television, Nauman manipulated space in order to provide a means for us to recognize *how* we perceive space, rather than *what* we perceive, while manipulating what he called the "functional mechanism of a person."[12]

BODY SPACE

Such active and passive experience of one's body and space itself occurs when one attends the performance of artists such as Simone Forti, Trisha Brown or Deborah Hay. All three performers bring to the gallery the specific training of dancers (each having passed through—with varying degrees of critical appraisal—the working methods of dancers such as Merce Cunningham, Ann Halprin, Martha Graham or the Judson Group) so that their body language is concerned with the dancer's ability to articulate and experience both the body itself and the space in which it moves. They rejected the formal articulation of conventional dance which isolated body parts into appendages of arms, legs, head, and then facial expression and symbolic gestures. Rather were they concerned with "individually selecting something in the environment and observing its movement, then abstracting an element from the observed movement that they could take on with their own bodies."[13]

Kinaesthetic movement (sensing internal body movement and the changing dynamic configurations of the body) was an important aspect of the work. It could be explained by using the example of a juggler throwing balls in the air. The skills of the juggler depend on a balance between the body and its minute tensions, and a careful knowledge of the movement, thrust and fall of the balls. The dancers perform with this same double-edged consciousness: first the internal movement of the body and then the ways in which the body dislocates space.[14]

Inevitably each dancer introduced a particular personal perception of body-space. Simone Forti often worked from certain experimental psychology premises, allowing each movement to have its own presence and meaning. The *Huddle,* a dance construction requiring 6 or 7 people, attempted to define *mass* using bodies in space. It started out looking like a rugby scrum, then the mass began to move as one person detached himself and climbed over the human lump, one foot on someone's thigh, a hand in the crook of someone's neck, to the other side.

Her reflection on space awareness not only stemmed from behavioural demonstrations but also from subtler works by musicians such as La Monte Young or John Cage, which attempted to experience sound, space and movement simultaneously, with no distinctions between the work (music) and the people who filled the space.

BODY AS OBJECT

The outcome of these performances was also a means of rejecting the stylized conventions of formalist art, in this case of Minimalism. Encouraged by the interaction in New York between dancers and artists throughout the sixties, many of the discussions which revolved around minimal sculpture were applied to the various works presented by the dancers.

While minimal sculpture introduced a "new kind of physicality that came from the material, and not from internal psychological mechanisms," in dance the 'objecthood' of Minimalism was paralleled by a notion of the body as neutral object, outlining positions in space only. The dancers' work became more exploratory, developing the internal (even existential) consciousness of the body in space. The 'non-expressionistic' aspect of minimal sculpture took the form in dancing of 'non-theatricality': "A refusal to project a persona, but thinking of oneself in dancing as simply a neutral purveyor of information."[15] According to Yvonne Rainer, this tended to free dancers from the earlier dramatic and narcissistic content of traditional dancing. She wrote that her overall concern was "to weight the quality of the human body toward that of objects, away from the super-stylization of the dancer."[16] Her later work, however, returned to projecting 'persona' (a more private persona), or a kind of 'interior space' which led away from the investigation of space itself to more psychologically and folklore-oriented work.

GRAVITY

Trisha Brown on the other hand rarely played on exteriorizing fantasy or making private emotions public and general, but dealt with more direct space experience, using existing buildings as obstacles to be overpowered through physical effort. One piece consisted of performers appearing over the top of a building. They proceeded to walk down the seven stories of its vertical face, supported by mountaineering equipment. Another work, using the same mechanical support, took place along one wall of a gallery at the Whitney: the performers moved at right angles along the vertical wall-face. The audience would virtually swing back on their chairs in an attempt to view the dance sideways on, rather than from the top as they were obliged to do, as though watching the action from a few floors above ground. So within one conventional gallery space, Trisha Brown forced a further inversion of space perception by working against the laws of gravity.

She then reversed the process by executing performances with six dancers lying on the floor, going through various movement sequences. The audience stood around them and had to tip slightly forward, heads bent, to gain an overall view of the choreography on the ground. Or they

sat on the floor next to the performers, thereby seeing different parts of the body, soles of feet, top of head, side of torso or thighs. Articulating the body on the floor eliminated problems of balance, tension and gravity pull which occur when working vertically in space, and also allowed for quite different figurations.

SPECTATOR SPACE

But the 'integrity of each gesture,' which Trisha Brown has said is central to her work, is something of which we are seldom consciously aware in ourselves. It is only through becoming spectator to our own actions, either in a mirror which reflects 'present time,' or through video which relays not only present, but also past gestures, that experience is truly learned. In a recent piece, first shown at Projekt, Cologne in Summer 1974, and again at the Lisson Gallery, London, Dan Graham used both mirror and video to show each participant the 'accumulation' of their own movements. By using mirror and video, one reflecting the other, he incorporated also a sense of future time. On entering the cube one saw oneself first in the mirror and then, 8 seconds later, saw that mirrored action relayed on the video. Present time was the viewers' immediate action, which was then picked up by the mirror and video in rotation. One saw not only what one had recently performed, but knew that what one would perform, would then become on the video what one had just performed. Thus the visitor had to adjust to both present and past time, as well as to an idea of future time. All future action, the entrance of others into the structure, was anticipated as one waited to see how they would reappear in present time as recordings of past moments.

In this piece, *Present Continuous Past,* Graham explored the convention of mirrors as reflecting present time:

> *Mirrors reflect instantaneous time without duration . . . and they totally divorce our exterior behaviour from our inside consciousness—whereas video feedback does just the opposite, it relates the two in a kind of durational time flow.*[17]

But Dan Graham's pieces (particularly the pre-Projekt work) could be studied not only as an investigation of time and space, but also as a theory of audience/performer relationship—'spectator space' as he calls it. In line with this idea, the mechanics of many pieces were built so that the audience was at once the performer.[18] This interest was based on Graham's involvement with Bertolt Brecht and his theory of audience-performer relationships. He concentrated on Brecht's idea that in order not to alienate audience and performer, a self-consciousness and uncomfortable state should be imposed on the audience/performers.

Two Consciousness Projection (1973) examined the level of self-consciousness which could be projected by performers:

In this piece a woman focuses consciousness only on a television image of herself and must immediately verbalize the content of her consciousness. The man focuses consciousness only outside himself on the woman, observing her objectively through the camera connected to the monitor . . .

The spectator space in this and other similar pieces has, according to Graham, to do with social and perhaps even anthropological aspects of performance. His more recent works however, involving larger numbers of people, were structured so that the experiences of space and time were added to the earlier more 'psychological' pieces. For Graham the particular interaction between individuals, their action in public and private space, and the constructed spaces, made the pieces more 'architectural,' in the sense that architecture implies these relationships.

PRIVATE AND PUBLIC SPACE

The various works described above were often intended to divert the conventional function of the gallery as 'showing objects' by using it as a place to experience experience. Concept art implied in its early stages, directly or indirectly, a critique not only of the object but also the circle of art market, art critic and art institutions which surrounded it. By making so much of the work intangible it was hoped that these operations could be short-circuited. Of course the gradual acceptance of such work by this same circle, and its saleable objecthood in the form of text, photograph and document, has never truly revolutionized the use of art in the existing culture. But the USE of the gallery space itself has certainly become more flexible. The space need not be merely a showcase for marketable goods, but can at best be considered a public area for certain experimental workshops and reciprocal experiences. Although there are numerous other works which could fit this discussion, one further aspect should be considered: that of artists like Daniel Buren and Braco Dimitriejvic, who have sometimes refuted the gallery space, and by moving outside it have tended to act as a critique of, and attempted to manipulate our perception of, public space.

Buren's striped canvases, unchanged in nine years, presented in a gallery or outside it, imply a rhetoric on the idea of public and private space. By opposing the two, inside and outside, the gallery with its specialized audience becomes a symbol of private, exclusive territory. While the stripes in public space (metro, advertising billboards, sandwich men) force a new dimension on public space. Not by altering the space as such, but rather by enforcing the reality of each space.

Braco Dimitriejvic, on the other hand, plays with conventional cognition of public spaces by using it for private unknown persons. He erects monuments to 'casual passers-by' in public squares, or as blown-up photographs on billboards, buses or on monumental public buildings, and so

questions the relationship between specific public information and the individual and that between man and his exterior reality:

> *I refer primarily to our automatic acceptance of particular forms of information dispersal, while disregarding its real content, and to the passive and negative attitudes which are passed through education from one generation to the next.*

Public space is equally accepted by us in this unquestioning way, and we are conditioned to read it as being unusable for private activity. Dimitriejvic's work activates the space, and in so doing alters our perception of it.

THEORY AND PRACTICE, AGAIN

The description of these works makes one thing clear: performance art, now as in the twenties, directly reflects spatial preoccupations in the art world. But unlike the twenties, when the separation between theory and practice (in a dialectical form or not) was absolute, it is difficult to separate where 'conceptual' art ends and performance begins. For conceptual art contains the premise that the idea may or may not be executed. Sometimes it is theoretical or conceptual, sometimes it is material and performed. So too with performance art. It even uses a 'conceptual' language (photograph, diagram, documentation) to communicate ideas. So on the one hand, the language of conceptual art has expanded that of performance art to a point where the medium of communication is very similar. On the other hand, and in reverse, performance has altered the way that conceptual artists were working. Whether, for instance, Nauman considered his early body work as 'dance pieces without being a dancer,' or Bob Morris was influenced by working with Simone Forti and Yvonne Rainer, clearly the dancers' spatial attitudes and conceptual approaches had a reciprocal influence.

It is therefore interesting to see that Schlemmer's 'space as praxis' has been brought far beyond its original restrictions by the relationship between conceptual artists and performers. But it has not gone beyond a very loose interpretation of theory, a confusion between theory and written instructions, between theory and two-dimensional expression. Allowing for this generalized notion of theory as 'concept,' 'drawing' or 'documentation,' however, it is clear that when dance or conceptual art 'instructions' are performed, space is identified with practice. It is in space that ideas are materialised, experience experienced. Space consequently becomes the essential element in the notion of practice.

NOTES

[1] The publication *A Space: A Thousand Words* is an exact reproduction of the exhibition, including introductory texts by the organizers. It is available through the Arts Council of Great Britain.

[2] Quoted in Lucy Lippard's book *Six Years: The Dematerialization of the Art Object*, p. 127. The

broadcast took place in November 1969, with Lawrence Weiner, Robert Barry, Douglas Huebler, and Joseph Kosuth.

[3] Henry Flynnt Jr., 'Concept Art,' printed in *Anthology*, Heiner Friedrich 1961, ed. La Motte Young, 1963.

[4] John Cage, 'The Musical Object' quoted in P. Carpenter, *Current Musicology*.

[5] Yvonne Rainer, interview in *Avalanche*, summer 1972, p. 50.

[6] Kurt Lewin, *Principle of Topological Psychology*, New York, 1936. Lewin mentions three kinds of interaction between regions. The first is locomotion, the second communication, in which a part of region A extends to region B so that there's an overlap, and the third is a powerfield, in which a circle or oval develops from region A to cover region B. The powerfield would be the most inclusive.

[7] Vito Acconci, interview, *Avalanche*, fall 1972, p. 72.

[8] Ibid., p. 76.

[9] Willoughby Sharp, 'Body Works,' in *Avalanche*, fall 1970, p. 15.

[10] Carl Andre, interview in *Avalanche*, fall 1970, p. 24.

[11] Bruce Nauman, interview in *Avalanche*, winter 1971, p. 24.

[12] Moholy-Nagy discussed the effect of body mechanism in his essay 'Theatre, Circus, Variety': "The effect of the body mechanism arises essentially from the spectator's astonishment or shock at the potentialities of his own organism as demonstrated to him by others." (*Die Bühne im Bauhaus*, 1945, republished 1965 by S. Kupserberg, p. 45.)

[13] Simone Forti, *Handbook in Motion*, Nova Scotia College of Art Press, 1974, p. 31.

[14] Oskar Schlemmer discussed this in detail in his essay 'Mathematics of the Dance', 1926: "if one were to imagine space filled with a soft, pliable substance in which the figures of the sequence of the dancers' movement were to harden as a negative form . . . this would demonstrate the relationship of the geometry of the plane to the stereometry of the space."

[15] Yvonne Rainer, *Avalanche*, summer 1972, p. 50.

[16] Ibid.

[17] Interview with author, June 1975.

[18] Graham's pieces are particularly structured to allow for 'spectator space' and the spectators' unexpected perceptual changes. Whereas Nauman and Acconci's works are more directed to personalized projections of the artists' private space; an implied relationship between artist and viewer.

DARA BIRNBAUM, "Kiss the Girls: Make Them Cry" 1979 Videotape: color, stereo, 7 minutes. Installation view: window of H Hair Salon de Coiffure, NYC. *Photograph courtesy of the artist.*

For modernism, the canonical distinction made between fine art and popular culture is that fine art is self-critical while popular culture is mere entertainment. Social scientist Norman Klein shows that such a simple distinction is too easy: popular culture has its own forms of self-criticism; for example, talk shows that reveal what goes on "behind the scenes." Klein suggests that the subject of both high and low art is frequently the audience itself. In the past decade, in particular, art has referred increasingly to the shared audience experience. Audience culture, influenced very strongly by changes in the delivery and distribution of art, literature, video, and film, provides the most fruitful perspective from which to think about the presumed differences between art and kitsch.

The Audience Culture

Norman Klein

The frantic discomfort of guests on quiz shows has often been parodied on film, most recently in *Melvin and Howard,* where the life quest of Melvin's family is to win on a "Let's Make a Deal" format show. In the video art piece *Kiss the Girls and Make Them Cry,* Dara Birnbaum selected a less frantic format to play with, "Hollywood Squares." There are no housewives dressed as giant wedding cakes, or families going into bacchanalian frenzy at the sight of a dining room set. On "Hollywood Squares," the celebrities are the ones on trial.

All quiz shows attempt a certain Las Vegas urbanity. The tanned, omniscient narrator—the host—will regularly survey the greed of the contestants, and insult them benignly—a smirk, a one-liner, a deadpan "No kidding?" The audience laughs. But on "Hollywood Squares," this polyester urbanity is the entire show. Everyone is coolly observing everyone else's ignorance, the way that glamour compensates for limited knowledge. The show undercuts the celebrities, like a multiple-screen talk show. Meanwhile, the viewer is invited to feel part of this electronic courtliness, and to judge who is the quickest wit.

What then did Dara Birnbaum do with this half-hour of blinking, smirking and imping? She edited out moments where the celebrities respond to the audience, then proceeded to isolate ("alienate") them. She telescoped their faces in and out; she paused at awkward moments, and repeated them, until the viewer could catch the celebrities' discomfort—an awkward wave, the adolescent bluff, a wildly exaggerated grin.

Written for this volume, printed with permission of the author.

To further alienate the image, she introduced a musical sound track a few minutes into the piece—a bouncy version of "Georgie Porgie, kiss the girls and make them cry." The printed lyrics were flashed on the screen—a technique used often in videotapes shown in an art context. They also resemble the ideograms on Russian poster art of the twenties, or the bouncing ball cartoon shorts that came out of the Fleischer Studios. The viewer is asked to focus on the women; they seem to handle the icy Kino eye more painfully than the men.

One could write a cultural history of the past 200 years on how mass culture has been incorporated into painting, architecture, literature. If we chose to add folk culture to such a history, we could add volumes more. There is always a dilemma in the way such histories might be written, however—or the way Dara Birnbaum's piece might be seen. To borrow an example from criticism, even with the Frankfurt School (or particularly Adorno and Horkheimer), the distinctions between high and low culture are laid out as firmly as lines on the spectrum; art that is not self-critical belongs to the culture industry; art that claims to be self-critical is generically fine art, though it may not be free of the coloration of mass culture. It is generally assumed that the critic who examines this "crossover" must be clear, first of all, about which is art and which is not. For a start, we can say (bizarre I admit): Tarzan is not Tolstoy; Dostoyevsky is not Agatha Christie, and so on. Along that chain, Dara Birnbaum is not MTV, the rapidly growing 24-hour music network.

I will not belabor the reasons why these canonical distinctions are so central to criticism of mass/fine art (and particularly to literary criticism). It is ironic to remember, however, that among English Romantics of the 1790s, or French Romantics of the 1830s, or the Russian avant-garde in the 1920s, these distinctions were far less important. There were even attempts at a populist culture, a bit like "democratic art," as some Americans called popular wood engraving in the nineteenth century. "Romanticism is liberalism in literature," Hugo wrote in 1827, and his alliances with liberal publishers, and mass publishing, from 1830 onwards demonstrate in the most practical way possible what he meant.

There is also no need to belabor the recent shift away from canonical criticism; distinctions between the fine arts and mass culture are, again, loosening. Is this due to the shift in information systems—how culture is delivered? Shall we blame the computer or video for the change? (Or the steam-driven printing presses in 1836 in Paris for popular Romanticism spreading itself thin?) Shall we simply assign the problem to the generic crises of postmodernism? I would prefer to avoid rethreading all of that. Clearly, the most practical question must be whether there is anything that canonical criticism has ignored, anything of the referent or the intention of mass/fine art. I will try to address that question, using Dara Birnbaum's video piece as model.

The referent in much of video art is the television audience itself—prayerfully before the tube, making friends with the colored dots. *Kiss the Girls and Make Them Cry* has as its signified the commonly shared experiences of watching television. Whether we watch the shows or not, we are already informed of the experience (much the way we laugh at the image in a political cartoon).

At approximately the same time that Birnbaum's piece came out, Music TV began. After only a few years, MTV has already changed the way popular music is promoted. Increasingly, record releases have to be accompanied by whimsically nostalgic films of the rock group, from two to five minutes in length. Not surprisingly, Birnbaum's work has been compared to MTV (possibly even pirated there). By canonical standards, this is a serious "crime"; her work must separate itself from mass culture, must be self-reflective, even in its form.

The forms do indeed resemble each other uncannily. The telescoping montages, the eerie disjunction of music and narrative, the choppy editing (designed as an alienation effect) are common to both. However, they vary in one important way: the MTV pieces are often nostalgic narratives. Like kodachrome photos from the thirties, they have an oddly dyed, denatured look, a neon effect. They are dusky bits of business from Bogart and Bette Davis, from the "hep" forties, from gang epics like *The Warriors*, from television detective shows, from car crashes in movies. They are nostalgia turned into candle wax, but let us be clear about the issue: The nostalgia is not for the thirties itself. They are not airbrushed tabloids about the streets of New York after VE Day; and let us not simply call them "surreal," the miracle catchall phrase which says that here is mass culture sophisticated enough to pass as self-reflective.

These nostalgic puffs of filmed music are dreaming of the stuffed red velvet of neighborhood movie houses in 1945, of the neighborhood sense of community, when dad and mom went to a double bill every Tuesday night because the theater was air-conditioned. The nostalgia is for the audience of 1945, not the political or physical reality of that year. Mass culture is endlessly signifying how audiences felt, xeroxes of xeroxes, if you will—but rarely addressing the political or social conditions directly.

Dara Birnbaum is using a different format in that respect. There is little attempt at narrative, although some of her work plays with advertising scenarios. Like Nam June Paik's work, the theme is the Kino eye itself—how it changes people's expressions; how it is present at all times, denaturing the figures. MTV seeks to block the Kino eye; Birnbaum emphasizes it.

If only the distinctions were always that clear. Can we identify MTV as a sort of anti-Aristotelian narrative? Where does that place us in the canonical scheme of things?

The MTV experiments with narratives do, in their own way, propose

a modernism. For support, I would call on the essay about Superman by Umberto Eco, where the anti-Aristotelianism of cartoon strips is compared to Robbe-Grillet (with suitable filters in between: Eco is quite magnificent in this essay).[1]

We can compare Eco with the orthodox canon, for example Clement Greenberg in "Avant-Garde and Kitsch."[2] If we interpolate MTV into Greenberg's article, the canon suggests that Music TV is a feature of ersatz culture; it is kitsch, "using for raw material the debased and academized simulacra of genuine culture." MTV could not exist without "the availability close at hand of a fully matured cultural tradition, whose discoveries, acquisitions, and perfected self-consciousness kitsch can take advantage of for its own ends. It borrows from its devices, converts them into a system, and discards the rest."

Clearly MTV, like most mass culture, borrows mostly from its own genus—from Hollywood films, from the audience culture in rock concerts, network television, advertisements. The canon does not help us here. We are forced to equate this gaudy effluvium with devices from the fine arts, as a type of modernism. Instead, for the moment, let us try to step outside of the canon. We will imagine that a mass-produced modernism exists *parallel* to the fine arts, owing nothing substantial to "genuine culture." After all, to argue that Dara Birnbaum is "teaching" MTV its formulas is like the flea telling the horse which way to run.

What are our alternatives? We must imagine a mass-produced modernism that is also *without clearly defined* self-critical features. Mass culture as modernism resembles Barthes' description of the petit-bourgeois "unable to imagine the Other." The resistance to self-criticism can be summed up in the phrase: "It's only entertainment." Or, "I just enjoyed it, that's all."

But is there a generic form of self-criticism in the culture industry? There certainly is, though it does not resemble Brecht, Beckett or Duchamp (who were very sensitive to the self-critical features of popular entertainment). Self-criticism in mass culture appears nightly in shows like "Entertainment Tonight," a chirpy, "celebritized" version of what Russian Formalists called "the laws of production." And yet the ritual is quite fascinating, not to be tossed away without some review. These are shows "behind the scenes," about fashion models in "real life," about how special effects are made, about celebrities being frank. The talk show is a sub-industry. Increasingly, the guests do not talk about glamour or their sex lives, but about Vegas after hours. Or everyday folks are brought in to present their ant farms; Johnny chimes in once again about Nebraska. Tinsel town has gone professional, and the results are central to mass/fine art, but how in God's canon do we classify shows like that (and by extension, work like Birnbaum's)? I would recommend using a term like "audience culture."

With that term in mind, we imagine a modernism that can be discussed as a *social history of audience culture* (too vast a subject for a short essay, of

course). Considering how blurred the process of modernism has become (and always was?), the critical problem for mass/fine art is not one of canon; it is one of audience, certainly for video art. Shocks in the delivery and distribution of culture need to be intervened with in some way, reenacted (even special effects films like *Tron* review the process of intervention; we are not inventing a new subject). When surveying the range of video art, and commercial films that reenact the impact of television (cable, video games, computerized software), we find a world where "audience" has become the metaphor for both work and leisure. Perhaps "community" has been replaced by "audience," like the town meeting canceled for "Hollywood Squares." That may be why Spielberg finds such charm in re-invoking the magic of the old Saturday matinee, when the local movie theater was a sort of community (we think).

Birnbaum offers us the painful community of the matinee on television. Odd, isn't it? Years ago, Nam June Paik described video art as a statement on information overload. Well, we have gone beyond overload now. The bits are beginning to make sense. A few years ago, I interviewed "Star Trek" fans ("Trekkies," though they prefer the term "Trekkers"). There is an example of "audience" becoming community, when ten thousand gather at a conference to reenact the thrill of watching a television program. I asked one why she persisted as a Trekker. She answered: "The show and the TV ship are like a family to me." In comments like that lies the signified of video art—the referent—not simply the sin of our ways, but the nature of our rituals.

In the most perverse sense, I suppose, audience culture can only have itself to refer to (is that self-reflective?). The shared moments in front of the screen have become their own narrative, their own "object"; they are a shared myth. We live in a world of fantasy literalism, where even postmodernist architecture can look suspiciously like tourism. We "reference" the past as facades, like a film set. Recently I went to the MGM lot, where I saw a studio set of a street in Greenwich Village I used to visit as a teenager. The bricks were hollow plaster, and very clean. The background was painted, the garbage pails neatly overstuffed. It was like a photo of a building, isolated from its historical context—except that I was walking in the photo.

In "Hollywood Squares," when the grids separating the celebrities light up, we are given an architectonic design of a public place. The stars wave, they squirm, they react professionally. Increasingly, from quiz shows to people on the street interviewed for the five o'clock news, "average" Americans react very professionally to the Kino eye; they wave, they squirm, they treat the host as an equal, they pause for emphasis, they know where the camera is. We have abstracted our public life.

Brecht distinguishes this as a culture of "distribution," rather than "communication." He was obsessed by the contrasts and politics of audience culture. In 1921, he sits in a movie house unable to concentrate; his mind

is filled instead with visions of a woman thrashing a pig, of the Warschauer's consumptive maid living alone in silence in a dark flat. "And I no longer see where the great difference lies," he writes in his diary. "Far be it for me to feel pity, all I mean is how poor we are, ape-like and easily abused, wretched, hungry, submissive."[3] Consider Warschauer's maid today, gathering her fortitude in front of a quiz show.

NOTES

[1] Umberto Eco, "The Myth of Superman," *The Role of the Reader* (Bloomington: Indiana University Press, 1979), 116: "One could observe that, apart from the mythopoeic and commercial necessities which together force such a situation, a structural assessment of Superman stories reflects, even though at a low level, a series of diffuse persuasions in our culture about the problem of concepts of causality, temporality, and the irreversibility of events; and in fact a great deal of contemporary art, from Joyce to Robbe-Grillet, or a film such as *Last Year at Marienbad*, reflects paradoxical situations, whose models, nevertheless, exist in the epistemological discussions of our times."

[2] Clement Greenberg, "Avant-Garde and Kitsch," (originally published in 1939), *Modern Culture and the Arts*, ed. Hall and Ulanov (New York: McGraw-Hill, 1967), 175–191.

[3] Bertolt Brecht, *Diaries 1920–1922*, ed. Herta Ramthun, trans. and ann. John Willet (New York: St. Martin's Press, 1979), 148.

Critic and artist Douglas Davis engages in "post-structuralist detective work" to articulate a philosophy of performance very different from that of Kaprow's in the early sixties. Recent emphasis is on entertainment, imitation, creating roles, style, humor, pleasure, and references to rock music, all of which are equally different from modernism's insistence on seriousness, self-reference, and self-sufficiency.

Post-Performancism

Douglas Davis

AGING STUD (Tab Hunter): Horrible, isn't it? All those poor people. . . .
MIDDLE-AGED MOTHER, viewing roadside crash (Divine): It's just too horrible. I can't look.
STUD: You want to see something big, long and sleek? It's my new Corvette. Let's go for a ride.
——from *Polyester*, a film by John Waters, 1981

LOIS LANE (Margot Kidder): I'm going to slip into something more comfortable. (Leaves.)
SUPERMAN (Christopher Reeve) anxiously seeks his mother via computerized crystal; she materializes, suddenly, before him.
MOTHER (Susannah York): You must become one of them. . . . Once exposed to these rays all your great powers on Earth will disappear forever. But consider . . . once it is done, there's no returning. You will become an ordinary man. . . . O My son, are you sure?
SUPERMAN: I love her. (He is transformed.)
LOIS (returning): You did all that for me? I don't know what to say.
SUPERMAN: Just say you love me.
——from *Superman II*, a film by Richard Lester, 1981

When Molière defended the bourgeois values of "light comedy" in 1622 against the church, the salons, and the critics—the priests, in effect, of High Art—he simply claimed that "the people" deserved their choice of the light rather than the heavy. Now, in 1981, we hardly need to duplicate so basic a strategy. Of course it is always necessary to mediate the conflicting claims of high, middle, and low culture—and particularly to demonstrate that these claims can be equally satisfied in a single work of art, or entertainment (thus paradoxically refuting Molière, who wanted completely to sever "high" from "low" art). But this is not even required at present, deluged as we are with articles and exhibitions proclaiming the virtues of "Punk" and "New Wave" art. No, what is required is something bordering

Reprinted from Douglas Davis, "Post-Performancism," © *Artforum* (October 1981).

on post-structuralist detective work—to discover what links exist as content between these disparate activities, branded to date with bewitching, over-simplified labels. To hell with medium-as-medium, structure-as-structure, New Wave-as-the-next-thing. No more of that, please. Let us have instead a reliable verbal umbrella: "Post-Performance." And let us have these questions asked within its sound, safe shadow: what does Post-Performance tell us about changing attitudes in the culture? What values underlie the sudden proliferation in art writing of terms borrowed from popular music? Do these terms connect at all to the bipolar verbal axes that have split High Art since the 1920s, Dada at one end, modernism at the other? Is Punk in bed with Dada, New Wave with Late Modern? More to the point, is *Superman II* a New Wave epic, *Polyester* the scion of Punk (if not Tristan Tzara)? Hmm. Let's curl up with these questions in our own beds, and dream away . . . the answers.

> *I have come to realize that my concept of performance art has become old-fashioned. It is old-fashioned to insist that performance is sculpture action or sculpture evolved into the fourth dimension (time). . . . Now . . . there seems to be a return to the subject—the object not as an end in itself (aesthetic), but rather as material to explain a function . . . the object is used in a social, architectural, or religious function. The 70s is an age . . . of theatricality and decoration.*
> ———Tom Marioni,
> from the preface to *Performance Anthology*, 1979

> "*I Am Making Art.*"
> ———John Baldessari
> *I Am Making Art*, videotape, 1972

Between the moment that John Baldessari bent over and reached toward the floor with his hand in an early videotape—proclaiming Art to be the result—and Tom Marioni's confession, above, lies a tortuous psychic journey. I remember when I first confronted "performance," as a student at Rutgers in 1959. I received in the mail—by mysterious chance—a card printed by George Brecht. *Drip Music (Drip Event)*, it announced, with the following scripted instructions: "For single or multiple performance. A source of dripping water and an empty vessel are arranged so that the water falls into the vessel. Second version: Dripping." Though it was prompted largely by the ideas of John Cage, *Drip Music* has an obvious link to Roland Barthes' *Writing Degree Zero*, to Susan Sontag's *Against Interpretation*, to Frank Stella's shape-as-painting-as-shape. Not that it was obvious at the time. Then, it seemed like revolution. But the bareness of the text . . . the implicit refutation of theater . . . the concept of audience-as-activist . . . all these dominated art performance for the next two decades. Even Allan Kaprow's long, near-poetic scores seem, on second reading, clipped to the point of curtness ("Large wooden beams placed separately somewhere," one of them begins, ending with "getting more from less"). Even Vito Acconci's warm-

hearted invitation to viewers to encapsulate themselves alone in a small room with his image on a monitor is linked to this powerful, reductivist chain of ideas. Even Chris Burden's choreographed act of self-willed shooting becomes, in the words used to describe it, mute ("At 7:45 p.m., I was shot in the left arm by a friend. The bullet was a copper jacket 22 long rifle. My friend was standing about 15 feet from me.").

Certainly the bare, alternative space nonstage provided the perfect nonproscenium for these actions. Certainly the boundary between the High Art of Performance and the Low Art of Hollywood, vaudeville, and Broadway was clearly drawn in these years. We had the Solipsist Theater on our side, paradoxically in tune with the audience, which wanted nothing easy, pleasant, or funny, unless justified by art history. Certainly it didn't want skilled performance. Not the least virtue of Baldessari's *I Am Making Art* was its intriguing ambivalence—at once a critique of the defiantly awkward amateur, bending, moving, pointing to prove his esthetic purity, and a vintage work of performance itself, of performance-only-as-performance.

The nature of the performance medium is inherently theatrical, even if it's not the theatre of writers, directors, and designers. . . . In my earliest performances, I used myself conceptually, but when I started using other people, I became aware of being a pseudo-director of a pseudo-theatre.
——Scott Burton, *Performance Art 2*, 1979

And who is not a borrower? Didn't we get our face and our name from our parents, the words in our mouths from our country . . . our dreams and images from the books and pictures other people wrote, painted, filmed. . . . What of me and Antinova? I borrowed her dark skin, her reputation, her name which is very much like mine anyway. She borrowed the name from the Russians, from Diaghilev. I borrow her aspirations to be a classical ballerina. She wants to dance the white ballets. What an impossible eccentric!
——Eleanor Antin, *Before the Revolution* (a ballet), 1979

Temporarily needing a change from working both in monotones and monochromes, I bought recordings of old night-club and cabaret singers, and clothing of a soft texture and pastel colors. I don't know why. I just lived with it for a while.
——Connie Beckley, from text on *The Chiffon Magnet*, 1980

I gave up video for the Silver Screen!
——Douglas Davis, from *Silver Screen* (silent movie), 1979

Though it is often said that American society is manipulated by the purveyors of mass entertainment, the singular fact about our "leisure" choices is that they are temporally free. In the past, what we now think of as entertainment—song, dance, pageants, storytelling—were rigorously scheduled, by church and state. They occurred only on specific holidays

at specific times. Freed from endless labor and besieged by a diversity of possibilities, we choose a movie now, a stripper tomorrow (male or female), a museum the next day. Yes, pleasure is the goal of every free choice—ranging from hedonism to intellectual provocation. But why should art and pleasure be antithetical?

Now we find artist-performers turning from repetitive and reductivist strategies to song and dance, in effect. Perhaps it has nothing to do with art history at all, but with childhood television, "Saturday Night Live," mad Jack Smith (oops, a bit close to film—if not art—history). If the intent is non-art-historical, the result must still be attended by the historians. Yes, many individuals have made personal choices (Connie Beckley out of boredom; Scott Burton out of necessity; mine made on the dead run—away from video into the movies of yesteryear), yet the result is a new kind of performance-film-television-radio, sourced in the popular as well as the visual arts. The other night I saw a replay of the comedy sketch "Bad Conceptual Art" on "Saturday Night Live," starring Gilda Radner, undulating before two video monitors, one displaying a pair of lips smacking away, the other an unmoving profile of her own face. It was a deadly riposte, as effective as Charles Baudelaire besieging photography or Clement Greenberg slaying 3-D illusionism. You won't see it quoted by Robert Pincus-Witten . . . though all of his readers watched it.

The delight of imitation, of theatricality, of pretending to be other than what you are (Eleanor Antin as black? as ballerina?! Scott Burton as David Merrick). Yet it is all believable, and unstoppable. Look at James Stirling's new addition to the Fogg Museum in Cambridge, Mass. Here is a squat little box of a building pretending to be grand. Around the door, fronted by a tiny glass-roofed arcade, there are two preposterously fat classical columns supporting . . . nothing! The new Fogg is theater, sheer architectural theater, as deceitful as white-faced Eleanor pretending to be black-faced Eleanora. What happened to the rigor of honesty? The flat painting that had to be flat, the performer who had to be himself/herself; the bareboned Art Space as bareboned Art Space? We shall see . . .

> Don't you know the world has changed
> But you'll always be the same
> ——The Fleshtones, lyrics, 1981

From the standpoint of dressing, the ["New Wave"] style calls for a sophisticated appreciation of once-neglected fashion artifacts and attitudes carefully fused into a timeless present tense.
——Gentlemen's Quarterly, 1981

We must remind ourselves that the classical and Gothic languages of architecture are two of the Occident's great triumphs. To cut ourselves off from this tradition in mindless pursuit of novelty and originality is to alienate ourselves from our

culture. It is as if we were to jettison the English language, with its unrivaled heritage and powers of expression, in order to communicate in the new, but lifeless, and simplistic forms of Esperanto or Dada.
———Allan Greenberg, *The Sense of the Past*, 1981

Why We Delight in Representation. Of this we discoursed in . . . Athens. . . . Why we are disturbed at the real voices of men, either angry, pensive or afraid, and yet are delighted to hear others represent them, and imitate their gestures, speeches, and exclamations. . . . For . . . he that only represents excels him that really feels, inasmuch as he doth not suffer the misfortunes; which we knowing are pleased and delighted on that account.
———Plutarch, ca. 46–120 A.D.

I feel closer to [Rodney] Dangerfield, because I'm exaggerated, or rather in my mind I'm exaggerating . . .
———Michael Smith, *Performance Art 2*, 1979

If direct recall is cultivated most sharply in architecture—in buildings that try to imitate the pleasures and passions of the past, through marble arches and Palladian formal symmetry—it thrives as well, though less acclaimed, in Post-Performance. We have forgotten that when Blondie first appeared, it was a rock group, not Deborah Harry alone. I remember when I first saw them, on Manhattan CATV's Channel J. I thought: This is History, if not Parody. Not only was the lead singer shaking and vibrating as the great comic strip heroine might, but the music had a nostalgic tinge, in its rhapsodic sweetness, its deft, whistle-clean lyrics; the band reeked of preparation, of rehearsal, of exact timing, of carefully coordinated theatrical presence and musical arrangements. In those days, Blondie was as revivalist as Philip Johnson's AT&T building, now rising on 56th Street in Manhattan, or his neo-Renaissance RepublicBank Center in Houston, complete with slanted, gabled roofs.

Rehearsal is the modality of revivalism. Why? Because one only rehearses or prepares in order to be what one isn't. Originally, punk said *I am what I am, take it or leave it* (a twist on Popeye's *I am what I am and what I am I am*). Originally, punk, like much of early performance, cultivated the appearance of spontaneity, of doing only what the moment demanded. In this sense, Acconci masturbating beneath the sloped floor of the Sonnabend Gallery could be seen as Performance punk. Joseph Beuys talking to a dead hare was Pre-Punk punk. Now imagine Laurie Anderson before her mirror sawing away on her phone-filtered violin, like Jack Benny the night before Carnegie Hall, cultivating an *Aktion*. No, cultivation does not reduce the element of spontaneity, no, no. It simply casts a mold—the form—in which performers present themselves as they open up to the inherent risk of live action, whether before an audience or a camera. What is often forgotten in the standard modernist denunciation of revivalism is that imitation is nearly always imperfect and therefore unique, however

JACKIE APPLE, "The Garden Planet Revisited" 1982 performer: Arthur Taussig
Photograph by Salli Sachse, courtesy of the artist.

much the content or form is based upon the past. In fact, imitation fails and revivalism turns sour only when they completely succeed, or take too many spoonfuls of sugar.

> I don't wanna hold your hand (I just want to beat you up)
> ——Art, lyrics, 1980

> I'm sorry I teased you/I really want to/How would you like it if I . . . /Sucker!
> ——The Waitresses, lyrics, 1981

> Die young, stay pretty/Die young, stay pretty/Deteriorate in your own time/
> Deteriorate in your own time/Tell 'em you're dead and wither away
> ——Blondie, lyrics, 1980

> *Coming out of P.S.1 . . . one wondered about the New Wave. Good, bad, horrid, avid or genuine. It is a kick in the teeth of art history, a turning point.*
> ——Edith Schloss
> *International Herald Tribune, 1981*

Despite the crockery and the claptrap, Mr. Schnabel is at times a painter of remarkable powers. The picture called "Death," painted on a surface of shocking pink velvet, is quite unforgettable. If this work, and all of Mr. Morley's, can be taken to represent a new wave, then painting is in for some interesting times.
——Hilton Kramer
New York Times, May, 1981

It might be fun to figure out what "Punk" or "New Wave" originally meant. Certainly they meant different things, back then, though art writer after art writer now claims they are inseparable, two sides of the same pink velvet. In Berlin, circa 1977, I saw the band Sadista Sisters twang up an abortion on stage, flinging the bloodied results of their mock operation at the audience. We all remember the Sex Pistols' violent trip across the U.S. in 1978, culminating in the breakup of the band and the death of Sid Vicious one year later. Though they may have been influenced by the hard-charging, hard-playing New York Dolls, the Sex Pistols' defiant nose-thumbing of their audience was based securely in British class warfare. They deliberately provoked the ears with monotonous lyrics, clanging chords, dissonant nonrhythms. At this very same moment we witnessed the parallel birth of "Art Rock," sired at once by Steve Reich, Philip Glass, LaMonte Young (all of whom were in turn sired by the venerable John Cage), and Punk itself, witnessed by memorable crowds at Artist's Space in 1978, where American bands such as the Theoretical Girls, the Gynecologists, and Teenage Jesus and the Jerks first appeared. Again we heard in Art Rock repetition, simplification, the reduction of theatricality (later exemplified in its purest conceptual form by Disband), minus the sneering hostility.

It's just plain fun to recall, the author repeats, that "New Wave" at first signalled a break with most of this. Not in the chain forged between Rock and Art by countless personal links (David Bowie, Mick Jagger, Brian Eno were all art students at one point; the Yoko Oko–John Lennon marriage openly consummated the two worlds). That chain remained. But "New Wave" was "New" in 1978–79 because it was old, or rather different, recalling past harmonies and softer nuances. Most of all the lyrics were *listened to,* in the small clubs that now seem to be fading (Max's Kansas City, CBGB), while dancing revives in larger, plusher halls. Certainly Blondie is the classic, turning, triumphant New Wave band, openly seducing its audience, blowing theoretical kisses if not girls, followed closely by Adam and the Ants, Talking Heads, Squeeze, and many more.

Why has this sharp, clean break lost its meaning in recent months? How can Diego Cortez's "New York/New Wave" exhibition, bristling with the graffiti-style energy of visual punk—as first announced in the meticulously compiled "Times Square Show" one year ago—adopt the same label? No, it's not simply indifference to words. It's the Molière Syndrome. It's the notion that waves, breaks, changes in the popular arts are merely commercially malleable, without serious meaning. That's wrong, my friends,

wrong. Beneath Punk and New Wave, between *Polyester* and *Superman II,* there are two distinct attitudes. Indeed, they may be . . . beneath everything

> *Suddenly, it appears, the Return of Style is at hand. Songs that swing or carry the torch or conjure up dinner dates and flowers. Wit, charm, savvy, romance. Music by Rodgers, lyrics by Hart. A blue piano, a swaggering trumpet. Frank Sinatra serving orange juice for one. Ella Fitzgerald scatting with the Basie Band. Bobby Short vainly fighting the old ennui. Fred Astaire doing anything at all.*
> *Style.*
>
> ——Sidney Zion, "Outlasting Rock,"
> *New York Times,* June 1981

> *Fuck Style Let's Dance.*
>
> ——David Sandlin, *Zipper* magazine, 1981

What is replacing the New Wave, in music, while it roars like thunder through the halls of art? No, no, Rock is not being replaced, not even the New Right can legislate that. *Dancing.* Lyrics, once sustained by small clubs and audiences, are fading away, fading in the din of feet stomping, moving, ignored by bands who do nothing but play for dancing, the Raybeats, the Individuals, the D.B.'s, more on the way. Max's gives way to . . . Bond International . . . where Art Deco rules, beginning with gold fluted stairs, angling sharply left, sharply right, each step singing—like a church organ—as one ascends the stairs, leading to an ocean liner ballroom, swooped in soaring curves. The New Wave was therefore not an end, but a beginning, an evolutionary step. Remember that Blondie became popular only through the song "Heart of Glass," laced in disco rhythms. Whatever happened to disco? Well, it has been replaced by Rock Dancing (so you see, Left follows Right, as Right follows Left). Yes, the New Wave was a step toward . . . rhythm & blues? Well, more than that. . . .

> *If a nonmatrixed performer in a Happening does not have to function in an imaginary time and place . . . respond to often-imaginary stimuli . . . project the subrational or unconscious elements in the character he is playing . . . what is required of him? Only the execution of a generally simple and undemanding act.*
>
> ——Michael Kirby, from *Happenings,* 1965

> *In the actor . . . the first self works upon the second till it is transfigured, and thence an ideal personage is evolved—in short, . . . from himself he has made his work of art.*
>
> ——Benoit Constant Coquelin, 1887

> *An actor . . . must in a way forget himself . . . in order to assume those of his part. He must forget the emotion of the moment, the joy or sorrow born of the events of the day.*
>
> —— Sarah Bernhardt, 1924

If the nonmatrixed performer dominated the happening, the matrixed actor stands at the center of Post-Performance. Moreover, he/she stands— sometimes in fact, always in theory—on the proscenium stage. This is in no sense a distancing. In the beginning, we all felt the proscenium had to be leveled, in order to bring audience and performer closer together. Acting, the double nature of the performer, had to go as well, since the assumption of a fictional character widened the space between you and me. Better that I become myself, my honest self, in order to meet with honest you. But who is entirely honest? Who is entirely one face at all moments of the day, year after year? What began to dawn upon the makers and takers of early Happenings, upon those who furiously pursued the close-in theater of solipsism, were these truths: honesty is pretence, when demanded by the occasion. No single one of our selves can be endlessly exploited (not even Vito Acconci can level with us night after night, year after year, without running short). Forced intimacy—like forced spontaneity—creates distance. Every pair of minds and eyes needs a space in between to survive. Further, there were examples of early artists-as-actors, playing consistent roles. I have already mentioned Jack Smith. But there were, there are, Joseph Beuys, James Lee Byars, Andy Warhol, always in disguise, whether hat, costume, or blank-faced gait.

Now there is more. In Post-Performance, there is the pleasure of assumption, of creating the role that is at once yourself, and someone else. Think about Lynn Hershman playing Roberta Breitmore, in 1976, a "real" person living then, in California, with interests very close to those of the artist herself. And think of Eleanor Antin playing Eleanora Antinova, dancing with Diaghilev, half a century ago, swinging back and forth, black-faced on a stage, surrounded by costumed retainers. Can't you see the matrix closing? Roberta as near-fiction, Eleanora as pure fiction? Or . . . here is the catch . . . has the real Eleanor Antin finally emerged, through black paint? I never felt more truly myself than when I played Charlie Chaplin, in *Post-Modern Times*. Not because I had always wanted to *be* him (I had always wanted to be myself, *sans imagination,* as Michael Kirby had directed me). No, because I was Chaplin without knowing it, dating back to childhood memory. The point is this: we are by nature matrixed, that is, defined always by the artifice of the moment, which is conditioned, in turn, by the artifices bequeathed by the past. When we indulge this fact, we paradoxically liberate ourselves and cultivate delight in those who watch us.

To admire on principle is the only way to imitate without loss of originality.
————Samuel Coleridge, 1817

We never used a script. The important thing in getting a story was to get the idea. . . . Now like in Safety Last *we had the climb. And we shot that first. . . . When you know you have a very fine finish, you're very excited . . . to go on and make the rest of it come up to it.*
————Harold Lloyd, 1958

In . . . the Biograph's latest comedy feature, a decided novelty has been introduced.
In one of the scenes the characters are made to speak their lines by means of
words that appear to flow mysteriously from their mouths. This is the first time
that "talking pictures" have been shown, and they will prove bewildering and
amusing to everyone.

———Ad for the film *Looking for John Smith,* 1906

Nothing demarcates the modern movement from the past more clearly
than its hatred of "imitation." My pocket encyclopedia tells me that "Neo-
classicism" is characterized by "controlled imagination and lack of enthu-
siasm." In other words, to act even in the spirit of those who preceded us
is . . . bankruptcy. Think now of the relentless drive in late modernism to
objectify all phenomena—to produce the surface-as-surface, word-as-word,
self-as-self. Purged of all reference, then, the object (the solipsistic per-
former in this sense is the object) becomes clean, gene, new. Yet when we
turn away from restless invention, when we face backwards, what a wealth
of ignored tools falls into our hands! Is the silent movie a closed cycle,
admitting no further refinements? How do Buster Keaton and Harold
Lloyd stack up against Piet Mondrian and Jules Olitski? Or think of radio.
Think of listening, alone, to "The Shadow," to "Dracula" ("Is this your
wife? What a lovely throat"), to Jack Benny, timing his reply to the question,
"Your money or your life?" (Answer: Pause. Pause. "I'm thinking it over").
Or: Think of the theater, conducted on a proscenium, lifted above the
audience in order to more directly engage the imagination.

Imagination? What's that? The faculty of the mind that takes percep-
tion beyond the materialist limits of the physical form. It cannot be con-
trolled, this faculty (can you restrain it when you see Kazimir Malevich's
White on White?). In this sense, deprivation—the sound taken away from
you in the silents, the sight withheld by radio—is provocation. The per-
former who presents himself/herself as self, limits the audience's interpre-
tation to what is seen and heard. The performer who presents himself/
herself as someone else—as Rodney Dangerfield (Michael Smith), Ricky
Paul (Eric Bogosian)—releases the full powers of interpretation. Imitation
is a beginning, a place to start.

Lack of enthusiasm? Think, finally, of the film *Napoleon,* Abel Gance's
revived three-screen epic from the '20s. How did it stand up against brand
new multimedia installations? Should we brand any artist who decides to
follow his lead—rather than the lead of recent art history—Neoclassical?
Yes, post-*Napoleon* art implies the use of narration, story, historical recall.
But none of that, not even the dreaded "script," dictates a sacrifice of
richness. On the contrary. When you hear about Acconci's *Seedbed*—about
countless performances between 1965 and 1978 (including my own)—you
know it all. The dematerialized concept, the gesture, was, in effect, the
script, as well as the performance. Post-Performance narration is more than
structure. It is the vehicle to explore meaning beyond the gesture. It gladly

risks recall and thus courts the false charge of imitation. If this be Neo-classicism, we stand or fall on that ground.

If the A-effect is to achieve its aim, the stage and the auditorium must be cleared of "magic."
———Bertolt Brecht, "The Alienation Effect," 1949

Art and Illusion, illusion and art
This is the song that I'm singing in my heart
Art and illusion, illusion and art.
———Laurie Anderson, lyrics, 1975

Glamour is used as Uniform. Glamour is seductive, a promotional entity. . . . It designates the self, commodifies it, supplying the customers with the image as product . . . where self, customers and image are all having fun!
———Edit deAk, press release for "Dubbed in Glamour," The Kitchen, 1980

DREAM
In the day
when I'm awake

and things are changing,
changing,
things are at stake,

I feel the heat
of something
gleaming
inside my head.

It's the DREAM.

You don't have to hold
my hand.
Take me to a foreign land.

Things are not
always
what they seem

In the DREAM

Wish-fulfillment
is the key
to the dream
inside of me.

Dream it near
dream it far
dream a kingdom
dream a star.

DREAM.

I think it's real
I can see
and feel,
I fantasize
I close my eyes

in the DREAM.

——Song composed by Jane Hudson,
performed at the Mudd Club, 1981

An unconcern with audience is a legacy of the Romantic movement in early
nineteenth-century Europe . . . The new conception of the artist was of someone
whose production cannot be rationally directed toward any particular audience
. . . a visionary whose sources of creativity are outside his conscious control . . .
——Martha Rosler,
Exposure, Spring 1979

What then is the special element that entertains? I have no answer to the question,
although I should have one. All I know is that in its nature it imparts a sensation
of pleasantness (and not of catharsis), it loosens up, it frees me . . . it refreshens
and it soothes . . .
——Istvan Petur
from *Rádió és Televizió Szemle.* Budapest, 1973

Western observers were bewitched and bewildered by the glorious Polish summer:
not only the establishment voices, who love strikes only when they are staged on
the other side . . . but the Western Left, which has some excuses for its perplexity.
What do you do with a movement which starts, as the Gdansk strike did, by
singing the International and the religious patriotic hymn to "God, who has
protected Poland over centuries"?
——Daniel Singer, *The Road to Gdansk,* 1980

You will not find a single serious essay or article written about the art
audience in the last 100 years. Indeed, the presence of the audience was
hardly even acknowledged in art rhetoric until the 1960's, when the new
interest in artists' books, films, and video tapes required it—as did the
premise behind the rise in public funding for the arts. Now we regularly
hear, for example, that 300 million visits are paid to museums every year.
But not a line about *individuals,* about the psychic context that bears witness
to every work of art, whether painting or performance (media theories,
television "ratings," and political polls evidence the same blindness). There
are endless analytic studies of the physical effects of art objects, which imply
sensory receptors somewhere, equipped with eyes. But nothing about the
specific viewing person, endowed with the ultimate power of mind. Which
means we are peculiarly barren in theoretical depth when it comes to issues
like parody, reference, comedy, imitation, irony. Each of them requires the
receiving mind in order to exist at all.

As Post-Performance reaches out to embrace small, clearly identifiable audiences—via cable television, National Public Radio, record albums, video-discs, clubs like the Ritz, the Mudd Club, the late Hurrah's—this apparent lack of interest in the audience approaches comedy itself. Of course we are mute on the subject of audience because it signifies what is forbidden, in High Art: to act out of any concerns other than solipsistic or formal ones. Certainly this is what led Michael Fried to say, "Art degenerates as it approaches the condition of theater." But this begs the definition of "theater." Does it simply mean a work that connects with the preconceptions of its audience? If so, much of the painting that Fried admired and supported in the '60s is "theater," in the sense that the work evolved out of a logic clearly understood by those who displayed, discussed, and purchased it. No, none of these materialist definitions will satisfy us, in the end, any more than the search for Victorian Marxist behavior will define Solidarity (as either Left or Right in nature). Art is either Art or Non-Art because of its specific nature (which is a compound, always, of physical and nonphysical qualities, including, of course, content). In that sense, art can eat theater alive, and still survive. It can hang alone in a room . . . or dance around a nightclub floor. Dance on, fair, dear Art, dance on . . . and on.

> **Serious** . . . a. 1440/ad.F.serieux or late L. seriosus, f.L.serius./ 1. Of persons, their actions, etc.: Having, involving, expressing, or arising from earnest purpose or thought; of grave or solemn disposition or intention; not light or superficial; now, often concerned with the grave and earnest sides of life. b. earnestly bent or applied; keen-1672. 2. Earnest about the things of religion; religious-1796. . . . not jesting, trifling, or playful; in earnest. Hence, of theatrical compositions or actors, not jocular or comic.-1590. . . . Of grave demeanour or aspect-1613. 6. Weighty, important, grave . . . 1584.
> a. He was too s. to smile; indeed, I cannot remember him ever smiling, except sadly-1880. . . .
> ——Oxford English Dictionary

For a generation that ruthlessly ignored history, the root meaning of critical code words was unimportant. Yet the code words are themselves coded, by events, tradition, received denotation, as well as connotation. When I was growing up, the highest accolade that could be paid any artist was this: "serious." That the term was dipped in the rise of Puritanism, that it connoted attitude or style only, not content or quality (of any kind), was beside the point. No, it was the demeanor that was grave, not the thought. Think, too, of all the words that circled around this central manner: "Important" . . . "Significant" . . . "Difficult" . . . "Severe" . . . "Tough" . . . "Rigorous." Think of the color black, of repetitive speech, of Cor-ten steel: "I cannot remember him ever smiling." These are matters of form and approach. If we have passed through a tough, grave, important period in art, we have also seen instances of seriocomic revolt: remember Ad Reinhardt's comic strips, playing on the other side of his grave paintings; remember Barnett

Newman's *Who's Afraid of Red, Yellow, and Blue;* remember Warhol's de-
meanor, never smiling, in the service of wit. If, finally, foolishness is ap-
pearing again, in film, song, and story, this tells us nothing about the essence
of the matter, whatever you say, *October* (the editors are no longer "con-
fident," in issue number 16, that they can wipe the smiles off our faces).
Serio-comedy attends the art of the moment as gravity embellished the art
of yesteryear.

> *Comedy is a thing of pleasure, not of clowning, something measured not exag-*
> *gerated, gay not impudent; and those who give the name of comedy to all sorts*
> *of wantonness, are using a definition of their own fancy. Jests season a work*
> *but not always; for there are serious episodes that are not all clarified by jests.*
> *And when the latter are inserted, they disrupt the whole tale. But the charm of*
> *the study is the excellence of a well-expounded incident which, tho it is not full*
> *of absurd sallies, has unity of action and a logical progression of scenes, as the*
> *play demonstrates. This yields a pleasure which remains a food to noble minds.*
> *Hence, those who consider comedy close to buffoonery are in error.*
> ——Nicolo Barbieri
> from *La Supplica.*
> "What is a Buffoon?," 1634

What is the role of humor in art? When we hear laughter in a museum
or gallery context—in any context where the art audience is present, say
Hurrah's or the Ritz—does it spring from a shared body of information
or opinion? We began to laugh in the mid-'60s, with Pop. It was cool, edgy
laughter—only Robert Rauschenberg and Jasper Johns roared, mostly at

JOHANNA WENT, "A Head of Fashion" 1983
Photograph courtesy HIGH PERFORMANCE.

parties—but it was laughter. No joke can succeed with any audience unless it is based on a shared set of ideas, if not attitudes. When I introduced a set of lines in *Silver Screen* that played with the idea of flatness, I heard the gallery audiences guffaw, out loud. That doesn't happen when the movie is shown to theater audiences, where other, broader lines provoke the laughs. I vividly recall Donald Kuspit's riposte to Miriam Schapiro's feminist statement at a Cooper Union panel in 1979, eliciting huge belly laughs that reflected an anti-feminist position missing from Kuspit's words (but present in the audience). Comedy, in this sense, is as much a formal device in recent performance as the idea of art-only-as-art, which led to the gestural theater of the '60s and '70s. Comedy is comedy only when it is based on shared precedent. It is also, therefore, a rhetorical device in art writing, and lecturing, reflecting backward and forward at once, like the footnote. No, don't say DOWN WITH THE FOOTNOTE IN THE '80s, no, no. Rather, let us transform the footnote into a solid punch line:

Paramodernism is more in the nature of a rear-guard action than a vanguard assault in that it seeks to reassert qualities, such as decorative color and form, emotional stimulation and the sumptuous use of evocative materials, that were expunged from art during the reign of color-field abstraction and hyper-realism . . .

——Helen A. Harrison
New York Times, June 1981

Don't think I can fit it on the paper
Don't think I can get it on the paper
Go ahead and rip up, rip up the paper
Go ahead and tear up, tear up the paper.
——Talking Heads, lyrics, 1979

Post-Post-Performance
(SUPERMAN III appears, ripping through this page from below. He scans it anxiously. Confused, he taps on his crystalline computer to summon his mother. She appears, fast as ever.)
MOTHER: What is it now, my son?
SUPERMAN: Where is Divine? Just a few pages ago, she stood right there (points toward upper left).
MOTHER: My son, she belongs to another time. She is there, now, not here.
SUPERMAN: Back in the Cafe Voltaire, with Tzara and Huelsenbeck?
MOTHER: No, son. She is sparking the boys at Woodstock Nation.
SUPERMAN: Good for her. But I'm living now, on this page, filled with answers to the questions raised on page 271. Shouldn't I supply them, now, here?
MOTHER: At this point, the answers are self-evident, my son. Where is Lois? There's an important question.
SUPERMAN: She left me, again! This time she called me . . . Para-modernist!
MOTHER (horrified, at last): No!
SUPERMAN: Can't you tell? Just look at me. The moment I returned to my

Kryptonite stature, Lois looked at me . . . and concluded that I had become decorative again . . . sumptuous . . . evocative. "You've gone back!" she said pointing at my red cape. "You're not vanguard! You're rear-guard!"
MOTHER: *Humph! I wouldn't stand for that sort of talk from a layperson.*
SUPERMAN: *You can't blame her. She wants me to be lean, sleek, mild-mannered. So I can make love to her. She wants a normal Modern Male. She wants . . . Clark Kent!*
MOTHER: *Why? Aren't you more fun to look at the way you are? You're certainly slimmer than Divine. As for love, I'm sure you can make it, if you try.*
SUPERMAN (brightening noticeably): *You are? You really are? How?*
MOTHER: *Love is like art. Remember that, my son. Millions of people make it every day.*
SUPERMAN: *They do? Hmmmm. It sounds sort of . . . commonplace.*
MOTHER (fading out): *Don't worry, son. Some people make it . . . better than others.*
(SUPERMAN III *straightens up, smiling. He flaps his decorative red cape defiantly in the wind, even blows it a kiss. Then he leaps UP, toward you, and away.*)

——Douglas Davis, 1981

Since the sixties, artists have engaged in a variety of activities outrageous to common sense. Not surprisingly, these activities, and sometimes even the artist, have been subsumed under the category of art. Critic and scholar Thomas McEvilley analyzes category shifts of this kind—identifying as "art" a process or object or person which is not normally so considered. He relates perform-ance rituals to ancient Tantric and Greek rites, in particular to fertility and blood sacrifices and to shamanic magic and ordeal. In both kinds of contem-porary performance, explicit reference is often made to these historical origins and to the roles that shamans play in other societies. Many involve making conscious decisions—vows—to undergo ordeals the significance of which can be understood by relating the performances to their magical, mythical, and religious antecedents.

Art in the Dark

Thomas McEvilley

The development of the conceptual and performance genres changed the rules of art till it became virtually unrecognizable to those who had thought that it was theirs. The art activity flowed into the darkness beyond its traditional boundaries and explored areas that were previously as un-mapped and mysterious as the other side of the moon. In recent years a tendency has been underway to close the book on those investigations, to contract again around the commodifiable esthetic object, and to forget the sometimes frightening visions of the other side. Yet if one opens the book— and it will not go away—the strange record is still there, like the frag-mentary journals of explorers in new lands, filled with apparently unan-swerable questions.

When Piero Manzoni, in 1959, canned his shit and put it on sale, in an art gallery, for its weight in gold; when Chris Burden had himself shot in the arm and crucified to the roof of a Volkswagen (in 1971 and 1974 respectively); when two American performance artists, in separate events, fucked human female corpses—how did such activities come to be called art? In fact the case at hand is not unique. Similar movements have occurred occasionally in cultural history when the necessary conditions were in place. Perhaps the most striking parallel is the development, in the Cynic school of Greek philosophy, of a style of "performance philosophy" that parallels the gestures of performance art in many respects.[1] If this material is ap-

Reprinted from Thomas McEvilley, "Art in the Dark," © *Artforum* (Summer 1983).

proached with sympathy and with a broad enough cultural perspective it will reveal its inner seriousness and meaning.

One of the necessary conditions for activities of this type is the willingness to manipulate linguistic categories at will. This willingness arises from a nominalist view of language which holds that words lack fixed ontological essences that are their meanings; meanings, rather, are seen to be created by convention alone, arbitrary, and hence manipulable. Ferdinand de Saussure pointed toward this with his perception of the arbitrariness of the link between signifier and signified. Even more, Ludwig Wittgenstein, by dissolving fixed meaning into the free-for-all of usage, demonstrated a culture's ability to alter its language games by rotations and reshapings of the semantic field. By manipulating semantic categories, by dissolving their boundaries selectively and allowing the contents of one to flow into another, shifts in cultural focus can be forced through language's control of affection and attitude. In the extreme instance, a certain category can be declared universal, coextensive with experience, its boundaries being utterly dissolved until its content melts into awareness itself. This universalization of a single category has at different times taken place in the areas of religion, philosophy, and, in our time, art.

A second necessary condition is a culture that is hurtling through shifts in awareness so rapidly that, like the tragic hero in Sophocles just before the fall, it becomes giddy with prospects of new accomplishments hardly describable in known terms. At such moments the boundaries of things seem outworn; the contents flow into and around one another dizzyingly. In a realm that, like art some twenty-five years ago, feels its inherited boundaries to be antiquated and ineffective, a sudden overflow in all directions can occur.

The tool by which this universalization of the art category was effected is a form of appropriation. In the last few years appropriation has been practiced with certain limits; the art category as a whole is left intact, though inner divisions such as those between stylistic periods are breached. The model of Francis Picabia is relevant here. But twenty-five years ago appropriation worked on the more universalizing model of Duchamp. In this case, the artist turns an eye upon preexisting entities with apparent destinies outside the art context, and, by that turning of the eye, appropriates them into the art realm, making them the property of art. This involves a presupposition that art is not a set of objects but an attitude toward objects, or a cognitive stance (as Oscar Wilde suggested, not a thing, but a way). If one were to adopt such a stance to all of life, foregrounding the value of attention rather than issues of personal gain and loss, one would presumably have rendered life a seamlessly appreciative experience. Art then functions like a kind of universal awareness practice, not unlike the mindfulness of southern Buddhism or the "Attention!" of Zen. Clearly there is a residue of Romantic pantheistic mysticism here, with a hidden ethical request. But

there is also a purely linguistic dimension to the procedure, bound up with the nominalist attitude. If words (such as "art") lack rigid essences, if they are, rather, empty variables that can be converted to different uses, then usage is the only ground of meaning in language. To be this or that is simply to be called this or that. To be art is to be called art, by the people who supposedly are in charge of the word—artists, critics, curators, art historians, and so on. There is no appeal from the foundation of usage, no higher court on the issue. If something (anything) is presented as art by an artist and contextualized as art within the system then it *is* art, and there is nothing anybody can do about it.[2]

Conversely, the defenders of the traditional boundaries of the realm will be forced to reify language. They will continue to insist that certain things are, by essence, art, and certain other things are, by essence, not art. But in an intellectual milieu dominated by linguistic philosophy and structural linguistics, the procedure of appropriation by designation, based on the authority of usage and the willingness to manipulate it, has for a while been rather widely accepted. During this time the artist has had a new option: to choose to manipulate language and context, which in turn manipulate mental focus by rearrangement of the category network within which our experience is organized.

The process of universalizing the art context goes back at least as far as Duchamp's showings of Ready-mades. Dada and Surrealism, of course, had their input. But the tendency came to maturity in the middle to late '50s, when Alain Robbe-Grillet, for example, insisted that if art is going to be anything it has to be everything.[3] At about the same time Yves Klein, extending the tradition of French dandyism, said, "Life, Life itself . . . is the absolute art."[4] Similarly, in America, Allan Kaprow suggested that "the line between art and life should be kept as fluid, and perhaps as indistinct, as possible."[5] Duchamp had appropriated by signature, as Klein did when, in about 1947, he signed the sky. Later Klein would designate anything as art by painting it with his patented International Klein Blue. Manzoni sometimes designated preexisting objects as art by signing them, and at other times by placing them on a sculpture base. In 1967 Dennis Oppenheim produced his "Sitemarkers," ceremonial stakes used to mark off areas of the world as art.

These procedures were sometimes employed in conscious parody of the theological concept of creation by the word. In 1960 Klein, imitating divine fiat, appropriated the entire universe into his Theater of the Void, as his piece for the Festival d'Art d'Avant-garde, in Paris. In the next year he painted a topographical globe International Klein Blue, thereby appropriating the earth into his portfolio; soon Manzoni, responding, placed the earth upon his Sculpture Base (*Socle du monde*, 1961), wresting it from Klein's portfolio into his own. Of course there is a difference between fiat and appropriation. The purely linguistic procedure of forcefully expanding

the usage boundaries of a word does not create a wholly new reality, but shifts focus on an existing one. Any action that takes place in the appropriate zone is necessarily real as itself—yet semantically a kind of shadow-real. Insofar as the act's prior category is remembered, it remains what it was, just as a loan-word may retain a trace of its prior meaning—only it is reflected, as it were, into a new semantic category. Thus the process of universal appropriation has certain internal or logical limits; it is based on the assumption that a part can contain the whole, that art, for example, can contain life. But the only way that a part can contain its whole is by reflection, as a mirror may reflect a whole room, or by implication, as a map of a city implies the surrounding nation. The appropriation process, in other words, may rearrange the entire universe at the level of a shadow or reflection, and this is its great power. At the same time, as with the gems strung together in the Net of Indra, only the shadowy life of a reflection is really at issue, and this is its great limit.[6]

The infinite regress implicit in such a procedure was illustrated when, in 1962, Ben Vautier signed Klein's death and, in 1963, Manzoni's, thereby appropriating both those appropriators of the universe. The idea of signing a human being or a human life was in fact the central issue. In 1961 Manzoni exhibited a nude model on his sculpture base and signed her as his work. Later he issued his "Certificates of Authenticity," which declared that the owner, having been signed by Manzoni, was now permanently an artwork. But it was Klein who most clearly defined the central issue, saying, "The painter only has to create one masterpiece, himself, constantly." The idea that the artist *is* the work became a basic theme of the period in question. Ben acted it out, not long after the signing of Klein's death, by exhibiting himself as a living moving sculpture. Soon Gilbert & George did the same thing. As early as 1959 James Lee Byars had exhibited himself, seated alone in the center of an otherwise empty room. Such gestures are fraught with strange interplays of artistic and religious forms, as the pedestal has always been a variant of the altar.

It was in part the Abstract Expressionist emphasis on the direct expression of the artist's unique personality that prepared the way for the claim that the artist's person was in fact the art. Through the survival in the art realm of the Romantic idea of the specially inspired individual, it was possible, though in a sort of bracketed parody, to confer on an artist the status of a royal or sacred being who is on exhibit to other humans.

The underlying question (and an insoluble knot in philosophy) is that of the relation between substance and attribute; specifically, how does one tell the agent from the activity? Certain Indian texts, exploring imagistically the relation between god and the world, ask how one can tell the dancer from the dance. In the visual arts the question has always seemed easier, since the painter or sculptor or photographer has traditionally made an object outside him- or herself. But universalizing appropriation had dis-

solved such a conception, and in performance art, as in the dance, the agent and activity often seem inseparable. In the last twenty years various performance artists (James Lee Byars, Chris Burden, Linda Montano, and others) carried this category shift or semantic rotation to its limit by moving into galleries and living there for extended periods as performances. In this situation even the minutest details of everyday life are temporarily distanced and made strange—made art, that is—by the imposition on them of a new category overlay that alters the cognitive focus of both the performer and the beholder. Something parallel, though with fewer possibilities for irony, occurs when novices in ashrams are advised to regard their experiences, at every moment of the day, as sacred and special.

That these creations by designation are linguistic, involving a willed change in the use of the word "art," does not altogether rob them of mystery and effectiveness. It should be emphasized that category shift by forced designation is the basis of many magical procedures. In the Roman Catholic mass, for example, certain well-known objects—bread and wine—are ritually designated as certain other objects—flesh and blood—which, in the manifest sense of everyday experience, they clearly are not; and the initiate who accepts the semantic rotation shifts his or her affection and sensibility accordingly. Art has often been thought of as exercising a sort of magic; around 1960, some artists adopted an actual magical procedure—basically a linguistic form of what Sir James Frazer called "sympathetic magic." At that moment art entered an ambiguous realm from which it has not yet definitively emerged. For the magical rite is already an appropriation of a piece of reality into a sheltered or bracketed zone of contemplation; when it is reappropriated into the realm of art, a double distancing occurs. Furthermore, the universalization of any category, or the complete submission of its ontology to the process of metaphor, blurs or even erases its individual identity. To be everything is not to be anything in particular. In regard to the universal set, the Law of Identity has no function. The semantical coextensiveness of art and life means either that art has disappeared into life, melting into it everywhere like a new spark of indwelling meaning, or (and this departs at once into theistic metaphor) that life has dissolved into art. In short it means ultimately that the terms have become meaningless in relation to one another, since language operates not by sameness but by difference, and two sets with the same contents are the same set.

The art of appropriation then, is a kind of shadowy recreation of the universe by drawing it, piece by piece, into the brackets of artistic contemplation. Artists engaged in this pursuit have concentrated on the appropriation of religious forms, of philosophical forms, of political forms, of popular forms, and more recently, of art historical styles. These enterprises have met different fates. The appropriation of religious contents has been the most unpopular, even taboo, while that based on philosophy, especially linguistic philosophy, for a while acquired a marketable chic. In this dis-

292 Art in the Dark

crimination the Apollonian (to use Nietzsche's dichotomy) surfaced over the hidden depth of the Dionysian. Apollo represents the ego and its apparent clarity of identity; Dionysus, the unconscious, in which all things flow into and through one another. In the Apollonian light each thing is seen clear and separate, as itself; in the Dionysian dark all things merge into a flowing and molten invisibility. That our culture, in the age of science, should favor the Apollonian is not surprising. The value of light is beyond question; but where there is no darkness there can be no illumination. Rejection of the Dionysian does not serve the purpose of clear and total seeing.

Universal appropriation has an exacting task if it is to be practiced with sufficient range of feeling not to trivialize life. The levity, the sense of the will to entertain, that prevailed when Ben or Gilbert & George displayed themselves as sculptures was balanced by the sometimes horrifying ordeal through which the appropriation of religious forms unfolded. It was necessary to descend from the pedestal, with its Apollonian apotheosis of the ego, into the Dionysian night of the unconscious, and to bring into the light the logic of its darkness.

In Vienna in the early 1960s, Hermann Nitsch began presenting a series of performances that, in 1965, he would consolidate as the OM, or Orgies Mysteries, Theatre.[7] His work was a focused exercise to bring the performance genre to its darkest spaces, its most difficult test, at once. In OM presentations the performers tear apart and disembowel a lamb or bull, cover themselves and the environment with the blood and gore, pour the entrails and blood over one another, and so on. These events last up to three hours (though Nitsch is planning one that will last for six days and nights). They have occasionally been shut down by the police. They have occurred in art galleries and have been reported in art magazines and books.

The OM Theatre performances open into dizzyingly distant antiquities of human experience. In form they are essentially revivals of the Dionysian ritual called the *sparagmos*, or dismemberment, in which the initiates, in an altered state produced by alcohol, drugs, and wild dancing, tore apart and ate raw a goat that represented the god Dionysus, the god of all thrusting and wet and hot things in nature.[8] It was, in other words, a communion rite in which the partaker abandoned his or her individual identity to enter the ego-darkened paths of the unconscious and emerged, having eaten and incorporated the god, redesignated as divine. In such rites ordinary humanity ritually appropriates the aura of godhood, through the ecstatic ability to feel the Law of Identity and its contrary at the same time.

Euripides, an ancient forerunner of the Viennese artists, featured this subject in several works. Like Nitsch, he did so partly because this was the subject matter hardest for his culture, as for ours, to assimilate in the light of day. In the *Bacchae* especially he presents the dismemberment as a terrifying instrument of simultaneous self-abandonment and self-discovery.

The Apollonian tragic hero, Pentheus, like our whole rationalist culture, thought his boundaries were secure, his terrain clearly mapped, his identity established. Rejecting the Dionysian rite, which represents the violent tearing apart of all categories, he became its victim. Disguising himself as a Maenad, or female worshiper of Dionysus, he attempted to observe the ritual, but was himself mistaken for the sacrificial victim, torn apart, and eaten raw. In short, his ego-boundaries were violently breached, the sense of his identity exploded into fragments that were then ground down into the primal substrate of Dionysian darkness which both underlies and overrides civilization's attempts to elevate the conscious subject above nature.

Nitsch writes of his work in consciously Dionysian terms as celebrating a "drunken, all-encompassing rejoicing," a "drunken ecstasy of life," a "liberated joy of strong existence without barriers," "a liturgy of exultation, of ecstatic, orgiastic, boundless joy, of drugged rapture . . ."[9] He has created, in fact, a purely classical theory for it, based on Freudian and Jungian reinterpretations of ancient religious forms, on Aristotle's doctrine of catharsis, and on the ritual of the scapegoat as the wellspring of purification for the community.

Another stage of the OM ritual finds a young male standing or lying naked beneath a slain carcass marked with religious symbols and allowing the blood and guts to flow over his naked body. Again an ancient source has been appropriated. In the initiation rite called the *taurobolium*, the aspirant was placed naked in a pit over which, atop a lattice of branches, a bull, representing the god, was slain and disemboweled. When the initiate emerged covered with the bull's blood and entrails, he was hailed as the reborn god emerging from the earth womb.[10]

These works demonstrate the category shift involved in the appropriation process. In part this shift from the zone of religion to that of art represents the residual influence of Romanticism: the artist is seen as a kind of extramural initiation priest, a healer or guide who points the alienated soul back toward the depths of the psyche where it resonates to the rhythms of nature. In addition, it is the neutrality of the unbounded category that allows the transference to occur. Religious structures in our society allow no setting open enough or free enough to equate with that of ancient Greek religion, which was conspicuously nonexclusionary; the art realm in the age of boundary dissolution and the overflow did offer such a free or open zone. Günter Brus, another Viennese performer, has claimed that placing such contents within the art realm allows "free access to the action"[11]—a free access that the category of religion, with its weight of institutionalized beliefs, does not allow. The assumption, in other words, is that in the age of the overflow the art context is a neutral and open context which has no proper and essential contents of its own. Art, then, is an open variable which, when applied to any culturally bound thing, will liberate it to direct experience. That this was the age of psychedelic drugs,

294 Art in the Dark

and that psychedelic drugs were widely presumed to do the same thing, is not unimportant. As this tradition advanced along the path to the underworld, it was increasingly influenced by psychopharmacology with its sense of the eternally receding boundaries of experience.

Soon after Nitsch's first performances in Vienna, Carolee Schneemann presented a series of now-classic pieces also based on the appropriation of ritual activities from ancient and primitive sources. The general shape of these works arose, as among ancient shamans and magicians, from a variety of sources, including dream material and experiences with psychedelic drugs. Like Nitsch's works, Schneemann's are based both on depth psychology and on the appropriation of contents from the neolithic stratum of religious history, especially the religious genre of the fertility rite.

In *Meat Joy* (Paris, 1964) nearly naked men and women interacted, in a rather frenzied, Dionysian way, with one another and with hunks of raw meat and carcasses of fish and chickens. They smeared themselves with blood, imprinted their bodies on paper, tore chickens apart, threw chunks of raw meat and torn fowl about, slapped one another with them, kissed and rolled about "to exhaustion," and so on.[12] The sparagmatic dismemberment and the suggestion of the suspension of mating taboos both evoke Maenadism and the Dionysian cult. The wild freedom advocated by this ancient cult, as well as its suggestions of rebirth, seemed appropriate expressions of the unchecked newness that faced the art world as its boundaries dissolved and opened on all sides into unexpected vistas, where traditional media, torn apart and digested, were reborn in unaccountable new forms. The Dionysian subversion of ego in the cause of general fertility has become another persistent theme of appropriation performance. Barbara Smith has performed what she calls a Tantric ritual, that included sexual intercourse, in a gallery setting as an artwork.[13]

In general, performance works involving the appropriation of religious forms have fallen into two groups: those that select from the neolithic sensibility of fertility and blood sacrifice, and those that select from the paleolithic sensibility of shamanic magic and ordeal; often the two strains mix. Both may be seen as expressions of the desire, so widespread in the '60s and early '70s, to reconstitute within Modern civilization something like an ancient or primitive sensibility of oneness with nature.

Though the erotic content of the works based on the theme of fertility has been received with some shock, it is the work based on the shamanic ordeal that the art audience has found most difficult and repellent. Clearly that is part of the intention of the work, and in fact a part of its proper content. But it is important to make clear that these artists have an earnest desire to communicate, rather than simply shock. Seen in an adequate context, their work is not aggression but expression.

In 1965 Nitsch formed the *Wiener Aktionismus* group in conjunction with Otto Mühl, Günter Brus, and Rudolf Schwarzkogler. Much of their

work focused on the motifs of self-mutilation and self-sacrifice that were implicit, though not foregrounded, both in Klein's career and in the OM Theatre performances. Brus, during his performing period (1964–1970), would appear in the performance space dressed in a woman's black stockings, brassiere, and garter belt, slash himself with scissors till he ran with blood, and perform various acts ordinarily taboo in public settings, such as shitting, eating his own shit, vomiting, and so on. Schwarzkogler's pieces presented young males as mutilated sacrificial victims, often wounded in the genitals, lying fetally contracted and partially mummy-wrapped as if comatose, in the midst of paraphernalia of violent death such as bullet cartridges and electrical wires. Not only the individual elements of these works, but their patterns of combination—specifically the combination of female imitation, self-injury, and the seeking of dishonor through the performance of taboo acts—find striking homologies in shamanic activities. The same motifs reappeared, not necessarily with direct influence from the Viennese, in the works of several American performance artists who have stretched audiences' sympathies beyond the breaking point.

Paul McCarthy, a major exponent of the art of the taboo gesture, first heard the calling not from the Viennese but from Klein. As a student at the University of Utah in 1968, he leapt from a second story window in emulation of Klein's Leap into the Void.[14] By about 1974 his work had found its own distinctive form, developing into a modernized shamanic style so difficult for audiences to bear that the pieces were usually published only as video tapes. These performances, like Schneemann's, were often developed from dream material, indicating their intimate relation both with shamanic magic and with depth psychology. Like Brus, McCarthy has sometimes appeared dressed as a woman, and has worked, like Schwarzkogler, with the themes of self-mutilation and castration; some pieces have acted out the basic female imitation of feigning menstruation and parturition (magical pantomimes that are common in primitive initiation rites). In others, McCarthy has cut his hands and mixed the blood with food and water in bowls, clearly echoing various sacramental rites from the Dionysian to the Christian. In still others that, like Nitsch's, have sometimes been shut down by the police, he has acted out the seeking of dishonor as an exploration of the Dionysian-Freudian depths of psychobiological life. In *Sailor's Meat*, a videotape from 1975, for example, he appeared in a room in a wino hotel wearing black lace panties smeared with blood and a blonde female wig and lay on the bed fucking piles of raw meat and ground hamburger with his cock painted red and a hot dog shoved up his ass. As Old Man in *My Doctor*, 1978, he slit a rubber mask over his head to form a vagina-shaped opening on it and from the vagina gave birth to a ketchup-covered doll. The piece was a conscious remaking of the myth of the birth of Athena from the cleft brainpan of Zeus, a myth that reverts to the age when male priests and their divinities sought to incorporate the female

principle and its powers. In *Baby Boy,* 1982, McCarthy gave birth to a doll from between his ketchup-covered male thighs as he lay on his back with his feet in the air like a woman in missionary-style sexual intercourse. In these and other works self-mutilation, female imitation, and the performance of taboo acts are combined in a structure roughly parallel to that of Brus' work, though with a greater range of expressiveness.

Similar materials recur in the work of Kim Jones. In a performance in Chicago in 1981, Jones appeared naked except for a mask made of a woman's panty-hose, covered himself with mud (as both African and Australian shamans do when performing), and lay naked on the fire escape in the cold to accumulate energy (a shamanic practice known worldwide but most famous from Tibet). Returning to the performance space, he produced a mayonnaise jar filled with his own shit, smeared himself with it, embraced members of the audience while covered with it, and finally burned sticks and green plants till the smoke drove the remaining audience from the gallery. In another piece, Jones cut himself with a razor blade 27 times in a pattern suggesting the body's circulatory system, then pressed himself against the gallery wall for a self-portrait.[15]

Understandably, to audiences habituated to the traditional boundaries of art, to audiences for whom easel painting was still the quintessential art activity, these performances were offensive and even insulting. Of course, the point of such works when they first appeared was in part their seeming to be radically, even horrifyingly, out of context. But for twenty years they have been part of the art scene, if somewhat peripherally, legitimized by art world context and critical designation again and again. In order to understand the wellsprings of such works, in order to approach them with a degree of sympathy and clarity, it is necessary to frame them somewhat in cultural history, where in fact they have a clear context.

Many of the artists discussed here feel that shamanic material and primitive initiation rites are the most relevant cultural parallels to their work. But most of them feel that the tone of their work arose first, often under Freudian or Jungian influence, and was later confirmed and further shaped by some study of shamanic literature.[16] The question of origins, then—whether from shamanic literature, or from the Jungian collective unconscious, or from the Freudian timeless repository of infantile memory, or from all these sources—though it is worthwhile to state, cannot be answered. In any case it is important in terms of any theory of the function of art that these artists have introduced into the art realm materials found elsewhere only in the psychiatric records of disturbed children and in the shamanic thread of the history of religion.[17]

In societies where the shamanic profession is intact, shamans have been perhaps the most fully-rounded and powerful cultural figures in history. The poets, mythographers, visual artists, musicians, medical doctors, psychotherapists, scientists, sorcerers, undertakers, psychopomps, and priests

PAUL MCCARTHY, "Halloween' 1978.
"Halloween" photographer Ron Benom. Photograph courtesy of the artist.

of their tribal groups, they have been one-person cultural establishments. They have also been independent, uncontrollable, and eccentric power figures whose careers have often originated in psychotic episodes—what anthropologists call the "sickness vocation."[18] As a result, when societies increase their demands for internal order, the old shamanic role, with its unassimilable combination of power and freedom, is broken up into more manageable specialty professions; in our society, the doctor, the poet, the artist, and so on, have each inherited one scrap from the original shaman's robe. Beginning with the Romantic period an attempt was made to reconstitute something like the fullness of the shamanic role within the art realm; poets especially were apt to attribute both healing and transcendentalizing powers to the art experience. This project has been acted out in the last twenty years by those artists whose work appropriates its materials from the early history of religion.

Perhaps the most shocking element in the various performance works mentioned here is the practice of self-injury and self-mutilation. This has, however, been a standard feature of shamanic performances and primitive initiation rites around the world. Siberian shamans cut themselves while in ecstatic states brought on by drugs, alcohol, drumming, and dancing.[19] Tibetan shamans are supposedly able to slit their bellies and exhibit their entrails.[20] Related practices are found in the performance art under discussion. Chris Burden crawled through broken glass with his hands behind his back (*Through the Night Softly*, 1973). Dennis Oppenheim did a piece in

which for half an hour rocks were thrown at him (*Rocked Circle/Fear*, 1971). Linda Montano inserted acupuncture needles around her eyes (*Mitchell's Death*, 1978). The Australian performance artist Stelarc, reproducing a feat of Ajivika ascetics in India, has had himself suspended in various positions in the air by means of fishhooks embedded in his flesh.[21] The number of instances could easily be multiplied.

The element of female imitation, found in the works of Brus, Mc-Carthy, Jones, and others, is also a standard shamanic and initiatory motif, involving sympathetic magic. Male shamans and priests around the world, as well as tribal boys at their puberty initiations, adopt female dress to incorporate the female and her powers.[22] In lineages as far apart as North Asian and Amerindian, shamans have worn women's clothing and ritually married other men.[23] Akkadian priests of Ishtar dressed like their goddess, as did Ramakrishna in 19th-century India. A Sanskrit religious text instructs the devotee to "discard the male (*purusa*) in thee and become a woman (*prakriti*)."[24] Various tribal rites involve the ritual miming, by men, of female menstruation and parturition, as in the works of McCarthy.[25] Freudian and Jungian theories of the bisexuality of the psyche and the need to realize it are relevant both to archaic and to modern exercises of this sort.[26]

Female imitation and self-mutilation combine in certain practices of ritual surgery found in primitive cultures around the world, though most explicit in Australia. In Central Australian initiation rites, for example, a vulvalike opening is cut into the urethral surface of the penis, symbolically incorporating the female principle into the male body.[27] Bruno Bettelheim has observed this motif in the fantasies of disturbed children. Brus, in a performance, once cut a vulvalike slit in his groin, holding it open with hooks fastened in his flesh. Ritual surgery to create an androgynous appearance is common in archaic religious practice generally, as an attempt to combine male and female magical powers into one center. The emphasis on the mutilation of the male genitals in much of the Viennese work is relevant here. In classical antiquity the priests of Cybele castrated themselves totally (both penis and testicles) in their initiation, to become more like their goddess; thereafter they dressed like women and were called "females." In subsequent ecstatic performances they would cut themselves in the midst of frenzied dancing and offer the blood to the goddess.[28]

The public performance of taboo acts is also an ancient religious custom with roots in shamanism and primitive magic. Both art and religion, through the bracketing of their activities in the half-light of ritual appropriationism, provide zones where deliberate inversions of social custom can transpire; acts repressed in the public morality may surface there, simultaneously set loose for their power to balance and complete the sense of life, and held safely in check by the shadow reality of the arena they occur in.

A little-known Sanskrit book called the *Pasupata Sutras* formulates this practice in detail, under the heading of the Seeking of Dishonor.[29] The

practitioner is enjoined to court contempt and abuse from his fellow humans by behavior deliberately contrived as the most inappropriate and offensive for the situation, whatever it may be. In shamanic contexts such practices had demonstrated the shaman's special status beyond convention, his ability to breach at will either metaphysical or ethical boundaries. In yogic terms the goal of the practice was the effacement of ego by the normalization of types of experience usually destructive to the self-image.[30] The shaman, the yogic seeker of dishonor, and the ritual scapegoat figure all offered themselves as targets for calamity, to draw it away from the communities they served. They were the individuals who went out on the razor's edge and, protected in part by the brackets of religious performance, publicly breached the taboos of their times. Today the exhibitionistic breaching of age and gender taboos, as well as other forays into the darkness of the disallowed within the brackets of the art performance, replicates this ancient custom, sometimes with the same cathartic intention. As the shoals of history break and flow and reassemble, to break and flow again, these and other primitive practices have resurfaced, in something like their original combination, in an altogether different context.

The preparation of his or her own body as a magico-sculptural object, for example, is a regular and essential part of the shaman's performance. An Australian shaman may cover his body with mud (symbol of recent arrival from the netherworld) and decorate it with patterns of bird down fastened on with his own blood; an African shaman may wear human bones, skulls, and so forth, and may surgically alter his or her body in various ways; a Central Asian shaman may appear in a skeleton suit with mirrors on it. Frequently the shaman's body is tattooed or scarified or painted with magical symbols. Similarly, Schneemann has presented herself as a "body collage" decorated with symbols from ancient fertility religions. In a mixture of archaic and Christian materials, Linda Montano in *The Screaming Nun*, 1975, "dressed as a nun, danced, screamed, and heard confessions at Embarcadero Plaza [in San Francisco]."[31] Other pieces by Montano have involved dancing blindfolded in a trance, drumming for six hours a day for six days, shape-changing and identity-changing, self-injury (with acupuncture needles), and astral travel events. Mary Beth Edelson's "Public Rituals" have involved the marking of her naked body with symbols from ancient goddess cults, the equation of her body with the earth, and the declaration of the end of patriarchy (*Your Five Thousand Years Are Up*, 1977).[32] Kim Jones, as Mud Man, or Bill Harding emerging covered with mud from a hole in the ground in the middle of a circle of fire, are reconstituting before our eyes images from the elementary stratum of religious forms.

A motif that is absolutely central to shamanism, and that often also involves body decoration, is the attempt to incorporate the power of an animal species by imitation of it. Shamans in general adopt the identities

of their power animals, act out their movements, and duplicate their sounds.[33] The claim to understand animal languages and to adopt an animal mind-set is basic to their mediation between culture and nature. Echoes of the practice are, of course, common in the annals of performance art. In Joseph Beuys' conversation with the dead rabbit the knowledge of an animal language combines with a belief in the shamanic ability to communicate with the dead. In *Chicken Dance*, 1972, Montano, attired in a chicken costume, appeared unannounced at various locations in San Francisco and danced wildly through the streets like a shaman possessed by the spirit and moved by the motions of her animal ally. Terry Fox slept on a gallery floor connected with two dead fish by string attached to his hair and teeth, attempting, like a shaman inviting his animal ally to communicate through a dream, to dream himself into the piscine mind in *Pisces*, 1971.

In such behavior a style of decision-making is involved that has much in common with the peculiar arbitrariness and rigor of religious vows in general, and with one called the Beast Vow in particular. Among the Pasupatas of India (the same who formalized the Seeking of Dishonor), the male practitioner commonly took the bull vow. (The bull is the most common shamanic animal by far.) He would spend a good part of each day bellowing like a bull and in general trying to transform his consciousness into that of a bull. Such behavior was usually vowed for a specific length of time, most frequently either for a year or for the rest of one's life. A person who took the frog vow would move for a year only by squatting and hopping; the snake vower would slither.[34] Such vows are very precise and demanding. The novice, for example, may pick a certain cow and vow to imitate its every action. During the time of the vow the novice follows the cow everywhere: when the cow eats, the novice eats; when the cow sleeps, the novice sleeps; when the cow moos, the novice moos—and so on. (In ancient Mesopotamia cow-vowers were known as "grazers.") By such actions the paleolithic shaman attempts to affect ecology by infiltrating an animal species which can then be manipulated. The yogic practitioner hopes to escape from his or her own intentional horizon by entering into that of another species.

These activities are echoed in performance pieces in various ways. Bill Gordh, as Dead Dog, spent two years learning how to bark with a sense of expressiveness. James Lee Byars wore a pink silk tail everywhere he went for six months. Vito Acconci, in his *Following Piece*, 1969, would pick a passerby at random on the street and follow him or her till it was no longer possible to do so.

What I am especially concerned to point out in activities like this is a quality of decision-making that involves apparent aimlessness along with fine focus and rigor of execution. This is a mode of willing which is absolutely creative in the sense that it assumes that it is reasonable to do anything at all with life; all options are open and none is more meaningful

or meaningless than any other. A Jain monk in India may vow to sit for a year and then follow that by standing up for a year—a practice attested to in the *Atharva Veda* (about 1000–800 B.C.)[35] and still done today. In performance art the subgenre known as Endurance Art is similar in style, though the scale is much reduced.

In 1965 Beuys alternately stood and knelt on a small wooden platform for 24 hours during which he performed various symbolic gestures in immobile positions. In 1971 Burden, a major explorer of the Ordeal or Endurance genre, spent five days and nights fetally enclosed in a tiny metal locker (2 feet by 2 feet by 3 feet). In 1974 he combined the immobility vow with the keynote theme of the artist's person by sitting on an upright chair on a sculpture pedestal until, 48 hours later, he fell off from exhaustion (*Sculpture in Three Parts*). In *White Light/White Heat*, 1975, he spent 22 days alone and invisible to the public on a high shelf-like platform in a gallery, neither eating nor speaking nor seeing, nor seen by, another human being.[36]

The first thing to notice about these artists is that no one is making them do it and usually no one is paying them to do it. The second is the absolute rigor with which, in the classic performance pieces, these very unpragmatic activities are carried out. This peculiar quality of decision-making has become a basic element of performance poetics. To a degree (which I do not wish to exaggerate) it underscores the relationship between this type of activity and the religious vocation. A good deal of performance art, in fact, might be called "Vow Art," as might a good deal of religious practice. (Kafka's term "hunger artist" is not unrelated.)

Enthusiasms of this type have passed through cultures before, but usually in the provinces of religion or, more occasionally, philosophy. What is remarkable about our time is that it is happening in the realm of art, and being performed, often, by graduates of art schools rather than seminaries. In our time religion and philosophy have been more successful (or intransigent) than art in defending their traditional boundaries and preventing universal overflow with its harrowing responsibilities and consequences.

A classic source on the subject of Ordeal Art is a book called the *Path of Purification* by Buddhaghosa, a fifth century A.D. Ceylonese Buddhist.[37] It includes an intricately categorized compendium of behavioral vows designed to undermine the conditioned response systems that govern ordinary life. Among the most common are the vows of homelessness—the vow, for example, to live out of doors for a year. This vow was acted out in New York recently by Tehching Hsieh, who stayed out of doors in Manhattan for a year as a work of art. Hsieh (who also has leapt from the second story of a building in emulation of Klein's leap) has specialized, in fact, in year-long vows acted out with great rigor. For one year he punched in hourly on a time clock in his studio, a device not unlike some used by forest yogis in India to restrict their physical movements and thus their

intentional horizons. The performance piece of this type done on the largest scale was Hsieh's year of isolation in a cell built in his Soho studio, a year in which he neither left the cell nor spoke nor read. Even the scale of this piece, however, does not approach that of similar vows in traditional religious settings. Himalayan yogis as recently as a generation ago were apt to spend seven years in a light-tight cave, while Simeon Stylites, an early Christian ascetic in the Syrian desert, lived for the last 37 years of his life on a small platform on top of a pole.

The reduced scale of such vows in the art context reflects the difference in motivation between the religious ascetic and the performance artist. Religious vows are undertaken for pragmatic purposes. The shaman seeking the ability to fly, the yogi seeking the effacement of ego, the monk seeking salvation and eternal bliss, are all working within intricately formulated belief systems in pursuit of clearly defined and massively significant rewards. Less is at stake for the performance artist than for the pious believer; yet still something is at stake. An act that lacks any intention whatever is probably a contradiction in terms. For some artists (for example, Burden) work of this type has functioned as a personal initiation or catharsis, as well as an investigation of the limits of one's will; others (including Nitsch) are convinced that their performance work is cathartic for the audience as well and in that sense serves a social and therapeutic purpose. Rachel Rosenthal describes her performance work as "sucking diseases from society."[38]

But in most work of this type attention is directed toward the exercise of will as an object of contemplation in itself. Appropriation art in general (and Vow Art in particular) is based on an esthetic of choosing and willing rather than conceiving and making. Personal sensibility is active in the selection of the area of the universe to be appropriated, and in the specific, often highly individual character of the vow undertaken; the rigor with which the vow is maintained is, then, like a crafts devotion to perfection of form. Beyond this, the performance is often based on a suspension of judgment about whether or not the act has any value in itself, and a concentration on the purity of the doing. This activity posits as an ideal (though never of course perfectly attaining it) the purity of doing something with no pragmatic motivation. Like the Buddhist paradox of desiring not to desire, it requires a motivation to perform feats of motivelessness. It shares something of Arnold Toynbee's opinion that the highest cultures are the least pragmatic.

In this mode of decision and execution the conspicuously free exercise of will is framed as a kind of absolute. Displays of this type are attempts to break up the standard weave of everyday motivations and create openings in it through which new options may make their way to the light. These options are necessarily undefined, since no surrounding belief system is in place (or acknowledged). The radicality of work in this genre can be ap-

praised precisely by how far it has allowed the boundaries of the art category to dissolve. Many works of the last twenty-five years have reached to the limits of life itself. Such activities have necessarily involved artists in areas where usually the psychoanalyst or anthropologist presides. The early explorations discussed here required the explicit demonstration of several daring strategies that had to be brought clearly into the light. Extreme actions seemed justified or even required, by the cultural moment. But the moment changes, and the mind becomes desensitized to such direct demonstrations after their first shock of brilliant simplicity. When an artist in 1983 announces that his or her entire life is designated as performance, the unadorned gesture cannot expect to be met with the enthusiastic interest with which its prototypes were greeted a generation ago.

NOTES

[1] See Thomas McEvilley, "Diogenes of Sinope (c. 410–c. 320 B.C.): Selected Performance Pieces," *Artforum*, March 1983.

[2] For a more detailed discussion of this process see Timothy Binkley, "Piece: Contra Aesthetics," in Joseph Margolis, ed., *Philosophy Looks at the Arts*, Philadelphia: Temple University Press, 1978, pp. 25–44.

[3] Alain Robbe-Grillet, *For a New Novel*, New York: Grove Press, 1965, p. 43.

[4] For this and other references to Klein the most convenient source is Thomas McEvilley, "Yves Klein, Conquistador of the Void," in exh. cat. *Yves Klein (1928–1962), A Retrospective*, Houston, Texas, and New York, 1982.

[5] Allan Kaprow, *Assemblages, Environments, Happenings*, New York: Harry N. Abrams, Inc., 1966, p. 188, reproduced in this volume.

[6] For the image of the Net of Indra see Garma C.C. Chang, *The Buddhist Teaching of Totality*, University Park, Pa., and London, 1974, pp. 165–66.

[7] In English, see, e.g., Hermann Nitsch, in exh. cat. *The Spirit of Vienna*, New York: René Block Gallery, 1977, p. 64.

[8] For the *sparagmos* see W.K.C. Guthrie, *The Greeks and Their Gods*, Boston: Beacon Press, 1950, pp. 45, 149, 171–72; and Walter F. Otto, *Dionysus, Myth and Cult*, Bloomington: Indiana University Press, 1965, pp. 192 ff., etc. For the presence of various drugs in ancient wines, see Carl A.P. Ruck's essay in R. Gordon Wasson, *The Road to Eleusis*, New York: Harcourt Brace Jovanovitch, 1978.

[9] *The Spirit of Vienna*, pp. 31–32.

[10] For the *taurobolium* see Franz Cumont, *The Oriental Religions in Roman Paganism*, New York: Dover Publications, 1956, p. 66.

[11] Brus in *The Spirit of Vienna*, p. 8.

[12] Carolee Schneemann, *More than Meat Joy: Complete Performance Works and Selected Writings*, New Paltz, N.Y.: Documentex, 1979, p. 66.

[13] "As Above, So Below," 1981; see *High Performance* 15, vol. 4, no. 3, Fall 1981, pp. 19–25. Many of the performance works mentioned in this essay were first documented in *High Performance*, a basic source on the subject.

[14] I have written about the history of Klein's leaps elsewhere (see note 4 above). The famous photograph is a photomontage of a leap made over a net (tarpaulin, really). But the evidence is indisputable that Klein did, on two occasions before the photographed event, make leaps from comparable heights, sustaining injury both times. It is intriguing to note how resistant people are to accepting this fact; at a panel discussion at the Guggenheim Museum in New York after the opening of the Klein retrospective (Nov. 21, 1982), this was the central, and often heated, topic of discussion.

[15] The making of blood imprints, which was found also in Schneemann's work and parodied in McCarthy's performances of painting with his penis dipped in ketchup, reverts of course to Yves Klein. In addition to his body prints in ultramarine blue, Klein on two occasions made blood prints of women's naked bodies (once using the model's own menstrual blood), which he subsequently destroyed for fear of their negative magic. The directness of the imprint method influenced neo-primitive performance widely. Recently the Italian performance artist Giuditta Tornetta has made blood imprints of her own pregnant body as performance works.

[16] The works most commonly mentioned as influential are Sir James Frazer, *The Golden Bough*, often in the abridgment and revision of Theodore Gaster, and Mircea Eliade, *Shamanism*, New York: Bollingen Foundation, dist. by Pantheon Books, 1964.

[17] The parallels between tribal initiatory customs and the behavior of disturbed children are brought out by Bruno Bettelheim, *Symbolic Wounds: Puberty Rites and the Envious Male*, New York: Collier Books, 1962.

[18] Mircea Eliade, *Shamanism*, chapters 1 and 2.

[19] See, for example, S.M. Shirokogoroff, *Psychomental Complex of the Tungus*, London: K. Paul, Trench, Trubner & Co., Ltd., 1935, p. 364; V.M Michaelowski, "Shamanism in Siberia and European Russia, Being the Second Part of *Shamanstro*," *Journal of the Royal Anthropological Institute of Great Britain and Ireland* 24, 1894, p. 66.

[20] Fokke Sierksma, *Tibet's Terrifying Deities*, from "Art in its Context; Studies in Ethno-Aesthetics, Museum Series," vol. 1, the Hague: Mouton, 1966, p. 73.

[21] For the Ajivika austerity of hanging by hooks inserted in the flesh see Richard Morris, "Notes and Queries," *Journal of the Pali Text Society*, 1884, p. 95.

[22] The classic source for shamanic transvestitism is Robert Briffault, *The Mothers*, London: Allen & Unwin, 1952, vol. 2, pp. 532 ff. For speculations on the female origin of shamanism see Georg Nioradze, *Der Schamanismus bei den sibirischen Völkern*, Stuttgart: Strecker und Schröder 1925, pp. 51 ff., and Debiprasad Chattopadhyaya, *Lokayatá: A Study in Ancient Indian Materialism*, New Delhi: People's Publishing House, 1959, p. 285.

[23] Waldemar G. Bogoras, *The Chukchee*, Memoirs of the American Museum of Natural History 11, vol XI, New York: G.E. Stechert, 1904–09, p. 448; Hans Findeisen, *Schamanentum, dargestellt am Beispiel der Bessenheitspriester hordeurasiatischer Völker*, Stuttgart: W. Kohlhammer, 1957, ch. XIII.

[24] Cited by Chattopadhyaya, *Lokayatá*, p. 284.

[25] Bettelheim, *Symbolic Wounds*, pp. 109–121.

[26] See, e.g., Sigmund Freud, "Some Psychological Consequences of the Anatomical Distinction Between the Sexes," *Collected Papers*, London: Hogarth Press, 1950, vol. 5.

[27] Subincision is reported by Baldwin Spencer and Francis J. Gillen, *The Native Tribes of Central Australia*, London: Macmillan and Co., 1899, p. 263, and described in detail by M.F. Ashley-Montagu, *Coming into Being among the Australian Aborigines*, London: G. Routledge & Sons, Ltd., 1937, p. 293; varying psychoanalytical interpretations are given by Géza Róheim, *The Eternal Ones of the Dream*, New York: International Universities Press, 1945, and Bettelheim, *Symbolic Wounds*.

[28] Grant Showerman, *The Great Mother of the Gods*, Chicago, 1969, pp. 16–18. For a psychoanalytic interpretation see E. Weigert-Vowinkel, "The Cult and Mythology of the Magna Mater from the Standpoint of Psychoanalysis," *Psychiatry* 1, 1938, pp. 348–49.

[29] The text as a whole is not available in English; for excerpts and summary see Daniel H.H. Ingalls, "Cynics and Pasupatas," *Harvard Theological Review* 55, 1962.

[30] Yoga is primarily a redefining of shamanic practices in terms of later forms of thought. See Thomas McEvilley, "An Archaeology of Yoga," *Res* (Journal of the Peabody Museum, Harvard University, and the Laboratoire d'Ethnologie, University of Paris) I, pp. 44–77.

[31] Linda Montano, *Art in Everyday Life*, Los Angeles: Astro Artz Press, 1981.

[32] Mary Beth Edelson, *Seven Cycles: Public Rituals*, New York, 1980. In the feminist branch of performance art this shamanic element has been widely explored. It is well to pause for a moment over the fact of there being a feminist branch at all. There is of course more than a little justification in the history of religion for this development. In fact the prevalence of transvestitism in shamanism has led to an intriguing (but untestable) hypothesis that sha-

manism was originally a female practice that was adopted by men through the mediation of female dress. Still, the explicitly feminist thrust of some of this work involves it in areas of politics that breach somewhat the neutrality of the appropriation zone.

[33] Shirokogoroff, *Psychomental Complex*, p. 309; Wilhelm Radloff, *Aus Sibirien*, Leipzig: T.O. Weigel, 1884, vol. 2, pp. 20–50; Mary A. Czaplicka, *Aboriginal Siberia: A Study in Social Anthropology*, Oxford: Clarendon Press, 1914, pp. 171 ff; Findeisen, *Schamanentum*, pp. 30 ff; Adolph Friedrich and Georg Buddruss, joint eds. and translators, *Schamanengeschichten aus Sibirien*, Munich: O.W. Barth, 1955, p. 212.

[34] On the Beast Vow see M.G. Bhagat, *Ancient Indian Asceticism*, New Delhi: Munshiram Manoharlal Publishers, 1976, p. 145; Chattopadhyaya, *Lokayatá*, ch. 2; Ingalls, "Cynics and Pasupatas."

[35] *Atharva Veda*, XV. 3; and see Haripada Chakraborti, *Asceticism in Ancient India*, Calcutta: Punthi Pustak, 1973, pp. 368, 371, 437.

[36] For the works by Chris Burden cited here see *Chris Burden, 71–73*, Los Angeles, 1974, and *Chris Burden, 74–77*, Los Angeles, 1978.

[37] Bhikku Nyánamoli, trans., *The Path of Purification (Visuddhimagga)*, Berkeley, Calif.: Shambhala Publications, dist. Random House, 1976. For the parallels drawn here, see, for example, the "tree-root-dweller's practice" (p. 74), and the "open-air-dweller's practice" (p. 75).

[38] There are countless other examples of artists who might describe their work in such terms; some are omitted due to considerations of space, others because their work seems sensationalistic in motivation.

BIBLIOGRAPHY (With Emphasis on Theory and Criticism Since 1970)

BOOKS

BATTCOCK, GREGORY, ed. *Minimal Art.* Dutton, 1968.

――――. *Idea Art.* Dutton, 1973.

BAUDRILLARD, JEAN. *For a Critique of the Political Economy of the Sign.* Telos Press Ltd., 1981.

BENAMOU, MICHAEL, and CHARLES CARAMELLO, eds. *Performance in Postmodern Culture.* Coda Press, 1977.

BUCHLOH, BENJAMIN H. D., ed. *Michael Asher: Writings 1973–1983 on Works 1969–1979.* The Press of the Nova Scotia College of Art and Design and The Museum of Contemporary Art Los Angeles, 1983.

BUREN, DANIEL. *5 Texts.* John Weber Gallery, 1973.

BURNHAM, JACK. *The Structure of Art.* Braziller, 1971.

――――. *Great Western Salt Works.* Braziller, 1974.

CARMEAN, E. A. JR. *The Great Decade of American Abstraction: Modernist Art 1960 to 1970,* catalogue. Houston: The Museum of Fine Arts, 1974.

DANTO, ARTHUR. *The Transfiguration of the Commonplace.* Harvard University Press, 1981.

FOSTER, HAL. *The Anti-Aesthetic: Essays on Postmodern Culture.* Port Townsend, Washington: Bay Press, 1983.

FRASCINA, FRANCIS, and CHARLES HARRISON, eds. *Modern Art and Modernism.* Harper & Row, 1983.

FRIED, MICHAEL. *Absorption and Theatricality: Painting and Beholder in the Age of Diderot.* University of California Press, 1980.

――――. *Three American Painters.* Harvard University Press, 1965.

GABLIK, SUZI. *Progress in Art.* Rizzoli, 1977.

GELDZAHLER, HENRY. *New York Painting and Sculpture.* The Metropolitan Museum of Art, 1965.

GILBERT-ROLFE, JEREMY. *Immanence and Contradiction. Recent Essays on the Artistic Device.* Out of London Press, 1984.

GOLDBERG, ROSELEE. *Performance: Live Art 1909 to the Present.* Abrams, 1979.

GREENBERG, CLEMENT. *Art and Culture: Critical Essays.* Beacon Press, 1961.

HASSAN, IHAB. *Paracriticisms.* University of Illinois, 1975.

HOBBS, ROBERT C. *Robert Smithson: Sculpture.* Cornell University Press, 1981.

HOLT, NANCY, ed. *The Writings of Robert Smithson.* New York University Press, 1979.

HONOUR, HUGH, and JOHN FLEMING. *The Visual Arts: A History.* Prentice-Hall, 1983.

HUGHES, ROBERT. *The Shock of the New.* Knopf, 1981.

JOHNSON, ELLEN H., ed. *American Artists on Art.* Harper & Row, 1982.

――――. *Modern Art and the Object.* Harper & Row, 1976.

JUDD, DONALD. *Complete Writings 1959–1975.* New York University Press, 1975.

KIRBY, MICHAEL. *Happenings.* Dutton, 1965.

KOSTELANETZ, RICHARD, ed. *Esthetics Contemporary.* Prometheus, 1978.

――――. *The Theatre of Mixed Means.* Dial Press, 1968.

KRAUSS, ROSALIND. *Passages in Modern Sculpture.* Viking, 1977.

KRAMER, HILTON. *The Age of the Avant-Garde.* Farrar, Straus & Giroux, 1973.

KUSPIT, DONALD. *Clement Greenberg, Art Critic.* University of Wisconsin, 1979.

LIPPARD, LUCY R. *Changing: Essays in Art Criticism.* Dutton, 1971.

――――. *Get the Message? Activist Essays on Art and Politics.* Dutton, 1983.

――――. *From the Center.* Dutton, 1976.

――――. *Overlay: Contemporary Art and the Art of Prehistory.* Pantheon, 1983.

———. *Six Years: The Dematerialization of the Art Object.* Praeger, 1973.
LOEFFLER, CARL E., ed. *Performance Anthology: Source Book for a Decade of California Performance Art.* Contemporary Arts Press, 1980.
LYNTON, NORBERT. *The Story of Modern Art.* Prentice-Hall, 1983.
MEYER, URSULA, ed. *Conceptual Art.* Dutton, 1972.
NOCHLIN, LINDA. *Realism.* Penguin Books, 1971.
OLDENBURG, CLAES. *Raw Notes.* New York University Press, 1973.
PINCUS-WITTEN, ROBERT. *Postminimalism.* Out of London Press, 1977.
———. *Entries (Maximalism). Art at the Turn of the Decade.* Out of London Press, 1983.
PLAGENS, PETER. *Sunshine Muse.* Praeger, 1974.
ROSE, BARBARA. *American Art Since 1900: A Critical History.* Praeger, 1975.
ROSENBERG, HAROLD. *The De-Definition of Art.* Macmillan, 1973.
ROSENBLUM, ROBERT. *Modern Painting and the Northern Romantic Tradition: Friedrich to Rothko.* Harper & Row, 1975.
ROSKILL, MARK, and DAVID CARRIER. *Truth and Falsehood in Visual Images.* University of Massachusetts Press, 1983.
ROTH, MOIRA, ed. *The Amazing Decade: Women and Performance Art in America 1970–1980.* Astro Artz, 1983.
RUSSELL, JOHN. *The Meanings of Modern Art.* Harper & Row, 1981.
SELZ, PETER. *Art in Our Times: A Pictorial History 1890–1980.* Abrams, 1981.
SMAGULA, HOWARD. *Currents: Contemporary Directions in the Visual Arts.* Prentice-Hall, 1983.
SOLOMON, ALAN. *New York: The New Art Scene.* Holt, Rinehart and Winston, 1967.
SONDHEIM, ALAN, ed. *Individuals: Post-Movement Art in America.* Dutton, 1977.
SONFIST, ALAN, ed. *Art in the Land.* Dutton, 1983.
SONTAG, SUSAN. *Against Interpretation.* Dutton, 1966.
STEINBERG, LEO. *Other Criteria: Confrontations With Twentieth Century Art.* Oxford University Press, 1972.
TOMKINS, CALVIN. *Off the Wall: Robert Rauschenberg and the Art of Our Time.* Penguin, 1981.
———. *The Bride and the Bachelors.* Viking Press, 1965.
———. *The Scene: Reports on Postmodern Art.* Viking Press, 1976.
WOLFE, TOM. *The Painted Word.* Farrar, Straus & Giroux, 1975.

ARTICLES—I. Defining Modern and Postmodern Art

BANNARD, WALTER DARBY. "Notes on American Painting of the 60s." *Artforum* (January 1970).
BORDEN, LIZZIE. "Three Modes of Conceptual Art." *Artforum* (June 1972).
BUCHLOH, BENJAMIN H. D. "Allegorical Procedures: Appropriation and Montage in Contemporary Art." *Artforum* (September 1982).
———. "Documenta 7: A Dictionary of Received Ideas." *October* (Fall 1982).
———. "Figures of Authority, Ciphers of Regression." *October* (Spring 1981).
BUREN, DANIEL. "Function of the Studio." *October* (Fall 1979).
BURN, IAN. "Pricing Works of Art." *The Fox* 1 (1974).
CARRIER, DAVID. "Recent Aesthetics and the Criticism of Art." *Artforum* (October 1979).
CLARK, T.J. "Clement Greenberg's Theory of Art." *Critical Inquiry* (September 1982).
CRIMP, DOUGLAS. "On the Museum's Ruins." *October* (Summer 1980).
———. "Pictures." *October* (Spring 1979).
———. "The End of Painting." *October* (Spring 1981).
———. "The Photographic Activity of Postmodernism." *October* (Winter 1980).
ELDERFIELD, JOHN. "Grids." *Artforum* (May 1972).

FOSTER, HAL. "Between Modernism and the Media." *Art in America* (Summer 1982).
———. "The Art of Spectacle." *Art in America* (April 1983).
———. "The Expressive Fallacy." *Art in America* (January 1983).
FRIED, MICHAEL. "Art and Objecthood." *Artforum* (Summer 1967).
———. "How Modernism Works: A Response to T.J. Clark." *Critical Inquiry* (September 1982).
GRAHAM, DAN. "Art in Relation to Architecture/Architecture in Relation to Art." *Artforum* (February 1979).
———. "Signs." *Artforum* (April 1981).
GREENBERG, CLEMENT. "Modern and Postmodern." *Arts* (February 1980).
HAFIF, MARCIA. "Getting On With Painting." *Art in America* (April 1981).
HENNESSEY, RICHARD. "What's All This About Photography?" *Artforum* (May 1979).
HERTZ, RICHARD. "A Critique of Authoritarian Rhetoric." *Real Life Magazine* (Summer 1982).
HOBERMAN, J. "In Defense of Pop Culture: Love and Death in the American Supermarket Place." *Village Voice Literary Supplement* (November 1982).
———. "Vulgar Modernism." *Artforum* (February 1982).
HUEBLER, DOUGLAS. "Sabotage or Trophy? Advance or Retreat?" *Artforum* (May 1982).
KAPROW, ALLAN. "Non-Theatrical Performance." *Artforum* (May 1976).
———. "The Real Experiment." *Artforum* (December 1983).
KRAMER, HILTON. "Postmodern: Art and Culture in the 1980s." *The New Criterion* (September 1982).
KRAUSS, ROSALIND. "Grids." *October* (Summer 1979).
———. "The Originality of the Avant-Garde: A Postmodernist Repetition." *October* (Fall 1981).
KUSPIT, DONALD. "Art, Criticism and Ideology." *Art in America* (Summer 1981).
———. "The Unhappy Consciousness of Modernism." *Artforum* (January 1981).
———. "Tired Criticism, Tired 'Radicalism.' " *Art in America* (April 1983).
LAWSON, THOMAS. "The Uses of Representation." *Flash Art* (March/April 1979).
———. "Too Good To Be True." *Real Life Magazine* (Autumn 1981).
MCEVILLEY, THOMAS. "Heads It's Form, Tails It's Not Content." *Artforum* (Summer 1982).
MASHECK, JOSEPH. "Cruciformality." *Artforum* (Summer 1977).
———. "Iconicity." *Artforum* (January 1979).
MELVILLE, STEPHEN. "Notes on the Reemergence of Allegory, the Forgetting of Modernism, and the Conditions of Publicity in Art and Criticism." *October* (Spring 1980).
MORRIS, ROBERT. "Notes on Art As/And Land Reclamation." *October* (Spring 1980).
NEHER, ROSS. "Bathysiderodromophobia." *The Fox 3* (1976).
OWENS, CRAIG. "The Allegorical Impulse: Toward a Theory of Postmodernism." Parts I, II. *October* (Spring, Summer 1980).
PEPPE, MICHAEL. "Why Performance Art is So Boring." *High Performance* (Spring/Summer 1982).
RATCLIFF, CARTER. "Art and Resentment." *Art in America* (Summer 1982).
———. "Critical Thought, Magical Language." *Art in America* (Summer 1980).
———. "The Short Life of the Sincere Stroke." *Art in America* (January 1983).
ROSE, BARBARA. "Abstract Illusionism." *Artforum* (October 1967).
———. "A New Aesthetic," catalogue essay. *A New Aesthetic* (Gallery of Modern Art, Washington, 1967).
ROSENTHAL, MARK. "From Primary Structures to Primary Imagery." *Arts* (October 1978).
ROSLER, MARTHA. "For an Art Against the Mythology of Everyday Life." *Journal of the Los Angeles Institute of Contemporary Art* (June/July 1979).
ROTH, MOIRA. "Visions and Re-Visions." *Artforum* (November 1980).

SALLE, DAVID. "New Image Painting." *Flash Art* (March/April 1979).
SCHJELDAHL, PETER. "Falling in Style." *Vanity Fair* (March 1983).
SINGERMAN, HOWARD. "Paragraphs Towards an Essay Entitled 'Restoration Comedies'." *Journal of the Los Angeles Institute of Contemporary Art* (Summer 1982).
STARENKO, MICHAEL. "What's an Artist to Do? A Short History of Postmodernism and Photography." *Afterimage* (January 1983).
TILLIM, SIDNEY. "The Function of Art as a Form of Value." *Artforum* (May 1983).
TUCKER, MARCIA. " 'Bad' Painting," catalogue essay. *"Bad" Painting* (The New Museum, 1978).

II. Artists and Artworks

ALLOWAY, LAWRENCE. "The Revival of Realist Criticism." *Art in America* (September 1981).
BOIS, YVE-ALAIN. "Ryman's Tact." *October* (Winter 1981).
BOURDON, DAVID. "A Heap of Words About Ed Ruscha." *Art International* (November 1971).
————. "A Redefinition of Sculpture," catalogue essay. *Carl Andre Sculpture 1959–1977* (Laguna Gloria Art Museum, Austin, Texas, 1978).
BURNHAM, JACK. "Alice's Head: Reflections on Conceptual Art." *Artforum* (February 1970).
BUTTERFIELD, JAN. "Interview With Wayne Thiebaud." *Arts* (October 1977).
CASTLE, TED. "Jene Highstein: A Full Roundness." *Artforum* (November 1979).
————. "Suzanne Harris: The Energy of Time." *Artforum* (Summer 1980).
COLLINS, JAMES. "Painting, Hybrids and Romanticism: John Baldessari." *Artforum* (October 1974).
CRIMP, DOUGLAS. "Richard Serra: Sculpture Exceeded." *October* (Fall 1981).
DELAHOYD, MARY. "Seven Alternative Spaces: A Chronicle, 1969–75," catalogue essay. *Alternatives in Retrospect* (The New Museum, 1981).
GABLIK, SUZI. "The Graffiti Question." *Art in America* (October 1982).
GABRIELSON, WALTER. "Narrative/Humanist Painting in Los Angeles in the Seventies," catalogue essay. *Decade* (Art Center College of Design, 1981).
GELDZAHLER, HENRY. "Hockney Abroad: A Slide Show." *Art in America* (February 1981).
GILBERT-ROLFE, JEREMY. "Appreciating Ryman." *Artforum* (December 1975).
HICKEY, DAVE. "Available Light," catalogue essay. *The Works of Edward Ruscha* (San Francisco Museum of Modern Art, 1982).
HORVITZ, ROBERT. "Chris Burden." *Artforum* (May 1976).
KAPROW, ALLAN. "Roy Lichtenstein," catalogue essay. *Roy Lichtenstein at Cal Arts* (California Institute of the Arts, 1977).
KONTOVA, HELENA. "From Performance to Painting." *Flash Art* (March 1982).
KOZLOFF, MAX. "The Poetics of Softness," catalogue essay. *American Sculpture of the Sixties* (Los Angeles County Museum, 1967).
LARSON, KAY. "For the First Time Women Are Leading Not Following." *Art News* (October 1980).
LEIDER, PHILIP. "Stella Since 1970," catalogue essay. *Stella Since 1970* (The Fort Worth Art Museum, 1978).
LINKER, KATE. "Melodramatic Tactics." *Artforum* (September 1982).
LIPPARD, LUCY. "The Structures, The Structures and the Wall Drawings, The Structures and the Wall Drawings and the Books," catalogue essay. *Sol LeWitt* (Museum of Modern Art, 1978).
LOEFFLER, CARL. "Popularizing the Populist Or Performing Popularistic Populism." *Art Com* (Number 20, 1983).
LYOTARD, JEAN-FRANCOIS. "The Works and Writings of Daniel Buren." *Artforum* (February 1981).
McEVILLEY, THOMAS. "James Lee Byars and the Atmosphere of Question." *Artforum* (Summer 1981).

MELVILLE, STEPHEN. "How Should Acconci Count For Us?" *October* (Fall 1981).

NEMSER, CINDY. "Subject-Object: Body Art." *Arts* (September/October 1971).

NODELMAN, SHELDON. "Sixties Painting and Sculpture." *Perspecta 11 Yale Architectural Journal* (1967).

OWENS, CRAIG. "Amplifications: Laurie Anderson." *Art in America* (March 1981).

———. "Back to the Studio." *Art in America* (January 1981).

———. "Phantasmagoria of the Media." *Art in America* (May 1982).

———. "Telling Stories." *Art in America* (May 1981).

PERRONE, JEFF. "Jan Groover: Degrees of Transparency." *Artforum* (January 1979).

PINCUS-WITTEN, ROBERT. "Blasted Allegories: The Photographs of John Baldessari," catalogue essay. *John Baldessari: Art as Riddle* (University Art Galleries, Wright State University, 1982).

PLAGENS, PETER. "Present Day Styles and Ready Made Art." *Artforum* (December 1966).

RATCLIFF, CARTER. "Mostly Monochrome." *Art in America* (April 1981).

RICARD, RENE. "Not About Julian Schnabel." *Artforum* (Summer 1981).

———. "The Pledge of Allegiance." *Artforum* (November 1982).

RICKEY, CARRIE. "Decoration, Ornament, Pattern and Utility." *Flash Art* (June/July 1979).

———. "Naive Nouveau." *Flash Art* (Summer 1980).

ROBBINS, D.A. "The 'Meaning' of 'New'—The 70s/80s Axis: An Interview With Diego Cortez." *Arts* (January 1983).

RORIMER, ANNE. "Michael Asher: Recent Work." *Artforum* (April 1980).

ROSENBERG, HAROLD. "Twenty Years of Jasper Johns." *The New Yorker* (December 26, 1977).

ROTH, MOIRA. "Towards a History of California Performance." Parts I, II. *Arts* (February, June 1978).

RURIN, WILLIAM S. "Frank Stella," catalogue essay. *Frank Stella* (Museum of Modern Art, 1970).

SCHJELDAHL, PETER. "David Salle: Interview." *Journal of the Los Angeles Institute of Contemporary Art* (September/October 1981).

———. "The Ardor of Ambition." *Village Voice* (February 23, 1982).

SMITH, BARBARA. "Paul McCarthy." *Journal of the Los Angeles Institute of Contemporary Art* (January 1979).

SOLOMON-GODEAU, ABIGAIL. "Playing in the Fields of the Image." *Afterimage* (Summer 1982).

SOLOMON, ALAN. "New York: The Second Breakthrough 1959–64," catalogue essay. *New York: The Second Breakthrough 1959–64* (University of California, Irvine, 1969).

STIMSON, PAUL. "Fictive Escapades: Douglas Huebler." *Art in America* (February 1982).

STUCKEY, CHARLES. "Andy Warhol's Painted Faces." *Art in America* (May 1980).

TUCKER, MARCIA. "An Iconography of Recent Figurative Painting." *Artforum* (Summer 1982).

VAN BRUGGEN, COOSJE. "The Realistic Imagination and the Imaginary Reality of Claes Oldenburg," catalogue essay. *Claes Oldenburg: Drawings, Watercolors and Prints* (Moderna Museet, 1977).

WALLACE, JOAN, and GERALYN DONOHUE. "Edit deAk: An Interview." *Real Life Magazine* (Spring/Summer 1982).

WORTZ, MELINDA. "Surrendering to Presence: Robert Irwin's Esthetic Integration." *Artforum* (November 1981).

"Expressionism Today: An Artists' Symposium." Interviews with Nineteen Artists. *Art in America* (December 1982).

"Kinds of Realism: Questions to Beal, Beckman, Close, Estes, Georges, Leslie, Pearlstein." *Allan Frumkin Gallery Newsletter* (Winter 1979).

"Situation Esthetics: Impermanent Art and the Seventies' Audience." Questions to Sixteen Artists. *Artforum* (January 1980).

INDEX